"For many decades, the Kuyperian tradition has ~~...~~ ishing a Christian imagination in the world of the ⌐⌐. ⌐⌐⌐ excellent collection proves the point, as well as demonstrating how Neo-Calvinism can resource artists and Christian thinkers to tackle together the challenges of the future."
Jeremy Begbie, Duke University

"*The Artistic Sphere* is an engaging antidote to stereotypes that often cluster around Calvinism and visual images. These essays are not characterized by a uniform viewpoint. There are refreshing differences of emphasis and interpretation in the way topics like beauty, the imagination, or the social roles of art are discussed. This book is an excellent introduction to how the visual arts were and are shaped, understood, and used in Reformational cultures."
Theodore Prescott, emeritus professor of art at Messiah University

"These carefully selected essays from over a dozen theorists offer a fascinating tour of the rich perspectives and signature insights of the Kuyperian aesthetic tradition. The result is a first of its kind: a feast of theorists, central ideas, and productive themes that form the most significant tradition of theological aesthetics in the modern world. This rich collection evinces what those within the tradition have long believed: the Neo-Calvinist approach is invaluable for anyone seeking to offer a theological engagement with the arts in the twenty-first century. It's exactly what we have been needing: a readable overview of the most influential, least-known theological aesthetics in the modern period. What a gift!"
Robert Covolo, Fuller Seminary, author of *Fashion Theology*

"*The Artistic Sphere* is an indispensable collection of essays, skillfully tracing the legacy of Reformed theological aesthetics for over one hundred years, from Kuyper to Romaine and beyond. With its Christian perspective deeply rooted in Scripture, this book offers a redemptive model for those in art and theology."
Sandra Bowden, artist, collector of religious art, and curator

"This book serves as an excellent example of how commitment to a theological tradition can represent not the narrowing down of a vision for the arts, in this case the visual arts, but an expansive vision for such arts; how rootedness within a particular tradition results not in limited possibilities for the arts but in richly varied possibilities for both content and form; and how the faithful immersion in an artistic tradition, here a Neo-Calvinist one, leads not to the stifling of honest debate but instead to generative discourse. This book is a tremendous gift to the heirs of the Kuyperian tradition—and to those of us also who stand outside it."
W. David O. Taylor, associate professor of theology and culture at Fuller Theological Seminary and author of *Glimpses of the New Creation*

"During my days as an art student, I hungered for a Christian worldview that celebrated the visual arts. When I came upon the writings of Francis Schaeffer and Hans Rookmaaker, it was a welcome feast. Their books introduced me to Reformed thought and led me naturally to the writings of Nicholas Wolterstorff, Calvin Seerveld, and E. John Walford—brilliant thinkers, all featured in this collection— who mined theological and aesthetic territory in fresh ways while remaining grounded in the material world and attuned to the artist's vocation. Like all traditions, Neo-Calvinist aesthetics advanced in fits and starts, but in this volume co-editors Roger D. Henderson and Marleen Hengelaar-Rookmaaker present a fine selection of essays, old and new, giving us a first-rate primer on visual art and Christian faith viewed through the lens of Reformed thought."

Cameron J. Anderson, visual artist and author of *The Faithful Artist: A Vision for Evangelicalism and the Arts*

EDITED BY
Roger D. Henderson and
Marleen Hengelaar-Rookmaaker

The

ARTISTIC
SPHERE

THE ARTS IN
NEO-CALVINIST
PERSPECTIVE

ivp
Academic
An imprint of InterVarsity Press
Downers Grove, Illinois

InterVarsity Press
P.O. Box 1400 | Downers Grove, IL 60515-1426
ivpress.com | email@ivpress.com

Cover design: David Fassett
Interior design: Daniel van Loon
Cover images: Getty Images: © Adrienne Bresnahan, © oxygen

ISBN 978-1-5140-0797-6 (print) | ISBN 978-1-5140-0798-3 (digital)

Printed in the United States of America ∞

Library of Congress Cataloging-in-Publication Data

Names: Henderson, Roger Douglas, editor. | Hengelaar-Rookmaaker, Marleen,
 editor.
Title: The artistic sphere : the arts in neo-Calvinist perspective / edited
 by Roger D. Henderson and Marleen Hengelaar-Rookmaaker.
Description: Downers Grove, IL : IVP Academic, [2024] | Includes
 bibliographical references and index.
Identifiers: LCCN 2023027071 (print) | LCCN 2023027072 (ebook) | ISBN
 9781514007976 (paperback) | ISBN 9781514007983 (ebook)
Subjects: LCSH: Christianity and art–Reformed Church. | Calvinism.
Classification: LCC BX9423.A77 A78 2024 (print) | LCC BX9423.A77 (ebook)
 | DDC 230/.42–dc23/eng/20230712
LC record available at https://lccn.loc.gov/2023027071
LC ebook record available at https://lccn.loc.gov/2023027072

30 29 28 27 26 25 24 | 13 12 11 10 9 8 7 6 5 4 3 2 1

DEDICATION

None of our predecessors were faultless but one, the son of Mary. If any of us were half as upright as sinners such as Calvin, Rembrandt, George Washington, or Abraham Kuyper, we should be very thankful. The confession of sin and of Jesus Christ as Lord, asking, "Thy will be done," is the only way any of us may ever be squeezed through the narrow gate into God's presence.

CONTENTS

ACKNOWLEDGMENTS

IF WE, WE BLESSED FEW who could contribute to this book, have done anything non-trivial, let us give thanks. Thanks because we have beheld meaning and value in artistic work which none of us will ever fully comprehend. Thanks be to God, the One who gave us an artistic sphere, artisans to unfold its possibilities, writers to write about it, and editors to bring a project like this to completion.

Ida Slump, your early encouragement helped give birth to it. Marleen, you rescued it when it stumbled—and saw it through thick and thin almost to the very end. Reneé van Riessen and Adrienne, your advice helped keep it on track. You, many artists, authors, advisers, printers, and two publishers, we thank you for your work, artistic and otherwise, and for your long-suffering labor in bringing this book to print—twice, once in Dutch and now in English.

INTRODUCTION

ROGER D. HENDERSON AND MARLEEN HENGELAAR-ROOKMAAKER

IN ORDER TO UNDERSTAND what is meant by "art in the Kuyperian tradition" or in what is sometimes called Neo-Calvinism, it is necessary to find out what John Calvin himself said and thought about art. The influence of Calvin's theology on the history of art has often been overlooked or subjected to misleading statements and stereotypes. For this reason chapters one and two of this book are devoted to clearing away caricatures of his ideas and showing how Abraham Kuyper (and other Christians) have been able to build fruitfully on Calvin's thinking about art.

The primary focus of this book is on the visual arts. Its contributors are art historians, philosophers, especially of aesthetics, and theologians, most of whom have been influenced by Neo-Calvinist or Kuyperian insights. Attention is given to this intellectual (philosophical and theological) tradition that was inaugurated in the Netherlands but has also been developed and carried forward in Canada, and the United States, as well as Australia, South Korea, South Africa, and Brazil.

The book and its essays are born out of the conviction that when the apostle Paul says, "We are God's handiwork, created in Christ to do good works, which God prepared in advance for us to do" (Eph 2:10), this also applies to artistic work. We humans are shaped by whatever culture we are exposed to, and it is indeed a great blessing to be surrounded by tangible artistic expressions of faith in Christ, especially ones skillfully fashioned.

This book has been made as accessible as possible. Its authors were encouraged to include short discussions of an artwork that would show what their view of art revealed when applied. Many color illustrations have also been included, as works of art is what this book is all about. Some of the chapters were written for a wide audience, others for a more philosophically oriented audience. In the last, theological section of the book, an overview is given by Victoria Emily Jones of developments in the area of theology and the arts that should help acquaint the reader with the recent flowering of this venerable discipline. Strictly speaking, her chapter colors outside the lines of Calvinism alone, as she also discusses representatives of other theological traditions.

A lot is going on in this book. There are crosswinds of agreement and disagreement, but the one constant is a gale-force wind saying, "Let there be art"; let us speak and be spoken to by the light, texture, shape, and sound of artistic works. The differences of viewpoint that emerge in this book, although potentially confusing, should be read as affirming the meaning-laden richness of art, an intrinsic part of God's inexhaustibly variegated creation.

The first two chapters show the surprising way in which the Calvinist tradition inspired great artistic work. In the opening chapter Marleen Hengelaar-Rookmaaker sketches a brief account of Calvin's view of the visual arts and then traces the way this vision has affected artistic developments in the following centuries, especially in the Netherlands. The chapter offers a well-informed tour (de force) of artworks and artists inspired by Calvinist Christianity from the sixteenth to the twenty-first century. In chapter two Adrienne Dengerink Chaplin scrutinizes in greater detail the historical context of Calvin's attitudes toward the arts. She considers the question, Did Calvin, as a deep thinker and highly nuanced writer, really hold a negative view of the arts, or was it the temptation toward superstitious and misdirected worship that motivated his warnings against images? She then assesses his influence on future generations.

In the third chapter Roger Henderson discusses Abraham Kuyper's Neo-Calvinist system of thought and how it gave rise to a heightened appreciation of the arts among Christians. Kuyper saw the visual arts as a God-given part of creation, meant for the glory of God and human enjoyment.

The same author describes in chapter four how Kuyper's idea of spheres received further philosophical development in Herman Dooyeweerd's systematic philosophy. Each sphere of life, he argues, has a center or focal point which characterizes its distinctive meaning, and all of the spheres together express and refer back to a unified whole pointing to God. The core of the aesthetic sphere is said to be harmonious arrangement: separate elements and groups of elements harmoniously organized for appreciation and understanding.

In the next chapter Hans Rookmaaker (1922–1977) discusses a series of paintings in Western art history to show how and why visual art has taken on disproportionately great significance, at the same time addressing the norms and qualities artists have pursued in their works. He shows how artworks make visible particular views of life and the world and the way they reflect the values of their culture and project their own priorities into that culture. He concludes that Christian artists should strive to speak truthfully, portraying both the beauty and brokenness of human and non-human nature. Rookmaaker distinguishes between modern art that expresses the meaninglessness and absurdity of life and contemporary art that is up to date in its forms yet free from the ideas of the modern avant-garde. Artists, he believes, should avoid superficiality, romanticism, and triteness in their work. Freedom, he says, is a necessary condition of creativity, good art, and true Christian faith.

In chapter six art historian John Walford, who studied under Hans Rookmaaker, incisively traces the development of his discipline and distinguishes the various perspectives and inner dynamics that have shaped it in the years leading up to the present. He considers the historical, sociological and philosophical impulses that played a significant role in its evolution. This essay affords the reader a rare glimpse into the major figures and themes that resulted in the neglect of certain periods of art history, while others were highlighted.

In chapter seven art historian James Romaine, who studied under John Walford, deals with the question whether we can use abstract art for Christian expression. He starts by quoting Hans Rookmaaker, whose answer was, "Why not?" yet added, "But I've never seen a good abstract painting because I ask for much more reality in a painting than what can be conveyed by

non-figurative means." Romaine then critically examines *I See the Promised Land (After the Rev. Dr. Martin Luther King, Jr.)*, a painting from 2000 by Tim Rollins and K.O.S., in which, he argues, abstraction encourages the viewer to look at a reality that is beyond the parameters of what can be seen. He then goes on to discuss Rookmaaker's understanding of Peter Paul Rubens and Jan van Goyen to assess how their art expresses more than the eye can see. Next he focuses on the art of Mondrian, which Rookmaaker critiqued for its lack of content and its negation of the value of reality around us. Romaine goes on to explain why he thinks Mondrian's paintings offer a very rich sense of reality.

Calvin Seerveld's topic is the many-sided gift of God to humanity called imagination. Imagination, he says, is an elementary part of existence given to us to be creative, make discoveries, grow in knowledge, and communicate in different and deeper ways than through reason alone. Various passages of Scripture are cited to show that we as humans are made to create and name things like fire, herbal tea, soap, and bubbles. He then mentions examples of God himself using imagination in making trees, chickens, cows, and exotic animals like lobsters and peacocks. Although imagination is a basic feature of existence, it can be used well or badly. Even though it is an excellent gift it also enables us to say no to God, to bring about trouble and destruction. Seerveld's next observation is that the Bible itself communicates to us in imaginative ways, with God's approval. Imagination is used in a special, full-time way by artists in creating works of art. This, however, does not mean that artists have a monopoly on its use. All human life involves imagination. In trying to explain why imagination and the arts have sometimes been viewed negatively, he points out misleading Bible translations and one-sided identification of imagination with the making of false images or idols. An opposite exaggeration arose in the Romantic idea of imagination in which art was seen as a source of revelation. After this the proper function of imagination within the arts is outlined. The chapter ends with an application of these insights to certain works of art.

The goal Nicholas Wolterstorff sets for himself in chapter nine is to show that Western aesthetics has unnecessarily narrowed down art to the single function of its contemplation, primarily in museums. By way of contrast he argues there is a much wider scope of artistic work present in almost

every area of life in every culture. He says he no longer approaches art in terms of action (as he did in his earlier book and period) but now sees it as embedded in social history, and as forming a social practice. He wants to liberate us from what he calls the "grand narrative of the arts," namely the idea and social practice that sees the purpose of art as only contemplation—high, refined, and separated from the rest of life. Instead we should recognize that memorial art, woodturning, photography, architecture, drama, fiction, sculpture, poetry, ceramics, hymns, folk songs, work songs, film, painting, and the like all function as art in the social dynamics of culture. In an early part of the chapter, Wolterstorff associates Kuyper with the grand narrative, but he ends by noting that Kuyper appreciated the way art can dignify the ordinary, opening our eyes to small, important, but seemingly insignificant things.

After analyzing the aesthetic dimension and asking what art is, Lambert Zuidervaart develops various ideas in chapter ten about how to ensure that the unique voice of art in culture receives sufficient support. Although vulnerable, he says, the arts and the artist are in a unique position to point out the inequalities and injustices of society. However, in order to assure that their messages are heard, the social and economic structure of Western society needs to be adapted. Zuidervaart explains how this adaptation could be brought about. At the end of the chapter he gives an interesting overview of the relationship between his ideas and those of the other authors in this book.

Chapter eleven digs deep into the physiology of aesthetic experience. Here Adrienne Dengerink Chaplin reviews what four philosophers say about how we, as humans and bodily organisms, respond to artworks and artistic events. She discusses what goes into a work of art and what such works elicit in our senses, emotions, and minds—much of it pre-consciously. Art is defined as the symbolic projection of feeling(s) into audible forms and visible shapes. Our engagement with it discloses feelings and meanings we could otherwise not normally grasp intellectually. As articulated prereflective feelings, art stirs and educates us in ways usually unavailable to the intellect or consciousness. This, she says, is how art can help us to recognize and explore deep nuances of meaning. She concludes by elaborating on themes met with in the chapters by Seerveld, Wolterstorff, and Zuidervaart. She builds on

them as well as on various things Scripture seems to imply about art, the body, and human feelings as given parts of God's good creation.

In a sensitive and carefully thought-out essay, William Edgar asks the question whether the traditional stress on beauty in the arts should be dispensed with, as Calvin Seerveld and others suggest. The question is addressed from various angles, and Seerveld's views on the subject are considered in detail. While Edgar distances himself from Platonic and other Greek views, he recognizes a certain inevitability and rightful place of beauty in art.

In chapter twelve Wessel Stoker discusses Gerardus van der Leeuw and Paul Tillich's ideas about art and religion. Though Gerardus van der Leeuw was a Calvinist, he distanced himself from the Neo-Calvinist thinkers of his time. Instead he recognized Paul Tillich as a suitable ally. He strongly influenced the development and reception of art in Holland's Reformed churches in the second half of the twentieth century. Wessel Stoker concentrates on the question of what makes an artwork religious. He attempts to define what the two theologians understand by religion and what properties they think qualifies an artwork as religious. Tillich, according to Stoker, considers this topic to be important because religious artworks are said to potentially function as religious revelation.

Victoria Emily Jones rounds off the book with a highly informative survey of ongoing art initiatives, programs, and institutions in the area of theology and art. Jones provides us with a fitting climax to our long tour of Christian artworks, people, and ideas. She offers an insightful view into how a renewal of artistic interest among Christians took place in the early seventies, one that has spawned artistic and institutional activity up to the present day. It is an outstanding overview of what has been happening among Christians in the arts in recent years. Along the way she summarizes and comments on many of the major themes and questions discussed in earlier chapters.

Our hope is that this book will spawn new reflection and discussion, and most of all encourage a wealth of new artistic work to the glory of God.

Part One

ROOTS

GENEVA'S ARTISTIC LEGACY: FROM CALVIN TO TODAY

MARLEEN HENGELAAR-ROOKMAAKER

THE REFORMATION HAD AN IMPACT NOT ONLY on the faith and theology of its followers but also on how they viewed the visual arts. As with other Protestant traditions, Calvinism developed its own relationship to art. To narrow our focus, our topic here will be Calvinism and art in the Netherlands, with an occasional mention of artistic developments and artists in other Calvinist countries.

By giving a historical overview of Calvinism and art, this chapter serves as an introduction to the rest of the book and will touch briefly on topics amplified in other chapters.

CALVIN AND HIS FOLLOWERS

In his *Institutes*, Calvin writes, "I am not gripped by the superstition of thinking absolutely no images permissible, but because sculpture and painting are gifts of God, I seek a *pure and legitimate use* of each."[1] This statement deals a square blow to all who think, many Calvinists included, that there is no place for visual art in the Reformed tradition. It makes clear that Calvin was not against the arts in general but that he was against those

[1] John Calvin, *Institutes of the Christian Religion* (London: Westminster, 1960), 1.11.12.

works of art that were *impure* on the one hand or *used in an improper way* on the other hand. He gave the following guidelines for what he considered "pure" art: submission to the Word of God, humility, sobriety and simplicity, faithfulness to the nature of things, skill, harmony, and moderation. That Calvin was positive about art in general should actually not surprise us, as his theology embraces all of creation as a good gift from God, including the gift of art.

What did Calvin consider to be an improper use of art? Critical of the devotional practices of his time, Calvin was wary of the danger of idolatry. He was against the veneration of images of Mary and the saints and the custom of praying before and through them. In order to prevent this, he not only advocated for the removal of these images from churches but also ordered that the doors of churches should be closed during weekdays. This is in line with his emphasis on the direct relationship humans can have with God. God is always with us; we can always communicate with him. We do not need to go to a church or stand before a statue in order to pray to him. We can and we should, according to Calvin, live our life of faith at home and in the world.

As to worship services, Calvin's emphasis was on the preaching of the Word. He saw the presence of images as a distraction from the inward focus on the Word of God read, preached, and sung. Calvin's theology also placed great emphasis on the Holy Spirit and his work in us during the church service. Five centuries later we may ask if images might not also help us to inwardly focus on God, but to Calvin images in churches fell in the category of improper use. However, it is not true that Calvin ordered the iconoclasm of his day. Rather, he wanted the magistrates to remove the paintings and sculptures in an orderly fashion.

Calvin also objected to images of God and Jesus. This sprung first of all from the second commandment and a fear of idolatry, but also from a concern that images of God and Jesus are bound to fall short of their majesty. Calvin said: "Surely there is nothing less fitting than to wish to reduce God who is immeasurable and incomprehensible to a five-foot measure!"[2]

[2]Calvin, *Institutes* 1.11.4.

To sum up Calvin's position, he cautioned that art should be used in the right way and that the art produced should be wholesome and pure. Granting this, he affirms and embraces the visual arts of his day: painting, sculpture, woodcuts, etchings, drawings, stained-glass windows, wood and stone reliefs, silver work, and scenes on tapestries.

As an example of the expanding Calvinist art production in the sixteenth century let us briefly consider a work by Gillis van Coninxloo. Born in Antwerp, after this city was reconquered by Spain in 1585, he fled to Frankenthal, a small Calvinist town near Heidelberg, Germany. This safe haven for many Calvinist artists became known for its tapestries and paintings of landscapes and, to a lesser extent, of biblical subjects. The Frankenthaler School, as this group of painters came to be called, made an important contribution to the development of landscape painting. Gillis van Coninxloo was the first painter who devoted himself to wood landscapes. Thus it comes as no surprise that in his *Elijah Fed by the Ravens* we see a combination of a large wood landscape and a small Elijah (fig. 1.1). Van Coninxloo moved to Amsterdam in 1595, as did many Calvinist painters who originally came from Flanders and France around this time. They were a major influence on the flowering cultural life of seventeenth-century Holland.

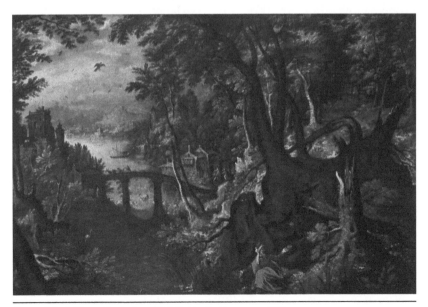

Figure 1.1. Gillis van Coninxloo, *Elijah Fed by the Ravens*, ca. 1590

THE SEVENTEENTH CENTURY

The seventeenth century in the Dutch Republic is usually referred to as the Dutch Golden Age. On the whole it was Calvinists who formed its trading, governing, and cultural elite. They lived in stately homes with rich interiors, in which art played a central role.[3] The Dutch Protestants actually did not call themselves Calvinists, which had a negative ring to it, but *gereformeerden*. They were not afraid to display their wealth, as prosperity was commonly thought to be willed and given by God. A moderate use of what creation has to offer was not considered sinful. Even a strict preacher such as Willem Teellinck was positive about art: "We also have decorated our houses impeccably with paintings and figures . . . as none of us has said that making sculptures or paintings is wrong in itself."[4]

This is remarkable, as it makes clear the distinct difference between the more art- and world-shunning Puritan culture of the English, Scottish, and Americans and the lifestyle of the Dutch. In the Netherlands, Puritans were read and valued for their teachings, but not for their behavioral dos and don'ts. Things that some *gereformeerden* considered worldly were the playing of cards, theater, dancing, and popular amusement—but not music (there was a lively culture of singing in the homes, usually accompanied by one or more instruments) and visual art. However, as to the latter it is possible to roughly distinguish between two streams: one that adhered strictly to Calvin's ideas about art and one that allowed itself more freedom. To the former belonged Jan Victors, a pupil of Rembrandt, in whose work no nudity or images of God, Christ, or angels were to be found. As to biblical works, he painted only Old Testament scenes.[5]

Jan Victors's painting *Abraham's Parting from the Family of Lot* depicts an Old Testament subject that has been portrayed by only a few others (fig. 1.2). After dissension arose between the shepherds of Abraham and Lot over inadequate pastures for both flocks, Abraham proposes here that Lot and he part ways, leaving the choice of direction to Lot. "Is not the whole land before you?" Abraham asks magnanimously. In Victors's

[3]Marianne Eekhout, *Werk, bid en bewonder. Een nieuwe kijk op kunst en calvinisme* (Walburg Pers/ Dordrechts Museum, 2018), 9.

[4]Eekhout, *Werk*, 9. The quote dates from 1611.

[5]Eekhout, *Werk*, 70.

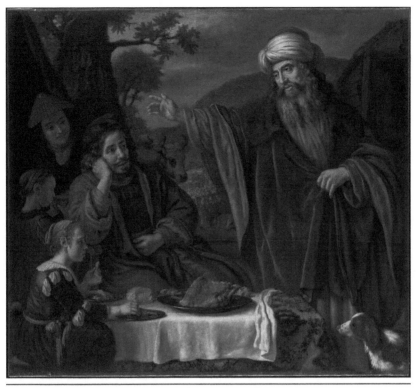

Figure 1.2. Jan Victors, *Abraham's Parting from the Family of Lot,* ca. 1655–1665

painting, Abraham bends toward Lot, longing to connect; he even seems to want to bless him. Lot (despite the quarrel between the servants in the background) is seated at the eating table with his family (not mentioned in the biblical text) but recoils, his hand on his stomach. His face speaks volumes. His wife behind him chuckles: what a fool is this Abraham. Lot chooses the "better" part and will end up in Sodom and Gomorra. As a paragon of faithfulness, the dog is located at Abraham's side. This is how this work contrasts the greedy broad way with the generous narrow way as a warning for the viewer.

The most well-known Reformed painter of the Dutch Golden Age was Rembrandt van Rijn. He is especially known for his portraits, mythological works, and biblical paintings. These biblical works were not made for churches but for the homes of citizens. Rembrandt stands out because of the craftsmanship, originality, and psychological depth of his work.

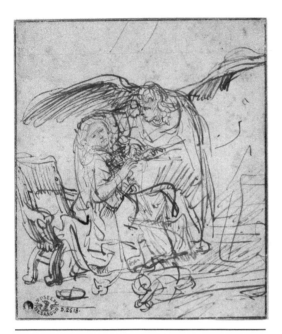

Figure 1.3. Rembrandt van Rijn, *The Annunciation*, ca. 1635. See the more elaborate discussion of this work by Marleen Hengelaar-Rookmaaker on the ArtWay website, www.artway.eu.

His drawing of the annunciation (ca. 1635) is dramatically different from the pious annunciation scenes we usually see with Mary and Gabriel reverently bowing toward each other (fig. 1.3). In Rembrandt's rendering of the conception of Jesus, Mary actually faints and slides from her chair when this impressive angel suddenly fills the room where she has been quietly reading her Hebrew Bible. She is portrayed as a woman of real flesh and blood. She looks flushed, perhaps ashamed about the intimacy of what is happening to her, while her shadowed face may also allude to the angel who "overshadowed" her. The angel looks at her full of concern, while extending his wing over her in a protective and blessing gesture.

Biblical scenes did not make up the principal part of the work produced by Reformed artists in seventeenth-century Holland, even though the genre of biblical history painting ranked highest in their regard. There were various other genres that gained prominence, such as portraits, landscapes, still lifes, church interiors, domestic scenes, and genre paintings. Portraits were sought after as people were viewed as made in the image of God, which meant that the individual increased in importance. Portraits furthermore tell the story of God's grace and care for people, while they also functioned as examples of virtue.

Another genre that had slowly come to the fore in the sixteenth century and blossomed in the seventeenth century was the still life, in which the objects also tended to have symbolical meanings. By way of this symbolism they dealt with the rich beauty of creation, the vanity of life, the danger of temptation, and the reality of sin. In the painting *Bouquet with Crucifix and*

Shell (1640s) by Jan Davidsz. de Heem and Nicolaes van Veerendael (fig. 1.4), we see different flowers, various fruits, and a large shell. They speak of the beauty of nature. But some flowers are almost at their end, and we also see some dry and fallen leaves and thistles. This is how the picture points to the transience and shortness of life. The clock makes this even clearer. Included in the picture are also a pen with a feather (symbol of frivolity) and a piece of paper on which is written: "But the most beautiful flower people do neglect" (*Maer naer d'Allerschoonste Blom / daer en siet men niet naer om*). This "flower" we see at the left: it is Christ on the cross, who came to redeem nature and life from their vanity. This picture is like a sermon that discusses creation, the fall, and redemption in one simple image.

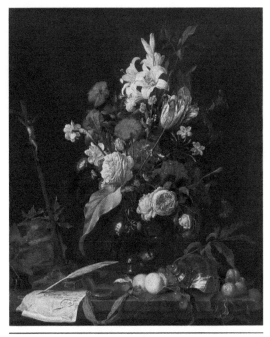

Figure 1.4. Jan Davidsz. de Heem and Nicolaes van Veerendael, *Bouquet with Crucifix and Shell*, ca. 1640

Then there are the genre paintings that portray domestic scenes and other slices of human life. As they depict the folly of human life, they usually contain a satirical undertone and a moral message. This genre, which goes as far back as Hieronymous Bosch, was further developed by Pieter Bruegel the Elder and his contemporaries and was continued by artists of the seventeenth century as an apt way to speak about the pitfalls of human behavior. These popular works were meant for education and entertainment.

Another important seventeenth-century genre was landscape painting. In these works nature is the main subject, which according to Calvin can be seen as God's second book of revelation and as a theater for the glory of God. These landscape paintings were not simple snapshots of actual

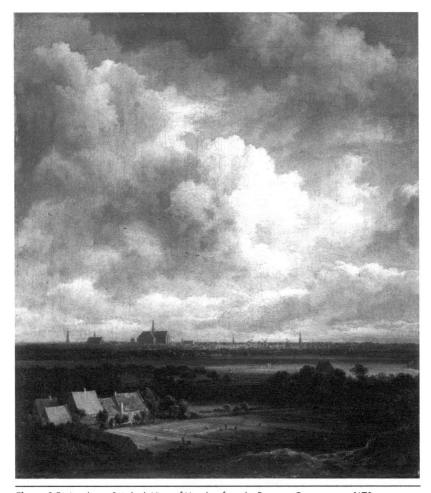

Figure 1.5. Jacob van Ruisdael, *View of Haarlem from the Dunes at Overveen*, ca. 1670

places, but all the elements in these works were chosen and interwoven with an eye to their meaning—a method John Walford calls "selective naturalism."[6] In Jacob van Ruisdael's *View of Haarlem from the Dunes at Overveen* (ca. 1670), we look down from the dunes over the fields toward Haarlem with its churches in the distance (fig. 1.5). The land in the foreground was reclaimed from the sea after flooding, thus pointing to damage and danger. However, we see restoration in the human commercial activity

[6]E. John Walford, *Jacob Van Ruisdael and the Perception of Landscape* (New Haven, CT: Yale University Press, 1992).

of the bleaching of the linen now taking place on the land. The sky makes up two-thirds of the painting, with the spire of the St. Bavo Church connecting earth and heaven. Some of the sky is blue, some parts of it are filled with clouds, but Haarlem itself—which adopted Calvinism around 1580— is gently flooded with heavenly light. In this way the painting speaks about God's presence and providence.[7]

Even though Reformed church interiors largely resisted representations of biblical figures and histories, it is not true that these churches were bare or that there was no appreciation of beauty. Recent research has shown that Dutch church interiors were not as sober as commonly thought.[8] The view we have of these interiors tends to be influenced by the austere picture the Dutch painter Pieter Saenredam painted of them, on the one hand, and by the whitewashed church walls of the nineteenth century, on the other. But in the seventeenth and eighteenth centuries, memorial boards hung against columns, along with decorated tombs, pulpits, and benches. The organ panels had paintings of biblical subjects, and coats of arms of magistrates and portraits of pastors adorned the walls. There were large illustrated (!) Bibles on lecterns, gilded chandeliers, delicately etched silverware for the Lord's Supper, and colorful stained-glass windows. There were wooden boards with beautiful calligraphy of, for instance, the Ten Commandments, which were accorded great significance for good conduct and were commonly read during the morning services.

We can conclude that the Calvinist artistic output of the seventeenth century reflects a rich and broad approach to life. It deals with the daily life of ordinary people, and it paints reality from a biblically informed worldview with a moral dimension. The goodness of creation, the brokenness and transience of life, our responsibility to live godly lives, and God's grace and providence are returning underlying themes. As to style, the Calvinist tendency is toward assimilation and adaptation rather than the development of a unique style of their own. Last but not least, it seems justified to say that the *gereformeerden* were characterized by a high visual literacy and a deep appreciation of skill and beauty.

[7]See the discussion of this work by James Romaine on ArtWay (www.artway.eu).
[8]Marijke Tolsma and Martin L. van Wijngaarden, eds., *Prachtig Protestant* (Zwolle, NL: Waanders, 2008).

THE EIGHTEENTH AND NINETEENTH CENTURIES

The seventeenth century drew to an end and with it its lavish art production. In the following century the cultural climate changed significantly, first due to economic stagnation and the decrease of the political importance of the Dutch Republic. Due to a waning of their wealth, its citizens were no longer able to fill their homes with works of art. It was also the age of the Enlightenment and the cultural dominance of the French, with its preference for the stylized beauty of Classicism on the one hand and the sentiment, soft colors, frivolity, and freedom from tradition of the Rococo on the other. Both these streams did not really fit the ethos and temperament of the *gereformeerden,* who lost their position as the social and cultural elite.

What Calvinist artists were active during this time? No well-known Reformed artist stands out in the eighteenth century. Recently I discovered two eighteenth-century paintings with Old Testament scenes in the old church of Wijk bij Duurstede, maker unknown. I suspect that there are more works like this, in other words that the production of art continued—though definitely reduced—by artists who now needed to struggle to survive. The truth is that this era of Protestant art still needs to be researched.

The same can be said about the nineteenth century, though to a lesser degree. We can, however, name a few Dutch artists of Calvinist leaning, such as Cornelis Kruseman, Ary Scheffer, Johannes Bosboom, and Vincent van Gogh.[9] This makes clear that among the mainstream of the Reformed—now called *hervormd*—there was at least some interest in art. This was less the case among the generally less well-off *kleine luyden* (little people) of the *gereformeerde* churches that in 1834 and 1886 split off from the more liberal mother church. It would seem that, especially through a lack of financial means (and not through any change in theology or teaching), the *gereformeerden* in the Netherlands lost their appreciation of art. Art—and their former rich visual culture—just bit by bit faded from their view.

Johannes (or Johan) Bosboom (1817–1891) specialized in church interiors, with seventeenth-century painter Emmanuel de Witte as his great example. In 1851 he married Truitje Toussaint, a well-known writer of historical novels

[9]See Eekhout, *Werk,* 98.

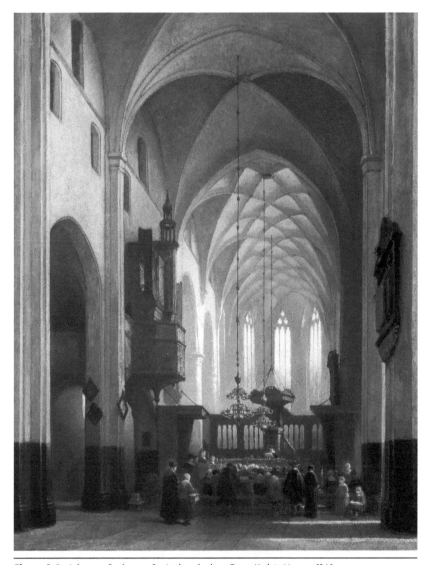

Figure 1.6. Johannes Bosboom, *St. Andreaskerk or Grote Kerk in Hattem*, 1860

who worked in the same Calvinist spirit as her husband. Besides oil paintings, he also made watercolors and sepia drawings of churches, often producing several versions of the same church. Here we see one of the paintings he did of the Andreaskerk in Hattem (fig. 1.6). It depicts the moment the afternoon service is about to begin, with the precentor just announcing the first psalm. You would think that Bosboom painted the scene as he saw it, but he actually

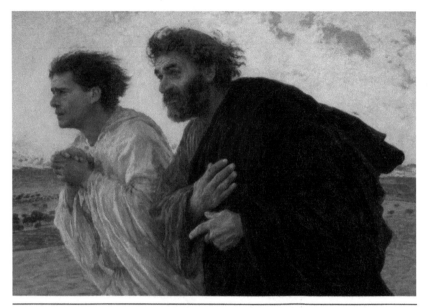

Figure 1.7. Eugène Burnand, *Peter and John Running to the Tomb*, 1898

rendered the people in seventeenth-century clothing and included several architectural and decorative elements that were no longer present in his time, such as the gothic tracery of the windows and the memorial plaques. Yet he did opt for the typically nineteenth-century whitewashed walls, which had previously been adorned with colorful medieval murals. In short, he was not interested in historical correctness, but rather in a seventeenth-century-like impression of the church interior that resembled his beloved models.

A Swiss Calvinist artist at this time was Eugène Burnand (1850–1921), who came from Moudon (close to Lausanne) but spent part of his life in Paris and elsewhere in France. He painted Swiss domestic scenes and landscapes but also illustrated a book about the parables and made biblical works, such as his famous *Peter and John Running to the Tomb* (fig. 1.7). In it we see the emotions of these two disciples powerfully portrayed: Peter aware of his guilt of his recent betrayal of Jesus and afraid to face him; John full of longing, but also so afraid that the tale of Jesus' resurrection may not be true after all.[10]

[10]See the discussion of this work by William Edgar on the ArtWay website (www.artway.eu).

In the latter half of the nineteenth century, a Calvinist artist of major importance was Vincent van Gogh. His father was a *hervormd* pastor and was part of a group of theologians called the Groninger School, which wanted to avoid any dogmatism and emphasized an inner surrender to Christ and a life of service to others. Thomas à Kempis and John Bunyan were widely read in this circle. Especially *The Imitation of Christ* and the radically committed lifestyle it advocates had a great influence on van Gogh with his intense personality.

Van Gogh painted landscapes, portraits, still lifes, domestic scenes, and biblical subjects, all of which we may recognize as closely connected to his Calvinist faith. He struggled to find ways to depict the world as God's creation and to show God's presence in all of reality. The naturalism and impressionism of his time, with their surface rendering of reality, made it necessary for van Gogh to look for new ways to represent meaning. In a letter to his brother Theo he says, "I would like to paint men or women with that indefinable something of the eternal, of which the halo used to be the symbol, and which we try to achieve through radiance itself, through the vibrancy of our colorations."[11]

To capture this presence and meaning, van Gogh's work became increasingly energetic and expressionistic. About van Gogh's faith, Jeff Fountain writes, "Critics traditionally have assumed van Gogh's disappointments with the church led him to break with institutional Christianity and to seek the divine in nature. Yet his own writings to Theo and his paintings of his latter phase bear witness to his preoccupation to the end with the person of Christ." For instance, in 1888, van Gogh said about Christ that "he lived serenely, as a greater artist than all other artists, despising marble and clay as well as color, working in living flesh. That is to say, this matchless artist, hardly to be conceived of by the obtuse instrument of our modern, nervous, stupefied brains, made neither statues nor pictures nor books; he loudly proclaimed that he made living men, immortals."[12]

[11] Letter from Vincent van Gogh to Theo van Gogh, September 3, 1888, https://vangoghletters.org /vg/letters/let673/letter.html and in Vincent Van Gogh, *The Letters of Vincent van Gogh*, rev. ed., ed. Ronald de Leeuw, trans. Arnold J. Pomerans (London: Penguin Classics, 1998).

[12] Letter from Vincent van Gogh to Theo van Gogh, June 23, 1888, in Van Gogh, *Letters of Vincent van Gogh*.

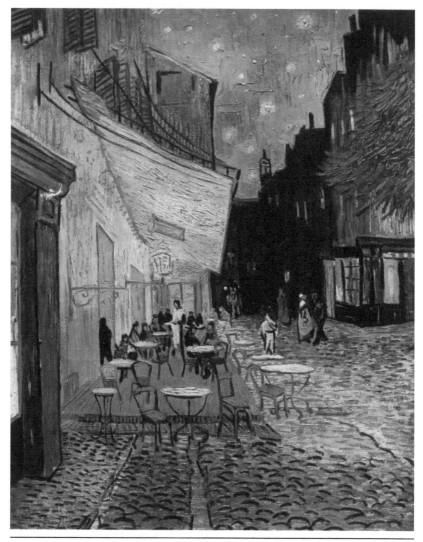

Figure 1.8. Vincent van Gogh, *Café Terrace at Night*, 1888. See Jeff Fountain's discussion of this work on the ArtWay website, www.artway.eu.

Recent research by independent researcher Jared Baxter, endorsed by various van Gogh scholars, declared *Café Terrace at Night* (fig. 1.8) "to depict the Last Supper, complete with a shadowy Judas slipping out the door, a central Jesus-figure with a cross behind him, and the remaining disciples seated at the tables. The whole scene is bathed in a golden-yellow

hue, van Gogh's typical allusion to the divine. Writing to Theo about this work Vincent said he felt a 'tremendous need for, shall I say the word—religion.'"[13]

THE TWENTIETH CENTURY—THEOLOGY, PHILOSOPHY, AND ART HISTORY

In the twentieth century the gap between the Christian community and the secular world of art became even wider, as avant-garde artists made work that was further and further removed in spirit from a Christian view of life. Yet there were also various theologians, philosophers, and art historians who emphasized once again the importance of art within a Christian framework.

In the Netherlands the first person since Calvin to point to the significance of art was Abraham Kuyper (1837–1920), who was a theologian and pastor, prime minister, leader of a political party, founder of a Christian university and editor-in-chief of a Christian newspaper. His impact on the Dutch Calvinist world was immense. He called himself a Neo-Calvinist, as he went back to Calvin and applied his thinking to his own time. Many know his famous quote, "There is not a square inch in the whole domain of our human existence over which Christ, who is Sovereign over all, does not cry, Mine!"[14] This also had its consequences for how he approached and appreciated art. One of his famous *Lectures on Calvinism* dealt with the visual arts. He also wrote a book on liturgy. He said, "The church is not hostile towards visual art, provided that it does not act as ruler and the outward beauty does not drive back the inner beauty."[15] He was a champion of good Christian art in all its breadth and even promoted murals and stained-glass windows in churches.

Kuyper's ideas were extrapolated into a philosophical system by Herman Dooyeweerd, in which art and the aesthetic were included as one of the

[13]Letter to Theo van Gogh, Arles, on or about 29 September 1888, in *The Letters of Vincent van Gogh*. See also the discussion of this painting by Jeff Fountain on ArtWay, https://artway.eu /content.php?id=2420&lang=en&action=show.

[14]Quote from Kuyper's inaugural address at the dedication of the Free University. Found in James D. Bratt, ed., *Abraham Kuyper: A Centennial Reader* (Grand Rapids, MI: Eerdmans, 1998), 488.

[15]Harry Boonstra, ed., *Abraham Kuyper: Our Worship* (Grand Rapids, MI: Eerdmans, 2009).

fifteen spheres of the created order. Hans Rookmaaker, a pupil of Dooyeweerd, became an art historian, while another of his pupils, Calvin Seerveld, specialized in the field of aesthetics. They both had pupils of their own: John Walford and James Romaine, for instance, follow in the footsteps of Rookmaaker, while Lambert Zuidervaart and Adrienne Dengerink Chaplin build on Seerveld's work. American Reformed philosopher Nicholas Wolterstorff also devoted a good share of his attention to the visual arts. In the Netherlands the art historian Willem Meijer also belonged to the Neo-Calvinist tradition.

These scholars did and do provide the conceptual framework for a tenaciously slow opening of the orthodox Protestant and evangelical world to the visual arts. Indeed, this process is still far from completed yet is definitely underway. These days there are many Reformed artists across the world making art for our homes and schools, for the public buildings and squares of our cities, for local galleries, and—when they are given the opportunity— for the more prestigious galleries and museums in the major cities of the world. In addition to this, many Protestant churches and—to a lesser degree—evangelical congregations have opened their doors to the visual arts and are developing an eye for the importance of beauty in the places where they worship.

Because this Neo-Calvinist line of reflection on the arts is only half the story of art in the Protestant world in the twentieth century, mention should also be made of Dutch Reformed theologian Gerardus van der Leeuw and German Lutheran theologian Paul Tillich, who each developed their own ideas about the visual arts. Tillich and van der Leeuw have impacted the more liberal Protestant churches. Tillich's influence is especially evident even today in various European countries and North America, while van der Leeuw's influence was limited to the Netherlands. Over the course of time, his followers incorporated Tillich's ideas.

Paul Tillich (1886–1965) contended that religion is not about a higher reality but instead deals with the meaning dimension of our own reality. Religion is not about God as object beside or above other objects, but about manifestations of the divine in and through all things. Hence religious art is not art that deals with a supernatural reality but art that deals with the search for and the experience of a deeper dimension of meaning in life. According

to Tillich, art should deal with existential questions; when it does so, art and religion are closely linked.

Gerardus van der Leeuw's (1890–1950) main undertaking was to clarify the relationship between art and religion. For him, art and religion are not the same; while religion deals with the holy and art with the beautiful, what is holy is more than what is beautiful.[16] He was concerned that the autonomous art of his time no longer had a need for religious subjects and that because of this art and religion had come to stand opposite each other as two hostile forces. It was this gap that he sought to bridge. His conclusion was that art should not be totally autonomous, but that real art should serve God and a higher reality.

Both these theologians were trying to formulate a response to an increasingly secular and autonomous art world. Van der Leeuw's work and the van der Leeuw Foundation, which his pupils founded in 1954, did much to introduce art into the mainline Reformed churches in the period of reconstruction with its many newly built churches after World War II. This new church art (murals, windows, sculptures, liturgical weavings, etc.) followed the modern idioms of the day, so that in its time this type of art was truly revolutionary. Indeed, I would call this period of introduction of art into mainline Calvinist churches a silent revolution, as what happened was totally new and unheard of in the history of Dutch Calvinism. In the 1940s to 1960s at least a part of this art was made by artists of faith, while increasingly non-Christian artists were involved in these projects.

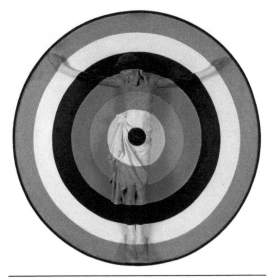

Figure 1.9. Jacques Frenken, *Crucifix/Target*, 1965–1966

[16]Gerardus van der Leeuw, *Sacred and Profane Beauty: The Holy in Art* (New York: Holt, Reinhart & Winston, 1963).

The followers of Paul Tillich had an even greater preference for the work of non-believing artists, as they stressed that art should ask questions and shock people out of their traditional beliefs. In the Netherlands these ideas were propagated by theologian Regnerus Steensma.[17] It led to the incorporation in church services of works like *Crucifix/Target* by Jacques Frenken (fig. 1.9).[18]

THE TWENTIETH CENTURY—ARTISTS

Roeland Koning (1898–1985) was one of the few Dutch Calvinist artists of the first half of the twentieth century. He studied art against his father's wishes. Koning did not want to paint "sweet Christian pictures" but rather wanted to capture the essence of his subjects, whether a portrait ("as human

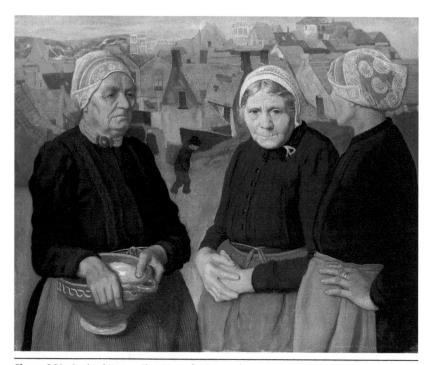

Figure 1.10. Roeland Koning, *The Wives of Fishermen from Egmond,* ca. 1927. See a discussion of Roeland Koning by Rob den Boer and a meditation on this work by José Verheule on the ArtWay website, www.artway.eu.

[17]Regnerus Steensma, *In de Spiegel van het beeld—kerk en moderne kunst* (Baarn, NL: Ten Have, 1987).

[18]See Regn. Steensma, ed., *Jezus is boos. Het beeld van Christus in de hedendaagse kunst* (Zoetermeer, NL: Boekencentrum, 1995), 84-85.

beings are the crown of creation"), a landscape, flower painting ("as a way to listen to God's voice in nature"), a still life, or biblical work. His painting of the crucifixion (1930) showed the crucifixion scene in all its raw reality. He also made a few works for churches. He won several prizes and awards, was a member of three renowned artist societies, and had exhibitions in various major Dutch museums.

From 1924 to 1927 he lived in Egmond aan Zee, a poor fishing town. There he painted the three women shown here (fig. 1.10). Recent research has discovered who these women are, uncovering bits of their hard lives, in which several of their children died young or at sea and they often had to cope by themselves when the men were out fishing. Koning portrayed them lovingly, with attention to the details of their costumes, caps, and jewels. How well he managed to capture their characters, their tested faith, inner strength, and quiet resignation.

Berend Hendriks (1918–1997) was one of the artists who actively participated in the church-building boom after World War II. Born into a Reformed

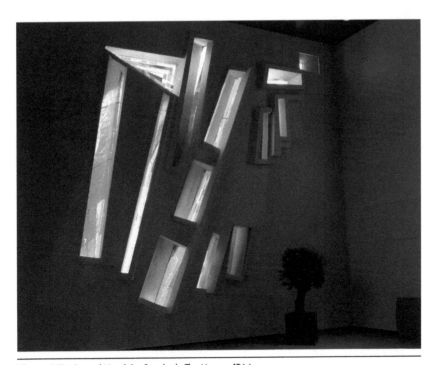

Figure 1.11. Berend Hendriks, Bergkerk, The Hague, 1964

horticultural family, he opted for art as his profession and still desired to serve his family background with his art. He studied at the prestigious Rijksacademie (National Academy) in Amsterdam, where Heinrich Campendonk was one of his teachers. He became a versatile artist who made paintings, murals, mosaics (especially with bricks), sculptures, and ceramics, and designed tapestries and windows (especially glass-in-concrete and glass appliqué). His abstract and semi-abstract works in these media found their way into a good number of newly built churches of modern architectural design.

About abstraction, Joost de Wal points out that it

> better matched the contemporary view of church and faith, which put a greater emphasis on the general and existential . . . than on the particular and distinguishing. Abstraction was "neutral" and meditative, a play of form and light that brought the holy closer without interference of figuration and traditional symbolism. Abstract art, moreover, was visual without being "image." Hendriks saw abstraction as the solution to the disintegration of a collective faith and the increase of individual convictions; via abstract art he could again unify all interpretations.[19]

As an example of this, his glass panels on the wall behind the pulpit in the Bergkerk (1965, originally Opstandingskerk) in The Hague (fig. 1.11) express a reality that is meaningful to all believers: "I wanted to indicate some lines from above to below and from below to above, from heaven to earth and from earth to heaven."[20] In its non-specified expression, the wall "will always reinforce the sermon and it will permanently point to the resurrection without being explicit."[21] Together with the windows in the two side walls, these glass bars are also about the Israelites' journey through the desert, with the horizontal panels at the sides depicting the people moving forward and the vertical ones at the front picturing God's presence in the column of fire.

[19]Joost de Wal, "Voorbij inktmop en verfspat. Nederlandse abstracte kunst en christelijke thema's: nieuwe beelden voor Avondmaal, kruisiging en opstanding," in Verdult Ph., ed., *God en kunst. Verdwijnen en verschijnen van het religieuze in de kunst* (Tielt, NL: Lannoo, 2009), 156-57.

[20]Regenerus Steensma, "Beeldende kunst na 1945. Theologische bezinning op het beeld," in *Honderdvijftig jaar gereformeerde kerkbouw*, ed. Regnerus Steensma and C. A. van Swigchem (Kampen, NL: Kok, 1986), 223.

[21]De Wal, "Voorbij inktmop en verfspat," 156-57.

The art of the 1960s to 1980s by Dutch orthodox Reformed artists was almost all figurative; it consisted of landscapes, portraits, still-life paintings, and church interiors. It was figurative art in a time in which abstract art was fiercely dominant. Against the tide of the art world, these artists persisted in making reality- and creation-affirming art.

Henk Helmantel (b. 1945) became the most well-known of these artists.[22] He mainly makes still-life paintings and church interiors (fig. 1.12). Over the course of the years, he has become one of Holland's bestselling artists, and in 2008 he was even elected artist of the year in the Netherlands. Even though his technique leans heavily on that of his seventeenth-century predecessors, his work has a contemporary feel to it. Although differing from his old models in a lack of symbolism, his paintings are serene and very beautiful.

Around the 1990s the art world became increasingly pluralistic and diverse. As in other areas of Western culture, the big stories of the various

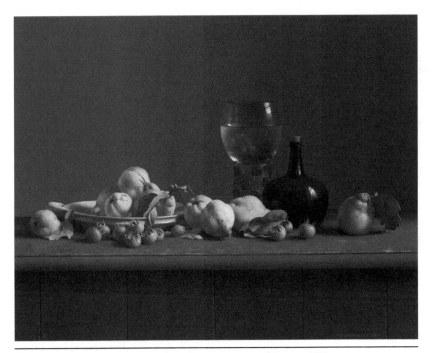

Figure 1.12. Henk Helmantel, *Still Life with Large Rummer and Quinces,* 2015

[22]Diederik Kraaijpoel and Hans van Seventer, *Henk Helmantel* (Aduard, NL: Art Revisited, 2000).

-isms—such as abstract expressionism and minimalism—lost their credibility, and a much more relativistic and tolerant art climate emerged. Figurative art became accepted again as one possible style among many others.

THE TWENTY-FIRST CENTURY

In today's art many styles, media, materials, and worldviews exist side by side. Contemporary art consists of installations, performance art, multimedia art, photography, video art, and computer art, besides old media, such as painting and sculpture. Contemporary works can be figurative, abstract, or conceptual.

As a start, let me mention three Reformed artists who make outstanding work in the figurative arena today. American artist Catherine Prescott (b. 1944) specializes in portraits and depictions of people. She does not just paint good likenesses of people but uses the tools of her craft with great purposefulness to bring out the character and emotional state of her sub-

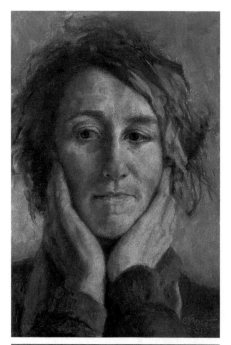

Figure 1.13. Catherine Prescott, *Daphne Holding her Neck*, 2015

jects. She does not idealize the people she paints. She makes their portraits intensely human and shows their struggles and vulnerability, but in a loving way (fig. 1.13). Her husband Theodore Prescott, also an artist, says this about her work: "The result is the uncanny sense that she has not only recorded how someone looks, but that she seems to know who they really are. In these paintings she separates portraiture from the common accusation that it necessarily flatters its subject and obscures true character."[23]

In the 1990s orthodox Reformed artists started to open themselves to religious subjects. This was the case in the Netherlands and the United States, but probably in other countries as well.

[23]Theodore Prescott, "Catherine Prescott: Three Portraits," https://artway.eu/content.php?id=1973&lang=en&action=show.

Before this their output had by and large limited itself to landscapes, portraits, and still-life paintings. Probably this was due to the Calvinist emphasis on the importance of all of life, the absence of church art, and the huge challenge of presenting religious and biblical subjects in a fresh and contemporary manner.

One artist whose work covers a broad array of themes (from landscapes and still-life paintings to social, religious, and biblical themes) is South African artist Zak Benjamin (b. 1951). His painting *Christ and Consumerism* (fig. 1.14) shows his originality in tackling religious themes. In it we see something that is a cross between an opened box of blocks and a computer. The blocks represent the building blocks of our lives or the keys that we hit again and again on our life's computer: a nice car, a big house, food, drink, relaxation, entertainment,

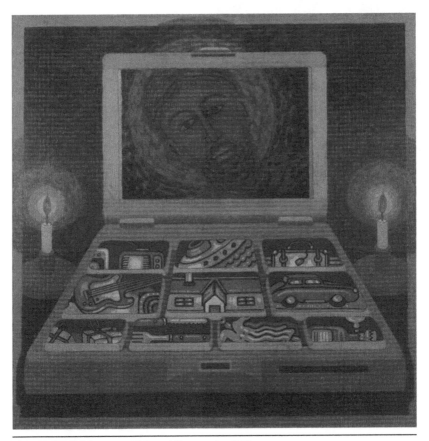

Figure 1.14. Zak Benjamin, *Christ and Consumerism*, 1999

Figure 1.15. Egbert Modderman, *Father and Son*, 2016

travel, television, and so on. They denote longings. The two burning candles beside the box stand for the religious and idolatrous quality of these building blocks. Yet, whatever key we hit, Jesus keeps on showing up on our screen, as he is the real fulfillment of all our longings. The screen cannot even contain him; he is much bigger than what we think we need.

In 2016 young Dutch artist Egbert Modderman (b. 1989) had his first solo exposition titled "The Beauty of Religion" in the Martinikerk in Groningen. Right away he sold all the twelve large, exhibited works, most of them with biblical themes. He comments: "These Bible stories describe human nature in all its simplicity, complexity and drama. I attempt to portray these human emotions in my work. My style can be described as figurative with a dramatic and religious flair." His painting *Father and Son* (fig. 1.15) deals with the story of the prodigal son, but instead of focusing on the father and the younger son—as is traditionally done—he portrays the father with the older son. We see this son taking care of his father, but while he is undeniably the "good" and responsible child, he looks the other way, showing that his head and heart are not really in it. The father on the other hand is all kindness, almost like an old fool extending his open hand to the younger son, to all of us. Though the black mantle of the son is contrasted with the white robe of the father, the collar of his shirt—a touch of grace—is white.

ABSTRACT ART

In the era of modern art, it was theoretically infused art movements such as cubism, De Stijl, constructivism, suprematism, abstract expressionism, and

minimalism that shaped the development and character of abstract art. Nowadays, abstraction has largely left this theoretical baggage behind and has become just another type of visual language. Just like abstract thinking, abstract art looks at reality from a distance so that it gets a better overview. It wants to get at the essence of things and leave out the particulars. Its aim is to capture basic processes and experiences that are applicable to various concrete situations—not a painting of one happy child, for instance, but a painting of the dynamics of happiness in general; not a portrayal of Jesus' resurrection, but of that which is characteristic of resurrection and new life. Through color, contrast, light and dark, lines, forms, and the title of the work, we as viewers can make all kinds of associations with various areas of reality. This means that abstraction is a visual language just like figuration and that it communicates to us, only in another way.

However, not all abstract art is directed toward representation. Sometimes it just wants to bring some color and beauty to a place while being mostly decorative or just wants to be a study in form or paint. Or it is out to create an atmosphere of serenity and peace. This is often the case with abstract art in churches.

Dutch artist Martijn Duifhuizen (b. 1976) likes to quote Mark Rothko: "There is more power in telling little than in telling all." In *Last Supper* (fig. 1.16), a minimalistic work from 2012, he has reduced the scene of the Last Supper to its essence. Here we see thirteen similar quadrangles; eleven are black with a thin golden rim, one is totally golden, and one is totally black. In this way Duifhuizen portrays divine and human nature. Jesus' rectangle is golden, while those of the disciples are black. Thanks to Christ

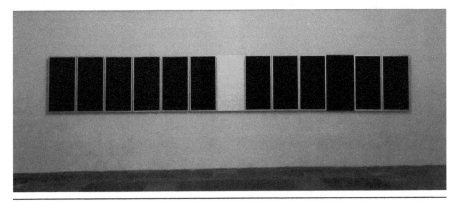

Figure 1.16. Martijn Duifhuizen, *The Last Supper*, 2012

Figure 1.17. Makoto Fujimura, *John—In the Beginning*, 2011

eleven have a golden rim, while Judas' rectangle is completely black "as Satan entered into him" (Jn 13:27). The artist remarks that the black is also meant meditatively: "Just as you become quiet when you enter a dark church, as if you enter a different frequency."

Presbyterian Makoto Fujimura's abstract and semi-abstract works have received wide recognition. Fujimura (b. 1960) is an American artist, born in

Boston to Japanese parents. As a student he acquainted himself with the ancient tradition of Nihonga painting in Japan. Besides an artist, he is also a writer, speaker, and cultural advocate.

John—In the Beginning (fig. 1.17) is part of a series of paintings commissioned by Crossway Publishing for an edition of the Gospels commemorating the four hundredth anniversary of the publication of the King James Bible. The painting shown here is the frontispiece of John's Gospel. Just like the first chapter of the Gospel of John, it deals with the origin of creation. We see splashes of bright red and blue and swarms of golden particles against a black background: glorious color, light and life overtaking the black void. We also see three green vertical lines, pointing to creation as a joint act by the three persons of the Trinity. As such, this painting is a representation of the mystery of creation.

CONCEPTUAL ART

Conceptual art started around 1960. It is a form of art in which intellectual and theoretical ideas tend to be more important than material considerations, including beauty. Conceptual artists begin with a concept for which they seek an adequate visual representation. To do so they move beyond the traditional borders of art and incorporate all conceivable materials, media, and objects: from found and made objects, paintings, photos, sculptures, texts and textile to sound, performance, and video. Conceptual works have addressed a varied array of themes: from social and political criticism to ideas about culture, nature, perception, reality, humanity, relationships, identity, suppression, and religious themes. They sometimes let us experience something. They can, for instance, create spaces that we can move around or lie down in, or they can have an interactive side by offering the viewer the opportunity to perform certain acts. They intend to offer us new insights and to renew our thinking. These works *can* be plainly obscure, but by now there are plenty of examples of installations that have appealed to a broad audience. The ones that do tend to be the ones that are carefully crafted and have beauty. Calvinist artists have also embraced this type of art. They have tied in with the reflective, critical, interactive, and socially minded sides of conceptual art in a way that is meaningful and enriching.

Figure 1.18. Margje Schuurman, *At the Other Side of the Door*, 2011

Margje Schuurman (b. 1988) is a young Dutch artist who is fascinated by the beauty and the deep layers of meaning in the "ordinary" and "simple" things of life. To convey and celebrate this meaning and beauty, she makes drawings, paper cuts, glass works, and installations. One of the things that draws her to installation art is the importance of connecting with a particular place. By acquainting herself with this place and the people who come there, works can materialize that fit in and belong there. In 2011 she made *At the Other Side of the Door* (fig. 1.18) for an exhibition in and around the buildings of the faculty of behavioral and social sciences of the University of Groningen. This work was placed in the Hortus, an old university garden designed to show the wonders of the world. The cut-out door suggests there is another world we can step into (literally in this case), like when we move into a new home, in a different country perhaps. The work may also refer to death or to a spiritual reality that is only a passage through a thin door away from us. Light is suggestively coming through the trees behind the door, while shadows darken the front—but another time of day and different weather will evoke another set of associations. The work makes me think of C. S. Lewis's *The Lion, the Witch and the Wardrobe*. It seems to be a child, after all, who is passing through the door. If you look carefully, however, the child may not be moving away from us but coming toward us. From this other reality someone is coming toward us! And the door is a person! This well-constructed work gives the attentive passer-by plenty to ponder.

Hans Thomann (b. 1957) is a Swiss artist whose sculptures and installations focus on the human figure and current concepts and ideals of humanity. His works ask questions about what it is that moves people today and where they are headed. He exhibits regularly inside and outside his country and he also makes works for churches, both Protestant and Catholic.

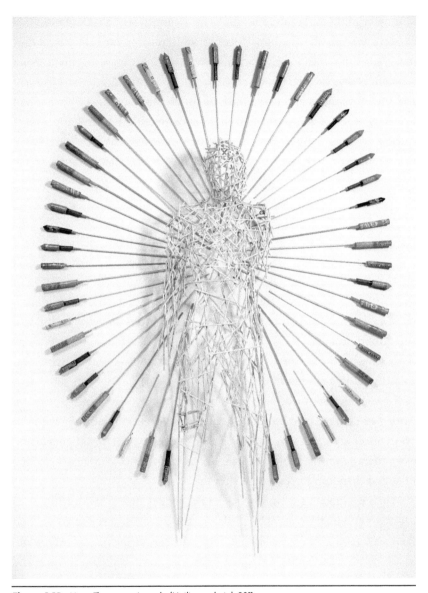

Figure 1.19. Hans Thomann, *Aureole (Heiligenschein)*, 2011

Thomann employs all kinds of materials and uses all kinds of modern techniques. He selects his materials for their meaning. In *Aureole* (fig. 1.19), for instance, the artist contrasts the rods of rebar steel of the human figure with wooden firework sticks. One material is nearly indestructible, and the

other will go up in flames in no time. The firework sticks radiate from this person's heart in all directions, forming an impressive aureole. Yet all they may do is shoot into the sky for all to see, produce a big bang, burst into a moment of dazzling light and evaporate. All that remains is a trail of smoke, and then nothing is left. It reminds me of the vanity theme of the book of Ecclesiastes. So much of our striving for riches, success, and approval is chasing after wind. But this white solid figure can also choose a humble life in contentment with God and devote himself to acts that "strengthen the things that remain."[24]

EPILOGUE

We have seen that throughout its history Calvinist art in the Netherlands and elsewhere has had its ups and downs. First there was a period of great flowering, especially in the Netherlands. This was followed by a period of increasing artistic poverty and lack of interest in art. In the twentieth century we saw a slow re-acceptance of the visual arts, which is now developing into what could become a new phase of flowering. It is certainly justified to say the latter when we look at the number of Protestant professional artists who are active at this moment.

Another development we have observed is the introduction of art in Reformed churches. To me this is a justified correction of Calvin's view of art in the church. There is no reason why images cannot be as beneficial to worshipers as words. Word and image each have their own way of speaking to us and therefore can complement each other.

When we look at the present art world, we see that it is not without its problems and that for young Christian artists especially it is not easy to find their way. Yet it is much easier than fifty years ago, as there is more freedom in the pluralistic art climate of today. Artists can look for their own voice and be accepted. When the quality and appeal of their work is high enough, they will even be appreciated by the art world, as the favorable reception of artists of faith in various countries show: Henk Helmantel and Marc Mulders in the Netherlands, Hans Thomann in Switzerland, Roger Wagner in the UK, David Robinson in Canada, and Makoto Fujimura in the United States.

[24]A quote from Bob Dylan's song "When You Gonna Wake Up?," *Slow Train Coming*, 1979, www.bobdylan.com/songs/when-you-gonna-wake/.

Artists can embrace what is good in today's art world and try to avoid its shadows. To my mind the greatest problem is that art is put on a pedestal and that, in order to meet this high calling, it has become esoteric and incomprehensible to most people. Hence the great challenge put before us—artists but also curators, museums, galleries, art critics, art educators, art websites, magazines, art organizations, and churches—is to bridge various gaps: between the art world and the public, between the Christian art world and the Christian public, and between the Christian culture and our culture at large. How great would it be if art would again be considered an important and valuable part of human life, if a new visual literacy would be developed, and church goers would once again start buying art?

What this asks for, above all, is a different mindset. We should stop regarding the artist as some sort of prophet who should be totally autonomous in all that he or she does. Instead, it would be much more helpful if artists would start to see themselves as servants: as servants of the communities, churches, and cultures they live in. Autonomy is not a biblical word; servanthood is. Makoto Fujimura recently introduced the term *culture care*, which wants to correct the old paradigm of hostility and suspicion between Christians and the culture surrounding them. Instead, he says, we should start to care for our culture with acts of generosity, care for our culture's soul, and offer it our bouquet of flowers.[25]

BIBLIOGRAPHY

Bakker, Nienke, Leo Jansen, and Hans Luijten, eds. *Vincent van Gogh—The Letters, The Complete Illustrated and Annotated Edition.* New York: Thames & Hudson, 2009.

Dyrness, William A. *The Origins of Protestant Aesthetics in Early Modern Europe: Calvin's Reformation Poetics.* Cambridge: Cambridge University Press, 2019.

———. *Reformed Theology and Visual Culture: The Protestant Imagination from Calvin to Edwards.* Cambridge: Cambridge University Press, 2004.

———. *Visual Faith: Art, Theology, and Worship in Dialogue.* Grand Rapids, MI: Baker Academic, 2001.

Eekhout, Marianne. *Werk, bid en bewonder. Een nieuwe kijk op kunst en calvinisme.* Walburg Pers/Dordrechts Museum, 2018.

[25] Makoto Fujimura, *Culture Care* (New York: Fujimura Institute, 2014).

Finney, Paul Corby, ed. *Seeing Beyond the Word: Visual Arts and the Calvinist Tradition.* Grand Rapids, MI: Eerdmans, 1999.

Fujimura, Makoto. *Culture Care.* New York: Fujimura Institute, 2014.

Geluk, C. G. *Cultuur in beweging. Een zoektocht naar creativiteit in het spoor van Calvijn.* Zoetermeer, NL: Boekencentrum, 2000.

Hengelaar-Rookmaaker, Marleen, and Aniko Ouweneel-Tóth, eds. *Handboek voor kunst in de kerk.* Amsterdam: Buijten & Schipperheijn, 2015.

Kraaijpoel, Diederik, and Hans van Seventer. *Henk Helmantel.* Aduard, NL: Art Revisited, 2000.

Kuyper, Abraham. *Lectures on Calvinism: Six Lectures from the Stone Foundation Lectures Delivered at Princeton University.* Grand Rapids, MI: Eerdmans, 1987.

——. *Onze Eeredienst.* Kampen, NL: Kok, 1911.

Leeuw, Gerardus van der. *Wegen en grenzen. Een studie over de verhouding van religie en kunst.* Amsterdam, 1932.

Meijer, W. L. *Kunst en maatschappij.* Goes, NL: Oosterbaan & Le Cointre, 1977.

——. *Kunst en revolutie.* Goes: Oosterbaan & Le Cointre, 1976.

Niet, C. A. de. *Johannes Calvijn Institutie.* Houten, NL: Den Hertog, 2019.

Oosterhof, Wout. *Niet door stomme beelden, het beeldenverbod in de hervormde traditie.* Gorinchem, NL: Narratio, 1991.

Pons, Anneke, ed. *Vensters op refodomes. Bevindelijke gereformeerden en moderne kerkbouw.* Apeldoorn, NL: Labarum Academic, 2015.

Romaine, James, ed. *Art as Spiritual Perception: Essays in Honor of E. John Walford.* Wheaton, IL: Crossway, 2012.

Schutte, Gerrit. *Het Calvinistisch Nederland. Mythe en werkelijkheid.* Hilversum, NL: Verloren, 2017.

Selderhuis, Herman J., ed. *Handboek Nederlandse Kerkgeschiedenis.* Kampen, NL: Kok, 2006.

Steensma, Regnerus. *In de Spiegel van het beeld—kerk en moderne kunst.* Baarn, NL: Ten Have, 1987.

Swigchem, C. A. van, T. Brouwer, and W. van Os. *Een huis voor het Woord: het protestantse kerkinterieur in Nederland tot 1900.* Staatsuitgeverij, NL, 1984.

Taylor, W. David O. *The Theater of God's Glory: Calvin, Creation, and the Liturgical Arts.* Grand Rapids, MI: Eerdmans, 2017.

——. *Glimpses of the New Creation: Worship and the Formative Power of the Arts.* Grand Rapids, MI: Eerdmans, 2019.

Tolsma, Marijke, and Martin L. Wijngaarden, eds. *Prachtig Protestant.* Zwolle, NL: Waanders, 2008.

Walford, E. John. *Jacob Van Ruisdael and the Perception of Landscape.* New Haven, CT: Yale University Press, 1992.

CALVIN AND THE ARTS: PURE VISION OR BLIND SPOT?

ADRIENNE DENGERINK CHAPLIN

HOW IS IT THAT CONTEMPORARY CALVINISM is inspiring an up-surge of Christian reflection on art while Calvin himself had so little interest in it?[1] To explore this conundrum, let me start by explaining how Calvinism has influenced my own thinking on the question.

I am neither a church historian nor a theologian but a philosopher whose overall thinking has been shaped by the Reformed Calvinist tradition through the inflection of the Dutch thinker and statesman Abraham Kuyper. For Kuyper, the domain of Calvinism was far broader than what most people understood by it in his time. Taking Calvin's emphasis on the sovereignty of God as his point of departure, Kuyper developed Calvin's theology into an all-encompassing worldview, in which the lordship of Christ extended over all dimensions of life—politics, economics, education, but also the arts.

Within this Neo-Calvinist Kuyperian tradition, my thinking about the *arts and aesthetics* in particular, has been informed by, among others, Dutch art historian Hans Rookmaaker, American philosopher Nicholas

[1]This chapter was initially presented as a lecture given at Union Theological College in Belfast on 18 September, 2009, and subsequently published in T. D. Alexander and L. S. Kirkpatrick, eds., *John Calvin 1509–1564: Reflections on a Reformer* (Belfast: Union Theological College, 2009), 137-49. Thanks to the editors for permission to reprint a slightly shortened version here.

Wolterstorff, and especially Canadian aesthetician Calvin Seerveld, emeritus professor of the Institute of Christian Studies in Toronto. But if the mention of a tradition might suggest a linear and coherent trajectory of thinking about the arts, nothing could be further from the truth. Between the aesthetics of the Calvin of Geneva and the Calvin of Toronto lies a four-hundred-year period that, with a few exceptions, was largely marked by its silence on the matter.

There is, admittedly an extensive art-historical discussion of the question whether Calvin, or rather Calvinism, was responsible for the new practices and styles of seventeenth-century painting, but the jury is still out on whether these were a direct result of Calvin's teaching or, as some argue, merely the unforeseen by-products of a changed set of social and economic circumstances.[2] And it is true as well that Abraham Kuyper, keen to demonstrate that Calvinism was not merely a theological or ecclesiastical movement, but a comprehensive view of life which also impacted the arts and culture, devoted an entire lecture of his famous 1899 Princeton Stone Lectures to the topic of Calvinism and art.

But serious reflection on the nature of art *as such* and its unique and indispensable role in the fabric of human flourishing has never been high on the Calvinist agenda. In popular opinion, of course, Calvin and art don't mix. Calvin is seen as the enemy of all things bright and beautiful and creative. So what has given Calvin this name? What *were* Calvin's views of the arts, and how do they fit in his broader theology of creation and culture? One of the better known—or notorious—features of Calvin's aesthetics is undoubtedly his negative view of visual, representational images in the context of worship. For Calvin such images have an *inherent* propensity to be used for idolatrous purposes: "the human heart is a factory of idols," and in the face of visible representations, human nature will always be tempted to idolatry.[3]

This raises the question whether his ban on images should be seen as a general theological principle or as a matter of strategy in the particular

[2]See, for instance, Reindert L. Falkenburg, "Calvinism and the Emergence of Dutch Seventeenth-Century Landscape Art—A Critical Evaluation," in *Seeing Beyond the Word: Visual Arts in the Calvinist Tradition*, ed. Paul Corby Finney (Grand Rapids, MI: Eerdmans, 1999), 343-68.
[3]John Calvin, *Institutes of the Christian Religion*, ed. John. T. McNeill, trans. Ford Lewis Battles (Philadelphia: Westminster, 1960), 1.11.8.

historic circumstances of Calvin's time. Put differently, is there a tension between his broader theology of culture and the arts and his particular stance on visual images in church? What, so to speak, is the logic of Calvin's iconoclasm? For a start, contrary to widespread opinion, Calvin did not shun aesthetic delight. A recurrent theme throughout Calvin's work is the notion of creation as the theater of God's glory. In a famous passage he writes: "Has the Lord clothed the flowers with great beauty that greets our eyes, the sweetness of smell that is wafted upon our nostrils, and yet will it be unlawful for our eyes to be affected by that beauty, or our sense of smell by the sweetness of that odor?"[4]

This is not the language of a cold intellectual merely concerned with abstract concepts and doctrinal thought. He also had a heart for music. Although not musically gifted in the way of his fellow Reformers Luther or Zwingli, Calvin was passionate about the importance of congregational singing and oversaw the translation and versification of all psalms into what came to be known as the Genevan Psalter. The psalms were apparently sung with such a lively beat and rhythm that Queen Elisabeth I supposedly referred to them as "Geneva jigs." All in all, the singing of psalms in the form of public prayers was meant for the edification of the church "so that the hearts of all may be aroused and stimulated to make similar prayers."[5] So much for music. What about the arts?

In Calvin's time the visual arts—painting, sculpture, engraving, and so on—would have been seen as part of a much broader category of manual skills, including such practices as shoe-making, blacksmithing, and weaving. Even so, all these, as well as non-manual "liberal" arts, such as philosophy, science, or law, were regarded very highly by Calvin. He saw them as gifts from God neither to be despised nor ignored. In characteristically strong language he asserts, "If we neglect God's gift freely offered in these arts, we ought to suffer just punishment for our sloths."[6]

All in all, Calvin's belief in the original goodness of creation and the importance of cultivating it for the common good and the glory of God,

[4]Calvin, *Institutes* 3.10.2.
[5]Jean Calvin, *Ioannis Calvini Opera Quae Superstunt Omnia*, ed. Guilielmus Baum, Eduardus Cunitz, and Eduardus Reuss (Brunsvigae: C. A. Schwetschke, 1871), 10:6.
[6]Calvin, *Institutes* 2.2.16.

provided him with a very positive attitude toward the arts, crafts, and sciences. In *practice* and by *disposition*, however, Calvin seemed to have very little interest in visual art. He could only see two purposes of paintings and sculpture: one, instruction—especially for the teaching of historical events—and second, pleasure, which, for him, basically meant idle amusement. At least this is how he talks about it in a letter to a young man whom he chastised for doing scholarship merely for pleasure: "Those who seek in scholarship nothing more than an honoured occupation with which to beguile the tedium of idleness, I would compare to those who pass their lives looking at paintings."[7]

So I think we have to be honest about the fact that, to put it mildly, Calvin did not have much of a visual sense. He was primarily a man of letters and had very little feeling for paintings.

There is, therefore, no little irony in the fact that there are literally dozens of portraits—paintings, engravings, miniatures, and the like—of Calvin, some produced during his lifetime, and many more based on images and sketches after it. A few examples of portraits considered to have been done during his life are Calvin as a young man by an anonymous Flemish painter in the sixteenth century; a portrait of Calvin, aged forty-one, by an anonymous French painter, made in 1550; another portrait by an anonymous sixteenth-century artist; an engraving of Calvin, aged fifty-three, by the French artist René Boyvin in 1562; and, last but not least, a portrait attributed to one of the most celebrated painters of his time and, some argue, of all times, Venetian Tiziano Vecellio, better known as Titian (fig. 2.1). There is very little known about the origin of this painting, but at least one source refers to the fact that when Calvin spent the winter of 1536 at the court of French Princess Renée in Ferrara, he and Titian would have met. Having arrived incognito as a refugee, he had ended up preaching in the court's chapel for an illustrious congregation of dukes, counts, and other notables, including Titian, and it was during that period that Titian was commissioned to paint Calvin's portrait.[8]

[7]Quoted in Philip Benedict, "Calvinism as a Culture? Preliminary Remarks on Calvinism and the Visual Arts," in Finney, *Seeing Beyond the Word*, 19. The letter was written to an unknown young man in 1540.

[8]J. H. Merle D'Aubigné, *History of the Reformation* (New York: Robert Carter & Brothers, 1876), 431.

Figure 2.1. Titian, *John Calvin*, 1563

There is, to be sure, no historical evidence that Calvin would have actually sat for these paintings. They may have been produced on the basis of sketches done during his public presentations, which may explain why, apart from such characteristics as the long face and beard, the scholars' cap with ear

flaps, and the serious expression, there are considerable differences between the detailed facial features in each painting. But even so, he must at least have known about them. And it would have been very interesting to know what he would have thought of them.

What, on his own terms, were they for? Instruction or pleasure? Or might these supposedly secular portraits also risk being turned into objects of idolatry? At least some other Genevans thought so. Some even blamed Calvin personally for allowing this to happen. As one critical voice commented shortly after Calvin's death:

> I ask, is it a sign of humility, a rejection of vanity, if one allows one's portrait to be painted? Or if one permits one's portrait to be hung in the public spaces of Geneva? Or if one allows one's portrait to be dangled around the necks of certain fools and women who have made Calvin their God? . . . Since Calvin had issued a written mandate condemning and calling for the destruction of saints' images along with those of the Virgin Mary and Jesus Christ himself, it could hardly be construed as an honor to Calvin to allow his portraits to be set up (and displayed) in public places or worn around (some fool's) neck. At the very least Jesus Christ is fully worthy (of being venerated in this manner).[9]

It is very likely that Calvin himself would have shared all these concerns. Of all people, Calvin was very aware of the temptation of self-admiration: "There is nothing man's nature seeks more eagerly than to be flattered," he writes in the *Institutes*.[10] He hated any adulation of himself as a person and, for that reason, never liked the term *Calvinist*.

THE BAN ON IMAGES

Let us now turn to the actual text that deals with Calvin's ban on images. In chapter eleven of book one of his *Institutes of the Christian Religion*, Calvin outlines his position in great detail and, it has to be said, with great flourish. So what exactly are Calvin's objections, and how do they stand up? The chapter contains basically two claims. First, it is forbidden to make any

[9]Quoted in Mary G. Winkler, "Calvin's Portrait: Representation, Image or Icon?," in Finney, *Seeing Beyond the Word*, 244. This quote is an English translation of a French passage from Jérome Bolsec, *Histoire de la vie, moeurs, actes, doctrines, constance et mort de Jean Calvin jadis ministre de Geneve* (1577).

[10]Calvin, *Institutes* 2.1.2.

images *of God*; and second, it is forbidden to use *any* images *in the context of worship.* Let's start with the first claim.

For Calvin this claim is directly rooted in Scripture: according to him, Exodus 20:4 and various other Scripture passages clearly stipulate that "it is unlawful to attribute a visible form to God" and that "we are forbidden every pictorial representation of God."[11] It is "brute stupidity . . . to pant after visible figures of God, and thus form gods of wood, stone, gold, silver, or other dead corrupted matter."[12] Calvin refers to the Persians who worship gods in the form of the sun and stars; the Egyptians who worship gods in the form of animals; and the Greeks who worship their gods in the form of humans. Yet his main target is the Catholics, whose religious images fill the churches around Europe. Calvin sees no difference between the idolatrous images of the Egyptians and the frescos and statues in these churches: "surely there is nothing less fitting than to wish to reduce God, who is immeasurable and incomprehensible, to a five-foot measure!"[13]

At first glance, this seems an irrefutable claim. God is the totally Other, and any attempt to capture him in a visible form is a sign of hubris: "Every figurative representation of God contradicts his being."[14] For Calvin it is absolutely clear that "God's glory is corrupted . . . whenever any form is attached to him"[15] and that "every statue man erects, or every image he paints to represent God, simply displeases God as something dishonourable to his majesty."[16] But is that really so? Is it true that *every* image of God displeases him? Is that indeed what Exodus 20:4 tells us? Perhaps it's worth having another look.

A key word in Exodus 20:4 is the Hebrew *pesel*, from the root *pasal*—to carve wood or stone—thus often translated literally as "graven image." Throughout Scripture, however, this word is never used for two-dimensional but always for three-dimensional objects carved or chiseled out of wood or stone, with or without a gold or silver covering. More importantly, such objects were always and by definition associated with idolatrous or

[11]Calvin, *Institutes* 1.11.1
[12]Calvin, *Institutes* 1.11.1.
[13]Calvin, *Institutes* 1.11.4.
[14]Calvin, *Institutes* 1.11.2.
[15]Calvin, *Institutes* 1.11.1.
[16]Calvin, *Institutes* 1.11.2.

superstitious practices. And although they were most common in pagan cultures, many Israelites too were still clinging on to them, as is clear from the stories of Rachel, who stole her father's portable household gods in Genesis 31, and Mical, who used a life-size statue to trick Saul's men into believing David was asleep in his bed in 1 Samuel 19. This makes this commandment a deeply pertinent one.

In order to clarify this particular meaning of the word *pesel*, most recent translations have avoided a literal translation and have opted instead for the term "idol" itself. This translation makes considerably more hermeneutical sense in terms of both surrounding verses: "You shall have no other gods before me" (Ex 20:3) and "You shall not bow down to them or worship them" (Ex 20:5). It also makes sense of the Jewish division of the Decalogue, in which Exodus 20:2—"I am the Lord your God"—is seen as the first "commandment" or, more accurately, "word," and Exodus 20:3-4 are combined as constituting the second "word."[17]

That being so, it seems justified to conclude that the second commandment is not a blanket ban on representational imagery *as such* but merely a prohibition of images used *as idols*. This leaves open the question whether the verse forbids *all* visual renderings of God. The text appears silent on this matter. We should do well to remember that God has always revealed himself in ways we can relate to as creaturely, embodied beings. Scripture provides us with many vivid and concrete images of God as king and servant, judge and comforter, shepherd and lamb, fortress and counselor, rock, light, wind, fire, and so on. These images allow us to imagine certain aspects of God even while their sheer diversity should serve as a warning never to reduce him to just any *one* of these.[18]

Perhaps the question is not so much whether we are *allowed* to use such representations but whether we can ever do *without* them. And that raises the real question: what *kind* of image or images do we have of him? Those who have read the widely popular book *The Shack* will remember the

[17]Calvin discusses the division of the Decalogue in 2.13.12. He argues for taking Ex 20:4 as a separate commandment.

[18]This view therefore challenges the formulation of (part of) the answer to question 109 in the *Westminster Larger Catechism*, which states: "The sins forbidden in the second commandment are . . . the making any representation of God, of all or of any of the three persons, either inwardly in our mind, or outwardly in any kind of image or likeness of any creature."

author's description of God as the large, warm, and kitchen-inhabiting African American woman—modeled, some say, on the Oracle character in the film *The Matrix*. Whatever you may think of the literary quality of the book or its perceived theology, it cannot be denied that, for some people, such a portrayal of God may provide a very healthy correction to that of a stern or judging father figure. Indeed, this has very likely has been one of its major sources of appeal. I would like to suggest that interior literary images such as these are not, in principle, fundamentally different from exterior, visual images. Both types of images enable us to relate to God as he reveals himself in our concrete existence. Both types can nurture and enrich our religious imagination.

Visual art may play a role in the process of clarifying and reflecting on our internal, tacit images of God. By rendering these internal images available for our experience, we may be able to share more openly and deeply the theological assumptions we subconsciously operate with. They may force us to return to Scripture and possibly even correct some long-held views. It is true that anthropomorphic images of God the Father will always remain a challenge. One may portray God as a draughtsman, as in William Blake's *Ancient of Days* (God as architect) (fig. 2.2), or as farmer, as in van Gogh's *The Sower*, or, of course, as Creator, as in Michelangelo's *Creation of Adam*, but artists have usually refrained from such anthropomorphic representations and opted for more abstract means such as the use of light, as in Rembrandt's paintings or in medieval churches and cathedrals.

Figure 2.2. William Blake, *The Ancient of Days*, 1794

Yet Calvin is puzzlingly quiet on the possibility of visual representations of God the Son. If one of the main reasons for banning images of God was his invisible nature, this reason does not apply to Christ, whom the apostle Paul refers to as "the image [*eikon*] of the invisible God" (Col 1:15). Calvin's main worry, of course, is that, as with all images, images and icons of Christ too may turn into objects of idolatry or superstition. In view of the excesses of the Catholic Church at his time, this is a justified and understandable concern. It should be remembered, however, that the church itself strongly denounced such idolatrous uses of images. To that end, the Second Council of Nicaea of 787 had introduced a distinction between, on the one hand, veneration or respect—*proskynesis* or *dulia*—which could be bestowed on people and images—and, on the other, worship—*latria*—which was reserved for God.

Calvin does not accept this distinction which he calls "a foolish evasion"[19] only serving to "hoodwink both God and men."[20] Not only does he refuse to acknowledge a distinction between *dulia* ("veneration") and *latria* ("worship"), he also refuses to accept a difference between an *eikon* ("image") and *eidōlon* ("idol"). In short, his obsession with the idolatrous use of images seems to blind him for any other use of them.[21] This may explain why all of Calvin's arguments enlisted to defend his second claim—the banning of *all* images in church—turn out to be either misguided or, at best, unconvincing. Let's take his three main ones.

First, Calvin complains that the images and statues of Mary and the saints are "examples of the most abandoned lust and obscenity. . . . Brothels show

[19]Calvin, *Institutes* 1.11.1.

[20]Calvin, *Institutes* 1.11.16. Thomas Aquinas, following John of Damascus and Augustine, holds a threefold distinction between, first, *dulia* (from *doulos*—"servant"), to be used for the veneration of images and the saints; second, *hyperdulia*, for the veneration of Mary; and third, *latria*, reserved exclusively for the worship of God. Calvin therefore misrepresents the position of the Second Council of Nicaea (AD 787) as saying that "not only were there to be images in churches but also that they were to be worshiped" (Calvin, *Institutes* 1.11.14). Thomas Aquinas's distinction between *latria* and *dulia* can be found in *Summa Theologica* II.2, q. 103, art. 3, and his distinction between *dulia-hyperdulia* in *Summa Theologica* III, q. 25, art. 5.

[21]See Calvin, *Institutes* 1.11.1n21. Calvin's refusal to acknowledge these semantic distinctions also impacts on his philological argument. Since, for Calvin, veneration is the same as worship, and *ikon* the same as *idol*, he misrepresents the Second Council of Nicaea's distinction as one between *eidolodouleia*—"idol service"—and *eidololatreia*—"idol worship." It seems to me that he may well have made up the term *eidolodouleia*, as it does not appear to exist in Greek outside Calvin himself.

harlots clad more virtuously and modestly than the churches show those objects which they wish to be thought images of virgins."[22] This can hardly be considered a conclusive argument. Were they to be dressed and presented in a more decent fashion the problem would disappear.

Second, in response to Pope Gregory's claim that images serve as the Bible for the illiterate or uneducated, Calvin claims: "If the church had done its duty there would be no 'uneducated.'"[23] While there may be some truth in that, it does not follow that image and word need to exclude each other. Indeed, they may well be mutually enriching.

Third and last, Calvin argues that, since the early church had done without images, so should we: "As long as doctrine was pure and strong, the church rejected images."[24] In this, however, Calvin is simply wrong. There is ample archaeological and art-historical evidence that the early church *did* have images—in its catacombs, its homes and its house churches—and so, as a matter of fact, did a number of Jewish synagogues. In Calvin's defense, it should be said that much of this archaeological evidence only came to light after Calvin's death, but even so, it does not stand up as an argument.

CONCLUSION

So where does that leave us? What conclusions are we to draw from this very brief journey into Calvin's thoughts on art and images? Let me suggest three.

First, Calvin's overall theology of creation, common grace, and culture provided him with a solid foundation for a positive appreciation of the arts alongside other crafts and sciences. This, we could say, was his prophetic vision.

Second, Calvin's underdeveloped sense of the specific nature of the art as a metaphorically rich and meaningful articulation of affective experience prevented him from seeing paintings and sculptures as anything other than as objects for instruction or pleasure.

Third, while Calvin is rightly concerned with the widespread misuse and superstitious practices surrounding visual imagery in his time, his erroneous exegesis of Exodus 20:4 and subsequent identification of *all* religious imagery with idolatry blinded him to a more positive role for them. This was

[22]Calvin, *Institutes* 1.11.7.
[23]Calvin, *Institutes* 1.11.7.
[24]Calvin, *Institutes* 1.11.13.

his major blind spot. Idols, as we know, can take on many forms and guises. They are not to be located in any one phenomenon in life. Icons and idols can change roles in different circumstances. As Jean-Luc Marion once wrote: "The icon and the idol determine two *manners* of being for beings, not two *classes* of beings."[25]

It is true that art, especially Art with a capital *A*, can become an idol. However, this is not because of its nature as an image or because of its visual character. It is because of the exalted status with which it is bestowed. By contrast, as Calvin Seerveld puts it, "Art is one way for men and women to respond to the Lord's command to cultivate the earth, to praise his Name. Art is neither more nor less than that."[26]

As will be clear, I have not been uncritical of Calvin's views of art and images. But I hope at least to have indicated—even if not demonstrated—that I consider his overall view of creation and culture as providing us with a life-affirming biblical framework from which to develop a more promising approach to the arts. And I also hope that, in the spirit of *semper reformanda,* Calvin would have been supportive of such a further development.

BIBLIOGRAPHY

Benedict, Philip. "Calvinism as a Culture? Preliminary Remarks on Calvinism and the Visual Arts." In *Seeing Beyond the Word: Visual Arts in the Calvinist Tradition*, edited by Patrick Corby Finney, 19-45. Grand Rapids, MI: Eerdmans, 1999.

Calvin, John. *Institutes of the Christian Religion.* Edited by John. T. McNeill. Translated by Ford Lewis Battles. Philadelphia: Westminster, 1960.

———. *Ioannis Calvini Opera Quae Superstunt Omnia.* Edited by Guilielmus Baum, Eduardus Cunitz, and Eduardus Reuss Vol. 10. Brunsviga, DE: C. A. Schwetschke, 1871.

D'Aubigné, J. H. Merle. *History of the Reformation.* New York: Robert Carter & Brothers, 1876.

Falkenburg, Reindert L. "Calvinism and the Emergence of Dutch Seventeenth-Century Landscape Art—A Critical Evaluation." In *Seeing Beyond the Word: Visual Arts in the Calvinist Tradition,* edited by Paul Corby Finney, 343-68. Grand Rapids, MI: Eerdmans, 1999.

Marion, Jean-Luc. "The Idol and the Icon." In *God Without Being: Hors-texte,* translated by Thomas A. Carlson, 7-24. Chicago: University of Chicago Press, 1995.

Seerveld, Calvin. *Rainbows for the Fallen World.* Toronto: Tuppence, 1980.

[25]Jean-Luc Marion, "The Idol and the Icon," in *God Without Being: Hors-texte,* trans. Thomas A. Carlson (Chicago: University of Chicago Press, 1995), 8, emphasis added.

[26]Calvin Seerveld, *Rainbows for the Fallen World* (Toronto: Tuppence, 1980), 25.

CHAPTER THREE

RUMORS OF GLORY: ABRAHAM KUYPER'S NEO-CALVINIST THEORY OF ART

ROGER D. HENDERSON

ART IS A WORD that meant many things to Abraham Kuyper (1837–1920), and his discussion of it and its relationship to Calvinism took place within a wide range of contexts. He believes that it has an often-overlooked place of significance in history. One of the most important and influential sets of lectures he gave during his long public career contained a chapter on art.[1] The God Kuyper worshiped established art as an *aspect* of life, with a *raison d'être* and integrity of its own. When God created birdsong, the colors of the sky, and the fragrance of the flowers, he was preparing for the possibility of human art. It was to constitute a *sphere* of existence, a part of life with its own divine ordinances and sovereignty. It was not trivial, not frivolous, not just a pastime for the rich and idle. Rather, "the artistic instinct is a universal human phenomenon," according to Kuyper.[2]

Through his many years as a member of parliament, church leader, journalist, and scholar, Kuyper exerted considerable influence on the course of

[1] A. Kuyper, *Calvinism: Six Stone-Lectures* (Grand Rapids, MI: Eerdmans, 1931); *Het Calvinisme: Zes Stone-Lezingen* (Amsterdam: Höveker & Wormser, 1899). Kuyper's English and Dutch works are available online at http://kuyper.ptsem.edu/.
[2] Kuyper, *Calvinism*, 144.

Figure 3.1. Jan Veth, *Portrait of Abraham Kuyper,* 1899

late-nineteenth-century Dutch history. His many novel ideas influenced the structure of his country's institutions. Kuyper's early conversion to Christ and second conversion to Calvinism gave him a philosophical-theological unity-loving principle of coherent diversity that guided him throughout his life. As a young student of theology and literature at Leiden University in the 1850s, he was attracted to ways of thinking far removed from anything Calvinistic.[3] However, after his emotional turnaround in faith, he eventually came to see the need of a system of thought in which all the different beliefs constituted a coherent whole. This meant that all the various things he believed and ideas he held to be true should fit together rather than conflict with one another. They should mutually support one another within a theology or worldview. This is part of what eventually brought Kuyper to Calvinism. In attempting to understand the unity of truth and of the teachings of Scripture, Kuyper became persuaded that Calvinism offered a highly coherent approach. This is what attracted him and eventually gave rise to what is now called Neo-Calvinism or Kuyperianism. He viewed the coherent diversity of culture as a normative aesthetic idea and ideal—implying that artistic work should seek to portray the rich variety of the created world in ways that reflect its deeper underlying unity.

At a very basic level Kuyper's Neo-Calvinism accepted the threefold biblical teaching that

[3]R. D. Henderson, "How Abraham Kuyper Became a Kuyperian," *Christian Scholar's Review* 22 (1992): 22-35. See also A. Kuyper, *The Problem of Poverty,* ed. and trans. J. Skillen (Sioux Center, IA: Dordt Press, 2011), as well as Steve Bishop and John H. Kok, eds., *On Kuyper* (Sioux Center, IA: Dordt Press, 2013).

1. the world was originally arranged and created good, "very good";

2. it was brought into a dysfunctional state, "subjected to futility" by wrong human (and angelic) choices and action; and

3. now the creation both enjoys and groaningly awaits Christ's transforming resurrection power.

This teaching was taken in an *unrestricted, unlimited sense*, applying to everything created, including art—but of course not to God the Creator. "As the sad consequence of sin, the real beautiful has fled from us. . . . The world once was beautiful, but by the curse has become undone. . . . Art has the mystical task of reminding us in its production of the beautiful that was lost and of anticipating its perfect coming in luster."[4] Art could and should reflect the challenges of a reality wonderfully created yet out of tune (with itself and its maker), now in a process of renewal in Christ with the promise of full redemption in the future.

While some of Kuyper's views on the specific nature of art are open to criticism, for example his idea of beauty and ancient Greek art, his understanding of an aesthetic sphere as part of the divine order of creation makes his approach valuable, regardless of deficiencies.[5] His highly controversial theories are sometimes more interesting and insightful than the less controversial ones of other authors.

ART AS A LIFE-SPHERE

The underlying assumption of Kuyper's Calvinist perspective is the claim that Christ is sovereign, the Lord of all. Sovereignty, authority, and power are interpreted as Christ's rule involving the work of the Holy Spirit given at Pentecost, and *creational ordinances* are established for each different sphere of life. "If God is and remains Sovereign, then art can work no enchantment except in keeping with the ordinances which God has ordained."[6] Each sphere is irreducible to any other, and each has a law or set of ordinances that functions as its unique norm, character, and growth principle.

[4] Kuyper, *Calvinism*, 154.
[5] For critical comments on Kuyper's idea of aesthetics and beauty, see Calvin Seerveld, for example, "Dooyeweerd's Legacy for Aesthetics," in *The Legacy of Herman Dooyeweerd*, ed. C. T. McIntire (Lanham, MD: University Press of America, 1985), 65.
[6] Kuyper, *Calvinism*, 155.

The establishment of an aesthetic *order* of existence implies that art is an indispensable part of culture and human life (how many movies are watched by us each week?). Artistic action, performances and artifacts constitute a distinct facet of human existence. The aesthetic sphere shows itself narrowly as "fine art" and broadly in the ways people fill, decorate, and arrange their environment. It offers the possibility of arranging and cultivating our cultural life-world in beautiful and pleasant ways. The aesthetic sphere is a treasure chest waiting to be opened up, unfolded, and *actualized* in arrangements, whereby the unity and beauty of creaturely existence might reflect the glory of God. It is a possibility given by God for studied creative labor, the results of which show different levels of *sophistication*; some can be monumental, calling for public display, while others are quaint features of domestic life. Art was not just a few material objects for Kuyper but activities based in God-given norms, the recognition and embodiment of which carry *implications* about truth and goodness.

Although he offered a wide variety of different theological and philosophical reasons for the importance of aesthetic life, his insistence on ordinances and a process of their cultural unfolding is basic to all his other claims. Artworks represent the embodiment of the principles or ordinances for this sphere in a more *or less* masterful, truthful, and obedient fashion. Artistic work should be free to function and develop in its own direction and not be dominated by another sphere.

UNITY AND NEO-CALVINISM

In trying to understand Kuyper's aesthetics, his early lecture "Uniformity: the Curse of Modern Life" (1869) is essential.[7] It was not until nearly two decades later in 1888 that he wrote an article specifically on art.[8] However, the early lecture has a direct bearing on art and a broad indirect bearing on his general way of thinking. In it he fiercely opposes uniformity, mindless standardization, and centralization—as did his mentor, G. Groen van Prinsterer. He contrasts it with real unity—still emphasizing the importance

[7] A. Kuyper, *Eenvormigheid, de Vloek van het Moderne Leven* (Amsterdam: H. de Hoogh, 1869); English translation: "Uniformity: The Curse of Modern Life," in *Abraham Kuyper: A Centennial Reader*, ed. J. D. Bratt (Grand Rapids, MI: Eerdmans, 1998), 19-44.

[8] A. Kuyper, *Calvinisme en de Kunst* (*Calvinism and Art*) (Amsterdam: J. A. Wormser, 1888).

of diversity within the bounds of unity. "In the unity of the kingdom of God diversity is not lost but all the more sharply defined."[9] Each unique achievement of unity is a gift of God's grace, either the special or the general kind: "Unity is only found at that point where it springs from the fountain of the Infinite."[10] This understanding of unity (and diversity) provides the framework of his thoughts on art and the beautiful. Unity is a necessary requirement and characteristic of good artistic work. "The flourishing of the arts is the true measure of the vitality of an era. Art is born out of a zest for the beauty of true unity, out of an impulse toward a fuller life."[11] The unity, however, must be real and not artificial; forcing things to be the same is a counterfeit unity. "I do not shrink from calling false uniformity the curse of modern life: it disregards the ordinances of God revealed not only in Scripture but throughout his entire creation."[12]

Kuyper believed that the world is many-faceted and many-layered, and that all its parts and their relationships are held together by Christ, making up a coherent whole. They constitute a unity that God brings about, treasures, and sustains moment by moment. Calvinism, he says, offers "an all-embracing system of principles" with "a unity of life-conception."[13] This is part of why "Calvinism" (later called Neo-Calvinism) was important and culturally relevant to him. He believed its integral view of faith and life was vital to a culturally formative Christianity. Kuyper's Neo-Calvinism made its appearance "not merely to create a different Church-form, but an entirely different form for human life, to furnish human society with a different method of existence, and to populate the world of the human heart with different ideals and conceptions."[14]

Without unity, nothing can thrive or even survive. Given the importance Kuyper attributes to unity, it is not surprising to find that he thinks it is a key property of the beautiful, and consequently that excellent artistic works display it to a high degree. Again Kuyper emphasizes that unity is not the same as uniformity.

[9]Kuyper, *Eenvormigheid*, 35.
[10]Kuyper, *Calvinism*, 150.
[11]Kuyper, *Eenvormigheid*, 36.
[12]Kuyper, *Eenvormigheid*, 37.
[13]Kuyper, *Calvinism*, 11.
[14]Kuyper, *Calvinism*, 17.

Look about you in the theater of nature and tell me: where does creation, which bears the signature of God, exhibit that uniform sameness of death to which people are nowadays trying to condemn all human life? Raise your eyes, look at the starry heavens, and you will see not just a single beam of light but an undulating, scintillating sea of light coming from myriads of bright-shining stars. . . . Uniformity in God's creation! No, rather infinite diversity, an inexhaustible profusion of variations that strikes and fascinates you in every domain of nature, in the ever-varying shape of a snowflake as well as in the endlessly differentiated form of flower and leaf . . . multiplicity of its colors and dimensions, in the capriciousness of its ever-changing forms. . . . But that artful embroidery of infinitely varying colors and shades does not lack unity of conception. . . . The drive for unity in God's revelation is . . . powerful.[15]

True unity arises internally by a symbiotic cohesion of parts—not by forcing art or anything else into preconceived molds or sameness. The key term for Kuyper next to *unity* is *coherence*.

THE DISCLOSURE PROCESS OF ART

Kuyper was a man with a plan, usually more than one, and he worked hard to find the connections between things and ideas, to show how ideas and actions were and should be connected. As a result he approached the subject of art from many different angles. After teaching aesthetics for a few years at the Vrije Universiteit at Amsterdam (the institution he helped start), a German academic report appeared in 1888 voicing surprise that a "Calvinist" University was offering an aesthetics course. In response he wrote an article explaining how the arts have been seen in various civilizations, and how they *should* be seen according to Calvinism. Part of his view involves the disclosure process of the arts in culture. The aesthetic facet of existence, he argued, is not given to us full grown but like a seed, it awaits cultivation, cultural unfolding, and development. It is part of the possibility and responsibility God has placed on us as part of our stewardship of creation.

Kuyper believed that God's universal kindness was visible in artistic expressions. This view was based on a distinction Kuyper drew between the saving grace of God in Christ and the preserving grace of God common to

[15]Kuyper, *Eenvormigheid*, 34-35.

all. The possibility of developing artistic work and artistic traditions was an expression of "common grace." He gives it as he gives rain to the just and unjust. Common grace is that by which God, "maintaining the life of the world, relaxes the curse which rests upon it, arrests its process of corruption, and thus allows the untrammeled development of our life in which to glorify Himself as Creator."[16]

Art involves the gift of opening up and unfolding part of the treasure chest of creation. However, because this grace allows people to ex-

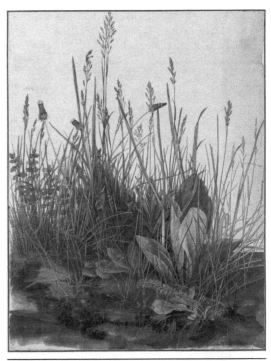

Figure 3.2. Albrecht Dürer, *The Large Piece of Turf*, 1503

press views and feelings about life and truth in their artistic work that can be far from biblical, not all Christians are happy to affirm art as a gift of God. The arts afford enjoyment and comfort, but they are not neutral, not inert, not unrelated to what people think, believe, and are. Artistic work and performance are both *representative* and *formative* of cultures and civilizations. Many native peoples represent God or the gods at a very basic sensual level, using images and carvings, which as sculptures can be beautiful but as idols problematic.

Although capable of being misused or abused, Kuyper recognizes human artistic creativity as a part of the original good creation and subject to redemption in Christ. It is one part of this coherent, multifaceted cosmos. Even if corrupted and misused in terms of the way or direction in which the arts are developed in a society, he argued that aesthetic activity is better than the all-too-common preoccupations with alcohol or sex.

[16]Kuyper, *Calvinism*, 30.

Normatively speaking, art should allow culturally formative work to comfort, ennoble, and enhance human life while reflecting God's glory. In other words, artistic work has both a structural and a factual side, and what is good structurally can be factually misguided or perverse. His discussions go back and forth between a structural and factual analysis of art, which at times can be confusing.

Kuyper believes that works of art *speak*, as one of his later students expressed it (Rookmaaker). They are *suggestion-rich* as another puts it (Seerveld). The aesthetic life-sphere can be unfolded in ways that direct our attention toward or away from the kingdom of God. Aesthetic work captures and conveys the feel, flavor, and scent of a life-direction. This, he says, can be observed particularly in great works of art and architecture. Certain works or edifices have regularly come to symbolize a culture and its religion. It is almost universally the case that each major religion has its own temple or representative building. In such edifices there is usually a signature pattern and style widely distributed in the artistic works of that culture. This is another implicit illustration of Kuyper's belief about unity, namely that there is an inherent tie between a particular religion or worldview and the artistic style or styles that grow out of it. People's ideas and their art tend to show patterns that fit together as part of their culture.

ART AND RELIGION

One of the main traditional sponsors of art, historically speaking, has been religion and religious worship in particular. For a long time "Art derived her richest motives from Religion. The religious passion was the gold-mine, which financially rendered her boldest conceptions possible."[17] "Art-style and the style of worship coincided."[18] It seems surprising then that Calvinism minimized if not terminated the use of tangible religious artifacts in worship. Historical Calvinism, Kuyper says, represents a stage of development in which images and artifacts are no longer considered necessary. Its unity is no longer expressed in one outward (religious) style or representation, nor is it oriented to one temple or place of worship. At this stage of development it can be practiced anywhere "in spirit and in truth" without the help of

[17]Kuyper, *Calvinism*, 146.
[18]Kuyper, *Calvinism*, 146.

artistic artifacts. Since Calvinist religious worship is no longer tied to images and can take place anywhere, it can be given a diversity of expressions. *Art and artistic style* no longer have to "coincide" with a religion. With the advent of Calvinism in Europe, art gained its freedom far beyond distinctly Calvinist countries to develop in a plurality of directions, forms, and styles of its own.

Calvinist Christianity has never had one building or style representing it. While some people may view this as a deficiency, a proof that Calvinism is incomplete as a theology or life-system, Kuyper surprisingly affirms it as a unique strength. Calvinism's focus on the sovereignty of God is part of the reason Kuyper gives for this lack of a distinct architectural style. The reality of a sovereign Creator cannot be expressed in or limited to one artistic style, because it points beyond anything created or creaturely and is simply too rich to be captured in this way. The usual alliance between religion and art became obsolete with the rise of Calvinism. This had a profound influence on European culture outside of Calvinist circles. "In its very want of a special architectural style, Calvinism finds an even higher recommendation."[19]

ORDINARY BEAUTY AND THE BEAUTIFUL

Kuyper recognized that his nineteenth century had traded the traditional European culture's concern for the unity and beauty of ordinary things for the benefits of mass production, utility, and uniformity. He sensed a shift away from *process* to *results*, from *craftsmanship* to *efficiency*. He knew artistic work needed explicit endorsement and practical encouragement in a cultural situation like this but equally wanted to avoid the excesses of art fanaticism and art crazes at the margins of culture. When he admiringly reflects on the thousands upon thousands of individually designed and built houses in cities such as Delft, Gouda, and Amsterdam, his concern for *everyday* art and the beauty of the environment becomes clear. He describes this as resulting from the longing of ordinary people to make things that are tasteful and carry a personal touch. Things brought forth in this way are

[19]Kuyper, *Calvinisme en de Kunst*, 145. "Calvinism, to the extent that it also put its stamp on our national life outside Calvinist circles in the narrower sense, rendered this undying service, that it restored art to itself, opened up for art a hitherto unknown world of common everyday life, opened the artist's eye to the beauty in the seemingly negligible, and fostered a love of freedom that stimulated the passion for art" (Kuyper, *Calvinisme en de Kunst*, 27).

often stylish, bearing the unique signature of their makers. While not highly refined, they inspire and are inspired by what we call the fine arts. They share beauty with them, albeit of different forms and types.

> What is it in the architectural styles of our old Dutch cities that so charms the visiting stranger? What else but the infinite variety in width or narrowness, the looseness of twists and curves, the pointed and obtuse angles of even our most elegant canals that tell you they were not *made* but *grew*. . . . You can immediately tell that no shoddy, money-hungry developer threw up that line of houses but that every dwelling is the fulfillment of a personal dream, the precious product of quiet thrift, based on a personal plan and built slowly from the ground up. Those tufted, tiered, triangular, and shuttered gables were not symmetrically measured with a level but reflected, every one of them, the thinking of a human being, the whimsicality of a somewhat overconfident human heart.[20]

The possibility of human *artistic* activity and the enjoyment of art was part of the good creation, the grace of God and people being made in his image—with five senses. A part of being made like this is the experience of being attracted by beauty. We are attracted to certain arrangements of things through our senses. In such experiences we perceive order, beauty, and the warmth of well-arranged surroundings. Behind the superficial forms of beauty, as well as sexual attraction and other types of beauty, something deeper and more profound lurks, something for which we were made and have an innate yearning. A student noted that Kuyper once noted in one of his lectures, "Our being cannot be satisfied unless the thirst for beauty that we experience is quenched."[21]

The human experience of being attracted, charmed, or fascinated by something or someone beautiful is an innate longing, a foretaste of the world to come. Kuyper believes that our interest in and attraction to the beautiful is an important factor in life and art. And although often associated with highly refined art, he was still willing to call the patterns and lines of a Dutch dike system a work of art.[22]

[20]Kuyper, *Eenvormigheid*, 26.

[21]Quoted in M. Hengelaar-Rookmaaker, "Art and the Public Today," in *The Complete Works of Hans R. Rookmaaker* (Carlisle, UK: Piquant, 2003), 5:187.

[22]Kuyper, *Calvinisme en de Kunst*, 27.

Like the other major life-areas, art too has its good and its bad examples and more or less masterful embodiments of its inherent norms. Kuyper touches on both: "that in many instances [the] love of art leads men to seek enjoyment in nobler directions and lessens the appetite for lower sensuality. . . . In my estimation, even the most injudicious aesthetical fanaticism stands far higher than the common race for wealth or an unholy prostration before the shrines of Bacchus and Venus."[23]

He advises that we keep our "eyes fixed upon the Beautiful in its eternal significance and upon art as one of the richest gifts of God to mankind."[24] As far as the art of painting goes, Kuyper mentions Rembrandt and the Dutch school's preoccupation with *reality*, its willingness to portray ordinary things and common people honestly and in *ennobling* ways. "There must be an art, which, despising no single department of life adopts into her splendid world the whole of human life."[25] The idea of art portraying things in *"ennobling"* ways and having an ennobling effect on us did not mean presenting a sentimental sugar-coated vision of reality, like a Thomas Kinkade painting.[26] It meant that the artist and musician seek to uncover and disclose lost goodness, hints of restoration, and rumors of glory.

Although the senses play a big role in our perception of beauty, what Kuyper calls the beautiful has a meaning that goes beyond the senses. "You can look at the material, the nature and the form of the beautiful, i.e., at the bearers of the beautiful as *they* appear in their existence, but never at the beautiful itself."[27] He understands the appeal that beauty makes on us as *a longing* planted in us by and for God. God himself is glorious and beautiful, and since human beings are made in the image of God and made for fellowship with God, they are attracted to earthly beauty as a foretaste of the glory of the world to come. Kuyper's idea of beauty was not superficial, nor mere sweetness. Humans were made for art, and art was made for humans because the deeper purpose of art is for humans to enjoy and reflect on the hidden glory of God. "Precisely because the *theiotas* (divinity) shines through in the glorious and the beautiful, and God 'is known to himself and

[23] Kuyper, *Calvinism*, 143.
[24] Kuyper, *Calvinism*, 143.
[25] Kuyper, *Calvinism*, 163.
[26] Kuyper, *Calvinism*, 153.
[27] Kuyper, *Calvinisme en de Kunst*, 15. My translation.

to no one closer,' every attempt at analyzing the beautiful, as Winckelman has said so well, must suffer shipwreck. The moment you analyze the beautiful it is gone."[28]

To a certain extent Kuyper did assume the Pythagorean or classical ideal of beauty and thought art should embody the beautiful. However, he departed from it in significant respects: first he knew the Pythagorean *mathematical* ideal of beauty did not capture the reality of a creation that was good in principle but broken in condition—a world on a bumpy path to redemption and glorification. True beauty comes from digging below the surface such as Rembrandt often did and from opening up reality as it truly is and what it points to. Second and consequently, he did not limit to museum art or art for art's sake, but also saw it as potentially enhancing ordinary life. Art was not properly autonomous or an end in itself. The goal of art was not limited to sheer contemplative delight. Although some works of art could function in this way, another common function of the arts was to simply add enjoyment and amusement to life. If Kuyper ever thought of art as having come into its own, it was in the Reformation period and particularly in the Golden Age of the Netherlands when fine paintings were abundant enough to be sold at open air markets next to the fish, baked goods, and vegetables.[29]

It follows from what Kuyper says that, whenever possible, churches and places of Christian worship should be handsome, well designed, and well-furnished—as were the first ones built in the Netherlands after the Reformation.

THE GREEK AESTHETIC ACHIEVEMENT

It was ancient Greece in Kuyper's opinion, and not the Enlightenment or Romantic periods, that established a benchmark for lifelike works of art widely displayed throughout the *polis*, or community. He says that "unbelieving nations . . . in their secular history are called by God to a special vocation."[30] And the Greek vocation was to achieve a breakthrough and

[28]Kuyper, *Calvinisme en de Kunst*, 14. My translation.

[29]The vast number of high-quality paintings dating from this period can still be seen in the large and small museums throughout Europe, not to mention the countless auction houses and private collections.

[30]Kuyper, *Calvinism*, 160.

discovery yet unknown to the world in art. Art "is a plant that grows and blossoms upon her own root. . . . Inasmuch as the Greek artists were the first to clearly see the law of the existence and growth of this art-plant, it is for this reason that all of the higher arts again and again borrow the pure impulse of that classical development."[31] "And although a further art development may seek newer forms and richer material, the nature of the original find remains the same."[32]

And yet Kuyper adds to this high assessment of the Greek achievement the statement: "Not for the sake of stopping short with Greece or adopting her pagan form without criticism. Art, like science, cannot afford to tarry at her origin, but must ever develop herself more richly, at

Figure 3.3. *Venus de Milo*, 130 BC

the same time purging herself of whatsoever had been falsely intermingled with the earlier plant."[33] While there may be some *tension* between his assessment of the Greek achievement and Greek paganism, Kuyper seems aware of the need to be discerning in borrowing from Greek artistic perspective or technique.

[31]Kuyper, *Calvinism*, 162.
[32]Kuyper, *Het calvinisme*, 158-59, 218-19. My translation.
[33]Kuyper, *Calvinism*, 163.

While the Greeks disclosed some of the treasures and laws of art to the world, it was the love of liberty characteristic of Calvinist and Reformation lands that opened artistic work to ordinary life, and not merely to mythological figures and themes depicted in human form. "When it comes to art, neither Greek mythology nor saints nor heroes are needed, but in any object of ordinary life a meaning can be perceived by artistic discernment which transforms something that was nothing, into an object of wonderment."[34] As we have seen, the beautiful is not narrowly restricted to what might be called high art but can be present almost anywhere: "Any color, tone, or line can, just as well as a characteristic mood, thought or deed, be beautiful in itself."[35]

From Kuyper's Neo-Calvinist perspective follows that human artistic work should neither slavishly mimic (broken) reality nor fly into high-flung fantasies. It is best when it focuses on reality but does not stop at appearance(s), just as the natural scientist, plant, or animal breeder seeks to bring out lines, characteristics, and vibrant qualities leading to improved novel strains. Artistic work should offer *a foretaste* of the way brokenness can give way to glory and examples of hard-won salvation and resurrection.

> The central impulse, and the central animation, in the mystical root of our being . . . seeks to reveal itself to the outer world. . . . Thus also no unity in the revelation of art is conceivable, except by the art-inspiration of an Eternal Beautiful, which flows from the fountain of the Infinite. . . . And since this is the very privilege of Religion, over intellect, morality and art, that she alone effects the communion with the Infinite in our self-consciousness, the call for a secular, all-embracing art-style, independent of any religious principle, is simply absurd.[36]

CONCLUSION

Sometimes Kuyper has a way of surprising his readers by saying the obvious. He took seriously the prophet's rebuke that idols cannot hear and graven images cannot see. And he then asks whether we really believe God can see and hear our music and works of art. He believes God can and quotes

[34]Kuyper, *Calvinisme en de Kunst*, 23.
[35]Kuyper, *Calvinisme en de Kunst*, 17.
[36]Kuyper, *Calvinism*, 150-51.

Psalm 94:9, which reads: "He that planted the ear, shall he not hear? He that formed the eye, shall he not see?" And, of course, Christians talk about singing songs of praise *to* the Lord. The sounds we make and the things we create are *accessible* to God—it would be nonsense to talk as we do if we did not believe this. We sing, pray, and act on the assumption that God is aware of our actions. Kuyper argues that all of this implies music, drawing, architecture, poetry, and the like are important to him and should be done well— by acquiring skills and an implicit knowledge of artistic norms. Kuyper believes God is a key recipient.

It may seem strange in our present culture to speak of norms, ordinances, or laws governing artistic work and its development. However, Kuyper assumes that in the process of acquiring or learning a craft or a skill we are being "inducted into a social practice" (as various philosophers such as Alasdair MacIntyre now refer to it), learning to do something special in which case a person is implicitly becoming familiar with the norms, laws, and ordinances of how certain things work and do not work. Artistic labor involves using this (sometimes hardly conscious) familiarity with norms to create and arrange things into desirable patterns that stimulate, enliven, and speak to their makers and recipients.

Artistic work, like other human activities, bears marks of those who make them. Even things used for destructive purposes are not without meaning. Works of art have meaning and reflect attitudes and parts of perspectives of those who make them. Each work contributes to an ongoing conversation and debate about human life, God, and the world. In conclusion, Kuyper asks, "Would it not be both a *degradation* and an *underestimation* of art, if you were to imagine the different branches into which the art divides itself, to be independent of the deepest root which all human life has in God?"[37]

BIBLIOGRAPHY

Begbie, Jeremy. *Voicing Creation's Praise: Towards a Theology of the Arts*. London: A&C Black, 1991.

Henderson, R. D. "How Abraham Kuyper Became a Kuyperian." *Christian Scholar's Review* 22, no. 1 (1992): 22-35.

[37]Kuyper, *Calvinism*, 151.

Kuyper, Abraham. *Calvinism: Six Stone-Lectures*. Grand Rapids, MI: Eerdmans, 1931.

———. "Eenvormigheid de Vloek van het Moderne Leven." Lecture, Amsterdam, April 22, 1869.

———. *Het calvinisme en de kunst*. Amsterdam: J. A. Wormser, 1888.

———. *Het calvinisme. Zes Stone-Lezingen*. Amsterdam: Höveker & Wormser, 1899.

———. *Souvereiniteit in eigen kring*. Amsterdam: J. H. Kruyt, 1880.

Puchinger, G. *Abraham Kuyper. De jonge Kuyper (1837–1867)*. Franeker, NL: Wever, 1987.

DOOYEWEERD'S AESTHETICS

ROGER D. HENDERSON

Forever, O Lord, your word is settled in heaven.
Your faithfulness is unto all generations:
You have established the earth, and it abideth.
They continue this day according to your ordinances:
For all things are your servants.

PSALM 119:89-91

A PROFOUND SENSE OF THE RICHNESS, diversity, and potential nobility of human culture animated Herman Dooyeweerd's many-layered philosophy and aesthetic theory. He viewed the work of the artist and musician as neither trivial, superfluous, nor neutral. As a real part of God's creation, the aesthetic dimension was given to humanity to be opened up and enjoyed. The possibilities of art and artistic work were not of human fabrication but a God-given part of our world. Artistic qualities and experiences come about through structures given to us to be disclosed and embodied in an endless variety of genres, cultural styles, and traditions. Real art is never simply a copy of nature but springs from cultivated aesthetic sensibilities.[1]

[1]Herman Dooyeweerd, *De Wijsbegeerte der Wetsidee* (Amsterdam: H. J. Paris, 1936), 3:81.

Even the most strictly representational works of art are "related to an ideal, harmonious sensory shape, evoked in the productive fantasy of the artist."[2]

The subculture in which the young Dooyeweerd grew up recognized the normative depth of religiously positive cultural attempts to give tangible expression to the glory of God. Even when hundreds of years old, the best examples of this still speak to us forcefully today, in deeply moving works such as those of Rembrandt, Vermeer, Bach, or Handel. Dooyeweerd's intellectual predecessors, G. Groen van Prinsterer and Abraham Kuyper, affirmed a strong historical link between Reformation Christianity and the Dutch Golden Age with its fantastic trove of artistic treasures and a close connection between Calvinism and freedom—political, social, and artistic freedom. This subculture, nourished by a biblical view of human and non-human nature, gave him an appreciation of the reality and significance of artistic cultural life. From this appreciation came a renewed (or "neo") Calvinism which recognized art (broadly defined) as an integral part of a God-glorifying human existence.

The aesthetic theory Dooyeweerd worked out is not simple nor particularly easy to understand. However, his work in this field affirmed the unquestionable importance of art for subsequent generations of artists, scholars, and teachers. His first philosophical goal was to distinguish each facet of reality, in this case, the given structure and character of the artistic or aesthetic sphere. At the same time he believed he had to explain the place and interrelationship of the aesthetic within the other facets of the creation. In order to accomplish this, he was convinced he had to identify the defining feature of an aesthetic sphere. His unique approach and way of thinking grew out of Abraham Kuyper's thought. For this reason some comparisons of their ideas will be necessary here. At the end of this chapter we will look at an application of Dooyeweerd's theory to a sculpture made in ancient Greece.

Among the first generation of students to complete their doctorate degree at the Free University at Amsterdam (the institution Kuyper helped start) was the young law student Herman Dooyeweerd. After completing his doctorate in 1917, he went on to develop some of Kuyper's key principles into

[2]Herman Dooyeweerd, *A New Critique of Theoretical Thought* (Philadelphia: P&R, 1957), 3:113.

what he initially called a Calvinistic philosophy. Some level of familiarity with Dooyeweerd's philosophy is necessary in order to understand his aesthetic theory. One of its basic philosophical ideas was derived from Kuyper's emphasis on the central importance of a person's worldview—or *levensbeginsel*, that which motivated and directed the life and thinking of a person—within a community. Kuyper made the claim that the directional thrust or guiding force of human existence came neither from our emotions nor our minds but from what he described as the biblical principle of the heart. The basic assumptions and issues of life come from the heart—of human beings who are inevitably part of a community—of shared belief. Although mysterious in its working, the heart is the hidden core, center, or *root* of human will and assent. It is nourished, fed, and directed by what we love. Although disrupted by sin it is the ultimate spring out of which we think, feel, and act.

One day while reading Kuyper, Dooyeweerd was struck by the significance of this idea—of the centrality of the heart. It soon became a foundational principle of his thinking. Out of it and the related idea of worldview, he derived the notion that the major communities of human thought are rooted in a "ground motive." Flowing from the heart, a ground motive was said to entail answers to a few of the most basic theological and

Figure 4.1. Herman Dooyeweerd

philosophical questions. Human thought and action were said to be driven or guided by deep, often unrecognized assumptions, presuppositions, and religious persuasion called ground motives. At its most basic level, the thrust and direction of thought begins here. Many other factors influence human life, thought, and action, but this is its most basic, persistent, and enduring source.

The background to Dooyeweerd's ideas was nourished by biblical teaching shaped by Augustine, Calvin, and Kuyper. Once his basic ideas were worked out, they became the context out of which he developed his aesthetic theory. His work and this (Kuyperian or Neo-Calvinist) approach to life and thought, stimulated the subsequent aesthetic reflection of various other authors (including some in this book).

THEORY BASICS

Various things helped give rise to Dooyeweerd's new system with its attention to art, economics, sociology, and the like. His first heuristic insight was that behind the various primary areas of life and corresponding academic disciplines, there had to be law. Accordingly, some idea of law was necessary to account for the structure and order of the cosmos. Something of this sort, he conjectured, had to be assumed by every thinker. A law idea of some kind would also be necessary in order to account for the diversity of the universe. "Modal law-spheres" was his answer. Although not to be identified with concrete things such as animals, vegetables, or minerals, the spheres provide the defining structural possibilities for various activities and the creation of artifacts. Out of these insights Dooyeweerd began to formulate a philosophical system with a novel form of analysis, allowing him to identify what turned out to be a little more than a dozen basic spheres of reality.

Each of the to-be-identified spheres required an identity that was irreducible, that is, a quality that could not be explained in terms of any other. The system was formulated by means of empirical analysis of the scientific disciplines, observable regularities in nature, and the scriptural teaching about ordinances God used and uses to structure and direct the universe.

According to Dooyeweerd, while there is a diversity of spheres, the unity of the cosmos is evident in the hints and analogies of each sphere. Every

sphere is its own unique kind of meaning, which accounts for the qualifying structure of a certain type of individual thing or activity. This philosophical approach involves a particular conception of time and meaning which tries to account for the underlying coherence or irresoluble unity of the universe. His new type of modal meaning-analysis allowed Dooyeweerd to elucidate the way the various spheres were rooted, experienced, and reflected in each other. For aesthetics this implies that artistic work derives from possibilities offered to humans through the ordinances of an aesthetic sphere of reality.[3]

MODERN ART AND THE AESTHETIC

Although his theory relates well to seventeenth-century art, it can also be illustrated by one feature of modern art. In terms of the Western art tradition, one strange thing about modern art is the way it frequently forces us to focus on the stuff out of which works of art are made. Materials are often conceived and used to construct things that allow a person to experience them either as materials or works of art or both. The artist intentionally highlights surfaces that appear able to undergo a transformation into "art." There are installations, assemblages, and arrangements of sticks, stones, steel, bits of fabric, glass, and gobs of paint on canvas like this in modern art museums everywhere from Tokyo to New York City. Many of them might be mistaken for works in progress, materials waiting to be used for something else. However, given the right context and a capable viewer, such arrangements appear capable of being experienced as aesthetic objects. (Sometimes this happens, and sometimes it doesn't; for some viewers the arrangement just remains an aggregate of elements lying on the floor or hung on the wall.)

[3]Dooyeweerd distinguishes fifteen law spheres or modalities and strenuously affirms (as did Kuyper) that each has a specific, i.e., targeted kind of sovereignty and universal coherence. Reality is a unified whole, and everything is interconnected. The ordinances of all the spheres exercise some degree of governance or pressure throughout all of reality, yet one specific sphere governs, or exerts normative pressure within, its own domain in a peculiar way. The process of manufacturing, buying, and selling things is economically qualified but still functions subject to ordinances of mathematical, spatial, physical, biological, linguistic, social, ethical, legal kind. Dooyeweerd describes two ways in which one feature or "moment" of one law-sphere act within all the other spheres. The two technical terms for these actions are *anticipations* and *retrocipations*, either going from the less to the more complex or from the more complex to the less complex spheres. For example, the influence of linguistic ordinances shows up in economics—describing your products or services well—and that of economics shows up in language—saying a lot in few words.

Figure 4.2. Carl Andre, *43 Roaring forty*, 1988

How does this illuminate Dooyeweerd's theory of an aesthetic sphere and its typical function? It does so by drawing attention to the way materials are absorbed or "enkaptically interlaced" into an aesthetically qualified work.[4] Such an arrangement may be perceived and experienced as an aesthetic artifact, which Dooyeweerd refers to as "aesthetically qualified." The existence of a human and non-human nature that is capable of experiencing and being experienced as art is quite amazing. Aesthetic experiences and artifacts can be composed of words, sounds, actions, or materials arranged in such a way as to constitute a dynamic interplay of elements whose leading function, according to Dooyeweerd, is harmony.

As a musician himself, Dooyeweerd knew of the way tension and dissonant elements long to be resolved. This is the inner goal of artistic work, as he sees it—a unity born out of a diversity of elements, creating a compelling whole. It is supposed to come about as a "harmonious objectification of an intentional (imagined) arrangement in the artist's mind."[5] Aesthetic work is not merely meaningful; it represents a distinct type of meaning. Some modern art fails at this and disintegrates into satirical and iconoclastic absurdity. According to Dooyeweerd's theory, artistic play has the serious goal of arranging things in ways that make coherent statements and illustrate harmonious aesthetic ideas. To be compelling, he argues, works need to aim for a coherent, harmonious consummation.

[4]*Enkapsis* is defined as "when one structure [or individual thing] restrictively *binds* a second structure of a different radical- or geno-type, without destroying the peculiar character of the latter." Dooyeweerd, *New Critique* 3:125n1.
[5]Dooyeweerd, *New Critique* 3:117.

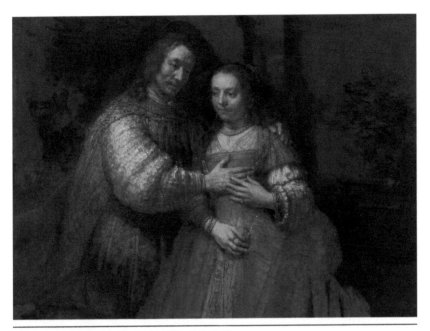

Figure 4.3. Rembrandt, *The Jewish Bride*, 1665–1669

Traditionally speaking, artistic works were designed to swallow up the materials out of which they were made into a measured meaning and beauty that transcended the materials composing them. An apparent exception to this rule was when a gifted artist (such as Rembrandt, and of course later Van Gogh) layered paint on a canvas so thick that it allowed (or even encouraged) the viewer to see it as paint, and yet still be swallowed up in the aesthetic function, such as the right sleeve of the man in this painting (fig. 4.3). As a whole, works were meant not to point back to their medium but beyond to an aesthetic accord. As a rule the recipient's awareness was intentionally drawn away from the medium and focused on a synthesis envisaged by the artisan or musician. According to Dooyeweerd's theory, this is the inherent goal of artistic creation. The work is an outward embodiment of something inward, something envisioned in the artist's or musician's own imagination—created for the capable and appreciative observer.

Dooyeweerd's technical distinctions or way of explaining this is to point out that aesthetic work properly encapsulates its materials—its canvas, paint, stone, or sound—in such a way so as to disclose the

aesthetic possibility of these materials via this sphere of reality. Incorporated in this sphere is human aesthetic receptivity. The medium is very much there and present; it occasions some thing or some experience that transforms (encapsulates) the medium into an aesthetic object and message. Dooyeweerd describes this as materials becoming artistically *qualified*, even though they do not stop being canvas, sound, or stone. The aesthetic function requires, but is not exclusively based on, human subjectivity: it is part of a beautifully arranged human and non-human "nature"—order of creation. Art (broadly defined)[6] requires the eye of the beholder, but, he says, "A truly *Christian* aesthetics can never absolutize the individual aesthetic subjectivity and make it a sovereign creator of beauty not bound by norms of the Divine world-order."[7]

The materiality of artistic work is recognized in Dooyeweerd's structural analysis. It is what carries the anticipated aesthetic intention, and as such is indispensable to the achievement of any artistic purpose—allowing sound waves or projected light particles to function aesthetically. "The task of the artist is to open or disclose the natural structure of his [or her] material through the aesthetic structure of the work of art, so that the natural structure itself (although only in its enkaptic functions) becomes a complete expression of this aesthetic structure."[8]

Dooyeweerd distinguishes a specific order or sequence of the aspects of reality. For example, the aesthetic sphere follows after the economic sphere. The aesthetic is in turn followed by the legal, whose essence is justice or rendering to each his due. This is *analogically* reflected in artistic matters as "in nothing too much." While the economic centers around utility or the *frugal* utilization of resources, aesthetic works and experiences center around harmony. Artistic experience is a time of enjoyment. This type of experience is restorative and recreative. It is meant to bring creation and (human) creatures back into balance, harmony, and shalom. As suggested above, Dooyeweerd's unique view of unity and diversity plays a key role in his acknowledgment of a distinct aesthetic sphere. Each sphere has its own

[6]Dooyeweerd mentions painting, sculpture, wood carvings, music, drama, and literary works as some of the different kinds of art works (*New Critique* 3:110). He distinguishes between performance art and fixed, tangible works of art.

[7]Dooyeweerd, *New Critique* 2:128.

[8]Dooyeweerd, *New Critique* 3:126; *De Wijsbegeerte der Wetsidee* 3:95.

defining feature. The basis of the aesthetic sphere is harmony or what he has described as "the proportional configuration of [lines and] planes."[9] "In its original meaning harmony always requires aesthetic unity in multiplicity."[10] He saw an illustration of this in the way harmony appears to build on or presuppose the economic principle of frugality. This, he says, is mirrored in the aesthetic sphere in terms of balance or harmony.

For the artist or musician, our culture's overemphasis on monetary wealth and economic utility engenders feelings of abnormality and encourages them to play the role of the rebel or prophet. It arises out of our culture's failure to recognize an aesthetic sphere as an inherent, given part of life. The leveling materialist assumption of our Western culture deprives art of its significance. Artistic work cannot be properly experienced or appreciated in terms of raw utility. Neither should artistic work be defined as useless or impractical (as some people have done). The effective use of materials plays an important role in both artistic creation and economic activity but qualifies only the economic. An analogy links the economic and the aesthetic sphere. Such analogical moments reveal the interconnectedness and coherence of reality.

DOOYEWEERD AND KUYPER

Both Kuyper and Dooyeweerd gave a vigorous defense of the more-than-subjective character of artistic work(s). Dooyeweerd did so primarily by distinguishing and describing aesthetic reality and works of art as having their own object functions, that is, factual existence as aesthetic artifacts. Artworks make use of a structural possibility of disclosing aesthetic meaning. Their meaningfulness is neither wholly a human nor wholly a given product; it is both. This is close to Michelangelo's idea that the sculptor's job is to uncover the sculpture hidden in the stone. Artistic artifacts are disclosed by humans, who are equipped with the capacity to learn to make and enjoy them. "To comprehend the objective reality of this work of art, the observer must contemplate it as the structural objective realization of the subjective aesthetic conception of the artist."[11] Artistic work is born in the artist's

[9]Dooyeweerd, *New Critique* 3:112.
[10]Dooyeweerd, *New Critique* 2:128.
[11]Dooyeweerd, *De Wijsbegeerte der Wetsidee* 3:82-83.

imagination and can be enjoyed by the observer precisely because the elements and necessary conditions for making and learning to enjoy them are provided beforehand in the structure of human and non-human nature.

Dooyeweerd took up Kuyper's point that art should not be dictated to by business, church, or state but should be guided by aesthetic considerations. He advocated the principle of "distributed authority" or "sphere sovereignty," as it was called.[12] Artistic work should serve but not be dominated by non-artists, people or institutions whose interest (and sphere of authority) is other than the aesthetic. Much of today's artistic work is financed and driven by business motives—with the primary and often narrow goal of profit. Quite apart from the principle involved, the economic motive tends to minimize the truly artistic impulse. For Dooyeweerd this amounts to a violation of the aesthetic sphere, the integrity of art, the artisan, or musician. The arts can serve many different ends, but everyone suffers when they are dominated by nonartistic motives. Such domination creates pressures keenly felt by artists and encourages them to subvert or ignore aesthetic norms.[13] Similarly, when the arts were organized and sponsored by the medieval church, they functioned as a tool of a certain type of religious worship. That became its purpose, the reason for its existence, the goal and function determining its character. Aesthetic development should not be dominated by a political, economic, or ecclesial hierarchy. Although great artistic and musical works have sometimes resulted, this limited artistic styles as well as worship expressions. Worship of God should not be turned into high art, nor art into a tool of the hierarchy. The worshipers' attention should be drawn to the One worshiped and not to the medium of worship. Nothing is wrong with serving non-aesthetic goals as incidental purposes, but much is lost or corrupted when such purposes become dominant.

The glory of the art works created in the Dutch Golden Age (created for buyers, and patrons as buyers) showed what freer artistic expression could mean in practice. This was in the back of Dooyeweerd's mind as he wrote.

[12]See an article with this title in *Philosophia Reformata*, 2017.

[13]His somewhat technical definition reads: "A work of art is free, when it is not enclosed in an *enkaptic* structural whole which lacks an aesthetic qualification" (Dooyeweerd, *New Critique* 3:121n1).

ARTISTIC SIGNIFICANCE

Dooyeweerd, following Kuyper, believes that artistic activity involves a distinct sphere and is inherently meaningful. Both reject the modern claim that culture is exclusively a human historical product or fabrication with no foundation of meaning. As Kuyper put it, "We do not have to organize society; we have only to develop the germ of organization that God himself has created in our human nature."[14] This holds true for artistic work according to Dooyeweerd. The underlying structures of cultural life rest on an order (read "ordinances") given by God, unfolded and embodied by people in different ways at different times and places.[15] Human and non-human nature have a carefully designed, finely tuned, and *knowable* structure that can be studied, intuitively grasped, and embodied in the midst of universal dysfunction. This is what accounts for both the wonderful possibilities and sad imperfections of art, music, and the rest of culture. Neither the people who study nor the things or people studied are in a pristine state; both are internally disrupted by sin.

The fact of an aesthetic sphere, based on divine ordinances waiting to be disclosed and unfolded, convinced Dooyeweerd that artistic works and musical compositions always express some view of the good, true, and beautiful. In a world where an aesthetic sphere is a reality, real artworks produced through human imagination are meaningful; they always express some particular meaning and hence are never trivial or neutral; they always indicate the artist's, the musician's, and their culture's sense of what the world is like. Attitudes and assumptions are represented in artistic compositions that point to what life and the world *should* be like. The things humans make are not autonomous or neutral; rather, they imply a commentary on what people and their culture believe is important, necessary, and needs saying.

Although Kuyper and Dooyeweerd each defend the idea of sovereign spheres of creation called into being and sustained in time by God,

[14]Abraham Kuyper, *Het Sociale Vraagstuk en de Christelijke Religie* (Amsterdam: J. A. Wormser, 1891); Kuyper, *The Problem of Poverty*, ed. and trans. J. Skillen (Sioux Center, IA: Dordt College Press, 2011), 62.

[15]A lot of what we understand as the pressure of law and norms on us is really the influence of time. Time is an instrument of God, an order to which we are subject. He has made it to bring things about, to arrange and order things, and to bring things to an end. We are ruled by means of temporal order. We talk of "the test of time," and rightly so.

Kuyper's spheres were societal in nature and almost unlimited in number. For Dooyeweerd they are cosmological laws or ordinances and limited in number—about fifteen. Although we read about law(s) and ordinances in Scripture, many of them are experienced and recognized only intuitively and inductively conjectured by observing regularities and repetitious effects.

While all spheres can be referred to as "law spheres," only the first four function as causal laws; the others work in a norm-like fashion inclining or pressuring people and cultures to behave in particular ways—without compelling them to do so. Each culture and time period presents its younger generation with its own examples of embodied norms and precepts in a wide range of more or less exemplary ways. Justice, beauty, frugality, solidarity, communication, and the like can be expressed in vastly diverse artistic forms. In language we see a good example of the unfolding of given norms or structural possibilities. These involve symbolization, phonology, human consciousness, and so on, which in turn depend for their possibility on ordinances given in human and non-human nature. Art, like language, is possible because human and non-human nature have been provided with the possibility of disclosing given structures such as sets of syntactic, semantic, and semiotic conventions and norms in a vast variety of ways.

CORE QUALITIES

Each of the law spheres has its own target function, even though they all exert some influence on all objects and activities. When we go to the store to buy something, we communicate, socialize, display style, move around, metabolize, and so on, but the target function or qualifying purpose of our visit is usually economic. This is what brought us to the store and what brought the store into being. Hence, the basic signature of a certain type of entity within a certain sphere is called its characteristic or qualifying function. It refers back to the peculiar core quality or norm that structures and chiefly "presses upon" us in that type of activity. Lots of other actions may go on during our visit to the store, but none are the target qualifying function. This is naturally different for a visit to a museum. Its target function would be aesthetic. Generally speaking, each human artifact and

activity is qualified by some sphere, dependent or founded on another and subject to all.

Dooyeweerd argues vehemently that each primary sphere or function can only be explained or reduced to another at the high cost of negating its true identity and reality. This he says means that each is properly "irreducible" to any other. This refers back to the idea of one core quality for each sphere called its "nucleus." The identity of a sphere is determined by locating a core quality or nucleus characterizing its unique function and the set of regularities observable in a group of phenomena. When an irreducible core quality is intuitively distinguished and articulated in a way that excludes the possibility of antinomy (a conflict of laws), we conclude that a unique law sphere has been found—with a structure and function that cannot be accounted for in any other way (or sphere).

A peculiarity of these core qualities is that they can be apprehended by intuition but not fully analyzed or comprehended. "It is the very nature of the modal nucleus that it cannot be defined because every circumscription of its meaning must appeal to this central moment of the aspect-structure concerned. The modal meaning-nucleus itself can be grasped only in an immediate intuition and never apart from its structural context of analogies."[16]

It is of such a basic character of predication that we can only perceive its effects and grasp it intuitively. This means that our conclusions about core qualities remain provisional.

THE HEART OF THE AESTHETIC ASPECT

What is the distinguishing feature or core quality of the aesthetic aspect of experience? "The nuclear moment of the aesthetic aspect is harmony in its original sense."[17] Although criticized even by scholars sympathetic to this philosophy, it should be remembered that Dooyeweerd sees the aesthetic sphere as a distinct kind of meaning. All of creation according to him has a "universal character of referring and expressing" that reaches beyond itself.[18] The aesthetic is particularly rich in this regard, symbolizing much more than can be said in words. As a peculiar type of meaning, aesthetic harmony

[16]Dooyeweerd, *New Critique* 2:129.
[17]Dooyeweerd, *New Critique* 2:128.
[18]Dooyeweerd, *New Critique* 1:4.

should be understood as rich, suggestive, and many-sided, involving a well-ordered arrangement that speaks loud and clear—in its own way. In order for artistic work to reach us, harmony is held to be necessary. It is defined negatively, using the classical Greek idea of "in nothing too much" (*meden agan*). Offering practical advice, Dooyeweerd says, "The aesthetically super-fluous . . . ought to be warded off in harmonic sobriety or economy if the harmony is to remain intact. And this standard is applied not only to highly cultured work of art but also to a primitive product."[19]

A good example of this is the way a symphony orchestra works, engaging many instruments to produce one harmonious, well-balanced effect. Artistic work involves creating arrangements out of contrasting elements and finding unique kind(s) of unity in diversity. Although harmony is its core quality, art should not be understood too narrowly as if it had no other qualities. Just as frugality is not the only goal of economic activity, nor justice the only characteristic of jurisprudence, neither is harmony the only goal of art.

While Kuyper's aesthetic thought centered on glory, Dooyeweerd's centers on harmony. However, both stress the crucial importance of *unity* in aesthetic matters. Pointing to harmony, a well-ordered arrangement, as the core quality of the aesthetic sphere, may seem rather minimal, but it encourages and affords the possibility of artistic reflection and labor based on something real rather than relegating it to lawless subjectivity. A theory of art that "denies any subjection to norms" undermines the aesthetic. To "absolutize the individual aesthetic subjectivity" is to negate the existence of art, making it anything anyone says it is or in fact nothing at all.[20]

THE FOUNDING SPHERE

A major part of the disclosure of art and music is the element of style—the historical unfolding of possibilities that bears the marks of a particular cultural orientation, period, and place—that which Dooyeweerd calls the "founding" feature of artistic work. The structural ordinances that afford the possibility of styles are only "known" in their disclosed or developed state. This means that the ordinances or norms constituting this and the other law spheres (impinging on the human mind and graspable by intuition) are

[19]Dooyeweerd, *New Critique* 2:128.
[20]Dooyeweerd, *New Critique* 2:128.

never manifest in their chemical purity. Like the rules for a game, they are embodied and only tangibly experienced when the game is played. The possibilities themselves are not created by human culture(s) but are offered for disclosure in advance. Dooyeweerd mentions the use of both conventional and non-conventional sensory symbolism; he says "it may vary considerably in different social circles and peoples at a different stage of cultural development or with a different cultural tradition. . . . Non-conventional is in general the sensory symbolism of original aesthetical means of expression."[21] Similarly, games exist and can be played because conventions and rules have been worked out in advance and exert normative pressure on players. The rules circumscribe and channel what may be done, but they do not determine what is done. Even after the cultural embodiment of rules has taken place, the application and outcome of these is dependent in large measure on what people do in response to them, that is, in response to the rules worked out by earlier generations.

Dooyeweerd asks, Through which functional aspect do artworks come into being? Which of the modal law spheres provide the basis or foundation for their actual fabrication? At first glance it might seem to be the material, for example, the stone or marble of a sculpture. However, since the same sculpture could be made out of wood, clay, or plastic, the material appears not to be its foundation, the determining factor bringing it about: "To the artist the marble is important solely as a medium of expression."[22] However, since artworks result from the "free formative control" of the artists, their foundation turns out to be the techno-formative or historical sphere. "The raw marble, as a natural product, does not yet have within itself anything that can serve as the typical original foundation of the individuality of this work of art."[23]

Works of art, says Dooyeweerd, have "a typical aesthetic qualification and a typical historical foundation."[24] When successfully realized through the artisans' imagination and hard work, they become tangible aesthetic artifacts with a reality and objectivity of their own. "In Praxiteles' Hermes . . . we

[21]Dooyeweerd, *New Critique* 2:379-80.
[22]Dooyeweerd, *New Critique* 3:125.
[23]Dooyeweerd, *New Critique* 3:119.
[24]Dooyeweerd, *New Critique* 3:126.

are really confronted with such a structure. With respect to its sensory form this thing is actually an image or copy of the visionary sensory shape, originally born in the productive fantasy of the artist."[25]

As to the debate about whether an artwork is purely a product of imagination or purely a copy of nature, Dooyeweerd takes a middle position: it involves both. In order for an aesthetic object to be seen for what it is the viewer must recognize it as an artwork: "To comprehend the objective reality of this work of art, the observer must contemplate it as the structural objective realization of the subjective aesthetic conception of the artist."[26] If an observer sees the object only as a lump of wood or stone, something is wrong. "To the degree that the marble strikes us as a resistive natural material, not completely controlled by the artistic technique, the work of art is a failure, or at least lacking in perfection. The internal structural unity, *intended* in the aesthetic conception, is then not fully realized objectively in the marble statue."[27]

Figure 4.4. Praxiteles, *Hermes and the Infant Dionysus*, ca. 340 BC, detail

[25]Dooyeweerd, *De Wijsbegeerte der Wetsidee* 3:82.
[26]Dooyeweerd, *New Critique* 3:114.
[27]Dooyeweerd, *De Wijsbegeerte der Wetsidee* 3:94.

AN APPLICATION OF THE THEORY

Dooyeweerd applied his theory to the famous Greek sculpture *Hermes and the Infant Dionysus* by Praxiteles (ca. 340 BC; fig. 4.4). He considers it a masterpiece and describes the wonderful technique Praxiteles employed to acquire such a lifelike effect in marble. "Consider," he states, "the inimitable position of the head of Hermes; the dreaming-pensive expression on the face; the tender warm tone of the body . . . the gracious position of the left arm bearing the boy Dionysus, while the right arm playfully shows a bunch of grapes to the child."[28]

He says the sculpture is not a straightforward copy of the models who posed for it. Although the models had an aesthetic function, as human beings they were not qualified aesthetically, nor by any other of their functions.[29] This artwork was the result of the skilled labor and aesthetic imagination of the sculptor. Praxiteles visualized the models in his artistic fantasy.[30] Anyone who fails to see the *Hermes* as an artwork fails to see the object before him or her; this is its identity, the kind of thing it is. The sculpture is a real, intentional object with aesthetically qualified meaning; it is more than the materials out of which it is made. The purpose and character of the sculpture actualize the aesthetic dimension, offering it to a receptive observer for aesthetic appreciation. Dooyeweerd says that the "objective sensory fantasy-form of the *Hermes* is not a merely intentional one, in the same sense as that of the subjective artistic conception. This fantasy-form has been depicted and realized in the marble material."[31] The artist's work of imagination has become something tangible. In the case of the *Hermes*, Dooyeweerd is convinced that the marble stone is completely swallowed up into the work as a unity and hence is a magnificent artistic achievement.

CONCLUSION

Dooyeweerd's philosophy gives a cosmic grounding to art and artistic work as one of the essential parts of human life. His aesthetic theory amounts to

[28]Dooyeweerd, *New Critique* 3:117.
[29]Because we are made after the image and likeness of God, we somehow go beyond our own limited collection of functions.
[30]Dooyeweerd, *New Critique* 3:113-14.
[31]Dooyeweerd, *New Critique* 3:119.

a defense of some basic reflective and unreflective elements of human experience. It does not allow the giving up of the basis of primordial human responses to things as beautiful or ugly, harmonious or chaotic, coherent or incoherent. His theory does this while remaining aware of the culturally formative influence of history, namely, of the way our cultural history helps shape our perspective of good and bad, pleasing and displeasing art. These are some of the ideas behind his defense of a partially classical theory of beauty and harmony in art.

BIBLIOGRAPHY

Dooyeweerd, Herman. *De Wijsbegeerte der Wetsidee, II–III*. Amsterdam: H. J. Paris, 1936.
———. *A New Critique of Theoretical Thought*. Vols. 2–3. Philadelphia: P&R, 1957.
Kuyper, Abraham. *Het Sociale Vraagstuk en de Christelijke Religie*. Amsterdam: J. A. Wormser, 1891. English translation: *The Problem of Poverty*. Edited and translated by J. Skillen. Sioux Center, IA: Dordt College Press, 2011.
Rookmaaker, Hans R. "Sketch for an Aesthetic Theory Based on the Philosophy of the Cosmonomic Idea." In *The Complete Works of Hans R. Rookmaaker*, edited by Marleen Hengelaar-Rookmaaker, 2:24-79. Carlisle, UK: Piquant, 2002.
Seerveld, Calvin G. "Dooyeweerd's Legacy for Aesthetics." In *The Legacy of Herman Dooyeweerd*, edited by C. T. McIntire, 41-79. Lanham, MD: University Press of America, 1985.

Part Two

ART
HISTORY

ART, MEANING, AND TRUTH

HANS R. ROOKMAAKER

Through art we can know another's view of the universe.

MARCEL PROUST

MODERN ART DID NOT JUST HAPPEN.[1] It came as a result of a deep reversal of spiritual values in the Age of Reason, a movement that in the course of a little more than two centuries changed the world. If we want to understand how new modern art is and why it carries the sort of message that it does, we have to confront it with the art of the period before the great change began.

For that reason I first want to discuss some works of "old art." It is not my intention to give a complete historical survey. My aim is to analyze briefly some particular works in order to see their meaning, content, and spiritual message. In doing so, a fact emerges which is common to them all and vital for an understanding of the particular role in society which art, and painting especially, has been called on to play. I have chosen works that represent the major historical movements that contributed to the culture of the period before the Enlightenment. The works belong to the great tradition that

[1]This chapter consists of chapter 1 of *Modern Art and the Death of a Culture* (London: Inter-Varsity Press, 1970); "Is Modern Art True?," *Opbouw* (1972): 278-80; "Letter to a Christian Artist," in *The Creative Gift: Essays on Art and the Christian Life* (Westchester, IL: Cornerstone, 1981).

began in the later Middle Ages and ended during the nineteenth century, the period when the new world emerged and modern art slowly took shape.

THE ICON

To illustrate what I want to say I have chosen, first, a Madonna by Duccio (fig. 5.1). I could have chosen many other paintings of the Madonna. Each would have some particular feature of its own and, of course, the paintings vary in quality. But all of them, or almost all, are alike in the points that I want to discuss.

Figure 5.1. Duccio, *Madonna with Child and Two Angels,* 1283–1284

The painting by Duccio is on wood and is quite small. As we look at it, we can ask ourselves what the artist meant when he was painting it. Or we can ask what people wanted the artist to create, for he did not stand alone as a creative artist but was closely tied to his community. What does the painting mean? Is it supposed to be a picture of something that could have been seen at Bethlehem in AD 1, a reconstruction of a photograph that could have been taken if they had had a camera? If we look at the picture—and perhaps even more if we look at representations of other biblical scenes—we shall soon see that this is not the case. Medieval people did not really think that the air in Bethlehem was golden! And they might even have realized that fashion had changed since then. The artist might well depict his Madonna in rich attire, even though he knew that she was poor, as the Gospel writers tell us (if he did not read the Bible for himself, the priest would have told him). So it is not AD 1.

What is it supposed to be then? A scene in heaven? But medieval people were theologically well-informed, and they would not have tolerated the thought that Christ would still be a baby in heaven. There is nothing to suggest that it is supposed to be set in the future. But neither does it seem to represent a specific scene on earth. So what does it mean?

Well, let us see what the picture itself says. It tells us obviously about the Madonna, called the "Mother of God"—that alone would be good enough reason to depict Christ as a baby. The Madonna is looking at us and seems interested in us, even if in rather an aloof way. She is obviously no ordinary person. Neither does the picture make an advertisement for childcare. She is more than human, yet still human. This is what the picture tells us. It is a sermon on Mary, if you like. In a deep and truly religious sense, the picture was a poster telling people to "go to Mary with all your troubles."

In Catholic churches, giving Mary an exalted position, these pictures are universal. The oldest are from before AD 500, the latest probably from yesterday. They do not tell about a reality of historical importance nor of a historical event, even though the picture is in fact related to an event such as the birth of Christ. No, these pictures talk about a reality claimed for this very moment, a reality that is to be believed and cannot be seen, that Mary, the Mother of God, can help you if you pray to her.

Such pictures we could call icons. They depicted something felt to be of supreme importance, and sometimes even the picture itself was considered holy. They stood for something supernatural, something above and beyond ordinary human experience, and were loaded with religious meaning. The painting was thus much more than a simple picture, a reminder of an important event, and very much more than a portrayal of something as humanly important as motherhood. They represented Mary, the Madonna, "Our Lady"!

But there is more to it than the subject matter alone. The artistic qualities have a part to play. The last thing the painters of these icons did was to take the subject just as an excuse for making a fine composition. Of course, if they were going to paint a picture of the Madonna, they wanted it to be as beautiful as possible. If one loves somebody, one never wants less. But the picture had more to say than just "Madonna." One can follow almost all the different stages in Mariology just by looking at these paintings. For instance, in the

fourteenth century one sees a new type emerge, the Madonna of humility, where we see the Madonna sitting on a cushion on the ground, often offering her breast to the child. This is a marked change from the Madonna as queen we see in the earlier periods and specifically in Romanesque times. After the fourteenth century the portrayal becomes more natural, with more attention to details like the hair, the chair, the background that often becomes a landscape. And in the Baroque period she sits on clouds, high above us mortals, often accompanied by adoring saints. They are setting us an example, the painting tells us. So the important thing is that it is precisely the artistic qualities of the composition that pass on the message—not just what we know or think about the Madonna ourselves.

BEYOND HISTORY

Though I have begun with a painting of a Madonna, I might just as well have chosen another theme, a crucifixion, an adoration of the Magi, or a resurrection. In all these I could equally have stressed that the artist was not concerned with historical events as such and certainly not with archaeological accuracy, but with dogma, with a creedal statement in a well-defined, traditional, compositional scheme. The styles might change and with them the theological overtones, but the basic ideas remain.

Many things did change. The Counter-Reformation came around 1560 as a Catholic reaction to the Protestant Reformation. The forms of piety, the subjective feelings in worship, the propaganda of the Catholic Church, the points of emphasis, all these changed while retaining the same basic ideas. One thing that was new was an emphasis on the greatness of the martyrs. Rubens, one of the greatest painters within this stream, painted some of the most convincing examples. His *Martyrdom of St Livinus* (see fig. 7.2) illustrates what I mean.

The saint is in the left corner in all his clerical attire, his arms outstretched, calling to God, giving himself to God. Just before, he had been standing before his judges telling them that he could not recant, even if they would otherwise put him to death, for there was an absolute truth, deeper and higher than anything else, that one may never deny. The judges themselves stood for another absolute truth, one that gave them the conviction that Livinus was dangerous. His tongue was to be cut out. This is what we see. He

calls to God and look, the heavens are open, angels come carrying wreaths to crown the martyr and others bring the sword of God's wrath. But it is not just a vision of a highly exalted mind: the soldiers see it too and flee. The horses stagger. The painting speaks of an open sky, a world that is not closed within itself: God and his hosts are there too. Truth has meaning.

Historical scenes, scenes from the Bible for instance, were no problem to the medieval person. He meant his picture to be a symbol of a truth deeper than the eye can see. But with the Renaissance, art began to have greater pictorial realism and this raised a problem. What will the artist depict: what he knows to be true or what the eye would have seen at that particular time and place? Let us take as an example Christ on the way to Emmaus. We know from the biblical story that there were three men on the road, and two of them did not yet know that the third was Christ himself. What must the artist show? What he or she knows or what the casual passer-by might have seen? Either way the artist is at variance with the biblical truth.

This problem is always present in one way or another in the portrayal of biblical narrative. The picture can be made historically exact (as in the nineteenth century), attempting to reconstruct what a camera would have recorded. But that would reduce the event to something of no more than historical interest. Or it can give the true, timeless message, but often only by losing the historical truth of the fact. And true Christianity is firmly based on historical facts. The fact that God led his chosen people out of Egypt is a historical event to which the whole Old Testament refers again and again. It is equally vital for Christianity that the event of the resurrection of Christ is recognized as really having happened in history. Otherwise, says Paul, "Your faith is in vain."

This dilemma led many seventeenth-century painters in the countries of the Reformation, in Holland for instance, to abandon painting biblical scenes entirely. Only Rembrandt really tried to overcome the problem. His drawing of Christ on the way to Emmaus shows his answer perhaps best of all. When we look at the drawing, at first glance there is nothing special about it. Three men are standing together near a house. Yet we gather that the middle one is most important. Rembrandt has made this apparent by pictorial means by making the side of the house dark, thus creating a rhythm, man-Christ-man-house, with the downbeat on Christ and the house. He

also makes Christ stand out as important by the way he has placed him between the two disciples. Then Rembrandt draws some trees in the distance in such a way that, although there is no halo, yet there is a suggestion of one. In this way the drawing is natural and yet it is much more than just three men on a road. It brings out the fact which he wanted to get across.

In discussing the Madonna I made it clear that such a painting is much more than just decoration or a memory of an event or a didactic statement about the structure of a situation. The painting is loaded with religious meaning. It is crucial that we understand this. For in this way we can understand why in the course of western European history, painting has very often been much more than just decoration or something that people enjoy looking at. It has often been more loaded than is justified by its being art. It has been taken to be of deeper significance than tapestry for instance or ceramics or often even than sculpture. And this was not only because of its subject matter but more often than not simply because it made visible a particular view on life and the world. It expressed deeply felt values and truths through the way the theme and the subject matter were handled. Modern art cannot be understood if we do not take this into account. Many works would be senseless, real junk, but for the fact that, being art, they are exhibited because they have a message of almost religious importance, interpreting humanity and the world, perhaps even as junk.

TWO LANDSCAPES

A landscape by Jan van Goyen, possibly the greatest of all landscape painters, will illustrate how art gives an interpretation of reality. Look at the picture (fig. 5.2). It is as simple as can be—a calm sea, storm clouds, some boats in the distance, and to the right boats lying alongside the harbor jetties. The furthest point is to the far left, the brightest highlight—it is very far away indeed. How has the painter managed to achieve such depth in the painting? The cloud formation helps, of course, with its peculiar kind of perspective effect. Then we look at the water: there are light strokes alternating with dark ones. On the dark strip toward the front there is a small boat that makes a kind of silhouette against the lighter strip "behind" it. Yet we must realize that this "behind" is achieved precisely by making the dark stand out against the light—an effect called *repoussoir*, a method of helping to make clear the

structure of the reality we see by creating depth. Where we see the tone becoming lighter and weaker, where for instance a boat is further away, this is known as *aerial perspective.*

It is important to realize that this is no superficial painting. The artist is very much aware of what he is doing. We realize this better when we try to analyze the composition. We read a picture from left to right. (This is probably related to the way we write; Japanese art, for instance, "reads" from right to left.) So, to use musical terminology, the introduction is in the little rowing boat on the left. Through it we are brought into the first theme: the far distance out to sea. Then there is a bridge passage: the boat that is exactly in the middle of the picture. The second theme, the right half of the painting,

Figure 5.2. Jan van Goyen, *Approaching Storm,* 1646

could be called *Boats in a Harbor.* It is, as such, much nearer and more complex than the first theme. The coda is to be found in the walls of the town that can be seen at the extreme right.

It is typical that this composition can be read on the surface in such a musical way. This is not just by chance. Many pictures by van Goyen and by many other painters of the seventeenth century can be read like this. We realize in this way too that the painter has brought together in his picture many different things that belong to the sea, or rather to an inland sea or lake. It gives a concentrated view and analyses the structure of its reality. It is not just a view from a particular point. A study of Jan van Goyen will show that he never painted a view from a particular position. There is no photographic quality in his painting. Yet we feel that it is so real. The simplicity of the painting is its greatness and artistry. It is so real that many people today bypass the picture thinking that it simply copies nature. Yet it never does. The paint is laid very thin and in almost only one brownish color, so that the

whole design is realized in fine differences of tone. Note too how the clouds underline the whole two-theme quality of the composition—something that is very different from what is natural.

How can it be so real then? Those who think that a painting must be a copy of nature to be realistic are mistaken: art never just copies nature but rather portrays reality in a human way. That means that this painting does not copy nature as a camera would, but depicts a human experience, a human understanding, an insight and emotion into what the truth about reality is. It speaks in an artistic way about reality, as all paintings do. This one speaks about clouds, bad weather coming, the sea, water, boats, work, and rest. It does not copy, but is about something that is of human relevance. In a way one can say that the painting gives a particular view on reality, a philosophy. But it is of course given not in words, even less in arguments, but in its own artistic way. In the same way the Catholic painter expressed a theological understanding of Mary and her role in religious life.

This painting, then, seems to be so natural that some people think it copies nature as a camera does, but in fact it presents a philosophy of reality that is very true and very deep. Where does this insight come from? The answer becomes clear when we compare the art of van Goyen, working in Holland, with some of his Belgian (Flemish) contemporaries. Holland was deeply influenced by the Protestant Reformation. Belgium was very much in the Catholic world of the Counter-Reformation. There is no doubt that the two attitudes toward reality, to the physical as well as to the spiritual world, were a result of the deep influence of the two faiths on the whole of their culture and thought patterns.

There is probably nothing more typical of a truly Protestant vision of reality than the painting by van Goyen we have been discussing. What is important is that he was painting out of a culture that had been reoriented according to the Bible. Even if we know that van Goyen was a Catholic himself, and however shallow or deep his own personal faith may have been, the fact remains that he was acting and thinking along the lines of a biblical view of nature. Perhaps this is an illustration of the way in which a biblical Christianity can act as salt in society. It is really a secondary fruit of the gospel. Individuals become Christians by accepting Jesus Christ as their Savior and Lord. The fact that he comes to indwell them by his Spirit means

that they will be bearing the fruit of the Spirit in their lives. This, working in and through the world, leads to the secondary fruits in culture, the consensus of Christian, biblical attitudes to work, money, nature, and the whole of reality which deeply influence the whole nation. And it is these which are reflected in the nation's art.

The landscape artists of the classical tradition, humanist in inspiration, depicted quite another world: a more lofty, ideal world, a setting fit for great human deeds, heroic acts, deep thoughts surpassing the mean, everyday world. Poussin, the great French painter who lived most of his life in Rome, is perhaps the best example of a man with such a vision. Claude Lorraine is another. A work of Poussin, his picture of the burial of Phocion, will illustrate what I mean (fig. 5.3). This is a beautifully constructed landscape, with a clear composition. We see a wonderful classical city in the near distance: Athens as Poussin dreamed it might have been. Phocion, a great man, a Stoic like Poussin himself, is being buried. The painting has a nostalgic mood: death is here, even in the classicist's paradise. Poussin painted a world as it should or might have been: a world inhabited by gods—in a deep sense allegorical figures—or heroes, ideal human beings from a lofty and poetic past. He painted more than the eye can see; he painted a norm, a wish, a vision of

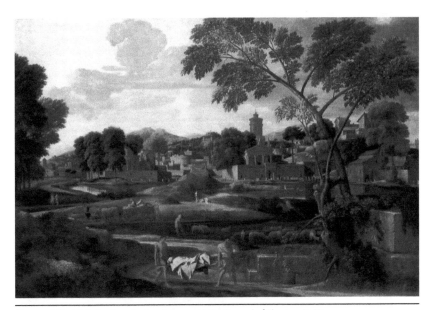

Figure 5.3. Nicholas Poussin, *Landscape with the Funeral of Phocion*, 1648

humanity. His art is imbued with a philosophy of life and the cosmos, ordered and well defined, deeply human while yet more than human.

Yet it is not a Christian vision. The difference between this and van Goyen's picture is striking: van Goyen sings his song in praise of the beauty of the world here and now, the world God created, the fullness of reality in which we live—if we only open our eyes. Poussin dreams of an earthly paradise with great men, a high humanity. But, alas, it is a fragile and easily broken paradise, it is a dream that will never be fulfilled. Van Goyen knows that the world is not without its storm clouds, that it is not unspoiled, but basically loves the world in which he lives.

TWO WORLDVIEWS

Jan Steen was van Goyen's son-in-law. His art can be compared with that of Rubens, living not so far away but in a totally different culture. The differences can be understood for the most part only as the differences between their Reformation and Counter-Reformation cultural backgrounds, even though Steen was himself a Catholic.

Look at his *St Nicholas Morning*, for instance, which pictures a typical Dutch festival during which the children get presents, presumably from Saint Nicholas (or Santa Claus), who has sent his servant down the chimney to place presents in the shoes put out for that purpose (fig. 5.4). But naughty children get only a brush. Now look at the story Jan Steen paints for us: the mother is asking the little girl what she received; a girl holds up a shoe with the brush her brother was given, teasing him, while his younger brother calls for the mother's attention. Near the fireplace we see an older boy holding a small child and singing a thank-you song together with another boy. Father or grandfather sits in the middle of the commotion enjoying the feast, while grandma in the background has something put aside for the boy who was given the brush. Steen has understood life perfectly, the psychology of a grandmother, the commotion and differences in attitude of the members of the family. And he has also not forgotten to give a rich picture of the many different kinds of special dishes belonging to the feast, piled to the left and the right.

Even if you had a quick eye for things, it would have taken time to see and understand all that was going on in a typical Dutch room in the seventeenth century. One simply cannot take it all in at a glance because of all the noise

Figure 5.4. Jan Steen, *The Feast of St Nicholas [St Nicholas Morning]*, 1665–1668

and commotion. Yet Jan Steen has succeeded in producing a very clear picture of it, because of his intimate understanding of it and his gift for composition. The scene would have been virtually an impossible one to photograph. The result would have been either a dull line of people sitting side by side or a chaos of quite unreadable forms. Or the people would have had to pose, making the whole thing into a tableau. Yet Steen's picture has nothing forced or artificially posed about it. Look how he "makes" space, by placing the people clearly one behind the other, and by the lines that go through the heads of the child, the father and the grandmother or that starts at the mother's head and go on through the father and sister. The whole story of the small boy crying as he is teased by the others is brought out by the line that goes straight through this space. And how is the commotion realized? Through lines forming Vs, for example, starting at the small shoe in the middle foreground, one line that is indicated by the stick held up by the little boy and another line follows from the handle of the little girl's bucket to her face and that of her sister. And look at the diagonal that follows the arm of the boy by the fireplace, then goes along the head of the mother and the strong orange color in the little girl's bucket over to the left-hand corner. All these very cleverly interrelated lines "make" the picture. This is no snapshot. It is a true human understanding of real family life, realized in an artistic way.

One is not normally concerned, when looking at pictures like this one, to think in terms of worldviews or philosophies. It all seems so natural, so open and free. And it really is open, free, and natural, real in a very deep sense. One more readily raises questions of worldview and philosophy when looking at a strange picture, one that seems unnatural. I am reminded, for instance, of the discussions that have centered on El Greco. Yet we must realize that the naturalness, the full humanity of such pictures as Jan Steen's, is not just a chance product. It must be controlled by a true insight into reality, an insight that must have a deep foundation, one that really leads to the opening up of reality. The very normality of the picture is founded in a deep understanding, a philosophy. This understanding comes, as I have said, from the Reformation, which means from the Bible's view of life. It is an understanding that leads life back to the foundation of biblical Christianity, Jesus Christ himself. It is an insight drawn from the well of life, from the Scriptures. Such things do not come cheaply.

Figure 5.5. Titian, *Venus and Music*, ca. 1550

We must look at one more picture in this section: Titian's *Venus and Music* (fig. 5.5). He painted several versions. Titian's world was a Catholic one. His contacts with the king and court of Spain connected him with the Counter-Reformation. Yet, as so often, Roman Catholicism went together with humanism, the third force beside the Reformation and the Counter-Reformation that contributed to the great European civilization of the seventeenth century. Humanism, this basic force that emerged with the Renaissance, took its starting point in humanity. It is human insight, human power, that would rebuild the world. At times it was non-Christian, even antichristian, but as a whole the humanists, because they were not deeply concerned with the church, compromised with the church—which after all could become somewhat dangerous with its Inquisition. As the Catholic world awakened out of its slumber with the Counter-Reformation, humanism was put in its place—a secondary place: it could cater to worldly activities and insight, not be concerned with religion.

Titian painted both altarpieces and other works with a marked humanist tendency. This painting of *Venus and Music* is one of them. To understand it one must ask who Venus is. Nobody worshiped Venus in a religious way, of course, or believed she really existed. No, the old pagan gods of antiquity were revived to be used as allegorical figures, through which invisible yet real

concepts could be symbolized and visualized. Mars stood for war, Hercules often for the human soul, Mercury for trade, and Flora for the world of flowers. Venus was the goddess of love and beauty. The sixteenth- and seventeenth-century conception of the world was in many respects a mixture: it combined the old scholastic philosophy, itself a synthesis of pagan Greek philosophy and Christian theology, with the rediscovery of late Greek and Roman thinking as well as the renewed insights into biblical truth of the Reformation. It was a world in which it was possible to speak of the reality of such concepts as beauty or love. They were realities outside humanity and people in their life and work had to reflect them, to realize them by working according to them. Love and beauty were not just human feelings and subjective tastes; they were really there. If people did not follow them, hate and ugliness would be the result.

So we must be careful and understand that the woman on the couch in this picture is not a real woman, which would make the picture somewhat strange, if not of questionable propriety! In a way there is no woman in the room with the musician at all. Titian makes it clear through his composition that she is of a different kind, living in a different realm. There is a jump in space between the feet of the Venus and the back of the musician. The organist looks back at her as he draws his inspiration from love and beauty. So the title of the painting is rightly *Venus and Music* as music is inspired by love and beauty. This mixing of allegorical figures with real ones was typical of the Venetian painters of the sixteenth century.

Venus is reclining. We often find reclining nudes in sixteenth- and seventeenth-century painting, and very often their position symbolizes inspiration. In a picture by Rubens a man looks at a reclining nude: Cimon is being inspired by her beauty and thus changed from rogue to gentleman, a story from Boccaccio with Neoplatonic overtones. We can see her too as Danae in a famous painting by Rembrandt in the Hermitage in Leningrad: the woman is a portrait of his young wife, and he speaks of her as inspiring him—mixing in a peculiar way allegory (in the form of an ancient myth) and reality.

The fact that these pictures show more than the eye can see means that they acquire a meaning that goes beyond photographic representation. They speak of human insight and understanding, of human values and truth. So, from the Madonna on, paintings give a philosophy of the world and of life. They are more than decorations, simply pleasant to look at. They have a

message and, what is vital to notice, a message realized by artistic means. The picture gets across what it wants to say, not just through its title but by its own built-in qualities of artistry and method.

THE ART OF THE TWENTIETH CENTURY

Now we make a jump to the twentieth century. Which understanding of reality and what values does the art of the last century communicate?[2] First of all it needs to be clear that twentieth-century art was not identical with modern art. There was a great deal of art that was not "modern," and there still were many artists who painted portraits and landscapes, whether in a naturalistic style or in a typically twentieth-century way, that we could call expressionistic (Matisse, for example). Modern art was no more than one current, although a very influential one.

That modern art is problematic may be clear. We want to try to show that modern art is not art with a certain style but rather art with a certain content. The question is: what content is characteristic of modern art? There are two directions: the abstract and the absurd. The artists who follow the absurd direction say that as artists they must protest, be critical and engaged. Politically

Figure 5.6. Picasso, *Female Figure with Hat, Sitting on a Chair*, 1938

speaking, many of these artists are anarchists. They argue that art must be connected with its time, and many people are moved by their works, as they see the artist as a prophet, a seer, and a critic of their own era.

[2]As this lecture was given in 1972, Rookmaaker speaks about his own time here. In order to distinguish his time, the twentieth century, from our twenty-first century, the editors have transposed some of this text to the past tense.

If, however, we walk around a museum of modern art, we notice something quite strange, namely, that these people who say they must criticize their times do nothing of the kind. Consider as an example the head of a woman painted by Picasso (fig. 5.6). This head is strange and looks as if it is made of woven straw. What might Picasso thereby be criticizing? Is he saying that in 1938 the women were all mad? Or that the fashion of the day was so strange? Or is he perhaps not referring to women in 1938? And perhaps not even to women in 1938? Perhaps not even to women? Does he perhaps, like the old art of the West, by way of this woman tell us something about humanity and the world? Is he perhaps saying that the world is mad? But in that case, this has nothing to do with the twentieth century.

One of Picasso's most famous pieces is *Guernica*. This painting is about the bombing of a little Spanish town. People say it is the most human painting he ever made. It is a strange painting, for when one stands in front of it there is no Spanish town to be seen. One sees misery and despair, but nothing specifically connected with the Spanish Civil War. Picasso was intensely engaged against Franco and the Nazis, but there is no swastika or Franco-cross to be seen.

A VIEW OF REALITY

The question one can pose and that we want to deal with is this: Is modern art true? This should always be our question when we occupy ourselves with art: Is it true? Is modern art really true? And our answer is yes and no. First the yes. This art speaks realistically about existentialist anxiety, despair, absurdity, meaninglessness, values that have lost their value, the emptiness of humans threatened by technology, the decline and demise of humanism, and all such things that were indeed found during this time. Many people regarded our world in this way.

In order to clarify this I will give a few quotations, beginning with C. S. Lewis.[3] Once upon a time, very long ago, he says, there were nymphs in nature. These nymphs were goddesses of springs, the trees were dryads, and the planets were gods. But then knowledge set in and slowly emptied the world. First the gods were removed, then the colors, then smells and sounds

[3]C. S. Lewis, foreword to *Hierarchy of Heaven and Earth*, by Douglas Harding (New York: Harper, 1952).

and tastes until at last nothing was left. All the things that used to be outside us we have internalized. These have now all become our observations, our feelings, our thoughts, and our ideas. Outside of them there is nothing whatsoever. However, so he says, that is not the end of it, for now people turn the same method on themselves, with the outcome that we who had personalized the entire world, turn out to be personifications ourselves. And when we get to this end, it turns out to be very much like zero: there is nothing left.

There is really nothing left. And that is precisely what Wols talks about.[4] He says that when you take a piece of paper, make some random marks on it, and then look at it, you always see something in it, for example a mountain; now destroy the mountain with your pencil and look again and you see a forest. So now destroy the forest. The clever thing about Wols is that he shows us all the stages. And they all lead to nothing, a zero point. What we see are coincidental forms that point not only toward the art of painting but also toward reality itself. They tell us that reality is a coincidental nought and that, because of that, the art of painting has become superfluous.

From these citations it may be clear that we also say no in answer to the question whether modern art is true. These things have nothing to do with the twentieth century. What Wols discusses are general matters. He tells us nothing about the nothing of Hitler, the nothing of Nixon, but he tells us about the nothing of the world. It is an interpretation, a view, an intellectual and spiritual attitude toward reality. It is a revolutionary activity in which values are destroyed. Why? Because these values have lost their value for modern people. Yet this is only a view; it is not reality itself. Therefore we repeat: is modern art true? And we answer: yes, of course, but only as the expression of a group. And this group is a strong minority. It is an expression of their intellectual and spiritual distress, of their alienation, their feeling of being sealed up in an alien world.

ARE WE CAPTIVES OF OUR TIME?

Yet there were also thousands of people who at this time were not modern in the way they regarded the world. From this it is clear that people can look at the world differently. This touches on an important question, namely

[4]Hans Platschek, *Nieuwe figuratieve kunst?*, trans. (German to Dutch) H. Redeker (Amsterdam: Moussault, 1960), chap. 7.

whether people are prisoners of their time. Must we view our times as others do? Hegel claims that history transpires in various stages. Upon reading him, one is in the first instance deeply impressed. Very soon, however, one discovers that a person is just a tiny cog in great historical drama. The historian and art historian Jacob Burckhardt wrote about the Renaissance as a historical necessity. This means that if you were an artist in 1440, you had to be a Renaissance artist. And if you are an artist in 1970, you must be a modern artist. But this is precisely the question. Are we really a captive of our times? We say no for people are not imprisoned in history; people can choose their way in freedom. This does not mean, however, that we can stand outside of our times, for we belong to our times, but we can say no to particular ideas and views. We are free to advance answers and offer our own solutions. Human beings are more than reeds on the stream of history and time. We are free. We can say that a different approach is possible.

Modernism is a view that has its roots in history and is connected with the past and with many other matters. It did not arrive out of the blue, yet it is but one particular answer to the problems. One may then ask what problems it is an answer to, and what is its content? In other words, one can ask what the solution is that modern art tries to give to the real problems of its day. In our opinion it is the answer of Neo-Gnosticism.

A year ago I read a book by Jonas. He is a great expert on Gnosticism.[5] At the end of Jonas's book there is a lengthy chapter about the similarity and difference between Gnosticism and Neo-Gnosticism. We shall try to make this clear. What is Gnosticism? It is a religion based on various myths, which tell a complicated story. The content of these myths is that there is a good god, and there is also an evil god. This evil god created the world. We people belong to the good god, but we are imprisoned in the evil world. Now, the trick is to get out of this evil world to the good god. This is the crux of Gnosticism: that the world is evil in its very essence and therefore we can have no contact with it; we are estranged from it insofar as we are good. The old Gnostic religion may have been as widespread as Christianity. Also Paul (in Col 2) and John (1 Jn 2:18) fought against Gnosticism. They warned people not to go along with it. Gnosticism was a powerful movement. It was about separating oneself from

[5]Hans Jonas, *The Gnostic Religion: The Message of an Alien God and the Beginnings of Christianity*, 3rd ed. (Kansas City, MO: Beacon, 2001).

the world. In the myths one has to fight against dragons and demons and all sorts of ghastly things. But today it is different, Jonas says. We too live in a bad world, but there are no longer any demons. In the old myths one might perhaps have had to fight a dragon. That is horrifying and, most probably, one would have lost. Yet one understands the dragon: it is hostile to us. Today, however, we are imprisoned in a world which in five minutes' time may be smashed to smithereens by a comet. Why? Because some or another evil spirit is ill-disposed toward us? No, just because something collided with the earth. Matter collides with other matter according to arbitrary laws.

With relation to these matters, I found a statement from 1836 by Carlyle, an English philosopher. He says that for him the universe has been stripped of all life, meaning, will, and hostility. It is a tremendous, inanimate steam-roller that rolls on and crushes us piece for piece and limb by limb. The cosmos is something entirely impersonal; there is no longer a good god one can turn to. One wants to try and escape the bad world but can no longer even fight against demons for one is unconditionally imprisoned. We could provide citations about this from Nietzsche, who also belongs to this school, Klee, and Franz Marc. Franz Marc is an early modern artist, the one who painted the blue horses. He writes that when he was young, he found humans ugly and therefore set about painting beasts. But as he painted animals, so he says, he discovered that beasts are ugly, and so he took a look at the world and discovered the ugliness of the world. He speaks literally about the "im-purity" of the world. From then on he started to paint abstractly.

Many more citations could be added from John Cage, Tinguely, Rauschenberg, and Duchamp. But I would like to leave it with just one, a citation from Ginsberg. Ginsberg was one of the leaders of the Hippies. In about 1950 he wrote a poem titled "Howl." He said about it in an interview that he had written that poem in the Gnostic tradition. It is a long poem, and we shall not cite all of it. It consists of three parts, and in the last part every stanza begins with "I'm with you in Rockland." It is clear that Rockland refers to a lunatic asylum, and that the asylum is the world. We are all im-prisoned in a lunatic asylum. Here is what Ginsberg writes:

> I'm with you in Rockland
> where you scream in a straitjacket that you're losing the game of
> the actual ping-pong of the abyss

I'm with you in Rockland
where you bang on the catatonic piano the soul is innocent and
immortal it should never die ungodly in an armed madhouse
I'm with you in Rockland
where fifty more shocks will never return your soul to its body
again from its pilgrimage to a cross in the void[6]

A "pilgrimage to a cross in the void"—that is human life according to Ginsberg. And it is a typically Gnostic pronouncement. It is a view and a religion. And it is not a religion that just sings songs, but it is an exceptionally aggressive one. It wants to change the world. It is a product of the crisis of our culture, but it also promotes this cultural crisis, helps to produce it.

IS A DIFFERENT VIEW POSSIBLE?

Our question now is: can we have a different view? And then we say: yes, we can. It is not necessary to be modern, for one must realize that the modern movement is just one movement, one sect, one view resulting from the banishing of God from this world. Nietzsche, who undoubtedly belongs with this current, has said, "God is dead." He added: "And we have killed him."[7] He also said that a stench hangs over Europe. And to this we could add: Can you smell it?

I would like to end with a story. It is a story of something that really happened. It took place in the mid-1950s on the Left Bank in Paris. Two students of Jean-Paul Sartre's, a young man and a young woman, are sitting beside each other on a bench, and they are weeping. Why are they weeping? Are they not permitted to go to bed together? Do they have an inconvenient papa or mama who would not approve of that? No, that is not the problem, for they have already had such experiences often enough. The problem is that they want to say to each other that they love each other. But they realize that if they do, one would think the other is just using a nice way, a nice façade, to say that he or she has a sexual urge. But in fact they do not just want to have sex with each other, they love each other. Yet they have no way to say so. This is a problem many young people have today. Often when I tell

[6]Allen Ginsberg, "Howl," in *Collected Poems, 1947–1997* (New York: HarperCollins, 2006).
[7]Friedrich Nietzsche, *The Gay Science* (Cambridge: Cambridge University Press, 2001).

this story people raise questions about it. They think it is a crazy story. This young man and young woman should just say: "We love each other, and who cares about Jean-Paul Sartre?" That would end the matter.

In a certain sense, of course, that is true. It is precisely as Christ has said: "The kingdom of God is among you." In that way the young man and young woman can say, "Love is here." They do not need to go far to find it. Yet we should be careful what we are saying here. Let us suppose they say to each other: "We love each other." And later they go into the woods and make love. Immediately they will have a guilty conscience and think: "Are we not kidding one another? Are we not just like rabbits? We talk about love, but is it not just a nice façade?" Therefore they first need to have an answer, or else they will have to live with this guilty conscience, with all the contemporary voices that deprive love of its meaning and drag it down. They need to have an answer to the huge question: is there really such a thing as love? Does love have meaning?

That young man and young woman have to look the truth in the eye and say: "Sartre was evidently wrong, for we love one another. We will go to Sartre and say to him that we have discovered that he is a liar. And that he deserves a punch in the nose." But Sartre would then say: "Don't you know that when I discussed these things I wept as well? That I had real tears in my eyes? But tell me, where does love come from? If you can show me that love is real, then I will be grateful to you. But if you also have no answer, just leave me alone." And we believe that Sartre is right, a cheap answer is not enough. And therefore, if we want to find the truth, we must begin somewhere else. And our answer is that we can never begin with human beings, for if we do that then we end where modern people have ended, namely in nothing. Or, to put it in other words, in Gnosticism.

But humans are more than history, and we are free to leap out of a world of modern thinking. That is our creativity. How can we get hold of the truth? Only by beginning where we are meant to begin, namely by honoring God as the Creator. Only by saying to one another: "We love one another. Thank you, Lord, we have received it from your hand." Otherwise it does not work. Without a tremendous break with Neo-Gnosticism—and with naturalism, which is directly connected with it—we will never be able to give an answer to modernism. Therefore we cannot say to a modern painter that he or she must paint a little like this and a little like that. No, we must give an answer

to the questions. Just as in every other field, whether it be politics or theology or whatever, an answer must be given to the deepest questions that the modern person poses. Otherwise we walk around with a guilty conscience because we have found a cheap remedy. And then the other is right to say that Christianity is just a super aspirin, a sort of drug or opiate, a tranquilizing agent. We shall have to take hold of the truth and find the courage to go against the stream.

We are not little reeds in the stream of history. Or rather, we are little reeds in the stream of history, but we are not compelled to go with the flow. We can resist the current. That could mean that you might be kicked, that you might sink, that you might be crushed, that you might not make it. That is possible. It is what we call martyrdom. We shall have to pray and work that many may have the courage to go against the stream. And we cannot do it alone; we need to be driven by a strong motor if we are to go against the stream. If many people were to go against the stream, the stream of history might even start to flow in a different direction.

CHRISTIAN ARTISTS

But how can Christian artists go against the stream of their culture? Often new Christians just drop their artistic careers because they think painting and art today are incompatible with being a real Christian. As this is an unnecessary and regrettable reaction, I have listed a number of principles that may be of some help.

If God has given us talents, we may use them creatively—or rather, we *must* use them creatively. A Christian artist is not different from, say, a Christian teacher, minister, scholar, merchant, housewife, or anybody else who has been called by the Lord to specific work in line with his or her talents. There are no specific rules for artists, nor do they have specific exemptions to the norms of good conduct God laid down for people. An artist is simply a person whose God-given talents ask him or her to follow the specific vocation of art. There may be circumstances when love toward God would forbid certain artistic activities or make them impossible, but the present moment in history does not ask for such a sacrifice. Quite the contrary. We—the Christian world and the world at large—desperately need artists.

FREEDOM

To be God's child means to be offered freedom—the Christian freedom Christ himself and Paul in his letters say much about. This freedom is most important for anybody who wants to do artistic work. Without freedom there is no creativity, originality, art, or even Christianity. This freedom can exist only if it is based on love toward God and our neighbors, if we become new people through the finished work of Christ, and if the Holy Spirit is given to us. Without this base, freedom may easily mean being free from God and consequently free to indulge all the cravings of the sinful heart of an unredeemed person. (For more on this matter of freedom, see Paul's letter to the Galatians.)

Christian freedom is different from humanistic freedom, the freedom people give themselves to build a world after their own devising (as was tried by the Enlightenment and the humanist development after that time in the Western world). Humanistic freedom leads to all kinds of problems, as our Western world is now learning from experience. Freedom in the biblical sense is in no way negative—shun this, don't do that, you must leave that alone, keep away from this. Christian freedom has nothing to do with a set of rules by which you must bind yourself; indeed, such rules may easily be pseudo-Christian. Freedom is the necessary basis for creativity, for creativity is impossible when there is timidity, when you allow yourself to be bound by narrow rules. Do not think the modern art world is free. Freedom is positive. It means being free from tradition, from the feeling that everything you do has to be original, from certain fixed rules said to be necessary in art, but also from the thought that to be creative you must break all kinds of rules and standards.

Freedom means also that there are no prescriptions for subject matter. There is no need for Christians to illustrate biblical stories or biblical truth, though they may of course choose to do that. Artists have the right to choose a subject that they think worthwhile. Yet nonrepresentational art provides no more freedom than the most involved allegorical or storytelling art. Freedom includes the right to choose your own style, to be free from tradition but also from modernity, fashion, today, tomorrow, and yesterday. Yet there is no need to slap people in the face, as some streams of art nowadays deem necessary. Christian freedom also is freedom from the sinful lust for

money, from seeking human praise, from the search for celebrity. It is the freedom to help a neighbor and give him or her something to delight in.

NORMS FOR ART

There are norms for art that are a part of God's creation. Without them *art* would be an empty word without sense. To say a person has been given a feeling for art and beauty (everybody has, to a certain extent), that he or she has been granted a strong subjective sense of artistic rightness, is but another way to say that he or she has been given an understanding of certain norms God laid down in his creation, the world in which we live. We call this *taste*, a feeling for design and color, the ability to grasp the inner harmony of a complex of forms and colors, the understanding of the inner relationship among elements of the subject matter, the ability to recognize the indefinable dividing lines between poor and good art, between worn-out symbols and fresh ways of saying things that are important to people.

These norms do not stand in the way when we want to live in Christian freedom; they are a part of our world and our nature. Only when people revolt and do not want to be creatures, when they want to be God and not human, do they feel constricted by these norms. For those who love the Lord and rejoice in his good and beautiful creation, these norms provide the opportunity to live and create in freedom.

ART HAS ITS OWN GOOD PLACE

When God created, he gave art or any artistic endeavor a place in this world in which we live, and that world he called good. I added "artistic endeavor" because we have to think not only of the rarefied museum type of art called Art with a capital *A* today, but also of all other types, including ceramics, dance music, pictures used in Sunday schools, and so on. Art is here because God meant it to be here.

Art has its own task and meaning. There is no need to try to justify one's artistic activity by making works with a moralistic message, even if one is free to emphasize moral values. Nor is there any need to think one has to serve as a critic of culture, always provide eye-openers to the non-artists, teach, evangelize, or do whatever other lofty things one can think of. Art has done its task when it provides our neighbor with things of beauty, a joy

forever. Art has direct ties with life, living, joy, and the depth of our being human just by being art, and therefore it needs no external justification. That is so because God, who created the possibility of art and who laid beauty in his creation, is the God of the living and wants people to live. God is the God of life, the life-giver. The Bible is full of this.

Art is not autonomous. "Art for art's sake" was an invention of the nineteenth century to loosen the ties between art and morality; that is, to give art the freedom to depict all kinds of sins as if they were not sinful, but simply human. The human understanding of depravity, of morality, of good and bad was thereby undermined or erased. The results we are seeing in the art of the twentieth century. The meaning of art is its being art; it is not autonomous, and it has thousands of ties with human life and thought. When artists cease to consider the world in its manifold forms outside the artistic domain, their art withers into nothingness because it no longer has anything to say.

Much abstract art has little meaning because it is only art. All its ties with reality have been cut. Art has its own meaning and needs no excuse. But it loses its meaning if it does not want to be anything but art and therefore cuts its ties with life and reality, just as scholarly work loses its importance and interest if learning is sought for its own sake. Art and science become aestheticism and scholasticism if made autonomous. They become meaningless idols.

The artists' work can have meaning for the society in which God put them, if the artists do not withdraw into an ivory tower or try to play the prophet or priest, or—turning in the other direction—in false modesty consider themselves to be merely artisans. Artists have to make art while thinking of their neighbors in love, helping them and using their talents on their behalf.

THE SPIRIT OF OUR ART

Most art today expresses a spirit, the spirit of our age, which is not Christian.[8] In some ways it is post-Christian, in others anti-Christian, in still others humanistic. Here and there are Christian artists who try to do their work in a godly spirit. But often their brothers and sisters leave them alone,

[8]Rookmaaker wrote this in 1966 and thus talks about the art of his own time. Some elements of the art of that time have remained the same; others, however, have developed further and changed.

distrusting their creativeness or doubting that they are Christians. False art theories that have pervaded the Christian world—the artist as an asocial being, a nonconformist in the wrong sense, a dangerous prophet, an abnormal being who lives in an alien world—are often responsible for this attitude. But some Christian artists hold these false views too and look down with contempt on their fellow Christians. There is a lot of confusion.

That the art of the world at large is also in a deep crisis does not make things easier. We live in a society where there is a manifest break between the mass of common people and the elite, and another break between the natural sciences and technical realities on one side and religion (most of the time rather mystical) of a completely subjectivist and irrational type on the other. We who live in this world cannot act as if these deep problems do not exist.

There is no real Christian tradition in the arts today to turn to. If artists want to work as Christians and do something that they can stand for and bear responsibility for, they have to start with the freedom based in a true faith in the living God of Scripture. They have to make art that is relevant to our day. Therefore, they have to understand our day. And, in order to gain from all that is good and fine today and yet avoid being caught by the spirit of our age and its false art principles, they must study modern art in all its different aspects deeply and widely, trying to analyze the language modern artists use, their syntax and grammar, in order to be able to hear correctly the message they profess to speak. To analyze, understand, and criticize lovingly, loving people but hating sin, in order to avoid their mistakes but gain from their achievements—that is the Christian artist's task. A new Christian tradition, as a fruit of faith, can grow only if artists who understand their work and task, their world and its problems, really set to work.

FREEDOM TO DO WHAT?

But what have Christian artists to offer the world? The artists have a freedom to do something, not just the freedom for freedom's sake. What should such artists aim at? Let's be careful not to lay down new rules. There are no biblical laws that art must be realistic or symbolic or sentimental, or must seek only idealized beauty. Christian artists are free, but not with a purposeless freedom. Christians who are artists are free in order to praise God and love

their neighbors. These are basic laws. What do they mean in practice? May I refer to Philippians 4:8—"Finally, brethren, whatsoever things are true, whatsoever things are honest, whatsoever things are just, whatsoever things are pure, whatsoever things are lovely, whatsoever things are of good report; if there be any virtue, and if there be any praise, think on these things" (KJV). Here we read what Christians standing in freedom as new persons, in God's strength and with the help of the Holy Spirit, must search for. This also applies to Christian artists. It is up to them to work, to pray, and to study, in order to realize as much as they possibly can of these truly human and life-promoting principles.

BIBLIOGRAPHY

Dyrness, William A. *Rouault: A Vision of Suffering and Salvation.* Grand Rapids, MI: Eerdmans, 1971.

Gasque, Laurel. *Art and the Christian Mind: The Life and Work of H. R. Rookmaaker.* Wheaton, IL: Crossway, 2005.

Hengelaar-Rookmaaker, Marleen, ed. *The Complete Works of Hans Rookmaaker.* 6 vols. Carlisle, UK: Piquant, 2001–2003.

Romaine, James, ed. *Art as Spiritual Perception: Essays in Honor of E. John Walford.* Wheaton, IL: Crossway, 2012.

Rookmaaker, Hans R. *Art and the Public Today.* Huémoz-sur-Ollon, Switzerland: L'Abri Fellowship Foundation, 1965.

———. *Art Needs No Justification.* Downers Grove, IL: InterVarsity Press, 1978.

———. *The Creative Gift: Essays on Art and the Christian Life.* Wheaton, IL: Crossway, 1981.

———. *Jazz, Blues, and Spirituals: The Origins and Spirituality of Black Music in the United States.* Phillipsburg, NJ: P&R, 2020.

———. *Modern Art and the Death of Culture.* London: Inter-Varsity Press, 1970.

———. *Synthetist Art Theories: Genesis and Nature of the Ideas on Art of Gauguin and His Circle.* Amsterdam: Swets & Zeitlinger, 1959.

Walford, E. John. *Jacob Van Ruisdael and the Perception of Landscape.* New Haven, CT: Yale University Press, 1992.

The Zwiggelte Group. *Reality Revisited by Six Dutch Painters.* Zwiggelte, NL, 1982.

Looking with Historical Depth: Hugo van der Goes, Filippino Lippi, and Albrecht Dürer

HANS R. ROOKMAAKER

For the right comprehension of paintings from ages past it is important to take stock of their historical, theological, and devotional background. In the discussion of the *Portinari Altarpiece* (fig. 5.7) by Hugo van der Goes we will therefore make a connection with the *Meditationes vitae Christi* by the thirteenth-century Franciscan Pseudo-Bonaventura and the medieval mystery plays that were based on this book. Upon inspection, the painting *The Intercession of Christ and Mary* (fig. 5.8) by Italian painter Filippino Lippi turns out to be a portrayal of a theological argument.

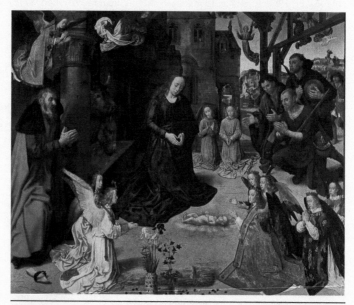

Figure 5.7. Hugo van der Goes, *The Portinari Altarpiece*, 1476–1479

Hence we take a look at Catholic theology to make sense of it. Albrecht Dürer's engraving *Melancholia* (fig. 5.9) in its turn is connected to the science and astrology of his time. However, for an accurate interpretation we must first of all open the Scriptures.

HUGO VAN DER GOES:
THE PORTINARI ALTARPIECE

In the 1470s the wealthy Florentine art dealer Portinari, who maintained tight trade relations with Flanders, commissioned the renowned artist van der Goes of the southern Netherlands to create an altar depicting the adoration of the shepherds. The altar would be placed in a Florentine church. This altar is one of the largest masterpieces of fifteenth-century art, as the central panel alone measures about three meters in width.[1]

Let's take a closer look at the painting. The figures standing around Mary and the child she is worshiping form a large circle, creating an excellent and well-organized composition. The details have been painted with great precision. Notice, for example, the still life with flowers in the foreground.

The scene looks so true to life that it makes one think the artist saw it with his own eyes. Actually, it is quite likely that he did see it, because during the fourteenth century this part of the biblical story was often dramatized in so-called mystery plays. During this same period (to focus for a moment on a very specific detail) there was a change in the way angels' garments were depicted. Prior to this time they were usually dressed in a sort of timeless white cloth, but during the time of van der Goes they were more often dressed in heavy, brightly colored priestly clothes, richly embroidered in gold. It is almost certain that the theater costumes of the mystery plays inspired them.

Portrayals of the adoration of the shepherds first made their appearance in the fourteenth century. During that time and even

[1]Originally published in Dutch in *Calvinistisch Jongelingsblad* 6 (1951): 34. Published in English in M. Hengelaar-Rookmaaker, ed., *H. R. Rookmaaker: The Complete Works*, vol. 4 (Carlisle, UK: Piquant, 2003).

before, people began to consider and meditate on the details surrounding the life of Christ. Mysticism placed great value on this. In this connection the work of Pseudo-Bonaventura, a Franciscan from the late thirteenth century, is very important. His book *Meditationes vitae Christi*, which contains meditations on the life of Christ, did not deal with theological dogmas and treatises as was common in the scholarship of that day but spoke to the heart. The author sketched the biblical scenes realistically and colorfully, inserting many details which are not included in the Gospel stories but come from the author's imagination. The book contained many dialogues that lended themselves perfectly to adaptation for the stage and had a great influence on the poets who wrote the mystery plays.

Pseudo-Bonaventura, for example, described Mary as leaning against a pillar just prior to giving birth. Consequently such a pillar makes its appearance in every depiction of the birth of Christ and adoration of the shepherds and the magi. It can also be found in this painting by van der Goes. According to legend, the stable where Jesus was born was a remnant of the ruins of David's palace in Bethlehem. It is a legend that likely emerged in an effort to explain the pillar that keeps cropping up in the nativity scenes, though no one really remembered where it originated.

The fifteenth-century depictions of the events surrounding Christ's birth are thus strongly influenced by a mysticism which in turn strongly influenced the popular piety of the time. This moderately mystical thought world still lives on today. We find it, for example, in the idea which often comes up in Christmas songs that we should pray at Jesus' cradle and kneel before the child.

When you look at this painting, you need no further support for the idea that such influences caused the artist to portray the story as he did. The fact that the people are dressed in the contemporary clothing of his day also supports this, even though fifteenth-century people did not yet have a modern understanding of history. For them anachronisms would not be troubling because they felt themselves to be part of the story.

Apart from that, one might ask oneself whether events really could have appeared like this. For example, would Mary really have knelt down in prayer before her child? The Gospels record nothing about shepherds kneeling down beside the Christ child either. That is only said of the Magi, and the newer translations prefer to record that they "paid him homage."

I will leave it at this, even though I have said far too little about this absolutely gorgeous painting. One could devote an entire article to the wonderful characterization in the faces of these shepherds alone!

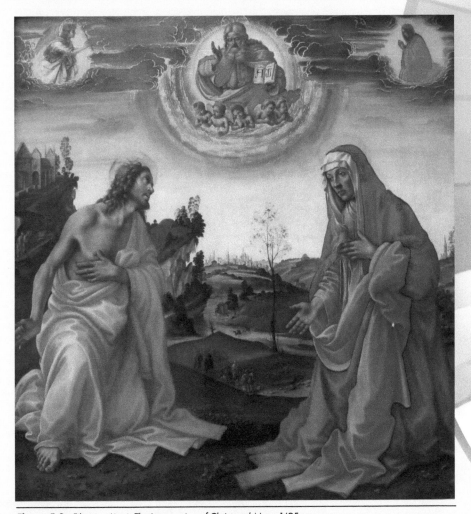

Figure 5.8. Filippino Lippi, *The Intercession of Christ and Mary*, 1495

FILIPPINO LIPPI: THE INTERCESSION
OF CHRIST AND MARY

In 1495 the Florentine painter Filippino Lippi created this painting for the altar of the monastery belonging to the Barefoot order in Palco near Prato.[2] The work is typical of that era, produced in the years just prior to the high Renaissance when Raphael would come to play the leading role. Its composition is well organized and clear, and displays a lively symmetry. Notice, for example, how the main figures on the right and left are posed in symmetrical-reverse positions. This could have resulted in the action rotating simply around a central point, but that effect is counter-balanced by a background land-scape which actually stretches out from right to left, moving toward the rocks on the left. The function of the little tree, which draws our attention because of its prominence, is to restore the symmetry, which otherwise perhaps would have been lost. It is placed equally far to the right of the center as the steep rocky cliff is placed to the left of it.

The painting is precisely painted without becoming overly fussy, in a naturalistic style, which means that the artist has attempted to reproduce reality as carefully and accurately as possible. The poses of the figures are based on careful study and sharp observa-tion and are anatomically correct down to the tiniest details. Take special note of the way the garments fall; they serve to accentuate the movement and posture of the main figures, but at the same time are rendered as naturally as possible.

The landscape too is exceptionally beautiful. We notice some influence of Flemish painting, which had risen to great heights with respect to landscape painting. The Florentine artists will undoubt-edly have studied carefully the huge Portinari altar by Hugo van der Goes, which had been in Florence for twenty years already, and they would have paid special attention to the gorgeous spread of the landscape in it.

In true art, form and content are inseparable. We will notice how all the aesthetic elements just discussed are combined to form

[2]Originally published in Dutch in *Stijl* 1, no. 1 (1952). Published in English in Hengelaar-Rookmaaker, *H. R. Rookmaaker*, vol. 4.

a unity between the representation and the statement that is present in the painting. You have probably been wondering what this painting is trying to say, what story it is portraying. It is actually not depicting a particular story from the Bible, an apocryphal book, or a legend. Despite the exquisite detailing and the artist's efforts to make everything look as natural as possible, he was not attempting a sort of photographic report of an actual event from the past. Rather, what we have before us much more resembles a theological discussion or argument.

In the center, in the valley just to the left of the tree, we see a group of kneeling figures. They are looking prayerfully up in the direction of the woman on the right, Mary, the mother of Jesus. These people are pleading with her to pray for the salvation of their souls. She seems to be straining her ears, her head inclined toward them slightly, while with her hand she is gesturing to her Son, who is kneeling on the left. Her left hand shows him her breast, thereby reminding him that she is his mother. And, to cite a Roman Catholic apologist,

> The expression "Mother of God" encompasses all the greatness of Mary and elevates her far above all other human beings. Because Mary is the Mother of God, she resides in heaven, closer to her divine Son than any of the other creatures, angels, and saints. She shares in his glory, and it is her special privilege to distribute God's grace in Jesus' name to human souls. She is the "Mediator of all Grace," because it was God's will that Jesus, the source of all mercy, came into the world through Mary.

According to the same apologist,

> It is fitting that Mary has a part in the distribution of the grace which Jesus earned through his death on the cross. After all, she became the Mother of Jesus because of her freely spoken "Yes, let it be with me according to your word." Freely she concurred with Jesus' sacrifice, experiencing it along with him as she stood below the cross with her

bleeding heart. Thus, Mary, albeit in a subsidiary way, had a part in bringing about our salvation.[3]

Now we understand why in the upper right and left corners of the painting, Mary and the angel of the annunciation are to be seen. It reminds us of her merits on the basis of that freely spoken yes-word, giving her the right to become an intercessor for others.

To the left is Christ. His head is inclined toward his mother, but his gaze is directed toward God the Father standing in the center at the top. With his left hand Christ points to the wound in his side, a reminder of his crucifixion. With his right hand he makes an imploring gesture, on which God the Father with a gesture of blessing offers his merciful forgiveness of sins to the souls who are being prayed for.

Carrying this idea further, we see how Christ takes this grace that has been poured out and with his blessing offers it to the believing observer. A similar duality can be seen in Mary's right hand.

It now has become clear that this painting constitutes a theological argument or, in other words, a sermon. It is a discourse intended to offer us comfort.

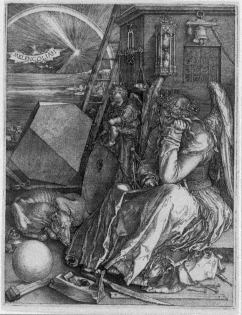

Figure 5.9. Albrecht Dürer, *Melancholia*, 1514

[3]Ignatius Klug, *Het katholieke geloof* (Heemstede, NL: DeToorts, 1939), 242-43.

ALBRECHT DÜRER: MELANCHOLIA

Albrecht Dürer had a deep respect for his intended public.[4] His unsurpassed series on the Revelation of John, for example, created in 1498—the work by which he established his name not only in that time but for all ages—was produced as a woodcut. That was because it is an inexpensive process that allows for easy duplication. In this way Dürer's art became more accessible to the "ordinary people." He had no interest in an art by the elite and for the elite; instead, he wanted his work to be of service. He understood well that by serving one's neighbor, one is also serving God. At the same time he found himself in educated circles where the spirit of humanism reigned, which placed special emphasis on a study of history, science, and art. His engravings were produced with these people in mind as they were made by way of a much more expensive and complicated method. For that circle of people he created his prints, often with deep philosophical themes. For us, as we are not familiar with the scholarship and culture of those days, these works are often very difficult to interpret.

One of these prints is his famous *Melancholia (Melencolia I)*, an engraving—or copperplate—dating from the year 1514. It is amazing how much has been written and researched in order to come to an accurate interpretation of this work of art. It is certain that astrology—a fashionable science in those days—plays a role in its intended meaning. Along with countless others, including people associated with Luther, Dürer was not free from the misconceptions of his time. But our intention is not to describe and assess all those different attempts at an explanation, since it would take us too far afield and would require endless research.

For it is our belief that even without these the print makes a clear statement. With incredible mastery Dürer created a mood that communicates even when we cannot accurately interpret every detail in the picture. I believe that this engraving serves as an

[4]Originally published in Dutch in *Stijl* 2, no. 1 (1953). Published in English in Hengelaar-Rookmaaker, *H. R. Rookmaaker*, vol. 4.

illustration of Ecclesiastes 1:17-18. Around the central figure we see all kinds of symbols of scholarship: a complicated geometrical shape, a globe, measuring rods, a scale, a grinding stone (the last two items apparently are a reference to alchemy, the natural science of that day), a compass, and much more, which the observant viewer will notice. In the middle of all that there is this figure, gazing ahead in a pensive way, having gained wisdom—specifically the wisdom of knowing that concerning the work of God, "no one can comprehend what goes on under the sun" (Eccles 8:17), for "whatever wisdom may be, it is far off and most profound—who can discover it?" (Eccles 7:24).

The melancholic nature of this work seems to express something of these profound thoughts. Yet there is no despair here, just a deep wisdom and humility; no rebellion, but an understanding of our own smallness in comparison with God's creation. Moreover, is it not the rainbow, the symbol of God's covenant, that we see in the background? No, the view of the future contains no hopelessness, despite a clear understanding of one's own powerlessness with respect to the many deep, unfathomable questions with which God has burdened people to occupy themselves (Eccles 3:10, 13).

It may be that no other artwork has ever struck such a profound note; even without an explanation of all the many details, the piece speaks for itself. Vanity of vanities, all is vanity—that is the message of this work of art, spoken along with the author of Ecclesiastes.

BIBLIOGRAPHY

Holmes, Megan. *Fra Filippo Lippi the Carmelite Painter*. New Haven, CT: Yale University Press, 1999.

Lane, Barbara. *The Altar and the Altarpiece: Sacramental Themes in Early Netherlandish Painting*. New York: Harper & Row, 1984.

Panofsky, Erwin. *The Life and Art of Albrecht Dürer*. Princeton, NJ: Princeton University Press, 2005.

THE VOCATION OF A CHRISTIAN ART HISTORIAN: STRATEGIC CHOICES IN A MULTICULTURAL CONTEXT

E. JOHN WALFORD

IN THE COURSE OF MY CAREER, I have often spoken about the vocation of the artist who is a Christian, but I have rarely had occasion to speak of the vocation of an art historian who is a Christian.[1] I suspect, however, that many of the same principles apply: just as there are many ways of being an artist who is a Christian, so there are many ways of being an art historian who is a Christian. Yet, since we are so few, we do well to be strategic about the type of art history we do, the nature of the topics we engage, as well as the audience and impact that we aspire to reach.

I perceive practicing art history as a subset of Christ and culture issues, which also means that individual choices will likely echo the position we take on the spectrum of Christ and culture modes of engagement. While H. Richard Niebuhr's book *Christ and Culture* (1951) has proved seminal for my generation, today's scholar would do well to rethink Niebuhr's approach and categories in light of the differences in our current, largely post-Christian,

[1]This text, unmodified, was first given as a spoken address delivered at the Art as Spiritual Perception Symposium, Wheaton College, October 2012, and first published online at https://artway.eu/content.php?action=show&id=1263&lang=en.

intellectual and cultural context. Indeed this task has been carefully ad-dressed by Craig A. Carter's book, *Rethinking Christ and Culture: A Post-Christendom Perspective* (2006) and should be duly considered, though I do not intend to pursue that dimension further here.

Rather, I will address some of the strategic dimensions of my own expe-rience as an art historian, starting with my own inheritance from the Dutch Reformed tradition of philosophical and art-historical thinking, specifically in the persons of Hans Rookmaaker and his colleagues at the Free University (Vrije Universiteit), Amsterdam. This will be followed by a discussion of the nature of art history when I entered the field. Further on I will expose some strategic implications from both these foundations.

MY INHERITANCE FROM CHRISTIAN DUTCH ART HISTORIAN HANS ROOKMAAKER

Critical to the Dutch Reformed intellectual tradition in which I was first educated was the vigilant attention paid to presuppositional thinking—that is, an acute awareness of the unspoken assumptions lying behind the schol-arship of others and hence critical evaluation and critique of the same from the perspective of biblical and theological principles, themselves as defined by that same tradition.

At the ground level of such Dutch Reformed thinking lay the presup-position that in one way or another the actions, and hence the art and art history as well, of all human beings are driven by the values and belief systems that ground and drive chosen courses of action. It is assumed that none of us operates neutrally—not even in the smaller matters of life—and that even if our presuppositions are partially or even largely lodged somewhere in our subconscious, they nevertheless inform and drive our actions. Just as people cannot play a game of soccer without some form of goalposts, so we cannot act in the world other than in a given direction, driven by some purpose or other, however ill-defined. To try to do so is to be like the double-minded man, mentioned in the book of James, unstable in all his ways and tossed about by every wave of fashion and intellectual ideology.

This also means that as art historians, we all must strategically choose and work from a tradition which for one reason or another we value, and we

must start from somewhere and something around us, however much we may eventually seek to adapt what we have been exposed to, according to our own maturing judgment and sensibilities.

THE NATURE OF ART HISTORY WHEN I ENTERED THE FIELD

What are the long-standing consequences of some of the foundational assumptions about the nature of art history in a humanistic, quasi-scientific, supposedly objective, modernist context, as practiced until challenged by more recent contextual and semiotic approaches? These newer approaches notwithstanding, the discipline still bears the strong, genetic imprint of its Enlightenment and nineteenth-century roots.

When I first entered the field as an undergraduate in 1969, art history was practiced primarily as the history of stylistic evolution, perceived as evolving through unified periods and styles. There was also a secondary emphasis on iconography, which I will come to shortly. Within the discipline of art history, there was a pretense of scientific objectivity in this methodology of art history as then widely practiced. This foundational methodology grew out of the accumulative impact of Johann Winkelmann's classification system of Greek sculpture, the seminal work of Austrian Alois Riegl, and Swiss art historian Heinrich Wölfflin. Wölfflin had studied under cultural historian Jacob Burckhardt in Basel and then went on to teach art history in both Germany and Switzerland (Berlin, Basel, Munich, and Zurich), where he influenced a whole generation of German-speaking art historians. (Burckhardt was the son of a Swiss, Protestant clergyman, and initially himself studied [Calvinist] theology.)

The modern foundations of art history as shaped by these German-speaking scholars were also fundamentally shaped by ideas stemming from German-idealist philosophy, and from Hegel in particular. When transferred into the discipline of art history it resulted in the notion, which has since then persisted, of the unity of period and styles as a manifestation of the Zeitgeist or spirit of an age. This term later became extremely suspect to art historians such as Ernst Gombrich, not least because it implied that Nazism might therefore be seen as inevitable and therefore irresistible. Meanwhile, such German-idealist thought left a profound, long-term impact on the methodology and unspoken assumptions of art history.

The seminal ideas of these early German-speaking art historians were passed down and presented to so many of my generation through earlier editions of Horst Janson's *History of Art*. (Janson was born to Swedish parents in St. Petersburg, Russia. During the Russian Revolution, his family fled to Germany, where he became a student of Panofsky, at the University of Hamburg. In 1935 he emigrated to the US, where he eventually taught at New York University.)

Here we need to also introduce two English art critics, Clive Bell and Roger Fry, since an account such as this would be remiss not to include the counterbalancing writings of these two men. In the 1920s and 1930s Clive Bell and Roger Fry, basing themselves on the formal, analytical principles of the Italian art historian Giovanni Morelli, rejected the literary basis of much humanistic, iconographic research and in its place championed pure form as seen in post-impressionists such as Cézanne, an artist who became a strategic precursor to the formalist tendencies in so much twentieth-century art and criticism. In process, this formalist trend challenged the text-driven, humanist iconographic critique, as championed by such scholars as Ernst Cassirer, Aby Warburg, and their fellow travelers and followers (mentioned below). The methodology of Clive Bell and Roger Fry is distinct from that of Wölfflin and his successors in that the latter link style to culture and history, whereas Bell and Fry as pure formalists believed that art has its own history, independent of context.

Each of these two main approaches offers advantages and disadvantages, and we will briefly indicate what we perceive these to be. As for stylistic analysis and formalism, they provided one possible form of historical classification and a chronological structure, the latter of which relates to the way we remember things. In short, this approach provided structure for the multiplicity of data. It focused attention on the formal and aesthetic choices of artists and their handling of materials and chosen media. For many it is perceived as upholding art as art, freed from other cultural concerns. The most evident disadvantage of this formalist approach is that it ignored interpretative questions and issues of broader human significance. There was thus a perceived narrowness of relevance. This approach tended to relegate art to a distinct category, separate from the rest of life, associated with visual pleasure and aesthetic contemplation, with no further social relevance.

As to the other main approach, when I started out as a student of art history, Janson's popularized, historical-evolutionary, stylistic approach was complemented by literary-based iconographic studies modeled by Ernst Cassirer, Aby Warburg, Edgar Wind, Erwin Panofsky, Fritz Saxl, and others. (It should be noted that Panofsky, Warburg, and Saxl were all connected to the University of Hamburg in the 1920s. Warburg died in 1929, and Saxl and Panofsky, both Jewish, left Germany in the 1930s, Saxl taking the great Warburg family library to London and Panofsky eventually settling at Princeton, New Jersey.) The advantages and disadvantages of this type of iconographic analysis could be summarized as follows: an iconographic approach provides insight in the content and meaning of art and therefore in its broad, human significance and social relevance. Its methods can support an array of diverse interests: spiritual, literary, material, geographic, thematic, and so on. However, practitioners of this approach typically ignore the material substance and formal considerations of art. They can be accused of reducing art to message and tying it too closely to modes of communication based on the written word. At worst, art is reduced thereby to a form of text illustration, though few such practitioners would understand visual art as merely that.

Besides the pure formalism of Bell and Fry, both of these two other approaches, the analysis of stylistic evolution and the iconographic approach, had been developed in German-speaking cultural contexts, and in my view this has had a profound long-term impact on the nature of art history as a discipline.

There was a distinct but unspoken humanistic bias in the values, interests and priorities of the leading German-speaking and/or German-educated figures, such as cultural historian Jacob Burckhardt, Alois Riegl, and Heinrich Wölfflin. This bias informed the most influential founders of modern art history. Furthermore, it has had great repercussions in the English-speaking world, given that a number of leading German-speaking scholars were of secular Jewish background and fled from Germany and Austria in the 1930s. What is significant for the art historian who is a Christian is to realize the degree to which this affected the treatment of art made for the church, and the neglect of the Christian content of so much of Western art. In turn, more recent methodologies have done little to correct these lacunae, since their priorities have tended to focus on material culture and on identity

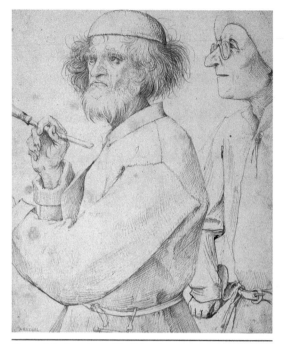

Figure 6.1. Pieter Bruegel the Elder, *The Painter and the Buyer,* 1565

politics, as manifest, for example, in feminist, gay, and postcolonial studies. Such lacunae, to me, suggest opportunity for the art historian who is a Christian to offer a distinctive contribution.

With the rise of Nazism, some of these leading German, Jewish scholars settled in the UK, as did the German Nikolaus Pevsner and the Viennese Ernst Gombrich. Others settled in the United States, as did Erwin Panofsky (teaching at New York University and Princeton), Jacob Rosenberg (a former pupil of Wölfflin, and in turn the mentor of Harvard's Seymour Slive), Walter Friedländer (another pupil of Wölfflin, who taught at the Institute of Fine Arts, New York) and others, coming just as art history was being more firmly established as an academic discipline in these countries. (Pevsner, Gombrich, Saxl, Panofsky, Rosenberg, and Friedländer all came from Jewish families, although Friedländer was raised as a Lutheran.) Vernon Hyde Minor in his book *Art History's History* writes of the great boon for American art history in the 1930s from the influx of German-trained, Jewish art historians.[2]

THE ENDURING CONSEQUENCES OF THESE HUMANISTIC FOUNDATIONS

The consequences of this history were the privileging of the humanistic, classical tradition, with Greek classicism and the Italian Renaissance treated as the cultural high marks and points of reference for much else. Classical ideals and their Renaissance and later Enlightenment revival, as well as

[2]Vernon Hyde Minor, *Art History's History* (Englewood Cliffs, NJ: Prentice Hall, 1994), 23.

classical mythology, could be regarded as possessing a universal value and truth that avoided head-on engagement with the claims and demands of Christianity. By contrast, medieval and much northern European art of the fifteenth, sixteenth, and seventeenth centuries, to say nothing of seventeenth-century Italian Counter-Reformation art, did not afford that ideological convenience, if engaged on its own terms.

From this preferred perspective, it followed that there was also a widely pervasive tendency to describe, focus on, and value northern art in terms of the history of its capacity to absorb Italian Renaissance forms and ideas. Let me underscore that I am not implying that early Christian, medieval, and Netherlandish art were not studied, only that the dominant methodology (stylistic analysis, and, to a lesser extent, classically oriented iconography) lent itself to accentuating some elements of the subject while passing over others, especially in the way that art history was broadly presented at conferences, to students, and in the most prominent and widely read publications. It also led to a virtual total disregard for indigenous forms of post-Gothic, northern architecture. Red brick Dutch, Flemish, and British modes of architecture were deemed non-architecture. Gray stone, Neo-Classical buildings that looked dull in cloudy northern climates were written about; red brick houses that looked good against the wet green pastures of England were largely ignored.

Perhaps most egregious from my perspective was a marked preference for treating religious art in stylistic terms that largely ignored the function and religious meaning of such art. Also much of the great religious art of Poland and Eastern Europe, even of Germany, to say nothing of the Spanish peninsula, was almost totally ignored, perhaps because it was alien to analysis, according to classical notions of proportion and harmony, and perhaps deemed displeasing or indeed inferior by such standards. Byzantine art fared little better, though it had its occasional champion, among them David Talbot-Rice.

Dutch seventeenth-century art—given its unconventional, bourgeois anti-classicism—was grudgingly allowed a short chapter in surveys, but even then, it was barely acknowledged as a precursor to nineteenth-century realism. Rosenberg and Slive, the authors of the volume on Dutch seventeenth-century art in the benchmark series of the *Pelican History of Art*, felt bound

to attempt to describe Dutch art in terms of the wider, German-idealist notion of the unity of periods and style, an approach which ill-served the distinct, northern traditions from which it emerged. When art historians, such as Eddy de Jongh, began to apply iconographic methods to the study of Dutch genre painting, a major art-historical war was unleashed, perhaps also because no one liked the Christian moralizing that became evident in the art. When thereafter I proposed that not only genre painting, but also landscape and still life, embodies a vision of reality informed by Christian thought, my mentor at Cambridge, Michael Jaffé, and later some of my peers in the United States, simply viewed such an idea with derision. They were committed to stylistic analysis.

Non-Western art was, in most general curricula, a non-subject, never spoken of, with the exception of Islamic art, which was seen as influencing the West through Sicily and Spain. Also patently evident in hindsight is the neglect of female artists by the older-mentioned practitioners of art history. To me all these lacunae and distorted perceptions of history suggest opportunity for the art historian who is a Christian to offer a wide range of distinctive contributions.

NEWER CONTEXTUAL APPROACHES: MARXIST, FEMINIST, AND POSTCOLONIAL ART HISTORY

In time these firmly entrenched methods of art history—formalism and style history as well as iconographic studies—came to be challenged and largely supplanted by what at the time was sometimes referred to, at least in England, as "the New Art History."

This so-called New Art History was often driven by Marxist and later Neo-Marxist cultural assumptions, which in time routed both the humanists and formalists in the name of placing material cultural context in a pre-eminent position. The nature of artworks came to be examined in relation to their function within the class struggle, their relationship to the means of production, the economy, and other aspects of material culture. Building on the work of social historians Arnold Hauser, Albert Boime, and Frederick Antal, Charles Harrison, and Paul Wood, in collaboration through England's Open University publications, did much to promote the spread of this methodology, as also practiced by individuals such as Michael Baxandall.

This approach was taken up in the United States by figures such as (British-born) T. J. Clark, Stephen Eisenman, and Keith Moxey. Soon, proportionally at least, the focus of such writings fell off the aesthetics of any given object onto its function within the class struggle, the economy, and other aspects of material culture—but still largely ignoring the religious context and its implications for the meaning of the art, often even when such was patent! Thus, with several notable exceptions, such as Barbara Lane and James Marrow, art historians routinely wrote about late medieval altarpieces without due consideration of the relationship of such works to the liturgy of the mass or the doctrine of transubstantiation.

This new sociological methodology proved immensely fertile for expanding the discourse of art history, inasmuch as the placing of emphasis on the impact of societal forces on the nature of art began to suggest to many younger art historians a whole spectrum of other dimensions of the social fabric that impinge on the making and viewing of art. Thus arose feminist, multiculturalist, postcolonial, and queer approaches to art history. Proponents of such approaches have typically taken their lead from literary scholars and work analogously in adapting nonartistic analytical frameworks from other disciplines to the study of works of art.

Emerging in the 1970s, feminist agendas were promoted early by Linda Nocklin, Griselda Pollock, Norma Broude, Mary Garrard, Lisa Tickner, and Ann Sutherland Harris. Initial concerns focused on trying to locate the largely absent woman-as-artist in history and on identifying the distinctive contributions of women. In the process, that expanded the range of art-historical inquiry to embrace crafts—often historically the only creative outlets for women—which earlier art historians had largely ignored.

Subsequent feminist studies tended to concentrate more on how art contributed historically and in the present to the construction of female identity and societal roles, functioning to create and perpetuate stereotypes, which were then opened to exposure and criticism from feminist points of view. Thereafter current contemporary female artists and their critical supporters have focused, among other concerns, on the reclaiming by women of their own bodies and their right to present it and deal with it according to their own choosing.

Taking their lead from such studies, Queer theorists such as Douglas Crimp draw strength from the ideas of Michel Foucault about how language and other forms of discourse construct gender and represent sexuality. The same is true for the construction of racial identity.

Such Marxist, feminist, and queer approaches to art history have done wonders in terms of widening the terms of discourse and possible topics for study. But it should also be noted that such methodologies also feed off a contemporary strain of individualism, under which lies driving concerns such as: How does it promote my ideology? What does it do to me and/or for me? Once again, the spiritual dimension of personhood, the ways in which humanity relates to God, were typically left out of account or treated in nontraditional, noninstitutional ways, inspired by non-Western mysticism that set aside traditional Christian belief.

As we did with formalist and iconographic approaches, let us pause to note some of the evident advantages and disadvantages of such above-mentioned forms of contextual analysis. Such approaches are most effective in drawing attention to the relationships between art and society and on drawing out the impact of social, political, and economic factors on the form, content, making, and reception of art. It can surely be valued as a healthy counterbalance to formalist, iconographic, and biographic approaches and can illuminate all three in fresh ways. However, such approaches can also have the effect of drawing attention off the aesthetic dimensions of an art object—and its inherent visual qualities—diverting attention to the nature of the surrounding culture. Art can be reduced to a springboard for discussion of social issues or politics by another name.

If we take the example of gender studies (as a subset of a contextual approach), we can note many virtues of such an approach. Gender studies brings the relationship between one specific aspect of the social context—gender issues and inter-gender power conflicts—into sharp focus. It thus has an implicit human-interest dimension for all people. It also gives fresh voice to those previously suppressed. It stresses—rightly or wrongly, according to one's own presuppositions—that gender identity is a social construction, not an essential, in-built dimension of our humanity. Gender studies also serves to unmask the pure aesthetic/formalist approach to representations of the human body.

Figure 6.2. John Walford, *The Gendered Eye*, 2008

There are also disadvantages in this approach: as with all contextual studies, gender studies can draw the attention away from the inherent qualities of a given artwork onto a narrow focus on a specific sociological issue. The view that gender is a social construction is not shared by essentialists, that is, those who believe that gender identity is a given of birth and genetics, not cultural context. Gender studies tends to support an instrumentalist view of art, where the focus of interest and the value accorded to art is chiefly related to its efficacy in promoting such gender concerns. Thus, overall aesthetic values are subordinated to gendered priorities.

Many analogous sets of advantages and disadvantages can be perceived in multicultural studies (understood as a subset of the contextual approach), and hence perceived pros and cons are analogous to those of gender studies: multicultural studies brings the relationship between one specific aspect of the social context—racial issues and interracial power conflicts—into sharp

focus. Like gender studies, this approach unmasks the pure aesthetic/ formalist approach to representations of other cultures. It, too, has an implicit human-interest dimension for those seeking to give a voice and a cultural space to diverse, often disenfranchised social groups. Thus, multicultural studies give a fresh voice and cultural space to those previously suppressed. It possesses the perceived virtue of being democratic and anti-elitist. However, as with all contextual studies, it can draw the attention off the inherent qualities of a given artwork onto a narrow focus on a specific sociological issue. It, too, supports an instrumentalist view of art (if that is viewed as a negative). Typically, as with gender studies, aesthetic values are subordinated to multicultural priorities.

ARTISTS' BIOGRAPHY AND RECEPTION THEORY

Besides such contextual approaches, there remain two other obvious parties in the dynamic of viewing and engaging art on which art historians have focused their attention, namely artists' biographies and the viewers' responses.

Taking first the analysis of artists' biographies, the great appeal of this approach is its accent on the human-interest drama and psychological dimension of artistic creativity, which harmonizes with the concept of art as self-expression. Such an approach plays well for an artist like Vincent van Gogh or perhaps Caravaggio, but it doesn't do much for a study of Jan van Goyen, about whose life circumstances only a minimal amount is known. Andrew Graham-Dixon's recent biography provides a depth of insight to an extremely wide cast of characters that shared the same stage as Caravaggio and makes for illuminating reading about his time, place, and surrounding circumstances; yet the paintings themselves end up taking a distinct back seat in the narrative. Thus, this biographical approach shifts attention from the art work to the artist and does not take account of work made by artists on commission, where their personal perspective plays a less dominant role in shaping the nature of the object commissioned. But it can help highlight the impact of patronage on the history of art.

At the opposite end of the spectrum to biographic analysis of the artist lies viewer response theory or reception theory: David Carrier considers Leo Steinberg, Michael Fried, and Michel Foucault's respective analyses of the spectator's role, also making reference to the thought of Ernst Gombrich and

Svetlana Alpers—a notable line-up of historians.[3] This essay is one good place to start to think about the implications of the viewer's position in relation to the object under consideration. Such historians raise two questions: first, where is the viewer situated in relation to the artwork? And second, what does such a viewer experience and perceive—both then, when the work of art was first made, and now, in a different context today? Consideration of the *psychology* of reception has been promoted by notable figures such as Rudolf Arnheim, Ernst Gombrich, Richard Wollheim, and David Freedberg. But I am in an inadequate position to comment on their undertakings.

Reception theory is deeply indebted to the semiotic theories of Roland Barthes. Rosalind Krauss, Mieke Ball, and Norman Bryson, for instance, all draw from semiotic theory to underscore that an image—or a work of art— can only be understood from the perspective of the viewer. It is the viewer who constructs meaning in relation to the object studied, and they all assert that meaning is valid regardless of what the artist might have intended. By contrast, earlier practitioners such as Panofsky, using an iconographic approach, sought out a presumed inherent meaning in a given work of art, discoverable through the study of pertinent contextual sources. Yet, art historians such as Krauss, Ball, and Bryson, building on the semiotic theories of Roland Barthes, are skeptical of such assumptions, since, for a start, they argue that the reading of context is itself subjectively constructed. Hence they seek instead to explore how meaning—or rather meanings—may be derived from the image by the viewer in dialogue with the object. Such meaning—or, better still, meanings—they argue, is/are what matters to us today, more so than any past, alleged, possible meanings.

Writing on still life, for example, Norman Bryson starts with the question of what such works might mean for us today.[4] He goes on to observe that meaning arises in the collaboration between signs (visual or verbal) and interpreters. In taking still life as his subject, this also provides him with occasion to consider the extent to which this genre's historically low estimation, and by contrast its potential to be deemed worthy of attention,

[3]David Carrier, "Where Is the Painting? The Place of the Spectator in Art History Writing," in *Principles of Art Historical Writing* (University Park: Penn State University Press, 1991), 159-77.
[4]Norman Bryson, *Looking at the Overlooked: Four Essays on Still Life Painting* (Cambridge, MA: Harvard University Press, 1990), 10.

might arise from matters of ideology and gender. Thus he also manifests a concern with the reception of such art by different types of viewers.

Reception theory asserts that the past is largely unknowable in terms of its original context. Every historical account is an artificial construction, revealing as much, if not more, about its present-day interpreters as about that which it seeks to interpret. What we do with knowledge of the past in the present is what really matters. Viewer response is relative, diverse, inclusive, and pluralistic, but actual and relevant in the present, whereas all historically grounded accounts claim an illegitimate authority for what are in reality covert power plays, which are ideologically driven.

VISUAL STUDIES VERSUS ART HISTORY

Finally, the question arises as to how wide the study of art should extend. Should art historians only consider a narrow canon of so-called masterpieces, which rings as elitist, especially in the context of a pluralistic democratic society, or should art historians study all forms of visual materials, regardless of any perceived hierarchy of aesthetic quality or value? Such questions opened the door to visual studies and/or visual and media studies.

In this essay we will set aside the issues raised by advocates of visual studies as opening another large topic. Suffice it to say that such studies raise the polemics of nonhierarchical populism and broad social relevance versus elitism and assertions of superior aesthetic quality. Proponents of this approach have built on the work of English art critic John Berger. Among them, besides many art historians such as Griselda Pollock, W. J. T. Mitchell, and Keith Moxey, have been prominent advocates of the values and virtue of visual studies. Lutheran art historian David Morgan, also a notable proponent of this approach, has applied it specifically to the study of popular religious prints and other such religious artifacts.

Analogously to multicultural, race, and gender studies, visual studies raise the polemics of populism and broad relevance over against the claims of elitism and its emphasis on the integrity of artistic quality and the formalist approach. The advantages of visual studies are that such an approach enlarges the discourse to include all and any visual materials. It is patently democratic and anti-elitist. Visual studies give voice to the visual expression of all strata of society and includes those functioning within the context of

popular culture. It thus provides a broader picture of visual discourse and its social and cultural significance. It deliberately dissolves the barriers between fine and applied art and between high and low culture. Its disadvantages are that its nondiscriminatory, egalitarian approach comes at the expense of recognizing any qualitative differences of aesthetic value between the "masterpiece" of a famous artist and the illustrations of a comic book. Thus populism trumps quality; breadth of audience trumps subtlety of invention or what Calvin Seerveld refers to as "allusivity."[5]

TRADITIONAL ART HISTORY VERSUS THE SO-CALLED NEW ART HISTORY

Traditional art historians attempted and still attempt to approach art on its own terms within its historical context. They pursue a form of historically grounded understanding, and, while recognizing the limitations of all historical construction as partial and approximate, believe that there is a past that merits and demands attempts at discovery on its own terms. Such art historians, among whom I would count myself, thus attempt to know and understand historical phenomena as much as is possible within its original context. But, as I have noted, historically such studies are themselves ideologically titled and may well leave matters of Christian import out of view.

By contrast, practitioners of the so-called New Art History view art in sociological and instrumentalist terms, typically at the expense of its aesthetic dimension. They approach artworks as sites of ideological debate and confrontation. At its most extreme, practitioners of newer forms of art history approach art in terms of what it means to us today, sometimes regardless of its original context. What matters is what it means to us, not what it meant to its first viewers. In their view, all attempts at historical reconstruction are no more than ideologically driven power plays.

In time, as the "new" art history dislodged the old, museum officials would start to complain that art history graduates from Harvard and elsewhere no longer knew how to look at a work of art in terms of its aesthetic merits but knew a lot about how to use the arena of art as a locus for discussions of authority, power plays, and the manipulation of social identities. As

[5]Calvin Seerveld, *Rainbows for the Fallen World* (Toronto: Tuppence, 1980), 131-35.

has been observed by others, such as Eric Fernie, such studies tended to overlook that in terms of its core identity art history depends on "the expertise of the eye" and supposedly studies "concrete objects" (Fernie's words).[6] To that sound reminder I would add that only a few of its practitioners have drawn attention to matters of Christian religion and its traditional belief systems as they inform art's history.

ENGAGING THIS METHODOLOGICAL SPECTRUM AS A CHRISTIAN

Let's first acknowledge that all young scholars start out by building on the preferred models of methodology imparted to them in graduate school. Thus, as in most other professions, typically graduate students set out and often stay close to the examples set before them in graduate school—perhaps only the most creative start ideological and methodological rebellions at this stage of their careers, if at all.

I will take as an example my experience as a PhD candidate at Cambridge, England, under famous Rubens scholar Michael Jaffé. When I proposed my dissertation topic, he started literally yelling at me: "Where did you get all that nonsense shoved in your head?" What I was proposing was that even when an artist paints something as seemingly innocuous as a landscape, there is a mode of interpretation at play. Thus a painted landscape becomes the expression of a given vision of reality, of what nature means to its viewers and users in any given time and place, how it is understood, and how it is used.

Strongly committed to what I had learned as an undergraduate in Amsterdam, the intensity of Jaffé's negative reaction taught me the need to build strong intellectual defenses for my point of view if they were to hold up to scrutiny from my professional peers and ideological opponents. Jaffé, as you might guess, was committed to the study of stylistic development. He was also, as a matter of record, a humanistic secular Jew, the significance of which I have considered earlier. The result was that I had to make my case credible on his methodological terms, and also to meet the approval of two outside readers from other leading British universities, both also practitioners of stylistic analysis. Through making such concessions, and as Jaffé

[6]Eric Fernie, *Art History and Its Methods: A Critical Anthology* (London: Phaidon, 1995), 21.

warmed up to my ideas, I at least ended up with a product acceptable for publication.[7] But looking back over my early publications, some are still not what I would have chosen to write had I been allowed to follow my own intellectual convictions, even if some of these survived being pressed into a structure not of my choosing.

So, where does all this leave the would-be art historian, who is a Christian and who also finds him- or herself in an extremely isolated minority within the field? I understand a Christian's call to be one of discernment. Given my own intellectual history, this has meant applying the Dutch presuppositional approach to the various methodologies of art history that I have encountered along the way, most specifically in relation to the humanist paradigm for art history in relation to the Marxist paradigm for art history and to postmodern skepticism and subjectivity.

However, I have also observed significant pitfalls to the Dutch presuppositional approach. These might be summarized as follows: most of all there is a danger of people seeing the false presuppositions in a given approach and rejecting what is built thereon. Thus, when Hans Rookmaaker's book *Modern Art and the Death of a Culture* was first published and began to be widely read and respected, Christian studio art students tended to find themselves frustrated by Rookmaaker's critique of much of modernism for its devaluation of human dignity.[8] As a result, drawing, I think, the *wrong* conclusions from his exposition, they would express exasperation, since they drew for themselves the conclusion that if this is flawed, that is flawed, and the other is flawed too, so what's left to build off? That was an unintended consequence of Rookmaaker's point of view and methodology—yet understandable. He for himself would never want to overlook the fruits of "common grace," the wisdom and fruits of the creative gifts that God has placed in all people, regardless of their beliefs. His intent was to teach *discernment*, that people might not follow others blindly, lacking all discernment as to the implications of various cultural manifestations. His expectation was that armed with better discernment, others would act in compensatory ways in response to the limitations and distortions found

[7]E. John Walford, *Jacob van Ruisdael and the Perception of Landscape* (New Haven, CT: Yale University Press, 1991).

[8]Hans Rookmaaker, *Modern Art and the Death of a Culture* (Downers Grove, IL: InterVarsity Press, 1970).

in whatever they were engaging within the surrounding culture. But he *never* imagined that others, reading his work, would simply dismiss such art as flawed and thus lacking value.

When teaching art history at Wheaton, I noticed an analogous response to art in students, who would often reason along lines such as: this art appears to have been inspired by false assumptions about the nature of humanity and/or reality and/or directed toward social goals that are less than admirable, socially manipulative, driven by lust, pride, greed, ambition, or whatever other vice might have been in play. The conclusion then drawn by such students was: therefore this is not godly fare and should be rejected by Christians. I would point out that there is no part of human culture that is free from the traces of sin, since culture is a fruit of flawed and sinful mortals, not perfect beings. The conclusion to be drawn is not withdrawal from society nor rejection of such art, but engagement therewith and making efforts toward its betterment. As Martin Luther once wisely observed, to paraphrase: abuse of a practice is no grounds to reject the practice per se; otherwise, you must first go out and destroy your own body.[9] This applies no less to art-historical practice and methodology. *The wiser path for the Christian is to start with discernment and to proceed with wisdom, taking what is to hand and seeking to make something more wholesome out of it.*

Let me expand a little on the notion of common grace, because I see this concept as enormously liberating for how we engage the unredeemed culture round about us. Those who are quick to judge and dismiss the ungodly fruits of other people and other cultures overlook one critical, overarching theme of Scripture, namely that God has gifted all of humanity diversely. Perhaps the clearest way to grasp this is to consider the account in the Old Testament of two distinct lines running through humanity: the line of Seth and the line of Cain. Seth's line, we are told, is given wisdom and knowledge of God but doesn't generate much in the way of material culture, music, the arts, technology, architecture, and the like. However, by contrast, Cain's line, while bereft of the knowledge and wisdom of God, is rich in the generation of material culture, for in this line arises music, the arts, technology, and city culture. Now notice: each group has been given something, and each lacks what the

[9]As alluded to by Carl C. Christensen, *Art and the Reformation in Germany* (Athens: Ohio University Press, 1979), 47nn37-38.

other has been given as a gift and mastered. It is the same for us today. There are those who help us out with their worldly smarts and skills, who are clueless about God's ways and wisdom; and there are those who are wise in the ways of God, who are clueless about art, medicine, car mechanics, finances, and the like. Each group needs the other. That, too, should give us some clues as to how to go about doing art history or practicing art.

I would therefore rather see Christian activity—in any arena—as a redemptive activity. Therefore, I see for the Christian wide opportunity to engage the full spectrum of art-historical methodology and to seek to complement what one is personally exposed to or drawn toward, reworking its methods as best one can to include the spiritual dimension of human consciousness and behavior, which seems to be so often bracketed out in the work of others. This is what I think it means to work toward a redemptive model for art history: working with the "plunder of Egypt" and making something wholesome out of it.

In Ephesians 4:23, we are exhorted, "Be renewed in the spirit of your minds." In my experience, Christian faith provides a fresh perspective through which to view the world and examine the scholarship of others. A Christian art historian is equipped in graduate school with the same set of tools as everyone else. Yet, in putting those tools to work while faced with the same material as everyone else, as we mature as Christians we should strive to develop what I have called "a Christ-crafted lens." This mode of viewing and reflecting puts a different cast on how and what one sees; it brings different aspects of reality into sharper focus or refocuses our perception of what everyone else is looking at.

TOWARD A REDEMPTIVE MODEL FOR ART HISTORY—MY OWN ATTEMPT

I have consciously resisted the formalist, stylistic-analysis approach of many introductory texts and sought to create an alternative to those that focused primarily on materials and techniques.[10] In my judgment, both approaches— whatever their inherent merits—left aside attention to the vision of God, humanity, and the meaning of life in the world and the surrounding physical reality as conveyed through art and architecture throughout the ages. As a

[10]E. John Walford, *Great Themes in Art* (Upper Saddle River, NJ: Prentice Hall, 2001).

corrective I was thus consciously blending aspects of visual analysis and iconographic and contextual approaches while trying to emphasize contextual spirituality and value systems rather than other social and economic factors.

My themes were chosen and organized according to my perception of fundamental human issues, deeming these effective points of contact for a student's first exposure to the world of art. In practice, space limitations and expected coverage severely limited my possibility to really develop any of those themes. Recognizing that no text or approach can do everything, I thus chose an approach and methodology that would as best possible, within the limitations of my own knowledge and abilities and the willingness of the publisher to allow such considerations, seek to draw out some of the spiritual and intellectual dimensions of artistic expression that tend to receive less attention when using other methods and approaches to the discipline. Thus by placing first in each chapter a section on spirituality, I was able to suggest that people's belief systems and religious convictions tend to set the tone for, or at least influence, all other priorities.

As a Christian I also wanted to show openness toward peoples of all forms of religious belief, cultural difference, sexual orientation, and so forth, recognizing all of humanity as created equally in the image of God, even though people of other cultural traditions have developed priorities and values different from those that I personally embrace. When I was in the process of contract negotiations with the publisher, who knew my personal faith convictions, he reminded me that a textbook is not a soap box for one's own biases. For my part I assured the publisher that I would seek to represent people of all persuasions fairhandedly and explain as best possible where they stood, as I understood it. For the record, I attempted to pay significant attention to non-Western art.

Let me be a little more specific about what I mean by working toward a redemptive model of art-historical methodology. First, my prime assumption is that we build off what we perceive as the best available of current practice, with "best" implying that which takes most full account of the nature, dignity, and "fallen" state of humanity, also recognizing that we are created as spiritual beings made for a relationship with our Creator, but a relationship sundered by human sinfulness. In relation to surrounding methodology I think it behooves us to keep an eye out for the lacunae in the work of others—what such work leaves out of consideration regarding

human spirituality and religious aspirations, as well as how it manifests the consequences of our rebellious, fallen natures.

I believe that in our professional practices—as in all arenas of our activity—we should strive to honor God and to uphold the dignity of humanity every way we can, always working toward human flourishing for all peoples. We are called, also within our professional practices, to follow the example of Christ, who takes what is broken and works to make something healed and whole out of it, as he does with the life of each who turns to him for their redemption. We can thus seek to sanctify the practice of art history, much as Christ sets to work sanctifying us; analogously, it will be a life-long process. Our call to love God and our neighbor, to exercise discernment and pursue what is good, wholesome, and up-building, applies no less to the way we go about our work as art historians, or as artists, or whatever it may be.

My own exploration these past few years of the expressive possibilities of digital photography and collage has, in the process, taught me a sound lesson in working with the plunder of Egypt. Put another way, I have learned to take from what I perceive as inherently conceptually flawed, as nevertheless seeing therein the potential means to achieve exactly what I am striving to achieve, in the process bending and molding my chosen models of practice to make them serve my ends, not necessarily those they were first designed to serve. Over the past seven or eight years, as I have striven to merge my knowledge of art history with the expressive potential of collaged digital photography, I have found myself endlessly striving for ways to get behind and beyond the surface of things. Photography—writing with light— is by definition a medium that works with how surfaces respond to and are transformed by fugitive qualities of light. But my sense is that the essence and character of reality lies as much below the surface as above or on it.

In seeking to embody this fuller sense of reality—that which lies below and behind the surface as much as on or above it—I found myself drawing from three streams of twentieth-century art, all of which as a Christian I judge to be built on questionable or flawed presuppositions about the nature of reality and/or human integrity, and yet they each offered me valuable resources. To briefly particularize, I have drawn from the practices of collage, surrealism, and appropriation, despite my critique of the basic premises of each. Thus I would judge collage historically to have grown out of a desire to figure

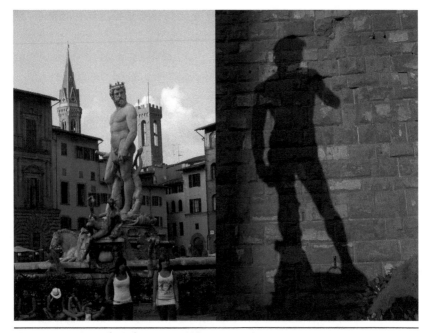

Figure 6.3. John Walford, *If Statues Could Envy, and Girls Meet Their Heroes*, 2018

fragmentation and dislocation, a disjunction of time, place, and action of which Christians, believing that all things hold together in God, might well be wary. For its part surrealism grew out of the desire to rebut the hubris of Enlightenment rationalism and to propose instead a more Freudian view of what drives human behavior, namely subliminal forces of love and hate, life and death, sex and desire working deep within the human subconscious. By contrast, a Christian might posit that human actions are driven by the fundamental loyalties of the heart and consequent life choices. As for postmodern practices of appropriation, it could be argued that a strategy of appropriation assumes a cynical rejection of human capacity for fresh creativity and/or cultural advance, seeing the process of history as essentially circular rather than linear, thus inviting a jaded recycling of past materials in an indifferent attitude of "what goes around, comes around." The effort to be distinct and unique becomes irrelevant. To this posture a Christian might respond that such a cynical view discounts that God has created each of us as unique individuals, in his image and likeness, thus fertile in imagination and creativity, essentially similar to other mortals, yet each nevertheless distinct.

For my own practice of digital photography, such a threefold critique notwithstanding, I have found great value in drawing from each of these diverse strategies and bending them to serve my own goal of seeking to make visible what lies beyond and behind the surface of reality: to render visible the inherently invisible. This experience has taught me more about the potential of taking strategies and methodologies that may well be inherently flawed, and then adapting and bending them to serve one's own preferred ends. This seems to me to be in line with the arch model of Christ's dealings with an imperfect world, filled with imperfect people and institutions. He works with what is on offer and available and works to make the best possible out of any given individual or situation. For an artist or an art historian, that seems to me to be the best way to engage the world around us. Indeed, there is no other world to engage, but the immediate one that we find ourselves in—that is, short of eternity and our own completed redemption.

ONE FINAL OBSERVATION

I will conclude by saying that for these reasons I thus think that a Christian has great freedom to engage the discipline of art history as he or she feels best equipped. Nevertheless, I would add one qualification, namely that we strive to hold true to our Christian allegiance and keep before us the need for strategic choices, in seeking to complement the work of others with perspectives and topics that have been and still are so often passed over. If we so operate, perhaps we can offer distinct and strategic contributions to the discipline rather than merely aping the latest fad—strategic, namely, in attending to what others let slip from view, which nevertheless a Christian perceives as of fundamental significance. But how are we to perceive such elements, unless our lives are deeply rooted in Scripture and Christian tradition?

BIBLIOGRAPHY

Adams, Laurie Schneider. *The Methodologies of Art: An Introduction.* Boulder, CO: Westview, 1996.

Barrett, Terry. *Criticizing Art: Understanding the Contemporary.* 2nd ed. New York: McGraw-Hill, 2000.

Baxandall, Michael. *Patterns of Intention: On the Historical Explanation of Pictures.* New Haven, CT: Yale University Press, 1985.

Bryson, Norman. *Looking at the Overlooked: Four Essays on Still Life Painting.* Cambridge, MA: Harvard University Press, 1990.

Bryson, Norman, Michael Ann Holly, and Keith Moxey. *Visual Theory: Painting and Interpretation.* New York: HarperCollins, 1991.

Carrier, David. *Principles of Art History Writing.* University Park: Pennsylvania State University Press, 1991.

Carter, Craig A. *Rethinking Christ and Culture: A Post-Christendom Perspective.* Grand Rapids, MI: Brazos, 2006.

D'Alleva, Anne. *Methods and Theories of Art History.* 2nd ed. London: Laurence King, 2012.

Fernie, Eric. *Art History and Its Methods: A Critical Anthology.* London: Phaidon, 1995.

Ferretti, Silvia. *Cassirer, Panofsky, and Warburg: Symbol, Art, and History.* New Haven, CT: Yale University Press, 1989.

Graham-Dixon, Andrew. *Caravaggio: A Life Sacred and Profane.* New York: W. W. Norton, 2010.

Hatt, Michael, and Charlotte Klonk. *Art History: A Critical Introduction to Its Methods.* Manchester, UK: Manchester University Press, 2006.

McEnroe, John C., and Deborah F. Pokinski. *Critical Perspectives on Art History.* Upper Saddle River, NJ: Prentice Hall, 2002.

Minor, Vernon Hyde. *Art History's History.* 2nd ed. Upper Saddle River, NJ: Prentice Hall, 2001.

Mitchell, W. J. T. *Iconology: Image, Text, Ideology.* Chicago: University of Chicago Press, 1986.

Moxey, Keith. *The Practice of Theory: Poststructuralism, Cultural Politics, and Art History.* Ithaca, NY: Cornell University Press, 1994.

Niebuhr, Richard H. *Christ and Culture.* New York: Harper, 1951.

Podro, Michael. *The Critical Historians of Art.* New Haven, CT: Yale University Press, 1982.

Pooke, Grant, and Diana Newall. *Art History: The Basics.* London: Routledge, 2008.

Preziosi, Donald, ed. *The Art of Art History: A Critical Anthology.* Oxford: Oxford University Press, 1998.

Raven, Arlene, Cassandra Langer, and Joanna Frueh, eds. *Feminist Art Criticism: An Anthology.* 2nd ed. New York: HarperCollins, 1991.

Rees, A. L., and F. Borzello, eds. *The New Art History, 1986.* Atlantic Highlands, NJ: Humanities Press International, 1988.

Rookmaaker, H. R. *Modern Art and the Death of a Culture.* London: Inter-Varsity Press, 1970.

Seerveld, Calvin. *Rainbows for the Fallen World.* Toronto: Tuppence, 1980.

Walford, E. John. *Jacob van Ruisdael and the Perception of Landscape.* New Haven, CT: Yale University Press, 1991.

———. *Great Themes in Art.* Upper Saddle River, NJ: Prentice Hall, 2001.

Ridentem dicere verum— Pieter Bruegel's *Peasant Wedding* of Circa 1567

E. JOHN WALFORD

Ridentem dicere verum quid vetat?
What prevents me from speaking the truth with a smile?

HORACE

Pieter Bruegel the Elder (ca. 1525–1569) was a prominent Netherlandish artist whose career unfolded, first in Antwerp and later in Brussels, amid the increasing tensions caused by the rise of Protestantism within the Hapsburg Netherlands, which fell within

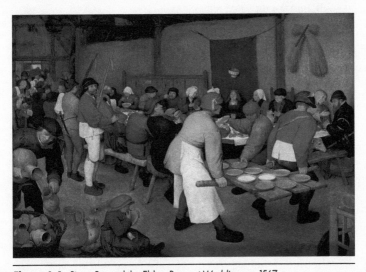

Figure 6.4. Pieter Bruegel the Elder, *Peasant Wedding*, ca. 1567

the dominions of the Holy Roman Emperor. In 1550 the Hapsburg Holy Roman Emperor, Charles V of Spain, passed the Edict of Blood, which decreed death as the penalty for heresy against the teaching of the Catholic Church. While Charles did not enforce this Edict, his son and successor, Philip II of Spain, began to enforce it aggressively in the Netherlands, ultimately leading to outright war with Spain. Within this turbulent and perilous context, it can be clearly demonstrated that Pieter Bruegel the Elder belonged to an active circle of artists, writers, and publishers, prominent among them the print publisher Hieronymus Cock, the cartographer and geographer Abraham Ortelius, and the influential humanist book printer and publisher Christophe Plantin. Like Bruegel, all three of these men were based in the thriving commercial and publishing center of Antwerp.[1] Characteristic of these circles to which Bruegel belonged was adherence to a form of Christian humanism, with roots in the modern devotion and the writings of Erasmus, which advocated a peaceful middle way between the extremes of both ends of the religious spectrum, Catholic and Protestant. They were inspired rather by devotion to the newly translated biblical record of the teachings of Christ and driven also by a form of truth-telling and social satire, inspired by Horace, Seneca, Cicero, the satirist Juvenal, and the ancient Stoic philosophers.

Bruegel's large, undated *Peasant Wedding* (fig. 6.4) is generally accepted on stylistic grounds as a work of circa 1567, thus late in his oeuvre. It is one of the most written about works of this Flemish master. Thus a good place to start in attempting to grasp its visual and intellectual significance is with a consideration of what the most prominent scholars of the last fifty years have had to say about this work. In light of their writings and

[1] See, Margaret A. Sullivan, *Bruegel's Peasants: Art and Audience in the Northern Renaissance* (Cambridge: Cambridge University Press, 1994), 5-46, for the intellectual and spiritual context of Bruegel's art and that of his immediate audience, especially 7-13 for the careful identification of Bruegel's professional circles and for Sullivan's detailing of the broadly Erasmian quest of this circle of Christian humanists: to seek a peaceful middle way amid the religious strife of their times, carefully avoiding the extremes of both ends, Catholic and Protestant alike.

widely diverse interpretations, and against the background of the artist's own working cultural context, we will attempt to see this work freshly in considering some hitherto overlooked connections between its visual components and earlier features of the artist's own oeuvre, hoping thereby to throw some fresh light on this much-admired painting.

Grossmann, writing in 1955, set the tone for many subsequent writers in seeing Pieter Bruegel's *Peasant Wedding* as a picture of gluttony, noting the foreground leitmotifs of the man pouring out the wine and the greedy child, licking out of a bowl.[2] Stechow, writing in 1969, noted that no painting of Bruegel has attracted more discussion and that there is no consensus as to its intended meaning, beyond that it represents a wedding banquet in which the groom appears to be missing. He adds, though, that in that time and place the groom was expected to serve the bride and her family on this occasion, and is perhaps to be identified as the man at the end of the table, passing dishes from the servers to the guests. Stechow also comments that there is an unmistakably satirical point to the entire scene. He takes it as a perversion of a sacred rite—noting the visual reference to paintings of the *Wedding at Cana* and even *The Last Supper*—with the consumption of wine and food callously taking preeminence.[3]

From the 1990s onward a later generation of scholars, recognizing this unmistakable satirical dimension to Bruegel's oeuvre, have sought to make sense thereof within the intellectual and cultural context of the artist's time and place. Sullivan, writing in 1994, sees Pieter Bruegel as the quintessential Erasmian artist, his works deeply informed by an Erasmian, Stoic Christian humanism. She sees Pieter Bruegel's work as morally serious but also inviting a smile. In treating the *Peasant Wedding* Sullivan pays prime attention to various visitors included among the peasant circle, seeing in them representatives of idleness—the friar and the

[2]F. Grossmann, *Pieter Bruegel: Complete Edition of the Paintings*, rev. ed. (London: Phaidon, 1973), 200-201.
[3]Wolfgang Stechow, *Pieter Bruegel the Elder* (New York: Abrams, 1969), 126-29.

nobleman at the right end of the table—and modern-day equivalents of the weeping and laughing philosophers, embodied by the two men on either side of the doorway in the far background, one grimacing, the other laughing. She also observes that the man in the fur-lined black coat, sitting under the crossed sheaves of corn, has something of the likeness and typical dress of Erasmus. Thus, overall, she takes this work as an image of the Stoic, Erasmian observer taking in the various foibles and failings of humanity, which, according to Sullivan, includes the false piety of the allegedly pregnant bride.[4]

Kavaler, writing in 1999, similarly to Sullivan sees Bruegel's imagery as being constructed on a socially specific substratum of ethical values with reason, self-knowledge, and self-restraint as important qualities. He elaborates on this identification by associating Bruegel and his work within the broad spiritualist movement in the Netherlands, loosely Erasmian, existing outside the church, seeking religious toleration and intent on following Christ, while avoiding involvement in the surrounding religious turmoil. In a characteristic work such as Bruegel's *Battle Between Carnival and Lent* of 1559, Kavaler notes that the artist clearly advocates for the Erasmian ideal of avoiding extremes and seeking the middle way. He also pays significant attention to *The Peasant Wedding* but rejects the view that this is a negative image of an excess of food and drink. Instead, Kavaler reads the painting as providing an embracing vision of community—representing a coherent social structure and so providing a picture of local identity and social practice. This, he notes, is extremely carefully and effectively observed and not at all a stereotype of peasants and their wider social context.[5]

In a similar vein to Sullivan and Kavaler, Meadow, writing in 2002 on Bruegel's *Netherlandish Proverbs* of 1559, draws parallels to Bruegel's *The Battle of Carnival and Lent*, painted the same year, and sees the artist's work in general as based in a humanist and

[4]Sullivan, *Bruegel's Peasants*, 98-126.
[5]Ethan Matt Kavaler, *Pieter Bruegel: Parables of Order and Enterprise* (Cambridge: Cambridge University Press, 1999), 23, 42, 149.

Erasmian interest in knowledge and improvement but also recognizes that the work deliberately opens itself to multiple paths of reading and response.[6] Among these possible "multiple paths," Gibson, writing in 2006, sees Bruegel's work as primarily jocular rather than moralistic, though Gibson suggests that the bride's thoughts are impure and, worse, that she is pregnant on top of it.[7]

Sellink, in his landmark 2007 monograph on Bruegel, notes how myths surrounding Pieter Bruegel's life and works have led to a range of notions about him. He was known as an artist who painted townsfolk, a well-read humanist who learned much from scholars such as Christophe Plantin and his cosmopolitan associates, a critic of the Catholic Church and the Hapsburg potentates (he also had quasi-Protestant leanings), a disapprover of the growing capitalistic ideology of the time, and finally as kind of heretical alchemist or perhaps a Christian who dabbled in mysterious spiritualities. He also notes that each generation fosters its own image of the master. Sellink states that, counter to such trends, he seeks to be as factual as possible, focusing on Bruegel's artistic evolution and the iconography of the work and drawing out its principal themes.[8]

With respect to Bruegel's *Wedding Banquet* of circa 1567 Sellink notes how the painting's low vantage point provides the viewer with direct access to the subject. Sellink notes that Bruegel has included a cross-section of society, including a landowner, a friar, and a notary or judge, and sets a humorous tone for the whole. But, asks Sellink, where is the groom? Perhaps, Sellink suggests, he is to be identified as the server in blue, noting that in sixteenth-century rural marriage traditions the groom would typically serve the guests, while the bride was seated at table. Sellink takes account of Gibson's suggestion that the bride's thoughts are impure and that she is pregnant, and further notes in the painting the foreground

[6]Mark A. Meadow, *Pieter Bruegel the Elder's "Netherlandish Proverbs" and the Practice of Rhetoric* (Zwolle, NL: Waanders, 2002).
[7]Walter S. Gibson, *Pieter Bruegel and the Art of Laughter* (Berkeley: University of California Press, 2006), 120-22.
[8]Manfred Sellink, *Bruegel: The Complete Paintings, Drawings, and Prints* (Ghent, BE: Ludion, 2007), 9.

allusion to the wedding at Cana. Sellink thus wonders if the artist is satirizing the peasant class or admonishing the viewer against greed and vulgarity—yet the author notes that none of the guests are drunk, sick, or brawling. Sellink concludes that perhaps the painting should be seen as a pleasing, peaceful escape from the surrounding turbulence of the Wars of Religion.[9]

In 2011 Silver produced yet another major monograph on the artist. Silver takes the view that Bruegel's *Peasant Wedding* is not so much a negative view of peasant excess as a well-observed representation of peasant customs and costumes. Silver notes that the foreground elements of food and drink set the tone for the whole, but sees these details as adding poignancy and humor to a work which demonstrates keen observations of country customs, presented from a notably low viewpoint which immerses the viewer within the event as if a participant. While he notes the effectiveness of Bruegel in representing peasant customs and costumes as well as their simpler looks and behavior, he does not think the work was intended to show examples of negative behavior and excess by simpler or more primitive peoples.[10]

In these varied points of view, we find thus a spectrum of interpretation from moralistic satire to jocular observation, all parties noting the humor in Bruegel's work. Disagreement lies perhaps mostly in the intent of that humor. The writings of these various authors provide rich points of entry for any serious exploration of Bruegel's *Peasant Wedding*. They provide us with significant information about the social and intellectual context in which Bruegel was working, underscore how the composition with its low viewpoint draws us into the wedding festivities, and sets the tone with its left foreground elements of food and drink. We also note considerable variation in how to interpret the whole, one ambiguity among others being the presence or absence of the bridegroom and, if present, with which figure he is to be identified.

[9]Sellink, *Bruegel*, 244-45.
[10]Larry Silver, *Pieter Bruegel* (New York: Abbeville, 2011), 348-52.

In the view of this observer a fresh insight on the painting and its significance may be obtained by a closer visual analysis than has hitherto been provided, also taking full account of all that has been written on the social and intellectual context of the work. Taking full account of the various elements judiciously noted by earlier critics, in my opinion insufficient attention has been paid to the dynamics of the eye glances of the chief protagonists. Eye glance is one of the most effective visual strategies for drawing a viewer's eyes through the underlying narrative intent of a composition, and in my view Bruegel uses it here to full and notable effect.

Thus, careful observation makes patently evident that the standing bagpiper is *not* looking down at the food on the serving tray, as some have alleged, but rather looks up at the server dressed in blue. Now note also that the guest in black with a green hat and his back to us and closest to the server in a blue coat, leans back and also gazes intently, even with some wondering astonishment, at the server in the blue coat. Furthermore, the well-dressed man with fur-lined collar, whom some identify as being dressed like a notary and Sullivan has noted as dressed and looking alike to Erasmus, also stares directly into the face of the server dressed in a blue coat. Sellink and others have suggested that there is evidence

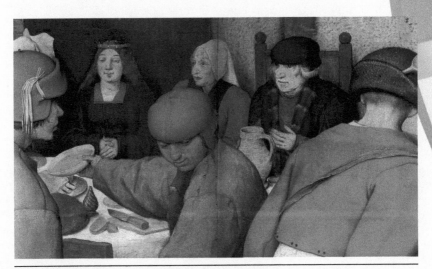

Figure 6.5. Pieter Bruegel the Elder, *Peasant Wedding*, detail

from social history to suggest that the groom served the wedding party on such an occasion, and Sellink has gone further than others in suggesting that the groom is perhaps to be identified as this same server dressed in the blue coat.

Given the evident satirical tone of virtually all of Bruegel's genre scenes and other figurative—as opposed to landscape—works,

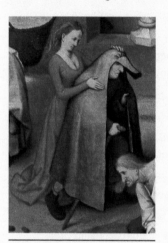

Figure 6.6. Pieter Bruegel the Elder, *Netherlandish Proverbs*, 1559, detail

such as the *Netherlandish Proverbs* and *Between Carnival and Lent*, there are grounds to suspect that these accumulative and intense eye glances serve a role that goes beyond merely identifying the groom, but rather say something about the bride and groom that goes to the core of the painting's intent.

A comprehensive survey of Bruegel's oeuvre shows that his *Peasant Wedding* is unique in presenting one of the chief protagonists dressed in this tone of blue. Many tiny figures are dressed in blue in his earlier *Children's Games* of 1560, set up in contrast to the sandy brown ground on which they play. But in the *Netherlandish Proverbs* (1559; fig. 6.6), one of the foreground pairings shows a deceitful woman dressed in red covering an older man with a blue cloak, illustrating with the sign of the blue cloak a Netherlandish proverb that the man has been cuckolded by his wife. Bearing in mind that the same artist painted both works, it is no longer so difficult to understand why the eyes of three of the prime protagonists of the painting all fix their eyes on the serving man dressed in a blue coat, while the bride has her eyes cast down in either modesty or shame.

Taking all this into account it is not at all surprising that Bruegel closes the back of his composition with two men flanking the distant doorway, one laughing, the other grimacing, like the ancient

philosophers Democritus and Heraclitus on observing the folly and deceit of all human nature. That these figures are placed far back in the composition comes as no surprise, because in Bruegel's *Peasant Dance* the familiar figure of the jester, the truth-teller, is set in the far-center background as well. This strategy of surprise

Figure 6.7. Pieter Bruegel the Elder, *Peasant Wedding*, detail

reversal had also been used slightly earlier by another Flemish artist, Pieter Aertsen. In my view Bruegel demonstrated a maturing harmony of form and content within his oeuvre, and while his later works such as the *Peasant Dance* and the *Peasant Wedding* are the most effective in this respect, I would be hard pressed to resist the conclusion that these are significant choices on the artist's part, choices made within a broadly Erasmian outlook on human behavior and one in which satire follows Horace's ancient dictum: *Ridentem dicere verum quid vetat?* ("What prevents me from speaking the truth with a smile?"). It seems that Bruegel does likewise, while like all great satirists always leaving an intriguing doubt in the observer's mind as to exactly what is going on.

BIBLIOGRAPHY

Gibson, Walter S. *Pieter Bruegel and the Art of Laughter.* Berkeley: University of California Press, 2006.

Grossmann, F. *Pieter Bruegel: Complete Edition of the Paintings.* London: Phaidon, 1955.

Kavaler, Ethan Matt. *Pieter Bruegel: Parables of Order and Enterprise.* Cambridge: Cambridge University Press, 1999.

Meadow, Mark A. *Pieter Bruegel the Elder's "Netherlandish Proverbs" and the Practice of Rhetoric.* Zwolle, NL: Waanders, 2002.

Sellink, Manfred. *Bruegel: The Complete Paintings, Drawings, and Prints.* Ghent, BE: Ludion, 2007.

Silver, Larry. *Pieter Bruegel.* New York: Abbeville, 2011.

Stechow, Wolfgang. *Pieter Bruegel the Elder.* New York: Abrams, 1969.

Sullivan, Margaret A. *Bruegel's Peasants: Art and Audience in the Northern Renaissance.* Cambridge: Cambridge University Press, 1994.

MORE THAN CAN BE SEEN: TIM ROLLINS AND K.O.S.'S *I SEE THE PROMISED LAND*

JAMES ROMAINE

IN A 1976 DISCUSSION AT WESTMINSTER THEOLOGICAL SEMINARY, H. R. Rookmaaker answered the question, "Can we use abstract art for Christian expression?" by saying, "Why not?" Then he added, "But I've never seen a good abstract painting because I ask for much *more reality* in a painting than what can be conveyed by non-figurative means."[1] Rookmaaker's rationale offers a framework for a critical examination of *I See the Promised Land (After the Rev. Dr. Martin Luther King Jr.)*, a painting from 2000 by Tim Rollins and K.O.S.[2] In this work, abstraction is a fulfillment of reality. By transforming our spiritual perception, Rollins and K.O.S.'s art encourages the viewer to look at a reality that is beyond the parameters of what can be seen.

Rollins and K.O.S., which stands for Kids of Survival, was a partnership that began in a South Bronx, New York City, classroom in 1982 and continued until Rollins's death in 2017. Initially, K.O.S. was composed of

[1]Hans Rookmaaker, "The Westminster Discussions: Faith, Art, Culture, and Lifestyle," in *The Complete Works* (Carlisle, UK: Piquant, 2021), 3:426. This combination of open-mindedness and frank opinion is characteristic of Rookmaaker's method.
[2]Tim Rollins and K.O.S., *I See the Promised Land (After the Rev. Dr. M. L. King Jr.)*, 2000, matte acrylic and book pages on canvas, 62 x 45 1/3 inches.

Figure 7.1. Tim Rollins and K.O.S., *I See the Promised Land,* 2000

African American and Latino teenage students from Intermediate School 52, where Rollins was a teacher. As an artist and educator Rollins developed an innovative pedagogy of combining reading and art making. This collaboration produced works of art that are in many European and American

museums. Rollins's motivations and methods in this project were, in part, influenced by Martin Luther King Jr. The civil rights leader emboldened Rollins with an ethos of personal, social, and spiritual change (what King called "the three dimensions of a complete life").[3] Rollins and K.O.S.'s art is firmly rooted in reality; it is not utopian. However, it confidently asserts that the world can be, and will be, remade. For Rollins and K.O.S., the work of art, in both its making and our viewing, was *already* a realization of a transformed reality.

The principal motif of *I See the Promised Land* (fig. 7.1) is an isosceles triangle that covers the entire painting. The work is painted on book pages from texts by King. (Painting on pages, either book pages or a musical score, structured in a grid on canvas was a signature element of Rollins and K.O.S.'s art.) In developing this work, which exists in several colors, each member of the collaborative imagined "the color of hope." The red that we see in the most successful rendition of the work was developed by K.O.S. member Emanuel Carvajal. Initially *I See the Promised Land*, with its imminent red triangle, may seem visually and conceptually impenetrable. This painting pushes back against expectations that art be depictive, decorative, or both. However, if we thoughtfully engage *I See the Promised Land*, if we ask it questions, this painting can be very rewarding.

SO WHAT?

The toughest question that a visually attentive and conceptually astute viewer might pose to a work of art is, "So what?"[4] To ask what purpose or proposition is at stake in a work of art requires art to be more than visually pleasing or conceptually superficial. "So what?" tests the work of art as a form of visual philosophy or theology. The work of art is critiqued as a particular vision of reality that is imbued with a conception of the past, present, and future. The "So what?" question is not cynical. It is critical, with

[3]Martin Luther King Jr., "Three Dimensions of a Complete Life," in *A Knock at Midnight: Inspiration from the Great Sermons of Reverend Martin Luther King Jr.*, ed. Clayborne Carson and Peter Holloran (New York: IPM/Warner Books, 1998).

[4]For a discussion of this "So what?" question in Rookmaaker's model, see my essay "The Legacy of Hans Rookmaaker: 'So What?," *Transpositions*, March 3, 2011, transpositions.co.uk/the-legacy -of-hans-rookmaaker-so-what/. Published as part of a symposium organized by the Institute for Theology, Imagination, and the Arts, University of St. Andrews.

the objective of finding visual delight, intellectual enrichment, and spiritual renewal in art.

As a scholar and educator Rookmaaker was attentive to the purpose and meaning of spiritual metanarratives in art. His writing reflects both an awareness of his own biblically informed identity as well as a critical examination of the metanarrative advanced by the work of art under investigation. Starting from those two points, Rookmaaker's project was to articulate the meaningful connection, or disconnection, between his own worldview and the conception of reality evidenced in the work of art. Having found this relationship, Rookmaaker would then invite the reader to join him in looking at and thinking about the work of art as a construction of reality. In this way Rookmaaker introduced the meaning and purpose of art to readers who might, initially, find art intimidating or unintelligible. This method gives Rookmaaker's writing integrity and urgency.

It is because the viewer is encouraged through the work of art to enter into and participate in the artist-constructed reality that Rookmaaker placed such importance on critically examining, from a biblically informed perspective, the metanarrative that each work of art calls into being. In Rookmaaker's estimation, the greatest fault that could be ascribed to a work of art is that this work failed to participate in a meaningful and biblically sound metanarrative. Rookmaaker, however, did not give free passes to artists simply because they shared his Christian worldview, neither was he indulgent of poorly constructed art. However, the quality of the artwork's construction found its fulfillment in its attachment to meaning.

In asking this "So what?" question of *I See the Promised Land*, this essay employs Rookmaaker's scholarship as both a foundation and foil. His critique of modern and abstract art articulates some of the issues that Rollins and K.O.S.'s art address. Rookmaaker's discussion of certain premodern artists evidences some of the means by which Rollins and K.O.S. also attempted to make an expanded spiritual reality present. Rookmaaker employed history as the measuring device for critically assessing modern art.[5]

[5] In his writings, as they are translated into English, Rookmaaker uses the term "modern art" to mean a particular movement within twentieth-century art characterized by irrationality and Gnosticism. See "Modern Art and Gnosticism," in *Complete Works* 5:292-335. This essay likewise uses the word *modern* to mean "modernist."

History establishes the criteria of what makes a work of art great; then, the art of the present can be assessed.

A second purpose to Rookmaaker's strategy was a proposition that there is continuity to history. Rookmaaker believed that this continuum of history reflected the sovereignty of God over creation. To reject this unity was to rebel against God. Rookmaaker celebrated change in art and recognized that every period of human history represented itself in its own methods and media. However, a total rejection of history was foolishness to him. In *I See the Promised Land*, Rollins and K.O.S. embraced history with a degree of seriousness that is unusual for a contemporary artist, but with the aim of impacting the future.

NARRATIVE AND METANARRATIVE

In examining *I See the Promised Land*'s visual language as a manifestation of a philosophy of reality, we should begin from the paradigm that a painting should be a depictive representation of observable reality, yet perhaps more beautiful. This concept that art should depict what the eye can see can be traced back, in part, to Leon Battista Alberti's treatise *On Painting* (1435), the first theoretical reflection on the development of pictorial space in Renaissance painting. In his treatise Alberti proposed that an image could function optically like a window. To advance their ability to visually describe narrative action in pictorial space, Renaissance artists developed a method of perspective. This system for creating the illusion of three-dimensional space on a flat surface depends on the convergence of lines at a vanishing point.

In fact, *I See the Promised Land* offers the viewer an option to read it as representational. We may see the red form as a path receding toward an unseen horizon line. An alternative reading that still regards the painting as pictorial space might see the red as an opening or parting of the text. This further evokes the Exodus narrative, already suggested by the title, and the parting of water. Perhaps this is the parting of the Red Sea, leading out of Egyptian captivity. Perhaps this is the parting of the Jordan River and crossing into the Promised Land. This Old Testament–inspired narrative connects three historical moments: the deliverance of the Hebrew nation, the civil rights movement, and the contemporary reality of the viewer.

In his essay "Do We Need to Be Modern in Order to Be Contemporary?" Rookmaaker describes a brief history of "naturalism." He notes that Renaissance artists "focused on visible reality," but that "in the following centuries, through the High Renaissance, Baroque, and Dutch seventeenth-century art, people wanted to express in art *more than what can be seen*."[6] This movement from narrative to metanarrative is evidenced, for example, in *The Martyrdom of St. Livinus* by Peter Paul Rubens (fig. 7.2).

Rookmaaker discusses this painting in the introduction to *Modern Art and the Death of a Culture*. He selected this work, in part, because it depicts a subject in which there is a clash of realities.[7] According to tradition, Saint Livinus was an Irish missionary who preached Christianity in the Netherlands. He was arrested by local pagans and commanded to denounce Christianity. Livinus refused, and, as we see in the painting, his tongue was cut out. However, Rubens's work is more than a testimony of perseverance. This painting depicts one narrative, that of the saint's physical suffering, within a larger metanarrative of divine action.

Rubens translated this confrontation of two religions into two modes of seeing. In the top third of *The Martyrdom of St. Livinus*, heaven opens up with a glorious vision of divine light and angelic figures. The saint sees the reality that awaits him. The horses and some of the soldiers see this glory and are terrified. But it seems that the three men torturing Livinus and the dog being fed the saint's tongue do *not* see this reality. At least, they do not react to it. The impact of Rubens's work surges from his ability to distinguish between visible reality and reality beyond sight without dividing them. Rubens's painting allows us to share the saint's vision of a fulfilled reality.

What Rubens's work contributes to our understanding of *I See the Promised Land* is the proposition that the work of art can show more than what the eye sees. Instead of reading the image as a form receding into pictorial space, it is possible to read it as a vertically ascending form. One detail of Rollins and K.O.S.'s work that may not be clearly discernible in

[6]Hans Rookmaaker, "Do We Need to Be Modern in Order to Be Contemporary?," in *Complete Works* 5:311-35; see 314-15; emphasis added.
[7]Hans Rookmaaker, *Modern Art and the Death of a Culture*, in *Complete Works* 5:9.

Figure 7.2. Peter Paul Rubens, *The Martyrdom of St. Livinus*, 1633–1635

reproduction is the fact that the apex of the triangle is beyond the top edge of the canvas. The rising lines do not yet meet. However, our instinctive sense of perception sees the triangle as complete. If the canvas represents the parameters of our visible reality, *I See the Promised Land* leads the viewer to see more. An invisible reality is made visible.[8]

One limitation to Rubens's model is that his subject is historically removed. Not only is it remote from us, it was also *already* historically distant from Rubens and his contemporaries. Whatever Rubens's painting demonstrates about reality in art, it requires the viewer to either imagine themselves in a different time and place or to translate Livinus's reality into their own time and place.[9] The art of Jan van Goyen, such as his painting titled *Approaching Storm* (see fig. 5.2), portrays a reality that was immediate to his contemporary viewers.

Nevertheless, as Rookmaaker interprets this painting, van Goyen also moves the viewer from narrative to metanarrative. As we read across van Goyen's painting from left to right, the composition moves us from the small boat to the sailboat to the clouds. We find ourselves transported from the temporal activity of fishing to the absolute reality of God's providence. Rookmaaker called this work "a hymn to the unity of creation."[10] However, van Goyen achieved this shift without depending on the spectacular vision we see in Rubens. Van Goyen firmly rooted this metanarrative in everyday life.

In comparing works by Rubens and van Goyen, we do not make the former into a mystic, removed from reality, or the latter into a mere illustrator of an observed scene. Both artists were calculated in developing a visual language that advanced their own theological paradigm. More than a study of what can or could be seen in a specific location at a specific time, van Goyen's painting depicts a structure perceived in the subject (the landscape). Therefore, the reality that we find visually articulated in van Goyen's art is as much or perhaps even more present in the visual language

[8]Modern artist Paul Klee famously wrote, "Art does not reproduce the visible; rather, it makes visible the invisible." "Creative Credo," 1920, reprinted in Herschel B. Chip, *Theories of Modern Art* (Berkeley: University of California Press, 1968), 182.

[9]In fact, St. Livinus, who lived approximately a thousand years before Rubens, is depicted as a baroque bishop.

[10]Hans Rookmaaker, *Art and Entertainment*, in *Complete Works* 3:40.

used, that is, the way in which the composition describes a perceived structure of reality, than in its subject matter.

This reading of Jan van Goyen's *Approaching Storm*, first as a painting and then as a depiction of a river scene, is consistent with Rookmaaker's discussion of this work. Van Goyen's method, as Rookmaaker notes, establishes contrasting areas/forms of light and darkness. For example, a light form against a dark background opens up space within the painting. This is not the illusion of pictorial space but the creation of "real" space, as abstract painter Hans Hofmann used the term in his essay "The Search for the Real in the Visual Arts."[11] In *I See the Promised Land*, Rollins and K.O.S. used red as *real* space. To see this, we need to be conscious of the real properties of color. The three primary colors, red, yellow, and blue have absolute characteristics. Blue visually moves away from the viewer; red visually moves toward the viewer; yellow stays put. This why a room painted blue seems larger than when it is painted red. Rollins and K.O.S. employed red's inherent character to visualize the potential of the work of art to move the viewer. This work is not only an illusion of movement, either receding or ascending. *I See the Promised Land* visually advances toward the viewer.

Rollins and K.O.S.'s use of red as movement, representational or real, is a method that brings us back to Rookmaaker's critique of modern art and abstraction. Modern art, according to Rookmaaker, either denies metanarrative or proposes a false metanarrative that places the artist, not God, at the center of history and reality. Rookmaaker described this problem saying, "In the nineteenth century artists often assumed an attitude of prophets, as if they were presenting a revelation of the deepest truths in the cosmos."[12] He added, "It is impossible to say how much damage this idea of the artist has inflicted on artists themselves, and how much the proper function art has lost as a result of such inordinate elevation. It is one of the causes of the abnormal position of modern art, of the chasm that exists between art, borne as it is by an esoteric clan, and the lives of 'ordinary' people."[13]

[11] Hans Hofmann, "The Search for the Real in the Visual Arts," in *Search for the Real and Other Essays* (Cambridge, MA: MIT Press, 1967).

[12] Rookmaaker, *Art and Entertainment*, 51.

[13] Rookmaaker, *Art and Entertainment*, 52.

PIET MONDRIAN

As much as any single abstract artist, Rookmaaker addressed Piet Mondrian's painting. Rookmaaker praised Mondrian, saying, "His harmony is real and not the trick of the charlatan, every line and every color says exactly what it claims and is always in its proper place."[14] However, Rookmaaker's criticism of Mondrian was not of his form but of his content or seeming lack of content. On abstract art, Rookmaaker wrote, "It is first of all a negation, a negation of the value of reality around us. Next, it is an effort by human beings to create something in full freedom, to build something detached from reality."[15] Whether or not Mondrian's process of resolving painting to its most fundamental structural elements (primary colors and straight lines) was, in fact, intended to be "a negation of the value of reality around us" depends on how we interpret his own statements. Mondrian's writings are prolific, thoughtful, and not always easy to read. However, he was more than a theoretician. Mondrian was, first of all, a painter working in the material of paint. The paintings themselves offer in my own experience a very rich sense of reality.

Rookmaaker was able to see, and to help his reader see, the presence of sacred content in a painting such as *Approaching Storm*, which did not employ a distinctly religious subject. However, he was less willing to recognize content, sacred or otherwise, in a painting that had no pictorial subject. The very evolution of Mondrian's art from his paintings of nature to abstraction was an attempt to prove that visual forms, without reference to other subjects (i.e., an area color that is an illusion of the sky), could convey content more absolutely. In Rookmaaker's estimation Mondrian failed. However, I don't think that we can call this pursuit of perfection a rejection of reality.

Rookmaaker's second critique of abstraction was that its genesis was found in the artist's inner *creative* reality rather than in the observable external *created* reality. It is an effort by human beings to create something in full freedom, to build something detached from reality. By "full freedom" he did not mean the liberty that Christians find in Christ, the freedom to be

[14]Rookmaaker, *Art and Entertainment*, 79.
[15]Rookmaaker, *Art and Entertainment*, 70.

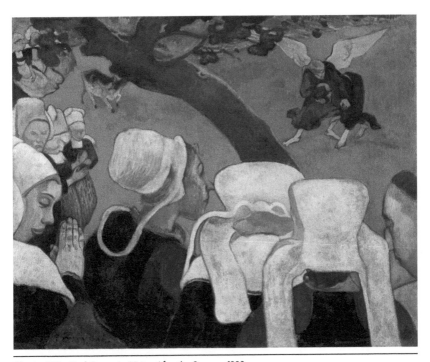

Figure 7.3. Paul Gauguin, *Vision After the Sermon*, 1888

fully human. He meant a false freedom from God or even to be like God. If modern art is an expression of freedom and the proposition that the artist could be like God, this largely has its foundation in the art of Paul Gauguin. In works such as *Vision After the Sermon* (fig. 7.3), Gauguin employed fantasy, painting grass red, as a means of escaping from reality. Gauguin's red grass represents a paradigm shift in Western painting's relationship to reality. Instead of depicting the external world of nature, Gauguin symbolized his interior world. Red, the opposite of green on the color wheel, manifests Gauguin's rejection of reality. Rookmaaker ascribed the same objective to Mondrian.

The degree to which Rookmaaker's conception of modern art was informed by his intensive study of Gauguin is a question that needs more examination.[16] Gauguin was one of the most narcissistic persons ever to

[16]Rookmaaker completed his dissertation, on Gauguin, at the University of Amsterdam in 1959. This was published in 1959 as *Synthetist Art Theories* and in 1972 as *Gauguin and Nineteenth Century Art Theory*, in *Complete Works*, vol. 1.

pick up a paintbrush. Rookmaaker's description of the modern artist as self-anointed prophet and priest is accurate of Gauguin's quest for messianic self-fulfillment in the dual pursuits of artistic egocentrism and Tahitian girls. We can only contemplate how Rookmaaker's attitude might have been somewhat differently formed if his principal conceptual starting point for modern art had been Paul Cézanne's pursuit of the "spectacle which the Omnipotent, Eternal Father God unfolds before our eyes" found in the structure of local nature or Vincent van Gogh's use of color to depict

Figure 7.4. Piet Mondrian, *Composition No. II (Composition with Blue and Red)*, 1929

"something of the eternal, of which the halo used to be the symbol" around the heads of humble laborers.[17] Recognizing Cézanne's use of form as structure and van Gogh's use of color as substance is important to our examination of *I See the Promised Land*. Rookmaaker's assessment that abstract art is without content presupposes that form and color are not themselves real content. While, as in *Vision After the Sermon*, form and color can be employed as "a negation of the value of reality," we should be careful in ascribing this to other artists.[18]

[17]Letter from Paul Cézanne to Émile Bernard, April 15, 1904: "You must see in nature the cylinder, the sphere, the cone, all put into perspective, so that every side of the object, of a plane, recedes to a central point. The parallel lines at the horizon give the extension, that is a section of nature, or, if you prefer, of the spectacle which the Omnipotent, Eternal Father God spreads before our eyes." Letter from Vincent van Gogh to Theo van Gogh, September 3, 1888: "I'd like to paint men or women with that something of the eternal, of which the halo used to be the symbol, and which we try to achieve through the radiance itself, through the vibrancy of our colors." "Letter 673," Vincent van Gogh: The Letters, https://vangoghletters.org/vg/letters/let673/letter.html. Rookmaaker was, of course, knowledgeable about Cézanne and van Gogh's art. However, his scholarship was more often concerned with what they contributed to Gauguin's aesthetic than with their differences.
[18]Rookmaaker, *Art and Entertainment*, 70.

We can address this question of reality in abstract painting by looking at a specific work by Mondrian. In *Composition No. II (Composition with Blue and Red)* of 1929 (fig. 7.4), his balance of primary colors demonstrates that Mondrian understood color itself as reality. In this painting, the power of the red draws us toward the upper left while the depth of the blue pulls us back to the right. The weight of the red is supported by strength of the blue. Mondrian's use of form and color has more of an affinity with Cézanne and van Gogh than with Gauguin. Mondrian built on the potential in van Gogh and Cézanne's work to develop a visual language of spiritual growth. His composition rests in a moment of equilibrium. In many paintings we find a resolution that is comparable to a roller coaster that has completed its journey and come to a stop. Mondrian's composition is more comparable to that roller coaster at the apex of its climb, at that moment of rest before the thrilling fall. His composition anticipates further movement of form. Mondrian's work strives for a perfect balance of form, line, and color. However, he pursues the absolute with actual means. Color, in Mondrian's art, is elemental material. Similarly, in *I See the Promised Land*, red is not only pictorial space; it is spiritual substance.

Rookmaaker criticized modern art's "avoidance of our everyday world."[19] He preferred van Goyen's depiction of vernacular landscapes. However, this "local" quality is also a limitation. A full appreciation of van Goyen's painting requires some knowledge of the Netherlands, its rivers and canals, and perhaps even some details of life in the seventeenth century. For some viewers, even in the twenty-first century, this presumption is not an obstacle. But we can't assume that everyone is equally familiar with van Goyen's subject. For some viewers (perhaps an African American or Latino teenager from the South Bronx) van Goyen's rustic river scene is as removed from their own experience of reality as Rubens's depiction of Saint Livinus. For these viewers, van Goyen's *Approaching Storm* functions as an escape from their own reality. If their response to van Goyen's painting is anything more than nostalgic (and nostalgic for an imagined world that they never lived in), this is because of the painting's aesthetic qualities. In fact the visual freshness of van Goyen's painting and the capacity of this work of art to

[19]Hans Rookmaaker, "Modern Art," in *Complete Works* 5:319.

make its subject feel immediate to the viewer is a testament to the artist's ability to create a compelling union of subject and composition.

With the recognition that subject matter can be as much of a barrier for some viewers as it is a bridge for others, Mondrian set out to make paintings that depicted the very structure of reality in visual terms that are equally local in every place and time. In other words, viewers will have different degrees of familiarity with the rivers and canals of the Netherlands and life in the seventeenth century. However, Mondrian presumed that everyone is equally familiar with the color red. While Mondrian's presumption is not perfect, the associations each viewer has with the color red will vary, red is still materially the same. We already noted Rookmaaker's attentiveness to the compositional, that is, abstract reality inherent in van Goyen's landscape. Mondrian's abstract visual language aimed to present reality more directly.

Mondrian articulated his artistic project, which he called *De Stijl* (meaning "the style"), in Neoplatonic and prophetic descriptions of a more perfect world, an attitude that Rookmaaker found troubling. Rookmaaker stated, "The idea that the artist is a prophet, a sort of antenna that can pick up the slightest movements of the spirit of the times well ahead of others, to present us with a new outlook on reality is a lie, to put it bluntly. An artist is an ordinary person, just like anybody else, who can go astray despite personal insights and ideals."[20] Rookmaaker was right to call on the viewer to "test every spirit" (1 Jn 4:1). Both artists and their critics are fallible. Rookmaaker educated his readers with tools of visual literacy, theoretically savvy art-historical knowledge, and biblical truth to examine every artist and work of art. This is the "So what?" question. At the same time, as Rookmaaker did not fail to recognize, there have also been artists who, by either divine revelation or human intelligence, have clearly seen the contemporary state of the human condition and spoken, through their art, prophetically into that reality.

In *Modern Art and the Death of a Culture*, published in 1970, Rookmaaker observed that we live in a world that is greatly impacted by Mondrian's vision. From art to architecture to design to fashion, Mondrian's effect is so pervasive that it has become indiscernible. Rookmaaker concluded his

[20]Rookmaaker, *Art and Entertainment*, 53.

discussion of Mondrian saying, "Whether he achieved . . . the 'plastic' realization of the absolute, is an open question."[21] History has answered this question. Whereas with each passing year van Goyen's world becomes increasingly remote from our own, Mondrian's work has, in the ninety-one years since he completed *Composition No. II* and the fifty years since Rookmaaker's scholarly critique, become increasingly current.

A NEW PARADIGM

The twentieth century was a seismic shift from an analog/mechanical world to a digital/cyber world. Now in the twenty-first century, technology connects us across time zones, so that people living on opposite sides of the world seem to be living simultaneously. People and information are able to move at speeds that accelerate the rate of change so that it seems like the future is already here in the present. The visual arts, as they have across all of history, have developed visual means of articulating the experience of the human reality in their own time. This digital world, in which distances of time and space seem not to exist, has found expression in nonpictorial art. In the age of the internet browser, Alberti's conception of painting as a pictorial window, with its implied single, fixed point of view, no longer works as a paradigm for creating art that visualizes contemporary experience.

Over the past three-quarters of a century, one of the principal projects of contemporary painting has been to develop a range of nonpictorial methods. This history of moving beyond pictorial painting has many parallels with the history of how pictorial space was developed in the Renaissance. Both developments were motivated by a matrix of historical, philosophical, and artistic factors. (Too many, in both cases, to fully account for here.) However, again in both cases, the process was deliberate, with the purpose of developing a method of painting appropriate to its own historical time. Those familiar with the history of Italian Renaissance art will recognize the names of artists such as Giotto and Masaccio. It is widely accepted that the pictorial space evidenced in Masaccio's frescos in the Brancacci Chapel provided inspiration for several generations of fifteenth-century Florentine painters. In the twentieth century the most significant break with pictorial space as

[21]Rookmaaker, *Modern Art and the Death of a Culture*, 75.

paradigm of painting was made in the work of Jackson Pollock, especially a group of so-called drip paintings he created around 1950. Since Pollock, all art-historically important painters have pursued nonpictorial methods.[22]

However, when we look back across the art of the first half of the twentieth century, it seems that only a few artists were anticipating this break with the pictorial paradigm of painting, which had prevailed over the visual arts in Europe and subsequently the United States since the Renaissance. Even Pablo Picasso's cubism or Wassily Kandinsky's abstraction were oriented toward reworking pictorialism rather than moving beyond it. However, Mondrian produced paintings that, in their total rejection of any illusion of form or space, anticipated Pollock's nonpictorial painting. If Pollock was our Masaccio, Mondrian was our nonpictorial Giotto. While still employing an analog visual language, *Composition No. II* and *Broadway Boogie-Woogie* seem at home in a digital world where reality constantly expands.

I See the Promised Land similarly recognizes the inevitability of change. However, Rollins and K.O.S. encourage the viewer to be an active agent of this renewal. This is history painting in the future tense. It visualizes a reality that has not yet taken place. The painting suggests that social and spiritual renewal requires a transformation of vision.

In *I See the Promised Land*, Rollins and K.O.S. referred to two of King's most famous sermons, "The Three Dimensions of a Complete Life" and "I See the Promised Land." The theme of a transformed vision of reality is central to both of these sermons. "I See the Promised Land" evokes Deuteronomy 34:1, in which Moses is taken up to Mount Nebo to see across the Jordan River. King's "The Three Dimensions of a Complete Life," whose title partly inspired Rollins and K.O.S.'s development of the triangular form as a means of visualizing King's vision, is based on a text in Revelation 21:1-2: "Then I saw 'a new heaven and a new earth,' for the first heaven and the first earth had passed away, and there was no longer any sea. I saw the Holy City, the new Jerusalem, coming down out of heaven from God, prepared as a bride beautifully dressed for her husband."

[22]It needs to be clarified that nonpictorial does not necessarily mean a rejection of representation or figuration. Painters such as Vija Celmins, Chuck Close, Marlene Dumas, Richard Estes, Eric Fischl, Lucian Freud, Jasper Johns, Anselm Kiefer, Roy Lichtenstein, Kerry James Marshall, Sigmar Polke, Gerhard Richter, Andy Warhol, and many more demonstrate the diversity of representational possibilities within nonpictorial painting.

Previously, we have looked at the red form in *I See the Promised Land* as an upward-pointing triangle. But it is also possible to see this form as descending, from beyond the painting, and expanding reality. In this reading, the work may evoke the outpouring of fire from heaven. It may also evoke the descent of the Holy Spirit as flame of fire. If reading this red form from bottom to top moves us into the future, then reading the form from top to bottom may suggest that this future is already realized in the present. Rookmaaker asked the right question in requiring the work of art, including abstract painting, to convey reality. *I See the Promised Land* answers that challenge by showing us more reality than can be seen.

BIBLIOGRAPHY

Anderson, Jonathan A., and William A. Dyrness. *Modern Art and the Life of a Culture.* Downers Grove, IL: InterVarsity Press, 2016.

Belkin, Kristin Lohse. *Rubens.* New York: Phaidon, 1998.

Berry, Ian, ed. *Tim Rollins and K.O.S.: A History.* Cambridge, MA: MIT Press, 2009.

Danchev, Alex. *The Letters of Paul Cézanne.* Los Angeles: J. Paul Getty Museum, 2013.

Gogh, Vincent van. *The Letters.* http://vangoghletters.org/vg/.

Hofmann, Hans. *Search for the Real and Other Essays.* Cambridge, MA: MIT Press, 1967.

Romaine, James. "The Legacy of Hans Rookmaaker: 'So What?'" The Institute for Theology, Imagination, and the Arts, University of St. Andrews. 2011. www.trans positions.co.uk/the-legacy-of-hans-rookmaaker-so-what/.

Romaine, James. *Art as Spiritual Perception: Essays in Honor of E. John Walford.* Wheaton, IL: Crossway, 2012.

———. *ReVisioning: Critical Methods of Seeing Christianity in the History of Art.* Eugene, OR: Cascade, 2014.

Rookmaaker, H. R. *Art and Entertainment.* In *The Complete Works of Hans R. Rookmaaker,* 3:3-131. Carlisle, UK: Piquant, 2001.

———. "Do We Need to Be Modern in Order to Be Contemporary?" In *The Complete Works of Hans R. Rookmaaker,* 5:311-35. Carlisle, UK: Piquant, 2001.

———. *Gauguin and Nineteenth Century Art Theory.* In *The Complete Works of Hans R. Rookmaaker,* 1:3-227. Carlisle, UK: Piquant, 2001.

———. "Modern Art and Gnosticism." *The Complete Works of Hans R. Rookmaaker,* 5:292-335. Carlisle, UK: Piquant, 2001.

———. *Modern Art and the Death of a Culture.* Wheaton, IL: Crossway, 1994.

———. "The Westminster Discussions: Faith, Art, Culture, and Lifestyle." In *The Complete Works of Hans R. Rookmaaker,* 3:407-59. Carlisle, UK: Piquant, 2001.

Part Three

AESTHETICS

THE HALO OF HUMAN IMAGINATIVITY

CALVIN SEERVELD

IN THE BEGINNING, ONE DAY SOON after God had created man and woman, the LORD took them for a walk, a little earlier than usual, while the sun was still bright.[1]

After an hour or so, when they stopped to set tea near a brook, they made a little fire first from fallen olive branches and twigs. While aroma of jasmine wafted pleasantly into their nostrils, the LORD did a curious thing. God stooped to rub two wetted fingers of the left hand in the wood ashes and smeared the ash over the poised thumb and circled forefinger of the right hand.

As Eve and Adam watched, the LORD God blew gently across the film of soapy water on the fingers, and a lovely, round, shimmering, colorful creature floated into the sunlit air.

The LORD performed the miracle a second time, while the man and the woman sipped their herbal tea in wonderment.

"Give it a name," said God.

So Adam and Eve called this creature "bubbles" and taught it to their grandchildren.

The story I just told is true to Scripture in disclosing the creatural feature of human nature we may call *imaginativity*.

[1]Calvin Seerveld, "The Halo of Human Imaginativity," in *Normative Aesthetics: Sundry Writings and Occasional Lectures* (Sioux Center, IA: Dordt Press, 2014), 1-44.

BIBLICAL ORIENTATION: HUMANS ARE CREATED
TO BE IMAGINATIVE BEFORE GOD'S FACE

The Bible reveals that the majestic, sovereign, merciful, and gracious LORD of Exodus 34:6-7 and Isaiah 40 delighted in tumultuous rainstorms, which brought forth tufts of grass in desert lands (Job 38:25-27); the LORD followed with fascination how young lions hid themselves to stalk prey for food (Job 38:39-41); the LORD enjoyed God's creation of fantastic animals like the horned female mountain goat gently crouching to deliver her young (Job 39:1-4), and watched snorting, fearless Arabian horses pawing the ground (Job 39:19-25), even before humans existed, says Job 38:4–39:30.

The LORD made trees, which normally outlive humans, to give birth in the spring while naked to leaves, green leaves which gradually turn into a breathing coat of many colors before they die to sail through the air to the earth. Only God could be so imaginative as to make a tree. And it's not just exotic animals that boggle one's imagination, like Australian platypuses or the huge, incongruous, lumbering, amphibious turtles that fascinated Darwin in the Galápagos Islands, or Atlantic Ocean seaboard lobsters, which swim gracefully backward, tail first, or the churlish peacocks God created for Flannery O'Conner to cherish, to the consternation of her mother:[2] God created ordinary chickens to eat kernels of yellow corn to form brown eggs beside red wheelbarrows near glazed rainwater on which so much depends. The LORD God of the universe, who rules the nations of the world, stooped to fashion cows who turn green grass into white milk, which when drunk builds human bones—amazing! No wonder the punch line to the book of Jonah lists as a reason the LORD wanted to save the wicked, pagan city of Nineveh was the presence of its cows (Jon 4:11).

Because Adam and Eve and their progeny were enabled to say no to God, as well as "thank you," God's enduring, outstanding invitation to women and men to tend and joy in the garden of creation, as you know, has produced feats at odds with one another. Miriam choreographed a jubilant dance of thanksgiving to the LORD on the banks of the Red Sea, which pleased God (Ex 15:19-21), but God's people took their Egyptian gold to

[2]Flannery O'Connor, *Mystery and Manners* (New York: Farrar, Straus & Giroux, 1969).

fashion a molten calf on a pedestal to be their ostensible leader, with fatal consequences (Ex 32). And the Bible record details results of good and bad imagination for millennia of history.

The point of our listening to Scripture on creation for direction at the outset is to become conscience-clear and certain that sinful imagination is not definitive for the gift of God that human imaginativity is, any more than proud autonomous reasoning illustrates the norm for obedient thinking that engenders wisdom. I do not want to argue from the Bible that because God prescribed for the high priest's ephod blue threaded pomegranates (Ex 28:33)—which do not exist on trees—therefore nonrepresentational painting is kosher; nor would I pit the final, X-rated Judges 17–21 against Philippians 4:8 in a debate about what artists may treat.[3] Dogmatic tenets of Scripture have their place in our confessional life, but the way to have Holy Scripture lead us to and in our human tasks on earth in history is not to stare at it cross-eyed, but have the Scriptures in full voice speak to our hearts, ring in our ears, fill our consciousness until the Holy Spirit convicts us as a body that how God made us creatures in the beginning is good, very good. And God made us to be imaginative.

The Bible itself spills over imaginatively. Whether it be the exciting, true, apocalyptic story of Numbers 22–24, a fable by embattled statesman Jotham (Judg 9:1-21); the terse, stichomythic drama of wisdom versus foolishness in the paragraphs of Proverbs 10–22; the history of Naaman the Syrian teaching the prophet Elisha a word from God (2 Kings 5); the poignant parables of rabbi Jesus (for example, Mt 13); or the visions of Ezekiel and Zechariah and John on Patmos: such imaginatively brimful writing may be hard on rationalists who want their knowledge in propositional form. It can be mistaken by Romantics as licensed gnosis, but the Bible as God-speaking literature is bread for the world, and for God's folk who receive its imaginative revelation as bona-fide knowledge of God's great deeds and guidance to save us from our sinful selves.

[3]I know that such *argumenta ad hominem evangelicum* (cf. Hans Rookmaaker, *Modern Art and the Death of a Culture* [London: Inter-Varsity Press, 1970], 236-43; Francis A. Schaeffer, *Art and the Bible* [Downers Grove, IL: InterVarsity Press, 1973], 12-14) have freed people to take the artistic talents of their children seriously, and for that I am thankful to God. It is not the best way, however, I believe, to have Scripture train us in discerning God's will to be discovered in creational revelation.

To teach the Bible as literature has always struck me like teaching economics for its mathematics, because you miss what's crucial—the compelling call of the LORD to repentance and adoption into the family of God. But the Bible is God speaking literarily, imaginatively. As I read it, the Bible does not support a *via negativa* approach toward God, although it is so that the LORD's way of doing things transcends our creaturely ways (Is 55:8-9): when the Bible likens the LORD God to a mother (Ps 131; Is 49:14-18), to a judge (Gen 18:16-33; Ps 75:6-8), to a rock (Ps 95:1-2; 1 Cor 10:1-5), to a husband (Hos 2), to a landlord-banker (Mt 25:1-13), to a moth (!) eating away our most coveted possession (Ps 39:12), to a man roused from drunken sleep when God's people are in desperate straits (Ps 78:56-66). Such imaginative comparisons are not just fanciful glosses but tell me truthfully what my God, the holy One, is like. Scripture tells me concretely of the God of Abraham, Isaac, and Jacob, as Pascal said, the covenanting LORD of the riffraff like Samson and Jephthah, not to forget Rahab, who by faith made it into Hebrews 11. The Scriptures give me deeply insightful, poignant knowledge when I am told as a lost sheep that the God of the universe is the Good Shepherd looking for me (Jn 10:1-18; Ps 23).

I'm just saying this: the fact that the very way God's authoritative Word for human life is booked, with the LORD's evident approval (2 Tim 3:16-17!), reinforces this initial basic truth that we human creatures all live, move, and have our meaning under the almighty LORD's injunction to be imaginative, to bewonder dappled things, finches' wings, whatever is fickle, freckled, sweet, sour, adazzle, and dim, and to heighten our awareness of that chorus of praise in creation by our unselfconsciously echoing, "golden echoing," the thesaurus of inventive initiative with which the LORD has entrusted us humans.

IMAGINATIVITY IS MAKING-BELIEVE AND DOING AS-IF, A BLESSING THAT PROVIDES NUANCED KNOWLEDGE

The crux of imagining as an irreducible kind of human activity is found in making-believe, as we say, in doing as-if. I am not yet talking about artistic activity. Imagining is more elementary than making art, is a more primary functioning, as when children make mud pies, play house, or walk on stilts as if they were fragile, praying mantis giants. Having fun and fooling around

are normally constitutive factors of imagining. A person busy imaginatively is liable to notice or concoct strange resemblances that remain allusive but fascinate, poised with metaphoric insight: if you were as melancholic lonely as Shakespeare's Jacques in *As You Like It* in a foreign country and happened upon an amorous couple, you might see that a kiss is simply a pleasant sucking way to transmit germs.

Fantasy is rudimentary imagining, whether it be the whiling pastime of discovering profiles in cloud formations as you lie on your back on a riverbank in the summer sun, or make up the conversation between an elderly dragon and a friendly witch whose broomstick is broken. The wit to tell jokes is an enriched form of human imaginativity in action, whether it be dirty jokes or the kind of laughter-inducing tales the medieval jester told who, because he had only empty pockets, decided to give his jokes to God as a sweet-smelling offering. When you entertain your neighbor or plan an adventure, one's imaginativity comes to the fore, and hints of surprise will dartle like grace notes around the meal and conversation, or remain hidden in the plan until unexpectedly, like something whimsical—there it is!—startling you gently into a pleased or puzzled smile. Games are congealed springs of imagining, occasions for persons to make-believe somebody is "it," or to act as if you have a powerful queen to protect your one-step-at-a-time, hobbled king in chess . . .

I could go on in describing this zone of full-bodied human activity topped up as imagining, but I have said enough perhaps to make the point convincing that there is a specific ontic structuring to human nature that sets us up, among all the other ways we are, to make-believe and act as-if, thanks to God's creative Word, "Let there be imaginativity to my human creatures!" How we men and women respond to this embedded gift of God, whether we gladly give it away in Christ's name, wrap it up and bury it like a bone in a hole in the ground, or thumb our imaginative nose in God's face, needs discussion too. But right now, on the import of the biblical truth of creation, we need to realize that every human creature—Asian, European, South American, atheist, pietist Christian, intellectual deconstructivist, New Age spiritualist: no man or woman can jump out of his or her imaginative nature.

Although I cannot develop a full-blown, biblically framed anthropology here, it is important for my argument still coming that I call your attention

to the fact that this quality of imaginativity characteristic of humans resides in all the other ways the LORD created us to be too. Imagining is of a different order than feeling or thinking, digesting food, or showing loyalty; to be busy imagining is different than speaking or being friendly. But all the varied ways we bodily exist in God's world are interrelated. So, if you are imaginativity-anemic or -hyper as a person, it influences the way you think, make promises, show emotional empathy and physio-organic spontaneity or not. I do not propose surgeons make imaginative guesses at which organ to excise when they pick up the scalpel, nor that theologians rest with fanciful hunches on exegesis of texts. And I do not hold that there is a lockstep consequence between the proportion of imagination one has and its effect on one's speech or friendships, comparable to the amount of blood or yellow bile in one's system, to use the old-fashioned humor psychology. But one's speaking and lovemaking and ability to implement plans are deeply colored by the caliber and exercise or atrophied lack of muscle tone to a person's imaginating. Would to God that a supple, sanctified imagining had more priority in mothers and fathers' parenting of children, in judges' sentencing of criminal offenders, in the diplomacy of heads of state bound to bring justice to citizens.

I am just mentioning this interweaving of imaginativity in our other acts not typically defined by imagining to keep our focused reflection in context.[4] The implication of my remarks is that artists do not have a corner or monopoly on imagination just because imaginativity is of special concern and prominence in artistry. Every walk of human life has a styleful moment and betrays richness or poverty of nuances—evidence that imaginativity is subterraneanly at work, or at a loss, within one's habit of greeting other persons, carrying on business transactions, or wrestling with the Lord in prayer.

And the good news about imagining is that it is not a stupendous, extraordinary jewel in the crown of humanity, but is a much more modest gift—infrastructural, you might say—to human nature; integral, not exclusive or optional. Imaginativity is in the neighborhood of whistling, winks, and blowing bubbles. What would life be without whistling when you are happy or afraid? If a speaker has no winks in his or her words but only stares

[4]Cf. Wallace Stevens, "Imagination as Value," in *The Necessary Angel: Essays on Reality and the Imagination* (London: Faber & Faber, 1951), 146-47.

and blinks statements at you, is that a way to love your audience? Blowing bubbles takes time, the kind of ample, unhurried, fascinating, leisural time a well-organized workaholic probably would find frivolous; yet when strangers held the hands of Jewish children, as Elie Wiesel reports, and told them stories as they made the last walk to the gas chambers of Auschwitz— blowing bubbles with them, as it were, lifting them out of their predicament— you can catch a sense of the blessing packed into God's little gift to us humans of imagining.

I know imagination can be devious and cruel, like clothes, or overwhelmingly powerful and breath-taking on occasion, but in the beginning we do well to fashion a humbled conception of imaginativity, to give imagination its creatural place in creation, with its own limited splendor, responsibility, and authority. Imagination is a good, God-given way humans explore and gain knowledge of nuances in the world, and embody and share such satisfying knowledge. I don't mean decorative filler for perceived facts and argued analysis. Imaginative knowledge gets into the crevices of things, ferrets out hidden riches, discovers the wrinkles in a face, the potholes in an intrigue, conjures up fabulous monsters or unicorns, dwells on the lambent sheen or the penumbra of shadows to the tangled skein of somebody's life. That's why there is this sparkle around making-believe, doing as-if, being merry with metaphor: realities often unnoticed, but important realities like the shadow-side of respectability or the courage in bashfulness, silent tears and quiet acts of love, which inhere being alive in God's world, are picked up, framed, as it were, surprising us and making all those who have eyes to see and ears to hear such bona fide, incisive knowledge of concrete reality wiser.

God's exuberant joy in playing around with humankind in the beginning of creation (cf. Prov 8:30-31) is the biblical grounding for my saying that it is wrong for anyone to neglect so choice a gift, or to dull, damage, or pervert your neighbor's imagination. I have seen an adult in anger at a young person's harmless, mischievous prank full of originality, dress down the child as the colloquial idiom goes, and clip the little one's imaginative wings even before it could fly. Such stunting of imaginativity is a serious evil since, because the misdeed is often not recognized as evil, it is therefore seldom repented of.

It is so that one person is more imaginative than another. Some of us may be born color-blind, turn tone-deaf, remain gawky, be humorless—imaginatively handicapped. But such creatural blemishes only give me the opening to introduce the ministry, as I understand it, of professional imaginators—artists, including poets and songwriters.

A PLATONIST PHILOSOPHICAL TRADITION DISTRUSTS IMAGINATION

I can pinpoint how the Platonist curse against images has embedded itself in the English language on imagination by referring to Romans 1:21 in the King James translation of the Bible. The crux of Paul's argument there is that those who are suppressing the truth of God's revelation in creation under-neath their injustice are inexcusable in terms of submitting to God because, in their firsthand creational experience of God's grace, they did not honor God as God, and were not thankful to God, "but became vain in their imagi-nations, and their foolish heart was darkened" (Rom 1:18-21). The Scripture rendered "imaginations" in King James's English is *dialogismois*, vain in their "deliberate reasonings" (see also 2 Cor 10:5). And the influential King James translation (1611) is consistent in other relevant passages, calling any "formations [*Gestalten*] of a person's inward, intentional designs" that are evil (cf. Gen 6:5; Lam 3:60) "imaginations." The primary meaning in English of *imagination* is (quoting the *Oxford English Dictionary*), "what does not cor-respond to the reality of things, hence vain, false," with a secondary meaning documented already in Coverdale's 1535 Bible translation, "scheming, plot, fanciful project."

The Platonic position condemned images as perceptual errors, illusions, and artists who wasted time making mirages, imaginary things, unless such phantasms taught morality, were poor citizens of the polis. Plato's error, in my judgment, was to identify a solid feature of God's good creation, namely, the sensible and handicrafted, as the locus of evil one should shun. Thinkers of the church have often been tempted to adopt this otherworldly stance, modified to be sure, to mitigate the localization of evil.[5] Somehow, in the

[5]Thomas Aquinas taught that *sensualitatis inclinatio* is a troubling *fomes*—kindling, a tinderbox for sin (*Summa Theologica* I-II, q. 91, art. 2, *resp.*)—but sin comes only from a deliberate act of free will not subject to reason; *natura humana per peccatum non est totaliter corrupta* (*Summa*

Platonizing process, the commandment not to worship homemade gods, idols (Ex 20:1-7; cf. Is 44:1-22), slipped a notch into becoming a prohibition against making images, thereby certifying depreciation of imagining. A tough strand in Talmudic studies,[6] and much Islamic teaching about godly activity, reinforced the suspect character of images and imagination.

I'll not rehearse the history, but a problem remaindered from the Platonic tradition Christianized, which still bedevils us, is that in common parlance *imaginary* and *fiction* refer to what is not true, or at least a matter that is not present and needing to be accounted for. From everything I've said so far, you know I believe we need to find a way to turn around this old preconception, because imaginative knowledge can deepen our grasp of God's world and bring to bear a dimension of praise and love otherwise missing in society.

> Love is not love which alters when it alteration finds,
> or bends with the remover to remove:
> O, no! it is an ever-fixed mark . . .
> Love's not Time's fool, though rosy lips and cheeks
> within his bending sickle's compass come. . . .[7]

It's the lilt in the language, the hesitating yet pulsing, steady rhythm set up by the alliteration, sibilants, and negatives, that testify to the durance of betrothed love through sickness and health, prosperity and want, aging, sin, and forgiveness: it takes the allusivity of poetry and what goes on imaginatively in between the lines and diction, as it were, to get at the reality, the truth of vowed commitment between two fragile human beings. I do not want to introduce a tiresome polemic between poetry and prose, since straight talk and legal precision have their own particular glory. It's just—let me put it this way—if there be no more imaginative, subjunctive play in our speech, we people will forfeit the knowledge of such polite, deferential

Theologica I-II, q. 109, art. 2, *resp.*). Young John Calvin, keen on *ad aedificandam pietatem* in the faithful rather than dwelling on anthropological subtleties, stresses the complete derangement of the whole human nature by sin: *neque enim appetitus inferior eum* [Adam] *illexit, sed arcem ipsam mentis occupavit nefanda impietas, & ad cor intimum penetravit superba* (*Institutio Christianae Religionis* 2.1.9).

[6]Richard Kearney, *The Wake of Imagination* (Oxford: Hutchinson, 1988), 43-49.

[7]William Shakespeare, "Sonnet 116," *Shakespeare, Twenty-Three Plays and the Sonnets*, ed. Thomas Marc Parrott (New York: Charles Scribner's Sons, 1938), 1109-10.

courtesy in human communication. (How often do we use the subjunctive mood in our fast email communications?)

THE MYSTICAL ROMANTIC MOVEMENT ADORES IMAGINATION AS REVELATION

A second major, wayward philosophical tack that thwarts, I think, our taking God's creation of imaginativity in humans seriously in its limited order of glory for our Christian living and learning is the tradition that credits imagination with suprarational *gnosis*, as a kind of inspired, ecstatic entry into mysteries that transcend ordinary mortality. Plato uses the prophetess Diotima of Mantinea's speech in his *Symposium* to delineate the erotic ascent of the initiate soul up from pederasty to a final contemplative transfixion before "the great Ocean of Beauty," "Beauty itself";[8] and Aristotle eulogizes the contemplative energy of divine reason in us, exhorting humans in the *Nicomachean Ethics* to strain "to make ourselves immortal."[9] The image-less, deiformic, superhuman illumination exalted by Plato and Aristotle was not called "imagination" but contemplative activity. Church thinkers christened its Neoplatonic-Plotinian version into the *visio Dei*,[10] and mystics, Christian and otherwise, have believed in being transported—"beside themselves"—into the presence of the hidden One to receive special revelations, like oracles. The movement of Western European Romantic idealism adopted, secularized, and converted this age-old visionary quest to meet God into a messianic humanism: they championed the god-like intuitive knowledge and creativity of genius, especially artistic genius, and called this power *produktive Einbildungskraft* (Fichte), *intellektuelle Anschauung* (Schelling), or "secondary esemplastic imagination" (Coleridge).

I need to tread carefully here because my Reformation-Calvinian faith tradition, augmented Lutheran, partial to the Dutch-Rembrandt focus, thrives best in an earthy, gutsy Christianity, and feels ill-at-ease with soul-ascent, extrabiblical communications, "victorious living," and rapture. I'm willing to learn. But for me the Holy Spirit leads and works intimately out

[8]Plato, *Symposium* 209e5–212a7.
[9]Aristotle, *Nicomachean Ethics* 1177b1–1178a2.
[10]Cf. Augustine, *Confessions* 9.10.23-26.

of Scripture, which is imaginatively intelligible. I don't want to step out of the Platonic frying pan of imagination into a Promethean fire. Personally, my visions of God stay close to Isaiah 6. Actually, God is closest to me in the LORD's voice. I hear God speak in different tones of Hannah or Deborah's songs (1 Sam 2:1-10; Judg 5); Psalm 2; 91; 39; 110; the prophet Isaiah; Amos; the New Testament texts of Romans and Hebrews: not demonic voices, but by my dwelling intently and at length in the Word written I hear my Lord speak comfortingly, remonstratively, pleading—God's got good voice!

A CURRENT FUSION OF THESE TWO POSITIONS JUDGES IMAGINATION TO BE POWERFUL AND SINISTER

Confronting us in our generation is a curious fusion of these two major philosophical aberrations I have mentioned—denigrating and over-rating imagination. Jean Baudrillard's lecture "The Evil Demon of Images"[11] epitomizes a current, Manichaean evaluation of imagination as powerful and sinister: images have almost occult power to bewitch people into believing the images are more real than ordinary reality—cinematic passion is made more real than my own mundane love-life—so imagination enslaves people to a satisfying unreality and hyper-reality, while the real world goes to hell. The gospel of Fichte—human egos create the world—has perversely come true with a Sartrean twist: we thought we were Pygmalions sculpting beautiful Galateas, but our pathological, creative human imagination has brought us Frankenstein's monsters! Our imagination has completely vaporized creational reality into culture, the work of our hands, and all of us—artist, technician, as well as viewer—have become facsimiles of Narcissus staring at ourselves in a hall of mirrors. For example, if we think that the highly selected TV images called "news" be reality, we are fools.

I leave our contemporary fixation with imagination hanging here for now and shall try to show in closing how artistic imagination can hold a blessing, so that we neither disparage God's good gift nor idolize its power, and also not damn it because of its demonic captivity but joy in redeeming its original glory and ministry.

[11]Jean Baudrillard, *The Evil Demon of Images*, trans. Paul Patton and Paul Foss (Sydney: Power Institute of Fine Arts, 2006), 13-34.

ARTISTIC IMAGINATION IS A PROFESSIONAL IMAGINATING CALLED TO PROVIDE NUANCED KNOWLEDGE FOR ONE'S NEIGHBORS OUT OF LOVE FOR GOD

Artists, including poets and website designers, I believe, are called by God to give leadership in practicing the integral human ability of being imaginative; artists become professional imaginators in making nuanced knowledge serviceable to the neighbors in God's world.

I have no truck with *le mystique d'artiste* because artistry is ordinary work like collecting and disposing the garbage of a city, or surgically removing somebody's gall bladder, or raising a new barn on the prairies, or drafting a treaty between belligerents after a war. Artists are persons who take their native gift to be imaginative, which is common to all women and men— which a budding artist may be endowed with in a special measure—and then by disciplined training deepen their imaginative ability until they are able to fashion objects and events that take on their own objective and eventful identity defined by the aesthetic quality of allusive, as-if similation[12] that I described earlier.[13] Art objects and artistic performances have the quality of being composed/constructed/performed entities whose skillful, symbolific disclosure of innovative conjunctures of meaning elicit the neighbors' imaginativity.

That's a touch of jargon to be philosophically precise, and it means this: while the LORD calls everyone to be imaginative, and to be thoughtful, and emotional, and just, and generous, according to God's creational will, the LORD blesses only some to become professional artists or theorists, professional counselors, statesmen and women, or business entrepreneurs. To become "professional"—I want to avoid the ancient classloaded distinction of trades in competition with "liberal arts"—means for me that you have the leisure to be intensely busy continually in caring for and mastering the complexities of a specific service in God's world for which you willingly give your lifetime. All professionals begin as apprentices; some practitioners remain amateurs, and other apprentices persist until they become master craftsmen and women as salespersons, jurists,

[12]*Similation* is a coinage by Karl Aschenbrenner defined as "the power of making apt comparisons" *The Concept of Criticism* (Dordrecht, DE: Redel, 1974), 313-19.

[13]Cf. C. Seerveld, "Imaginativity," *Faith and Philosophy* 4, no. 1 (1987): 49-53.

psychiatrists, philosophers, or design artists—each with their own zone of creatural glory and authority.

Artists, poets, novelists, as professional imaginators, are normal workers, in the creational sense of collecting manna daily by the sweat of their brows. Artists as professional imaginators, say I as a theorist, are laborers specialized in collecting nuances in God's world and in presenting out of love for God those fascinating quirks and quarks or deep-seated meanings as tasty manna to one's own kin and neighbors (cf. Rom 13:8-10). Artists as professional imaginators are leaders in imaginating, and that entails, from a biblical perspective, artists take the lead in the diaconal work—leadership is ministering!—of opening up anyone, especially the imaginatively

Figure 8.1. *Puer natus est nobis, Liber Usualis*, Solesmes, 1961

handicapped who only want to know what is exact, clear, indubitable (straight-laced brothers and sisters or technocratized neighbors who want things simple, left or right, up or down): open them up to the wonderful, alluring, subtle riches within and around us as God's creatures.

Let me illustrate briefly what I mean by knowledge of nuances: not logical, not sensed facts, but imaginative knowledge.

Puer natus est nobis—The *do-sol* melodic interval[14] opening the festive Christmas morning mass (fig. 8.1), without saying it, exuberantly says it all: "It's a boy!"—God has stooped to our weakness so we may be raised up to newness of life! Or *la-mi*: the Phrygian mode of Gregorian chant, close to the format of pained seriousness the Jews used to declaim the book of Job, casts whatever words fill its exquisite sorrowful melodic line with oxymoronic hopeful groaning (cf. Genevan Psalm 51)—*mi sol sol la mi sol sol re fa mi*—nuanced knowledge, preverbal, preconceptual, chiaroscuro knowledge.

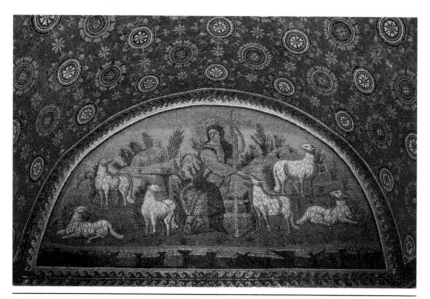

Figure 8.2. *The Good Shepherd,* mosaic, ca. 450

[14]Léon Wencelius, *Calvin et Rembrandt* (Paris: Societé d'Edition "Les belles lettres," 1937), 49-53, 130-50, 227-36. E.g., "We have seen that the combined portraits, all suffused with light by the depth of the spiritual armament and the dynamism that animates them, seem to be the expression of a vocation that has its meaning predetermined. . . . The physicians of *The Anatomy Lesson,* the Musketeers, the Drapers all reflect a specific vocation that should fulfill itself in a given form . . . all of which for Calvin must radiate the glory of the Creator" (230, editor's translation).

The earlier fifth-century faithful in Ravenna were not only attended in the mausoleum of Galla Placidia by the shepherd of Psalm 23 caressing inquisitive sheep, but also by a deep-blue vaulted sky filled with hundreds and hundreds of stars blinking like heavenly snowflakes, creating a warm, comforting architectural feel in the place. The animals here and there on the walls are not composed for taxonomic identification but to capture a sense of uncursed Eden where a deer does not thirst for water but has its belly caressed by tendrils of lovely, curlicue flowers, as if all creation renewed embraces those who die in the Lord (fig. 8.2).

These artists used their artisanry unobtrusively to lead in joy, cradle hurts, and brush away tears, to raise the spirits of the community they served, that is, lead them into the bona fide imaginative knowledge, which often comes upon you unawares and fills in the chinks of your life.

Geoffrey Chaucer's *Canterbury Tales* entertained his courtly readers with the rough-and-tumble horseplay of peevery between adults comically fixed in their ways, which Chaucer honestly exposes, gentled in humor, framed in a homely piety that invokes God's blessing as easily as one spits to show disgust. The prioress is a gentle nun with the dainty name of Eglentyne, chaste mouthpiece for ruthful stories of unsullied creatures who are harmed and hurt; but Chaucer lovingly dimples in her own weaknesses—having her wimple fluted and speaking French. The hearty wife of Bath who has gone on pilgrimages like package tours and has worn out and out-lived five husbands, a coarse sensual woman of enormous vitality, shameless aggressiveness, and incorrigible garrulity, ends her Arthurian tale of romance with a prayer:

> Jhesu Crist us sende
> Housbondes meeke, yonge, and fresh abedde,
> And grace t'overbyde hem that we wedde;
> And eek I praye Jhesu shorte hir lyves
> That wol nat be governed by hir wyves.[15]

To be bawdy with gentility and reverent with humor is rare, but the unsecularized mentality of the poet Chaucer deftly reveals *la gloire et le misère de l'homme*, the mixed bag of aspirations we earthlings are.

[15]Geoffrey Chaucer, *Tale of the Wyf of Bathe* 3.1258-62, *The Canterbury Tales*, in *The Poetical Works of Chaucer*, ed. F. N. Robinson (Cambridge: Houghton Mifflin, 1933).

John Bunyan's more solitary pilgrim, or Bunyan's 1684 poetic conversation between "The Sinner and the Spider," stands out from the chapbooks of the day and pamphlets of sects lambasting sects with a sunny humor, sharp eye for concrete lived life, and a colloquial idiom that makes Apollyon almost seem like a nickname. "Then he [Christian] was frightened, and he felt inclined to run back; but suddenly he remembered that no armor had been given him for his back, and that, should he run, it would probably be worse for him than for him to stand his ground. So he kept as boldly on as possible."

Puritan Calvinist Bunyan's candid narrative unmasks the humbug in everyman, and without heroicizing vivifies resolve against the temptation of fear so precisely you can almost feel it in the small of your back.

A still life with overturned dish and partially eaten pastry (1633) by Willem Claez Heda (fig. 8.3) gives burnished pewter and translucent glass highlighted halos of quiet splendor. The tipped plate, rumpled white cloth, and lemon peel drying out, footnotes of *memento mori*, still glory in the texture of fruit, glass, metal, and baked goods, and teach the eye to come to rest and to joy in how grace can illumine mean, inanimate objects with unspeakable repose.

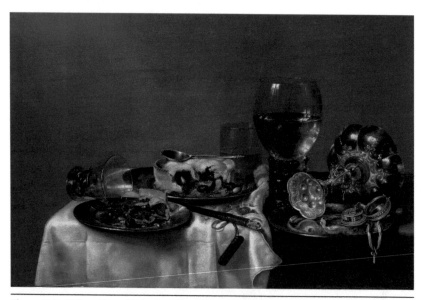

Figure 8.3. Willem Claesz Heda, *Breakfast Table with Blackberry Pie*, 1631

Most everyone knows by sight Rembrandt's *Staalmeesters* (1662), syndics of the cloth guild with servant interrupted, as it were, at business, where the black cut of the clothes, rich conservative table covering, and dignified balanced demeanor catches the committed economic thrift shining through their eyes, or, as Léon Wencelius commented two generations ago, "the Calvinist view of vocation" of these illustrious burghers.

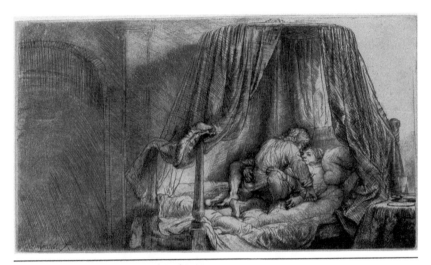

Figure 8.4. Rembrandt, *The French Bed,* 1646

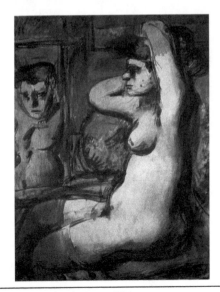

Figure 8.5. Georges Rouault, *Girl at the Mirror,* 1906

And artist Rembrandt could touch a butchered ox (1655) hanging in the back room with a fleshy grandeur worthy of the psalms that dwarfs the woman peeking through the doorway.

Much less well-known is Rembrandt's imaginative engraving of human intercourse (fig. 8.4): the couple, in the private recesses of their canopied bed, are busy at their lovemaking; it's all very normal, *gezellig*, untidy, connected. If you look closely, the woman has an extra arm. With two hands she clasps her man to her body, but the third, extra arm—like a seraph?—rests quietly on the bed covers. A redemptive touch, I'd like to say, whereby Rembrandt genially, off-handedly, intimates how ungainly and awkward we humans had better be in the physical intercourse of our love.

Georges Rouault did not look the other way when he saw the ugly ravages of sin on human creatures: this is how you paint in watercolor the nuances of misery, flecks of blue and rose on the body suggesting the cold, the bruises of being roughly manhandled, with the bitter falseness of putting a gay red flower in your hair, *filles de joie*, sitting on moth-eaten furniture (fig. 8.5). Rouault's artistic imagination has rendered compassionately the sad knowledge of the cruelty of self-gratifying male abuse at large in the world of God's creation.

Figure 8.6. Chris Anderson, *Historical Dislocations: History Repeats Itself (The Standoff)*, 1988

New York City artist Chris Anderson quotes Masaccio's fresco with powerful effect: the monotonous grid of a housing development is a place of banishment! Middle-class sameness which is nowhere because it is everywhere is a result of the curse.

When Michelangelo's *David*—David in the Bible fought the Philistines—towers over the standardized, colorless family ranch home (fig. 8.6), you realize even its cherished detachment is a mark of the Philistines; so we paint bright tropical colors on the van used for the annual vacation trek to get away from it all, a somewhat wistful, forlorn *memento paradisus*.

Canadian Edward Hagedoorn constructs a huge, eight-foot-by-eight-foot piece that shows the tanks of petro-chemical installations standing like unreal ghosts silhouetted against a pale, befouled green-blue sky, looking like deadly missiles set to shoot off into outer space; underneath is the reality of sewage pipes and muck, refuse, clogged deposits, on top of which filth grasses and flowers still miraculously grow—amazing grace![16]

Australian Warren Breninger portrays a woman drained of energy after pushing forth a baby—muscles contracting—exhausted from straining in labor (figs. 8.7 and 8.8). The somewhat swollen features, highlighted by an unreal shine of white-like sweat and grounded by the rough black frame underneath as if one is reduced to the basics of humanity in such an ordeal, cast the tired woman into stark relief. The black-blue across the cheeks and mouth hint at soreness, while the wisps of leaves in the dark seem to dance and skip wistfully, as if easier times might wait in the wings. There is a sense

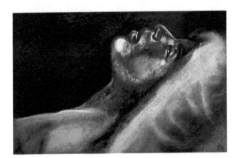

Figures 8.7. and 8.8. Warren Breninger, *Art as a Metaphor for Childbirth, No. 1 and No. 2,* 1986

[16]Edward Hagedoorn, *New Growth*, acrylic painting, pipe, mixed media, 1970, Colbourne, Ontario (now destroyed).

Figure 8.9. Joyce A. Recker, *Murmurs of the Heart,* 1990

of distance and uncompromising estrangement in the piece, which yet shows a fascination with the ordeal of bringing forth life. There is softness and love, as I see it, within the hardness. Its wry title, *Art as a Metaphor for Childbirth*, wants to say, I think, "That's me too as artist, as (Christian) artist, my friend."

Murmurs of the Heart by Joyce Recker (fig. 8.9) in Toronto uses precious purple heart wood with chicken wire to form a delicate, lovely rib cage, doubling as a cathedral, for a levitated heart of a rock caressed smooth by wind and water, as if pulsing above kindling that keeps it suspended, alive. There is something private and protected, warm and gentle, but sharply pointed and precarious about the whole ensemble. I'd play Anton Webern's music nearby, to complement the murmuring heart's exacting, chaste, crucial finesse.

Seagull I (1984; fig. 8.10) in bronze by Dutch sculptor Britt Wikström shows the gracious alighting movement of this tough, wizened bird, taut

Figures 8.10 and 8.11. Britt Wikström, *Seagull 1 and 2,* 1984 and 1985

body and tail, under the strong wings folding like canvas sails as the webbed feet grip the slippery rock. *Seagull II* (1985) (fig. 8.11) shows the scavenger ready for flight, poised for lift-off, where the raised wings give a cathedral soaring to the creature, a phoenix about to rise again.

> My heart in hiding
> Stirred for a bird,—the achieve of, the mastery
> of the thing![17]

Woman (1984; fig. 8.12) has the slenderness of a dancer, long legs and body, neck, arms extended to their limit, as if reaching for something beyond—raised mouth, nose, eyes beseeching?—while the capped hands form an arc arresting what fain would be, closing off this supple,

Figure 8.12. Britt Wikström, *Woman*, 1984

Figure 8.13. Gerard Pas, *Red Blue Crutches #1–#12*, 1986–1987

[17]Gerard Manley Hopkins, "The Windhover," in *Poems and Prose* (New York: Penguin, 1985).

Figure 8.14. Gerard Pas, *Vision of Utopia*, 1986

vulnerable (almost African) figure with a waiting composure. Britt Wikström collects her livelihood by teaching, making mosaic murals in schools and redemptive grave-stones, where birds of the heavens can come to wash their feet.

Canadian artist Gerard Pas takes the basic crutch, stigmatized by primary colors, through a contorting metamorphosis, as if the crutch going through the twelve stages of the cross is finally brought to its knees, transfigured by the imagination into a docile, balanced pyramid of expectant waiting (fig. 8.13).

The watercolor *Vision of Utopia* (fig. 8.14) by Pas goes boogie-woogie exuberant with color to celebrate an apotheosis of a trinity of crutches flying above a throne; Kandinskyesque slivers of geometric figures are pulled loose into the vortex of an unseen power: this ascension or assumption of the crutch—he had polio as a child—in anticipation of the day when the lame shall indeed leap for joy.

My few examples of nuanced knowledge provided by professional imaginators could continue for a long time. I purposely selected what is not spectacular, grandiose, but specimens of what I would call the results of Christian imaginativity, art imbued with an awareness of the surd of sin, carrying a spirit of hopeful joy in anticipation of Christ's apocalyptic return and final redemption of God's creation. Christian art is not art with pious additions, or a testimony on the book or record jacket, but is simply art consecrated as God willed it to be creationally—faithful similation, edifying grasp of nuance, humbly walking and blowing bubbles with the Lord.

Those of us who are saints also engage in *sinful* imaginative acts. Those who fail to recognize Jesus Christ is the Lord of all life can be striking

artists; but that does not imply they are anonymous Christians. What I have called the halo of human imagination is a common trust of God's grace that a human can dedicate, default on, pervert, or mismanage; the luster or halo is not a tongue of fire certifying the true faith of hearted obedience to the Lord.

What is important for us to resolve, I think, as we consider God's creation of humans with imaginativity is its ordinary glory, so that in the current climate of the recession of rationalism we do not promote the inflation of imagination.

Figure 8.15. Carl Bucher, *The Petrified*, 1979

Figure 8.16. Joe Fafard, *Pasture*, 1985

Imaginativity is not pivotal to human life, but it is integral to normal creatural well-being, shalom. And it would be a disaster if those who have gone professional with their creational gift of imaginativity, or if we who want to support such professional artistic and poetic action, did not realize it is to be hallowed into feeding the little ones of God's people and anybody adrift in God's world, to feed them with grace notes of imaginativity kindred to the psalms: a lament of sculptured prisoners of war standing outside the new International Red Cross and Red Crescent Museum in Geneva, grouped disconsolately in nondescript robes, waiting and waiting, composed of a material that is gradually petrifying (fig. 8.15); or a petition of bronze cows ruminating on a minute piece of grass under a few shade trees in the downtown heart of Toronto's financial district, hoping God who spared Nineveh will have the humor to accept this offering of a concrete city (fig. 8.16).

And for those of us who are not professional imaginators, one could do worse than be found by the Lord returning to judge the living and the dead holding the hand of your grandchild, or an orphan, blowing bubbles, not as an emblem of *vanitas*, but as a miracle occasioning wonder in the next generation, a miracle God once taught Adam and Eve in the beginning.

BIBLIOGRAPHY

Bunyan, John. "The Sinner and the Spider." 1684.

Dengerink Chaplin, Adrienne. *The Philosophy of Susanne Langer: Embodied Meaning in Logic, Art, and Feeling.* London: Bloomsbury, 2019.

Edgar, William. "Why Is the Light Given to the Miserable?" In *It Was GOOD Making Art to the Glory of God,* edited by Ned Bustard, 225-40. Baltimore: Square Halo, 2006.

Herrero, David Estrada. *Estética.* Barcelona: Editorial Herder, 1988.

Leeuw, Gerardus van der. *Wegen en Grenzen: Een studie over de verhouding van religie en kunst.* Amsterdam: H. J. Paris, 1955.

O'Connor, Flannery. *Mystery and Manners.* New York: Farrar, Straus & Giroux, 1961.

Rookmaaker, Hans. "Arts Needs No Justification." In *Western Art and the Meanderings of a Culture,* edited by Marleen Hengelaar-Rookmaaker, 4:315-49. Carlisle, UK: Piquant, 1978.

Seerveld, Calvin. "Christian Aesthetic Bread for the World." In *Normative Aesthetics,* edited by John Kok, 145-68. Sioux Center, IA: Dordt College Press, 2014.

———. "Helping Your Neighbour See Surprises." In *Contemporary Art and the Church: A Conversation Between Two Worlds,* edited by W. David O. Taylor and Taylor Worley, 209-16. Downers Grove, IL: IVP Academic, 2017.

———. *Rainbows for the Fallen World: Aesthetic Life and Artistic Task.* Toronto: Tuppence, 1980.

———. "WANTED: Vegetarian Kuyperians and Artistic Underwear." *Pro Rege* 46, no. 3 (2018): 24-28.

Steiner, George. *After Babel: Aspects of Language and Translation.* Oxford: Oxford University Press, 1975.

Wencelius, Léon. *Esthétique de Calvin.* Paris: Société d'Edition "Les belles lettres," 1937.

Yett, Danielle Raeann. "Making Sense: An Expansive Study of Imagination, Structural Metaphor, and Aesthetic Normativity with Calvin Seerveld." MPhil thesis, Institute for Christian Studies, 2019.

Zuidervaart, Lambert. *Artistic Truth: Aesthetics, Discourse, and Imaginative Disclosure.* Cambridge: Cambridge University Press, 2004.

The Meaning of the Crucifixion: Grünewald and Perugino

CALVIN SEERVELD

By nature a good painting or sculpture presents us with sound, discernible knowledge, albeit in its own particularly imaginative, painterly, or sculptural way—in color shades and texture, positioned shapes, nuance of line (mass and rhythm) and weighted design, all stamped allusively.[1] One misreads the knowledge won artistically if one thinks the painting or sculpture is simply a carbon copy of what is visible. No good painting has ever been a Xeroxed copy of what meets the eye. We evangelical Christians, if we want to understand art, have to break with the prejudice ingrained in us by the big lie of Plato that art as *mimesis* copy-cats material objects. Instead the artist apprehends things visible and invisible, very complicated meanings, affairs we all know experientially like sin and love and meekness but could never duplicate in a mirror; and the artist paints or sculptures that meaning-reality in a preverbal and a-logical way, more like a cartoon than a brute photograph.

To make this first point convincing, one need but look at a few paintings. Art is not vague because it is not analytically precise, and it is not confused because it is not articulated clearly in some language with dictionary references. Art is also neither ineffable nor mysterious nor more subjective a knowledge than analytic philosophical statements or straightforward English sentences about the weather. Artistic painting and sculpture simply have a different set of formative elements defining their existence as art

[1]Calvin Seerveld, "The Meaning of the Crucifixion: Grünewald and Perugino," excerpted from "A Contribution of Christian Aesthetics Toward Reading the Bible," in *Rainbows for the Fallen World: Aesthetic Life and Artistic Task* (Toronto: Tuppence, 2005), 79-84.

products, and one needs to learn how to read such artistic elements in order to understand that kind of genuine knowledge, knowledge characterized by the quality of suggestion and allusion.

One can explore the matter by pointing out certain features of two paintings around 1500 that depict the crucifixion, one by Matthias Grünewald (ca. 1460–1528; fig. 8.17) and one by Pietro Perugino (ca. 1448–1523; fig. 8.18). The vertical line of the cross in Perugino's altarpiece is perfectly centered in the space allotted and is symmetrically balanced on both sides by the two figures of Mary and John. The crossbeam is utterly straight, effortlessly fixed into position. But the upright post of Grünewald's cross is off-center. His crossbeam is real wood and sags, as if tortured by the hanging weight; it looks as if the wood is strung taut like a bow ready to snap. There are sharp triangular patterns directed down at the head of Christ, and the jabbing finger of John the

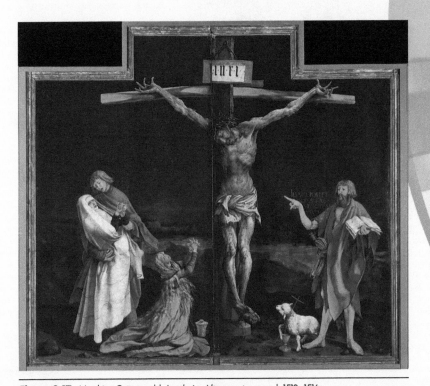

Figure 8.17. Matthias Grünewald, *Isenheim Altar*, center panel, 1512–1516

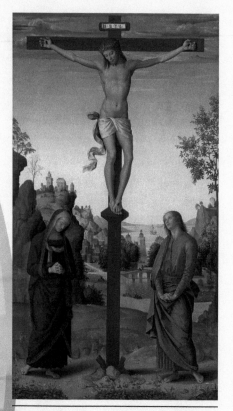

Figure 8.18. Pietro Perugino, *The Crucifixion with the Virgin, St. John, St. Jerome, and St. Mary Magdalene,* center panel, ca. 1485

Baptizer off to the right, makes the whole scene uneasy, awkward, piercing.

In Perugino's crucifixion scene, Mary and John are the same size as Christ and are at ease; the weight of each is on one foot, and the other trails lightly on the ground. Their hands are clasped in adoration, and they pray peacefully in their unruffled, fine clothes, while the sash about Christ's abdomen flaps festively in the still air. A decorative Italian landscape serves as setting; there is pleasant daylight, delicate trees, a bridge and a village—as if nothing in the least is wrong, nothing harsh or disturbed or ruined by sin. The world seems pensive, noble, and serene. But in Grünewald's painting Christ's body is disproportionally larger than the human figures—giving it an enormous centrality. There is no flapping banner sash around Grünewald's abdomen of Christ: the white looks more like a dirty, shabby tourniquet. John the Baptizer's cloak is unpressed and looks as if it has been slept in; the little Mary Magdalene is literally shriveled up by weeping sorrow. The beloved disciple John, in red to the left, has an exaggerated, long right arm to encircle the white-shrouded mother Mary, surrounding her with loving care. Christ's body is blotched with wounds, fingers are distorted by rigor mortis, armpits seem to be cracking from past torture, slumping legs hang lifeless and swollen. The rough crisis of the event is

spotlighted by a brown foreground and a green-to-black background which encloses the group in sober loneliness.

One could ask: Didn't Grünewald know John the Baptizer was dead when Christ died on Golgotha? And what is a lamb doing in his painting, carrying a little cross and dripping blood into a chalice? Also, didn't Perugino know Christ was crucified in Palestine and not in Italy—why falsify that? And there were many more people than two around at the time—why the inaccuracy?

And the right answer is this: neither Grünewald nor Perugino was trying to Xerox pictorially a given scene outside Jerusalem centuries before. No, their artistic account of the crucifixion of Jesus Christ under Pontius Pilate was painstakingly crafted to tell us something about that happening that incorporates the artist's whole vision of Jesus Christ's ministry.

Perugino shows the cross of Jesus Christ not as a horrible tragedy but as a careful act of God that should fill us with inward calm and peace. That is why the saintly figures stand transfixed beneath a painless Christ. It is so that no filigree of trees graced the place of a skull and no picturesque town and becastled peaks were seen by the newspaper reporters there, but the idyllic presence of John and Mary in Perugino's version carry the painterly message that Christ's death should be taken with restraint, simplicity, decorum, and steadfast, gentle belief.

Grünewald's *Small Crucifixion* (fig. 8.19), like the *Isenheim Altarpiece*, shows Christ piteously dead, spread-eagled so grotesquely that you know the Son of

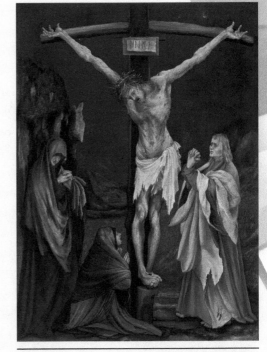

Figure 8.19. Matthias Grünewald, *The Small Crucifixion*, 1519

Man went through hell and was utterly forsaken by God. In the latter the troubling presence of John the Baptizer intensifies the ironic words incorporated into the painting, "He must increase, but I must decrease." Grünewald is exclaiming with painterly passion, "How inscrutable are the terrible, holy ways of God who reveals his overwhelming, saving strength in weakness." The white, wooly lamb is an almost too obvious iconic sign saying, "Behold—sorrow and love flow mingled down—the lamb of God who takes away the sin of the world!"

In my judgment, Grünewald gets more deeply and biblically than Perugino at the awful, hellish meaning of the crucifixion— God-become-flesh atoning for the sin of the world. And you can't wait in Colmar to walk around to the other side of the triptych to see his startling symbol of the resurrection, its strange colors professing unearthly divine power at work upon the earth of metal armor and huge slabs of stone. Renaissance-spirited Perugino is too balanced, too "beautiful," like Raphael, to be depicting the event that changed history from BC to AD. I would admit, however, that the pre-Reformation, late Gothic sensibility of Grünewald still seems caught by an apprehensive awe that has not claimed the full, Holy Spirited comfort of grace that is a free gift of God to those who repent and believe.

But my purpose now is not to exegete more fully these paintings. The simple point I am making convincing is this: art, so-called representational painting too, is not built to carbon copy neutral matters of fact. Good art of all ages has symbolified[2] reality with stylized selectivity of certain pregnant features. Artistic paintings present meaning cartoonfully, so to speak, highlighting and silhouetting the prehended affairs to intimate certain meanings rather than give it to you in a straightforward, indicative or deictic logical fashion. When you know how to read the aesthetically focused off-center or on-center shape, luminescent color, straight or crooked line and composition of the canvas or wood, then you

[2]*Symbolify* is a term to describe the artistic act of "objectifying certain meaning in a symbolically pregnant way."

most assuredly gain knowledge. You gain distinguishable, explicable knowledge—as definite as Grünewald and Perugino's sense of the crucifixion—but it is suggestionly qualified knowledge, and such artistic knowledge is as valid and sure, though different, as other sorts of knowledge.

BIBLIOGRAPHY

Becherer, Jospeh Antenucci, et al. *Pietro Perugino, Master of the Italian Renaissance*. London: Rizzoli, 1997.

Richter, Gottfried. *The Isenheim Altar: Suffering and Salvation in the Art of Grunewald*. Edinburgh: Floris, 1999.

Seerveld, Calvin G. *Rainbows for the Fallen World: Aesthetic Life and Artistic Task*. Toronto: Tuppence, 1980.

Williamson, George Charles. *Perugino*. Maidstone, UK: Crescent Moon, 2018.

CHAPTER NINE

RETHINKING ART

NICHOLAS WOLTERSTORFF

EVER SINCE THE MID-EIGHTEENTH CENTURY almost all philosophy of art, art history, and art criticism has been conducted within the framework of what I call "*the grand narrative concerning art in the modern world.*"[1] The grand narrative is a story that emerged in the eighteenth century concerning the art-historical and sociological significance of a development that took place in the arts in the early modern period, namely, the emerging middle class in Western Europe began increasingly to engage works of the arts as objects of what eighteenth-century writers on the arts called *disinterested contemplation.*[2]

THE GRAND NARRATIVE OF ART IN THE MODERN WORLD

There had always been art in the lives of Western Europeans: altarpieces, sculptures in and on churches and cathedrals, liturgical music, morality and mystery plays, work songs, folk songs, decoration of various sorts, dances, songs sung by traveling minstrels, ballads. And there had always been some Europeans who engaged at least some of these works as objects of attentive viewing or listening. When they did so, however, it was usually

[1]Nicolas Wolterstorff, *Art Rethought* (Oxford: Oxford University Press, 2015).
[2]I regard this as an infelicitous term for what the eighteenth-century writers had in mind. The term *disinterested* is too suggestive of passivity, and one does not contemplate works of music. A better term would be "absorbed attention for its own sake." In this essay, however, I will usually employ the eighteenth-century term, with the caveat mentioned.

with some interest in mind; they viewed or listened in the expectation that doing so would bring about something that would satisfy some interest on their part: edification, instruction, entertainment, and the like. Typically the works in question had been created to serve that interest. What was new in the early modern period was the increase in engagement of works of the arts by members of the emerging bourgeoisie as objects of *dis*interested contemplation.

In the eighteenth century, writing about the arts changed in a way that corresponded to this change in practice. Ever since the ancient Greeks the Western tradition had included writings about poetry, painting, sculpture, music, and architecture. These writings had usually treated those arts from the perspective of the Creator. In the eighteenth century, a shift of emphasis took place, from emphasis on the creation of works of the arts to emphasis on the engagement by the public of works of the arts, in particular to emphasis on the engagement of works of the arts as objects of disinterested contemplation. Speaking of this shift in emphasis, literary historian M. H. Abrams describes it as a shift from the *construction* model to the *contemplation* model.[3]

In his well-known essay, "The Modern System of the Arts," intellectual historian Paul Oskar Kristeller argued that corresponding to this shift in emphasis in writing about the arts was the emergence of our modern concept of the arts according to which poetry, painting, sculpture, music, and architecture belong together as arts, or *fine* arts, as they came to be called.[4] Previously this particular grouping was nonexistent. The ancient Greek term *technē* and the ancient Latin term *ars* are both standardly translated into English as "art." But both terms meant a skill or craft. The craft of sculpting was a *technē*, an *ars*, but so too was the craft of furniture-making.

Given that the pre-eighteenth-century writers discussed what came to be called "the arts" from the perspective of the Creator, it is entirely understandable that they did not possess our concept of *the arts*. Painting and sculpting are much more like goldsmith work and furniture-making than

[3]See M. H. Abrams, "Art-as-Such: The Sociology of Modern Aesthetics," and "From Addison to Kant: Modern Aesthetics and the Exemplary Art," both included in his collection *Doing Things with Texts: Essays in Criticism and Critical Theory*, ed. Michael Fischer (New York: W. W. Norton, 1989), 135-58 and 16-48, respectively.

[4]The essay is included in Oskar Kristeller, *Renaissance Thought II: Papers on Humanism and the Arts* (New York: Harper & Row, 1965).

they are like composing music. But when one discusses what came to be called "the arts" from the perspective of one who engages them as objects of disinterested contemplation, then a similarity leaps out: they all prove rewarding for this mode of engagement. Philosophers of art are often asked, What is art? It's important to realize that the concept of *art* that is employed in asking this question is an artifact of the eighteenth century, introduced by the eighteenth-century writers to discuss the new developments in poetry, painting, sculpture, music, and architecture.

The eighteenth-century writers not only identified the mode of engagement of works of the arts that was becoming increasingly common in their day, namely, disinterested contemplation; they undertook to legitimate that mode of engagement, indeed, to celebrate and urge it, by trying to pinpoint what made contemplation for its own sake worthwhile. The concept of *disinterestedness* is, after all, a negative concept. If one's contemplation is not for the sake of some interest that one has, what then makes it worthwhile?

The eighteenth-century writers employed two very different lines of thought in answering this question. Some, such as Joseph Addison, argued that disinterested contemplation, when practiced by persons of "taste," is pleasurable in a way that makes it superior to any other form of pleasurable activity.[5] Others, such as Karl Philipp Moritz, argued that works of the arts created for disinterested contemplation have the intrinsic worth of being beautiful, and that contemplation for its own sake of such works is worthwhile, because it puts one in touch with that object of intrinsic worth.[6] Later writers would use the concept of *aesthetic excellence* rather than the concept of *beauty* to explain what it is that makes a work worth contemplating for the sake of the act itself.

If engaging works of the arts as objects of disinterested contemplation was to become common and widespread, an institutional base was required. And so it was that what we now know as *the art world* began to take shape

[5]See Addison's eleven essays on "the pleasures of the imagination" that he published in his newspaper, *The Spectator*, from Saturday, June 21, to Thursday, July 3, 1712.

[6]Moritz's writings on art have never been translated into English. There are copious quotations, however, in the two essays by Abrams referred to above, and in the chapter titled "The Romantic Crisis," in Tzvetan Todorov, *Theories of the Symbol*, trans. Catherine Porter (Ithaca, NY: Cornell University Press, 1982), 147-221.

in the early modern period. Here is how the philosopher Larry Shiner describes the result:

> From a seventeenth-century world in which the arts were purposefully integrated into society and in which there were few separate art institutions, the expansion of the middle class and a market system for the arts led to the emergence of nearly all the modern institutions and practices of fine art: in painting, there were now art exhibitions, art auctions, art dealers, art criticism, art history, and a new emphasis on the signature; in music, there were now secular concerts, the elimination of stage seating in the opera, the development of music criticism and music history, the emergence of the "work" concept and its practices of exact notation, complete scores, and opus numbers, along with an end to borrowing and recycling; in literature there were circulating libraries, literary criticism, and history, the development of vernacular canons, the establishment of copyright, and a new status for the author as free creator.[7]

I have been describing the changes that were taking place in the early modern period in how the public engaged works of the arts and the corresponding changes that were taking place in the eighteenth century in how writers wrote about the arts. What I call *the grand narrative concerning art in the modern world* is a story about the art-historical and sociological significance of the changes that were taking place in how the public engaged works of the arts.[8]

As to the art-historical significance of the changes, the grand narrative claims that insofar as works of the arts were increasingly engaged as objects of disinterested contemplation and created for that function, the arts were coming into their own. When one engages some work of the arts so as to bring about something that is in one's interest, one's engagement is in service to that interest. Engaging the work for the sake of the engagement itself represents liberation from such service. So too when one creates a work of the arts so that the public, by engaging the work, can bring about something of interest to them, one's creation is in service to that interest. By contrast, creating a work that will reward disinterested contemplation represents

[7]Larry Shiner, *The Invention of Art* (Chicago: University of Chicago Press, 2001), 153.
[8]In chapter 3 of *Art Rethought*, I explicate in much greater detail than I can here the grand narrative concerning art in the modern world.

liberation from service to that interest. Over and over it was declared that when works of the arts are engaged as objects of disinterested contemplation and created for that mode of engagement, art is freed *from* bondage to interests and purposes outside itself and freed *for* pursuing its own internal values rather than the external values of church, business, government, or whatever. Art comes into its own.

This story, about art coming into its own insofar as works of the arts were increasingly engaged as objects of disinterested attention, was caught up into the Romantic story about the essence of modernization. The Romantics were the first great analysts and critics of modernity. The emergence of modernity, they said, is the fracturing of traditional unities: the fracturing of traditional relationships of human beings to nature, the fracturing of traditional economic relationships, the fracturing of traditional political communities. *Gesellschaft* replaces *Gemeinschaft*. The cause of this fracturing, so it was widely held, was the spread of instrumental rationality: calculations of instrumental rationality replace tradition as a guide to action.

Instrumental rationality and the fracturing that follows in its wake are not all-conquering, however. In works of the fine arts, said the Romantics, we find unity rather than fragmentation; and in the creation of works of the arts for disinterested contemplation it is imagination rather than rationality that is at work. Art for disinterested contemplation transcends the corrosive dynamics of modernity. Therein lies the sociological significance of the developments taking place in the arts.

I hold that this grand narrative should be rejected. Modern and contemporary developments in the arts do not have the art-historical significance of the arts coming into their own, nor do they have the sociological significance of artistic creation and works of the arts being socially other and transcendent. But before I substantiate these claims and present what I think should be put in place of the grand narrative, let me introduce what Abraham Kuyper says about art in the fifth of his *Stone Lectures*. What he says is an unusually lucid and revealing example of thinking about the arts within the framework of the grand narrative.[9]

[9]The edition I will be using is Abraham Kuyper, *Lectures on Calvinism* (Grand Rapids, MI: Eerdmans, 1931).

ABRAHAM KUYPER ON ART

Beginning in the eighth century, says Kuyper, the church gained "almost exclusive ascendancy over the whole of Europe. Thanks to this constellation, the Church, for several centuries became the guardian of higher human life. . . . In the literal sense of the word, all human development of that period depended entirely upon the Church. No science and no art could prosper unless shielded by ecclesiastical protection."[10]

"A right-minded guardian intends to render his guardianship super-fluous as soon as possible, and he who tries to prolong his control, even after his ward has reached maturity, . . . makes his guardianship itself an incentive to resistance."[11] The church ignored this truth and "persisted in swaying her absolute scepter across the entire domain of life." As a result, four great movements "to escape from ecclesiastical tutelage" arose more or less simultaneously: the Renaissance in the domain of art, republicanism in politics, humanism in science, and the Reformation in religion.[12]

Though these movements were distinct, they "repeatedly acted in concert. It was the one human life that, weary of any further guardianship, hastened in every way after a freer development, and, therefore, when the old guardian tried by main force to hold back the declaration of maturity, it was but natural that those four powers should encourage one another fiercely to resist, nor to desist before freedom was obtained."[13] It was especially the Calvinist Reformation, in cooperation with the Renaissance, that broke the bondage of art to the church, and simultaneously its bondage to the aristocracy. "Ecclesiastical power no longer restrained the artist, and princely gold no longer chained him in its fetters."[14]

And so it should be. For it is a law of historical development that, in the providence of God, society should eventually be differentiated into distinct spheres or domains, art being one of those, each sphere being free from domination by other spheres and free to follow out its own internal

[10]Kuyper, *Lectures on Calvinism*, 157-58.
[11]Kuyper, *Lectures on Calvinism*, 158.
[12]Kuyper, *Lectures on Calvinism*, 158.
[13]Kuyper, *Lectures on Calvinism*, 158.
[14]Kuyper, *Lectures on Calvinism*, 167.

dynamics.[15] "Art reveals ordinances of creation which neither science, nor politics, nor religious life, nor even revelation can bring to light. She is a plant that grows and blossoms upon her own root."[16]

> Art, like science, cannot afford to tarry at her origin, but must ever develop herself more richly, at the same time purging herself of whatsoever had been falsely intermingled with the earlier plant. Only, the law of her growth and life, when once discovered, must remain the fundamental law of art for ever; a law, not imposed upon her from without, but sprung from her own nature. And so, by loosening every unnatural tie, and cleaving to every tie that is natural, art must find the inward strength required for the maintenance of her liberty.[17]

In the passages quoted thus far it was especially visual art that Kuyper had in mind. His views about music went along the same lines. In the Middle Ages, "music was almost entirely deprived of its independent standing. Only in so far as it could serve the church was it permitted to flourish artistically." "As in every department of life, Protestantism in general, but Calvinism more consistently, bridled [at] the tutelage of the church, so also was music emancipated by it, and the way opened to its so splendid modern development."[18]

And what will guide the endeavors of the artist when art is no longer in bondage to church, government, or anything else outside its own sphere? What will guide the endeavors of the artist when art has gained "its right of independent existence"?[19] Beauty, says Kuyper, a "beauty that transcends the beautiful of nature."[20] "If you confess that the world once *was* beautiful, but by the curse has become *undone*, and by a final catastrophe is to pass to its full state of glory, excelling even the beautiful of paradise, then art has the mystical task of reminding us in its productions of the beautiful that was lost and of anticipating its perfect coming luster."[21] To attend to some beautiful

[15]Kuyper, *Lectures on Calvinism*, 162. On occasion Kuyper, instead of speaking of *art* as becoming a sphere of its own, speaks of "aesthetic life" as commanding "a sphere of its own" (*Lectures on Calvinism*, 150).

[16]Kuyper, *Lectures on Calvinism*, 163.

[17]Kuyper, *Lectures on Calvinism*, 163.

[18]Kuyper, *Lectures on Calvinism*, 168.

[19]Kuyper, *Lectures on Calvinism*, 162.

[20]Kuyper, *Lectures on Calvinism*, 154.

[21]Kuyper, *Lectures on Calvinism*, 155.

work of the arts is to experience a form of enjoyment that is nobler than almost all other forms of enjoyment; it is to "drink at the fountain of higher pleasures."[22]

Speaking of his own times, the latter part of the nineteenth century, Kuyper remarks that "artistic refinement, thus far restricted to a few favored circles, now tends to gain ground among broader middle classes, occasionally even betraying its inclination to descend to the widest strata of lower society. It is the democratizing, if you like, of a life-utterance which hitherto recommended itself by its aristocratic allurements."[23] What Kuyper meant, of course, was that art for disinterested aesthetic contemplation was being democratized; the middle and lower classes had always had other forms of art in their lives.

IDIOSYNCRASY AND DISCORDANCY IN KUYPER'S THOUGHTS ABOUT ART

Though Kuyper's way of thinking about art is obviously an example of thinking within the framework of the grand narrative, it's worth noting that, in one respect, it's a rather idiosyncratic example. The impression one gets from Kuyper's discussion is that for centuries artists had been straining at the leash to be freed from bondage to prelates and princes, especially prelates, and that now, after the great liberation movements of the sixteenth century, their sole concern is to create works of beauty.

Perhaps there were some artists in the middle ages who resented the fact that prelates and princes were the principle patrons of the arts and who felt themselves to be in bondage, captivity, servitude (Kuyper's words). But surely many painters in the Orthodox East gladly painted icons for the church, surely many painters in the Catholic West gladly painted altarpieces for the church, and surely many composers in both East and West gladly composed music for the church. Kuyper praises the contribution that composers Louis Bourgeois and Claude Goudimel made to the psalm singing of the Reformed churches.[24] Did he think that their doing so was an act of servitude?

[22]Kuyper, *Lectures on Calvinism*, 153.

[23]Kuyper, *Lectures on Calvinism*, 142.

[24]Kuyper, *Lectures on Calvinism*, 168-69.

It's not part of the grand narrative to hold that those artists who create for some public function other than that of disinterested contemplation are under the thumb of the church, the government, business, or whatever. What the grand narrative claims is that even if the artist is *voluntarily* creating for some function other than that of disinterested contemplation, his creation represents art not yet having come into its own, and that even if he is *involuntarily* creating art for disinterested contemplation when he would prefer creating art for the church, his creation represents art having come into its own. Creating voluntarily or involuntarily has nothing to do with whether or not one's creation represents art come into its own.

There's another oddity in Kuyper's thought about art, perhaps best described as a *discordancy,* that's worth taking note of, this discordancy far more consequential than the idiosyncrasy to which I just now pointed. Kuyper was right to note that in the early modern period there gradually came to birth an art world, comparable, in significant ways, to the world of business, the world of higher education, and so forth. Each of these is what Kuyper called a *sphere,* or a *domain.* The art world emerged as the institutional basis for engaging works of the arts as objects of disinterested aesthetic contemplation and for creating, performing, and presenting works for that function. Over the past fifty years or so the art world has undergone radical changes; both the aesthetic and the disinterested have lost their hegemony. What remains the case, however, is that there is an art world and that it is oriented around the practices of attentive viewing, listening, and reading, whether or not those be aesthetically rewarding and whether or not they be disinterested.

When Kuyper spoke of the sphere of the arts or of "aesthetic life,"[25] he clearly had his eye on the art world of his time. But the art world was not, and is not, the sphere of the arts in general. The practices of attentive viewing, listening, and reading are by no means the only ways in which we engage works of the arts. We sing hymns, we play background music, we write social protest poems, we descend into the Vietnam Veterans Memorial in Washington, DC, touch a name incised into black marble and weep (fig. 9.1).

[25]Kuyper, *Lectures on Calvinism,* 150.

Figure 9.1. Maya Lin, *Vietnam Veterans Memorial*, 1982

The conclusion to be drawn is that there is no sphere or world of the arts in general. It was a mistake of Kuyper to think that there was. There is the sphere constituted of the modern art world. But it is far from being the case that all art has a role in the modern art world. Of course, one can declare that only if a work has a role in the modern art world will one call it "a work of art." But nothing is accomplished by such a declaration. A hymn is a work of music; and we all agree that music is one of the arts. So even if one declines to call a hymn a work of art, it remains a work of one of the arts. So too for work songs, icons, memorial art, and so forth. Though there is an art world, and though that world constitutes a sphere comparable to the spheres of higher education, the media, business, medicine, and so forth, there is no sphere of the arts in general. Rather than constituting a distinct sphere of its own, art is interwoven with life in all the other spheres.

Why was Kuyper oblivious to this point? Why did he assume that the modern art world constitutes the totality of art in our lives? Why did the many ways in which we engage works of the arts other than as objects of disinterested attention fall out of his purview, along with the works so

engaged? I submit that it was because of the influence on his thinking of the grand narrative of art in the modern world. He assumed that the arts come into their "maturity" insofar as they are engaged as objects of disinterested contemplation for the sake of their beauty.[26] And that assumption led him, along with most other philosophers and theorists of art in the modern period, to focus exclusively on such art and to ignore all the rest. If art comes into its own when works of the arts are engaged as objects of disinterested attention, why attend to other ways of engaging works of the arts? Historians, sociologists, and anthropologists might find it interesting to do so; but why would anyone else?

WHY THE GRAND NARRATIVE SHOULD BE REJECTED

Consider the claim that art comes into its own insofar as works of the arts are engaged as objects of disinterested contemplation. Those who embrace the grand narrative claim or assume that the changes that took place in the early modern period in how works of the arts were engaged were not merely *changes* but that they represented *progress*, progress of a special sort: the arts were now coming into their own, reaching their historical destiny, their *telos*. The only way in which the arts could progress henceforth would be by disinterested contemplation becoming more firmly entrenched in the public and by progressive developments within the body of works made and presented for disinterested contemplation. Should some other mode of engagement gain prominence, that would constitute regression. I find both the progress-claim and the *telos*-claim dubious.

The claim that a certain change in some social practice represents progress over earlier stages of the practice is not itself problematic. Theoretical physics is a social practice; I dare say we all agree that the present stage of physics represents progress over earlier stages. Indicators of the fact that changes that have taken place represent progress are the fact that present-day physics has discovered the existence of entities of which the physics of earlier centuries had no inkling, the fact that present-day physics has explanations for phenomena that the physics of earlier times either could not explain or could only explain in ways that we now know to be mistaken, and the fact that what

[26]Kuyper, *Lectures on Calvinism*, 158.

was true in the physics of prior centuries has been incorporated into present-day physics and what was false has been discarded and left behind; it is no longer of interest to physicists, only to historians of physics.

Now turn to the arts. Nothing remotely resembling the telltale signs of progress in physics is to be found in the early modern developments in the arts. Physics leaves behind whatever it does not incorporate from the past into its present stage. In the arts, almost nothing has been left behind: liturgical art has not disappeared, memorial art has not disappeared, devotional art has not disappeared, social protest art has not disappeared, dance music has not disappeared. All these ways of engaging works of the arts are still with us. About the only thing that has disappeared is work songs; and their disappearance is due not to developments in the arts but to the changed nature of work in the modern world. If those other ways of engaging works of the arts had disappeared, we could then consider whether their disappearance, coupled with the increasing prominence of disinterested contemplation, represented progress in the arts. But they have not disappeared, so the question is moot.

Alternatively, had these other ways of engaging works of the arts continued but somehow lost their point because of the increasing prominence of disinterested contemplation, rather in the way that the physics of prior days has lost its point given present-day physics, then it might be right to say that the seventeenth- and eighteenth-century developments represented progress in the arts even though all those other ways of engaging works of the arts are with us still. But the rise into prominence of disinterested attention has not made those other modes of engagement lose their point; memorial art, for example, is as relevant as ever.

Or if those other ways of engaging works of the arts had continued but, because of the increasing prominence of disinterested attention, were now just repeating themselves, spinning their wheels, then too it might be right to say that the developments in the early modern period represented progress. But nothing of that sort has happened either. Those other ways of engaging works of the arts have proved to be full of creative developments. In liturgical music before the seventeenth century there was nothing remotely like the African American spirituals; in memorial art there was nothing remotely like the Vietnam Veterans Memorial.

If the early modern developments did not represent progress in the arts, then the question does not arise whether reaching that stage of progress represented the arts attaining their *telos*. But I submit that the idea of the arts as having a *telos*, and of attaining that *telos* in the early modern period, would be dubious even if the early modern developments had represented progress in the arts.

If some social practice reaches a stage of progress where a sort of *stasis* sets in and nothing new of any significance happens for some time, then one might conclude that it had reached its *telos*—though how one would decide whether it had reached its *telos* or had instead come to a dead end or was awaiting its next inventive genius, is a good question. But the early modern developments did not initiate a period of *stasis* in the arts. Art for disinterested attention, memorial art, liturgical art, social protest art—in all of them there has been extraordinary creativity over the past three centuries. The claim that the arts came into their own in the early modern period must be rejected both because the arts fail to exhibit any of the telltale signs of progress and because, even if the early modern developments had constituted progress, there has been no *stasis* in the arts that would lead one to conclude that they had reached their *telos*. Whatever we make of the early modern century developments, they do not have the art-historical significance that the grand narrative ascribes to them.

Neither do they have the sociological significance ascribed to them by the grand narrative. An obvious point to make here would be the influence of the market on artistic creation: the market is no less demanding than were aristocratic and ecclesiastical patrons. Let me instead make a less obvious point. Consider someone who composes a symphony. He does not invite his musical imagination to flow wherever it will and then look back at a certain point and notice that, lo and behold, what has emerged is a symphony. Having the traditional genre of *symphony* in mind, he aims to compose an excellent new example of that genre. And as for the availability of that genre as a candidate for his compositional activity, it is impossible to explain the emergence and endurance of that genre without appealing to a large number of sociological, economic, educational, and technological considerations. In most societies there was no such genre; it was because of developments more or less unique to modern Western society that the genre of *symphony*

emerged in our society. Symphonies are socially embedded rather than socially transcendent. The same point applies, mutatis mutandis, to works of other artistic genres.

There is another reason for rejecting the grand narrative: recent developments in the art world, especially in the visual art world, are such that the grand narrative simply does not apply. The grand narrative is a story concerning the art-historical and sociological significance of the changes that took place in the early modern period in the arts, that is, in poetry, painting, sculpture, music, and architecture (by the end of the eighteenth century, prose drama and fiction had also come to be called "arts"). The present-day visual art world presents for attentive viewing entities that are not works of any of those arts: fiber art, glass art, wood-turning art, photographs, ready-mades, installations, performance art, light art, earthwork art, sharks in formaldehyde, on and on it goes, and where it stops, nobody knows. The idea of *the arts coming into their own* simply has no purchase on these developments. One could, of course, refuse to call any of these works "art." But they are currently presented for viewing in the institutions of the visual art world and are commonly called "art." We need a new framework for thinking about art. The grand narrative won't do.

The recent developments to which I have just now pointed make the terminology in this area extremely confusing. So before I present my alternative framework for thinking about the arts, let me explain how I have been using, and will be using, various terms. When I use the term "the arts" with no adjective, I will mean the traditional (fine) arts: Kristeller's list, poetry, painting, sculpture, music, and architecture, plus prose drama and fiction, and perhaps dance. And by the term "a work of the arts" I will mean a work of one of those traditional (fine) arts. In the twentieth century a number of additional phenomena have come to be called "arts," for example, photography, film, and ceramics. I call these "new arts." When I want to refer to a work of one of those new arts, I will call it "a work of one of the new arts." By "an artwork" I will mean a work presented by some art institution for attentive viewing, listening, or reading. Some artworks are works of the arts, some are not; some are not even works of one or another of the new arts. Conversely, some works of the arts are artworks, some are not (for example,

work songs). When I speak of "art" rather than "the arts," I mean works of the traditional and new arts along with artworks.

A NEW FRAMEWORK

What do we want out of an alternative framework? What are the desiderata? Obviously we want a framework that does not commit us to the claim that the arts come into their own insofar as we engage works of the arts as objects of disinterested contemplation. But that's a negative desideratum. What are the positive desiderata?

One positive desideratum is that it be a framework that enables us to discuss not only attentive viewing, listening, and reading, along with the works so engaged, but also the many other ways in which we engage works of the arts, along with the works so engaged. Not only do we listen to symphonies; we sing hymns.

A second positive desideratum is that it be a framework that enables us to discuss not only various modes of public engagement of works of the traditional and new arts, but also the making and the public presentation of such works.

Third, writers about the arts have paid a good deal of attention in recent years to the social embeddedness of art. Rather than regarding art as autonomous and socially transcendent, they have brought to light the many ways in which art is involved in the social dynamics of our societies rather than transcending those dynamics. I suggest, as a third positive desideratum of the framework we are looking for, that it be a framework that enables us to discuss the many ways in which art participates in social dynamics.

And last, but by no means least, it must be a framework that enables us to discuss what has been taking place in the art world in recent years, especially in the visual art world, where works are presented for attentive viewing that are not works of any of the traditional (fine) arts. They are artworks, but not works of any of the traditional arts. Some are works instead of one or another of the new arts: film, photography, ceramics, and so forth. But a good many are not even that.

The two basic ideas in the framework that I propose are the idea of *the social practices of art* and the idea of *meaning in works of the traditional and new arts and artworks*. In *Art Rethought* I articulate both of these ideas in

considerable detail. Here I can do no more than give a brief glimpse of them. Begin with the first, the social practices of art. In an earlier book of mine, *Art in Action*, I argued that rather than focusing on works of the arts as if they were autonomous entities, we should place the works within the context of action; artistically we act, I said. I now think that that was too atomistic a way of thinking. The actions in question must be seen as enactments of social practices.

Here is obviously not the place to offer an account of what constitutes a social practice in general; I shall assume that the reader already has an adequate grasp of the concept.[27] Let me simplify things by explicitly speaking only of works of the traditional and new arts, not of artworks that are not works of those arts.

In each of the traditional and new arts there are multiple social practices for public engagement of works of the arts; you and I, as members of the public, are inducted into these practices. We are, of course, inducted into the social practice of paying absorbed attention for its own sake to some work of the arts; but we are also inducted into the social practice of singing hymns and patriotic songs, into the social practice of kissing icons, into the social practice of dancing to music, and many more.

Second, in each of the traditional and new arts there are multiple social practices for making works of art: the practice of composing hymns, the practice of composing symphonies, the practice of painting icons, the practice of painting easel paintings. Neophytes to the activity of artistic creation do not, in ignorance of the creative activity going on around them, ascend into some garret and there start producing paintings, sculptures, lyric poems, symphonies, and the like. They are inducted into some social practice of artistic making by going to art school, by taking lessons, by following models.

Third, in each of the traditional and new arts there are multiple social practices of performing or presenting works for engagement by the public: performance practices works of music and drama, display practices for paintings and sculptures, and so forth. In the modern world, one of the most common ways in which paintings are presented for engagement by the

[27] A now-classic analysis of the idea is in Alasdair MacIntyre, *After Virtue* (Notre Dame, IN: Notre Dame University Press, 1981).

public is being hung on a wall in good lighting. Initially this may strike one as so simple and uncomplicated as to make thinking of it as the exercise of a social practice seem like overkill. But reflect on the fact that in the Pitti Palace in Florence paintings are hung from floor to ceiling and wall to wall with hardly any breathing space between them, whereas in MOMA even medium-size paintings are given roughly fifty square feet of their own. Clearly there are practices coming to expression in these differences. Museums do not go out into the highways and byways hiring the unemployed to hang paintings, giving them full freedom to hang them as they wish. They induct novices into their own preferred version of an ongoing social practice and tradition.

I have been calling attention to the fact that in each of the traditional and new arts there is a multiplicity of social practices of public engagement, a multiplicity of social practices of artistic creation, and a multiplicity of social practices of performance or presentation. The pie can be sliced differently. Take the practice of absorbed attention for its own sake to works of visual art. Clustered together with that practice is the practice of creating works for that mode of engagement and the practice of displaying works for that mode of engagement. So too there is the triadic cluster of the practice of venerating icons, the practice of creating icons for that mode of engagement, and the practice of displaying icons for that mode of engagement. The practice of singing work songs is distinctly different. There is no distinction between performance and public engagement; the performance is the public engagement. And most work songs are not composed; they emerge.

Let's move on to meaning in works of the traditional and new arts. In *Art Rethought* I distinguish two types of meaning. What I call *maker-meaning* is what the artist was doing and trying to do in creating his or her work. What I call *social practice-meaning* is the significance the work has for those who participate in whatever be the social practice whereby it is engaged. Typically philosophers of art, art critics, and art historians have assumed that the only relevant social practice-meaning of works of the arts, when engaged as objects of attentive viewing, listening, or reading, is their aesthetic significance or meaning; I argue that their social practice-meaning when so engaged often extends far beyond their aesthetic significance. And when we turn, say,

to the social practice of singing while working, aesthetic significance pales before other considerations.

APPLYING THE FRAMEWORK

In *Art Rethought*, after articulating in considerable detail this alternative framework for thinking about art, I then employ the framework to analyze the social practices of memorial art, of art for veneration (icons), of social protest art, of work songs, and of a recent development in the visual art world that I call *art-reflexive art*.[28] In each case I then go on to analyze the social practice-meaning of a few examples of that form of art. After analyzing the social practice of social protest art, for example, I go on to analyze the social-practice meaning of Harriet Beecher Stowe's novel *Uncle Tom's Cabin* and the social-practice meaning of Käthe Kollwitz's lithographs.

To give the reader some sense of what the social-practice approach to art looks like when applied, let me very briefly summarize what I say about the memorial art of Belfast, Northern Ireland. Most

Figure 9.2. The Bogside Artists, *Death of Innocence (Annette McGavigan)*. The mural marks the death of a fourteen-year-old girl who was killed by a British bullet while walking home from school. The mural is just a few meters from where she died.

writers on memorial art assume its point to be to preserve or enhance memory by the public of some person(s) or event(s) from the past. I argue that though memorial art does often serve this function, it doesn't always.

[28]By "art-reflexive art" I mean art that is presented as arguably a counterexample to some component of the then-current ideology of art. Duchamp's *Fountain* was the first, and remains the most famous, example of art-reflexive art.

I give the example of a memorial concert that was held in St. Patrick's cathedral in New York City for the victims of 9/11. The concert was too evanescent to function to preserve or enhance public memory of the victims of 9/11. What it did do, I argue, is *honor* the victims. I argue that the essence of memorial art is to honor some person(s) or event(s) from the past.

Belfast is full of murals on large walls and on the gable ends of buildings, all painted by folk artists (fig. 9.2). Most of the murals are memorial art, specifically, *polemical* memorial art. Those painted by Protestants memorialize persons and events important in the story of conflict in Ireland as told by Protestants; the episode of King Billy crossing the River Boyne is central. Those painted by Catholics memorialize persons and events important in the story of conflict in Ireland as told by Catholics; the Easter Uprising of 1916 and the hunger strike of Bobby Sands are central. By way of honoring the heroes of each party, these memorials function to preserve and enhance group-identity, that identity being a blend of pride and grievance. To the best of my knowledge there is nothing like it anywhere else in the world.

No attempt is made to protect the murals against the elements. When they deteriorate, some are repainted, others are painted over. Some are well-painted; the aesthetic quality of most of them is merely so-so. But one would miss their significance entirely if one approached them in terms of aesthetic quality. If it's aesthetic quality that one is interested in, one will forgo the murals and instead spend a day or two in Belfast's very fine art museum. The murals are not functioning to reward absorbed aesthetic attention. They are doing something else, something that the residents of Belfast obviously regard as very important. To acknowledge and understand what that is we have to break the grip on us of the grand narrative of art in the modern world and open our eyes to the many other ways in which art inhabits our lives.

DOES THIS WAY OF THINKING ABOUT THE ARTS STAND IN THE NEO-CALVINIST TRADITION?

To the best of my knowledge, all my fellow philosophers of art who locate themselves in the Neo-Calvinist tradition inaugurated by Abraham Kuyper follow Kuyper in accepting the grand narrative of art in the modern world

as their framework for thinking about art.[29] They depart from Kuyper mainly in that they do not prioritize beauty as he did. Calvin Seerveld, elaborating some hints in Schiller and Kant, locates the aesthetic dimension in what he variously calls allusivity, suggestiveness, acting as-if, and making-believe. Lambert Zuidervaart, following in the tradition of Hegel and Adorno, argues that art has to do more with truth than with aesthetic delight. But all of them focus their attention exclusively on the art of the art world. An obvious question, then, is whether the way of thinking about art that I propose stands outside the Neo-Calvinist tradition.

Before I answer that question, let me observe that it has sometimes been suggested to me that the way of thinking that I propose stands in the pragmatist tradition. If one takes John Dewey's *Art as Experience* as the classic statement of the pragmatist approach to art, it clearly does not stand in the pragmatist tradition. In *Art as Experience* Dewey argues that the aesthetic dimension of experience is to be found throughout our lives, not just in our experience of art. But when Dewey thinks of art, he too thinks of the art of the art world. He has no more interest than do other philosophers in the many ways we engage works of the arts other than as objects of absorbed attention. He too thinks within the framework of the grand narrative.

I suggest that the way of thinking about art that I have proposed echoes a deep theme in the Calvinist and Neo-Calvinist traditions. I can use something Kuyper says in his lecture "Calvinism and Art" to make the point. Toward the end of the lecture Kuyper asks whether there was anything characteristic of Dutch art of the Reformation and post-Reformation period. He argues that there was.

Calvinism, he notes, insisted that everybody has a calling before God, not just princes and prelates but also butchers, bakers, and candlestick makers.

[29]Note by the editors: This does not apply to art historian Hans Rookmaaker. In his book *Art Needs No Justification* (Vancouver: Regent College Publishing, 2010) he discusses the ill-fated shift from art to Art and its harmful consequences. His book *Art and Entertainment* (first published in Dutch in 1962) also widens the scope of art that plays a role in our lives. In his article "Does Art Need Justification?" he advocates for art as part of our everyday reality: "Music, rhetoric, poetry make up a large part of our social functions and religious activities; and architecture, furniture and textile design, interior decoration, painting and illustration provide the setting for our movements and actions" (in *The Creative Gift: The Arts and the Christian Life*, in *Complete Works*, vol. 3 [Carlisle, UK: Piquant, 2021]). In line with this position he wrote the book *Jazz, Blues, and Spirituals* (published in Dutch in 1960; published in English in *Complete Works*, vol. 2).

"By the light of common grace it was seen that the non-churchly life was also possessed of high importance. . . . Having been overshadowed for many centuries by class-distinctions, the common life of man came out of its hiding-place like a new world, in all its sober reality. It was the broad emancipation of our ordinary earthly life."[30]

This profound alteration of religious and political sensibility was reflected in the art that was then being created. "Thus far the artist had only traced upon his canvas the idealized figures of prophets and apostles, of saints and priests; now, however, when he saw how God had chosen the porter and the wage-earner for Himself, he found interest not only in the head, the figure and the entire personality of the man of the people but began to reproduce the human expression of every rank and station."[31] Art opened "the eye for the small and insignificant" and opened "the heart for the sorrows of mankind."[32] In short, Dutch art of the period dignified the ordinary, or, more precisely, *revealed* the dignity in the ordinary.

I have argued that those of us who are philosophers of art should break the grip of the grand narrative on our thought and attend to the many ways in which we human beings engage works of the arts other than as objects of absorbed disinterested attention. We should attend to the many social practices of art and to the meaning of works within those practices. We should attend to the many ways in which art is woven into the texture of everyday life. To do so is to acknowledge the dignity of the ordinary.

BIBLIOGRAPHY

Wolterstorff, N. *Art in Action, Toward a Christian Aesthetic.* Grand Rapids, MI: Eerdmans, 1980.
———. *Art Rethought: The Social Practice of Art.* Oxford: Oxford University Press, 2015.
———. *Works and Worlds of Art.* Oxford: Clarendon, 1980.

[30]Kuyper, *Lectures on Calvinism*, 166.
[31]Kuyper, *Lectures on Calvinism*, 166.
[32]Kuyper, *Lectures on Calvinism*, 167.

The Social Protest Meaning of the Graphic Art of Käthe Kollwitz

NICHOLAS WOLTERSTORFF

German artist Käthe Kollwitz (1867–1945) was described by one writer as "impervious to developments in art in the first decades of the twentieth century.[1] Her diaries record no mention of Cézanne or Picasso."[2] To understand the meaning of her art, we must realize that she intentionally rejected the tradition of fine art represented by Cézanne and Picasso and located herself within the alternative tradition of social protest art.

In histories of aesthetic style, Kollwitz's work receives little if any notice. After noting that there is "a systematic exclusion of socially involved art from modernist art history," Renate Hinz goes on to observe that in such history, "Kollwitz is seen as a rather quaint figure whose art and values were embarrassingly 'uncool.' This is the way I was conditioned to look at her work."[3] While receiving scant mention in modernist art histories, in the tradition of social protest art Kollwitz's work rivals in

[1] Taken over with permission from Nicholas Wolterstorff, *Art Rethought: The Social Practices of Art* (Oxford: Oxford University Press, 2015).

[2] Elizabeth Prelinger, "Kollwitz Reconsidered," in *Käthe Kollwitz* (New Haven, CT: Yale University Press, 1992), 77. This publication also includes essays by Alessandra Comini and by Hildegard Bachert.

[3] Renate Hinz, introduction to *Käthe Kollwitz: Graphics, Posters, Drawings* (New York: Pantheon, 1981), vii. On Kollwitz's indeterminate place in the canon of modern art, see Hildegard Bachert, "Collecting the Art of Käthe Kollwitz," in Prelinger, *Käthe Kollwitz*, 130-32. She quotes Hilton Kramer as saying, "Kollwitz's art remained to the end more concerned with its themes than with style as an end in itself. . . . [She] was not a great artist, but her vision was authentic and her own" (131).

significance, if it does not surpass, the eighty-two great prints of Francisco Goya that have come to be called *The Disasters of War*.[4] She was one of the great artists of the first half of the twentieth century.

Kollwitz produced no abstract art, no landscapes, no still lifes, no interior views. The focus of everything she produced was human beings; sometimes there is nothing but human beings—no background, no indication of setting. And apart from the large number of self-portraits that she produced, always the human beings were members of the proletariat, down and out, suffering, oppressed— never the oppressors, only the oppressed, and never members of the bourgeoisie or the upper class.

Late in her life Kollwitz, looking back, remarked that initially she focused on the proletariat because that's where she found beauty.[5] Writing in response to a questionnaire on "the dignity of art" prepared by someone who had earlier called her work "gutter art" and said that she would have done better had she become a union functionary, she said that, originally, "the idea of a conscious commitment to serve the proletariat was the farthest thing from my mind. . . . The simple fact of the matter was that I found the proletariat beautiful. I felt moved to portray the proletariat in his typical attitudes."[6] For me, she said, "the Königsberg longshoremen had beauty; the Polish *jimkes* on their grain ships had beauty; the broad

[4]Goya created the prints late in his life and made no attempt to have them printed and published in his lifetime. They were first printed and published thirty-five years after his death, in 1863. I have described social protest art as art created "to energize and give expression to protest against social injustice" (*Art Rethought*, 195). In the case of Goya's *Disasters of War* series, though it was certainly created to give expression to the horrors of the war then raging in Spain, Goya did not take the steps that would have been necessary for the prints to energize protest against that war.

[5]Selections from Kollwitz's diaries and letters have been published; and there is by now a sizable secondary literature. In addition to the works mentioned above, I have found the following books helpful: Martha Kearns, *Käthe Kollwitz: Woman and Artist* (Old Westbury, NY: Feminist, 1976); and Otto Nagel, *Käthe Kollwitz* (Greenwich, CT: New York Graphic Society, 1971). All of these contain bibliographies, and all but Kearns contain a good many reproductions of her works.

[6]Quoted in Hinz, *Käthe Kollwitz*, xiv.

Figure 9.3. Käthe Kollwitz, *Working Woman (with Earring)*, 1910

freedom of movement in the gestures of the common people had beauty. Middle-class people held no appeal for me at all. Bourgeois life as a whole seemed to me pedantic."[7]

"It was not until later," she said, "when I came face to face with the poverty and misery of the workers, that I also felt the duty to put my art at their service."[8] "Unsolved problems such as prostitution

[7]Quoted in Kearns, *Käthe Kollwitz*, 81.
[8]Quoted in Hinz, *Käthe Kollwitz*, xiv.

and unemployment grieved and tormented me, and contributed to my feeling that I must keep on with my studies of the lower classes. And portraying them again and again opened a safety valve for me; it made life bearable"[9] (fig. 9.3). "The working-class woman shows me much more than the ladies who are totally limited by conventional behavior. The working-class woman shows me her hands, her feet, and her hair. She lets me see the shape and form of her body through her clothes. She presents herself and the expression of her feelings openly, without disguise."[10]

In her diaries and letters Kollwitz makes clear that she was very much aware of what she was doing when she rejected art for art's sake in favor of an art that would serve the purpose of social protest. In a diary entry of 1922 she wrote,

> I know, of course, that I do not achieve pure art in the sense of Schmitt-Rottluf, for example. But still it is art. Everyone works the way he can. I am content that my art should have purposes outside itself. I would like to exert influence in these times when human beings are so perplexed and in need of help. Many people feel the obligation to help and exert influence, but my course is clear and unequivocal.[11]

She wrote in a letter, "One can say it a thousand times, that pure art does not include within itself a purpose. As long as I can work, I want to have an effect with my art."[12] In a diary entry of 1916 she wrote, "A pure studio art is unfruitful and untenable, because that which does not create living roots—why should that exist?"[13] And in a diary entry of 1920 she wrote, "When I drew, and wept along with the terrified children I was drawing, I really felt the burden I am bearing. I felt that I have no right to withdraw from the responsibility of being an advocate. It is my duty to voice the

[9]Quoted in Lucy R. Lippard, "Foreword," in Renate Hinz, *Käthe Kollwitz, Graphics, Posters, Drawings* (New York, Pantheon, 1981) viii-ix.

[10]Quoted in Lucy R. Lippard, "Foreword," in Hinz, *Käthe Kollwitz*, ix.

[11]Quoted in Kearns, *Käthe Kollwitz*, 173.

[12]Quoted in Prelinger, "Kollwitz Reconsidered," 66.

[13]Quoted in Prelinger, "Kollwitz Reconsidered," 79.

sufferings of people, the sufferings that never end and are big as mountains. This is my task, but it is not at all easy to fulfill."[14]

Kollwitz's rejection of art for art's sake was answered by the rejection of her art by those who favored art for art's sake. Bachert quotes a German artist, Horst Janssen, as saying: Kollwitz began "as an excellent etcher. . . . [But] then she was confronted by fate with the real misery of the years 1918, '19, '20, etc., and the images of this misery upset her genuinely. . . . Wanting to react immediately . . . and quickly, . . . she exchanged the etching needle for broad charcoal and soft lithographic crayon, and it was all over with the art."[15]

KOLLWITZ'S CHOICE OF THE GRAPHIC ART MEDIUM

Kollwitz had a number of reasons for choosing graphic art prints—etchings, engravings, woodcuts, lithographs—as her medium rather than painting.[16] When Kollwitz left home in Köningsberg in 1884 for art studies in Berlin, she very much wanted to be a painter. Her instructor, discerning where her talent lay, urged her to concentrate instead on drawing, and introduced her to the graphic artwork of Max Klinger. Kollwitz resisted this advice and for five or six years worked at painting. She found the medium difficult, however, and was acutely dissatisfied with what she produced. In 1890 she took up etching and abandoned painting for good.

Her reason for abandoning painting was not only that she had no talent for it. In Klinger's book *Malerei und Zeichnung* (*Painting and Drawing*) she found a positive reason for turning to drawing and the graphic arts. Klinger contended that, on account of its dependence on color, painting was very much bound to the natural world and was, on that account, less successful than monochromatic prints for "conveying imaginative issues or approaches to the real world that

[14]Quoted in Prelinger, "Kollwitz Reconsidered," 81.
[15]Quoted in Bachert, "Collecting the Art of Käthe Kollwitz," 130-32.
[16]In the latter part of her career, she also created some remarkable sculptures.

extended beyond the sensuous apprehension of material things." Drawing, which Klinger understood to include graphic art, has more in common with poetry in its "potential for the expression of ideas; less complete and concrete in details . . . than painting, drawing was therefore more suggestive in its scope." Klinger described painting as a "pictorial art" whose aim is to provide "pure enjoyment." Drawing, by contrast, is a "reporting" art capable of confronting "the unbeautiful and the repugnant."[17] Liberated from the task of defining every detail, which Klinger held to be intrinsic to painting, "drawing could pursue its purpose of representing ideas. And instead of attempting to beautify things, the print could become a critical tool. 'All masters of drawing,' observed Klinger, 'develop in their works a conspicuous trend of irony, satire and caricature. They prefer to emphasize weakness, sharpness, hardness, and evil. Out of their works bursts almost everywhere a basic tone: The world should not be like this! They practice criticism with their stylus.'"[18] Given her burgeoning empathy with the oppressed, this highly pejorative contrast between painting, on the one hand, and drawing and the graphic arts, on the other, armed Kollwitz with a positive reason for abandoning painting.

She had another reason as well for turning to the graphic arts: a single work of graphic art can have many impressions, and these can be sold inexpensively relative to paintings. Given the emerging sense of her mission, this was important to Kollwitz.[19] She was successful on this score. Her prints were produced in many impressions, some in multiple editions, and were distributed widely and inexpensively.[20]

HOW KOLLWITZ'S PRINTS EVOKE EMPATHY

A work of two or three-dimensional representational art is like a novel in that it projects a world that we are invited to imagine. Its world is much more limited in scope, however, than is the world of a

[17]Max Klinger, *Malerei und Zeichnung* (Leipzig, 1899), 30-33.
[18]Klinger, *Malerei und Zeichnung*, 42-44. Quoted in Prelinger, "Kollwitz Reconsidered," 15-16.
[19]Prelinger, "Kollwitz Reconsidered," 16.
[20]See Prelinger, "Kollwitz Reconsidered," 56.

novel; the world of *Uncle Tom's Cabin* is vast in comparison to even
so peopled a world as Rembrandt's *Night Watch*. And it is very
different in its contents, the most important of the differences being
that it does not present us with the speech of characters, with their
actions over a stretch of time, or with their inner thoughts. Given
these limitations, how does a work of two- or three-dimensional
representational art evoke the emotional and moral engagement
with the projected world that is necessary for it to do its work as
social protest art? In particular, how did Kollwitz's art evoke
empathy and moral judgment? We have a good deal of testimony,
from reviews and other commentary, that it did exactly this. In 1927
an exhibition of Kollwitz's work was held in Moscow. Anatoly
Lunacharski, the People's Commissar for Culture, wrote in a review,
"She aims at an immediate effect, so that at the very first glance
one's heart is wrung, tears choke the voice."[21]

The core of how two- or three-dimensional social protest art
works lies in what Renate Hinz felicitously calls the "body language
of the oppressed."[22] It is the faces,
the gestures, and the ways in which
bodies are disposed, that evoke
empathy in us, for it is these that tell
us what the character is feeling.
When looking at her great print of
1903, *Woman with Dead Child*
(fig. 9.4), in which the mother is naked,
seated on the floor, bent over her
dead child, clutching the child to her
breast, we discern and empathize
with the extreme grief of the woman.
What is operative here is what

Figure 9.4. Käthe Kollwitz, *Woman with Dead Child*, 1903

the eighteenth-century Scottish philosopher Thomas Reid called
"natural signs," along with our interpretation of those. Natural signs
are "features of the face, gestures of the body, and modulations of

[21]Quoted in Prelinger, "Kollwitz Reconsidered," 82.
[22]Hinz, *Käthe Kollwitz*, xix.

the voice; the variety of which is suited to the variety of the things signified by them. Nature hath established a real connection between these signs, and the thought and dispositions of the mind which are signified by them."[23] Of course, some of these signs are learned, but Reid argued that many are natural. The only question in the region that he thought worthy of serious discussion was how to account for our interpretation of natural signs. Is it "by the constitution of our nature, by a kind of natural perception similar to the perceptions of sense?" Or do we gradually learn how to interpret them from experience, "as we learn that smoke is a sign of fire, or that the freezing of water is a sign of cold?"[24]

Reid argued for the former explanation. "The first time one sees a stern and fierce look, a contracted brow, and a menacing posture, he concludes that the person is inflamed with anger. Shall we say that, previous to experience, the most hostile countenance has as agreeable an appearance as the most gentle and benign? This surely would contradict all experience."[25] Add to this the point that when we see a sign and see the thing signified "always conjoined with it, experience may be the instructor and teach us how the sign is to be interpreted. But how shall experience instruct us when we see the sign only, when the thing signified is invisible?" This latter is the case here; "the thoughts and passions of the mind, as well as the mind itself, are invisible, and therefore their connection with any sensible sign cannot be first discovered by experience."[26]

In short, "when I see the features of an expressive face, I see only figure and color variously modified. But, by the constitution of my nature, the visible object brings along with it the conception and belief of a certain passion or sentiment in the mind of the person."[27] It is on account of this natural language and our innate ability to

[23]Thomas Reid, *Inquiry into the Human Mind*, ed. Timothy Duggan (Chicago: University of Chicago Press, 1970), 235.
[24]Thomas Reid, *Essays on the Intellectual Powers of Man* (Cambridge, MA: MIT Press, 1969), 635-36.
[25]Reid, *Essays*, 637.
[26]Reid, *Essays*, 637-38.
[27]Reid, *Essays*, 638.

interpret it that "a man in company . . . without uttering an articulate sound, may behave himself gracefully, civilly, politely; or, on the contrary, meanly, rudely and impertinently. We see the disposition of his mind, by their natural signs in his countenance and behavior."[28]

Kollwitz employed a couple of strategies to heighten the emotional effect on the viewer of the "body art of the oppressed." One of these was simplification. In her most powerful prints, there is nothing but anonymous human figures—no background, no setting, nothing to draw our attention away from the natural signs of grief and suffering. The figures occupy almost the entire space of the print. They are close to us; they confront us. They are drawn with extreme economy; witness again *Woman with Dead Child,* or the print of 1926, *Municipal Shelter* (fig. 9.5), in which a woman is seated on the ground, bent over her two sleeping children, sheltering them. And there is no color, just stark black and white.[29]

Figure 9.5. Käthe Kollwitz, *Municipal Shelter,* 1926

[28]Reid, *Inquiry,* 235.
[29]In Tom Fecht, ed., *Käthe Kollwitz: Works in Color* (New York: Schocken, 1988), Fecht argues that there is color in more of Kollwitz's print than we are accustomed to think. Perhaps. But it remains the case that relatively few have color and that, in those, the color is invariably subdued.

Kollwitz herself described her strategy as keeping "everything to a more and more abbreviated form . . . so that all that is essential is strongly emphasized and all that is unessential denied."[30]

A second strategy that she used, many times over, was to give to the overall composition a huddled triangular form. In their grief and suffering these people have turned inward; nothing protrudes. They are immobile. And the compositional form itself is expressive of grief.[31] Prelinger says this about *Municipal Shelter*: "Kollwitz made the entire formal configuration expressive: she exaggerated the hunched-over pose . . . in order to communicate the psychological fragmentation and emotional disintegration of the scene."[32]

When describing *Municipal Shelter*, Prelinger also speaks of the "stark monumentality of the composition."[33] Stark it certainly is. But is it monumental? I think not. The feature of the composition, so I guess, that Prelinger has in mind when she speaks of it as "monumental" is better described, I think, as *confrontational*. In Kollwitz's most powerful prints we are confronted with suffering human beings; there is nothing else to be seen. For *Uncle Tom's Cabin* to work on us as social protest art, we have to read it; that takes time. For Kollwitz's prints to do their work, all we have to do is allow ourselves to be confronted by their images.

In her diaries there are many passages in which Kollwitz talks about how difficult her art was for her, how long and hard she struggled to get it right, and how depressing that struggle often was. In the passages with which I am acquainted she does not explain just what it was that proved so difficult. My guess is that what she found difficult was getting the "body language of the oppressed" just right, so that it was free of sentimentality and so

[30]Quoted in Alessandra Comini, "Kollwitz in Context: The Formative Years," in Prelinger, *Käthe Kollwitz*, 108.

[31]In Nicholas Wolterstorff, *Art in Action: Toward a Christian Aesthetic* (Grand Rapids, MI: Eerdmans, 1987), 96-121, I develop a theory of expressiveness. Rather than presenting that theory here, I refer the reader to my discussion there.

[32]Wolterstorff, *Art in Action*, 43.

[33]Wolterstorff, *Art in Action*, 69.

that it spoke clearly and with power, immediacy, and
wide accessibility.

Of course we know, without being told, that there were some
who did not respond as Kollwitz hoped; they did not empathize
with the characters Kollwitz depicted and did not judge that they
were the victims of injustice. Their empathy was blocked, their
hearts hardened, by the indifference that had been cultivated in
them by their position of social privilege or by some narrative that
they had embraced to the effect that there was nothing to be done
about such unfortunates, or that their condition was their own fault.
One contemporary critic said, "Her blows were directed against a
hardening of the heart."[34]

HOW TRANSFERENCE WAS EVOKED

Kollwitz says in one place that her goal was "to arouse and
awaken mankind."[35] If her prints were to succeed in awakening
viewers, the emotional and moral engagement of viewers with
characters in the projected world of the work had to be transferred
to a similar engagement with live, flesh-and-blood human beings.
The Kaiser, Wilhelm II, was apparently apprehensive that Kollwitz's
prints would do exactly what she intended them to do, namely,
arouse and awaken humanity. The first public display of Kollwitz's
work was at the Berlin Art Exhibit of 1889, where she displayed her
series *The Weavers*. The jury voted to award her a gold medal; the
Kaiser vetoed the award. Earlier he had said, "Art should elevate
and instruct. . . . It should not make the misery that exists appear
even more miserable than it is."[36]

For Kollwitz's prints to effect awakening, viewers had to believe
that the projected worlds of the works were substantially true to
social reality—that the projected worlds showed the social reality
of the day. For someone living in Germany during the first third of

[34]Quoted in Comini, "Kollwitz in Context," 90.
[35]Kearns, *Käthe Kollwitz*, 164. Quoted in Agnes Smedley, "Germany's Artist of the
Masses," *Industrial Pioneers* 2 (1925): 9.
[36]Quoted in Hinz, *Käthe Kollwitz*, xix.

the twentieth century, it would have been impossible to believe that they did not show reality as it was. Germany was full of social agitation and unrest, rife with stories and news about impoverishment. One might have excused the impoverishment in one way or another; one might have been indifferent to it. But one could not have been ignorant of it. Kollwitz, with respect to poverty and other forms of suffering in early twentieth-century Germany, did the same sort of thing that Stowe had done with respect to slavery in mid-nineteenth century America: she invited and enabled viewers to imagine what it was like to be such a human being in a situation of that sort: a mother sleeping on the hard floor of a municipal shelter because she has nowhere else to go, huddled protectively over her two children.

HAVE KOLLWITZ'S PRINTS CEASED TO FUNCTION AS SOCIAL PROTEST ART?

In my discussion I have made ample use of the essay by Elizabeth Prelinger, "Kollwitz Reconsidered," in the volume *Käthe Kollwitz*, published by Yale University Press in cooperation with the National Gallery of Art in Washington. The book is the catalog of an exhibition in 1992 of Kollwitz's works. In the foreword to the volume, the director of the National Gallery, J. Carter Brown, notes that this was the third exhibition at the National Gallery of Kollwitz's work; previous exhibitions had been held in 1963 and 1970. Explaining the idea behind the third exhibition, Brown says, "Kollwitz is largely known in this country through political posters and restrikes of her prints. Her reputation has to some extent been dominated by an emphasis on the social content of her work, often at the expense of her remarkable artistic skills. The present exhibition aims to challenge and augment that view by focusing on the artistic aspect of her achievement."[37]

Introducing her essay in the same volume, Prelinger says,

[37] J. Carter Brown, "Foreword," in Prelinger, *Käthe Kollwitz*, 7.

because Kollwitz was a woman in a field dominated by men, and because she depicted socially engaged subject matter when it was unfashionable, critics have focused on those issues and have rarely studied the ways in which the artist manipulated technique and resolved formal problems. The literature tells too little of the artist as a gifted and technically inventive printmaker, draftsman, and sculptor, a virtuosic visual rhetorician who, in her best work, achieved a brilliant balance between subject and form.[38]

One can, of course, praise and relish the aesthetic merits of Kollwitz's works while acknowledging that they belong to the tradition of social protest art, just as one can praise and relish the aesthetic merits of *Uncle Tom's Cabin* while acknowledging that it belongs to the tradition of social protest literature. But the question these comments ineluctably raise is this: has Kollwitz been coopted by the tradition of fine art? Her prints are nowadays held by museums and art collectors; they are no longer available to the masses.

With full self-awareness of what she was doing, Kollwitz insisted that she had no interest in producing fine art; hers was an art of social protest. May it be that after playing a role in the social protest movements taking place in Germany in the first half of the twentieth century, Kollwitz's art no longer functions as social protest art but now functions as fine art, hanging on museum walls along with Cézanne and Picasso, admired along with their work for its aesthetic qualities, honored for its "technically inventive" contributions to printmaking? Does the body language of the woman huddled on the floor of the municipal shelter with her two small children no longer speak to us? Is it now the composition and the draftsmanship that draw us in? Has aesthetic delight displaced emotional empathy?[39]

[38]Brown, "Foreword," 13.

[39]Max Lehrs, a museum director who knew Kollwitz and was one of her most prominent advocates, remarked in 1903, "It would be very regrettable if [Kollwitz's etchings] found approval from the public merely because of their social

I think not. Be it granted that it is no longer art for the masses, as Kollwitz wanted it to be; it is now art for those who visit museums. And be it granted that the social protest movements in which Kollwitz expected her art to play a role are now long over. I think it remains very difficult not to engage Kollwitz's works as social protest art, very difficult to engage them purely as fine art. The cooptation of Kollwitz by museums has been far less complete than the cooptation, say, of medieval altarpieces. I think the reason for this is that, by removing all specificity and topicality from her images, Kollwitz gave them universal significance.[40] *Municipal Shelter* does not depict a particular woman sleeping with her children in a particular municipal shelter in Berlin in 1926. It depicts *Homeless Woman Sleeping with Children*, anywhere, anytime. In our day it remains the case that there are homeless women sleeping with their children in municipal shelters, under bridges, wherever they can find some protection. Käthe Kollwitz's extraordinary prints have not lost their power to arouse and awaken humankind.

Stowe developed her character Tom with great particularity; Kollwitz's characters lack almost all particularity. Yet both evoke empathy and moral judgment; and both awaken us to injustice in the real world and evoke in us the cry, "This must not be."

BIBLIOGRAPHY

Bachert, Hildegard. "Collecting the Art of Käthe Kollwitz." In *Käthe Kollwitz,* by Elizabeth Prelinger, 117-35. New Haven, CT: Yale University Press, 1992.

Brown, J. Carter. Foreword to *Käthe Kollwitz,* by Elizabeth Prelinger. New Haven, CT: Yale University Press, 1992.

content. . . . Art should not and cannot serve the changing goals of parties." Quoted in Bachert, "Collecting the Art of Käthe Kollwitz," 119.

[40]Renate Hinz remarks: "She did not want her aesthetic productions seen simply as topical art or as political manifestos based on ethical imperative. She wanted them to be regarded as objects of lasting value, which might well have been created for specific occasions . . . but which contained demands as yet unfulfilled, demands for a lasting peace and for truly humane living conditions for all people." *Käthe Kollwitz,* xvi.

Fecht, Tom, ed. *Käthe Kollwitz: Works in Color.* New York: Schocken, 1988.

Hinz, Renate. "Introduction." In *Käthe Kollwitz: Graphics, Posters, Drawings.* New York: Pantheon, 1981.

Kearns, Martha. *Käthe Kollwitz: Woman and Artist.* Old Westbury, NY: Feminist, 1976.

Klinger, Max. *Malerei und Zeichnung.* Leipzig, 1899.

Lippard, Lucy R. Foreword to *Käthe Kollwitz: Graphics, Posters, Drawings,* edited by Renate Hinz. New York: Pantheon, 1981.

Nagel, Otto. *Käthe Kollwitz.* Greenwich, CT: New York Graphic Society, 1971.

Prelinger, Elizabeth. "Kollwitz Reconsidered." In *Käthe Kollwitz,* 13-86. New Haven, CT: Yale University Press, 1992.

Reid, Thomas. *Essays on the Intellectual Powers of Man.* Cambridge, MA: MIT Press, 1969.

———. *Inquiry into the Human Mind.* Edited by Timothy Duggan. Chicago: University of Chicago Press, 1970.

Wolterstorff, Nicholas. *Art in Action: Toward a Christian Aesthetic.* Grand Rapids, MI: Eerdmans, 1987.

IMAGINATION, ART, AND CIVIL SOCIETY: RE-ENVISIONING REFORMATIONAL AESTHETICS

LAMBERT ZUIDERVAART

ART IS NOT A FRINGE ON THE GARMENT OF LIFE. It plays important roles in contemporary society. The same can be said about the aesthetic dimension. These insights, spelled out in Abraham Kuyper's *Lectures on Calvinism*,[1] are central to my own work and to the tradition of reformational aesthetics. But what is art?[2] What social roles does it play? And how should we characterize the aesthetic dimension and its place in human life?

I plan to address these questions as follows. First I give a general description of art, the aesthetic dimension, and their relationship. Then I present my conceptions of artistic truth and art in public. I conclude with some reflections on the reformational tradition in aesthetics.[3]

[1]"Understand that art is no fringe that is attached to the garment, and no amusement that is added to life, but a most serious power in our present existence, and therefore its principal variations must maintain, in their artistic expression, a close relation with the principal variations of our entire life." Abraham Kuyper, *Lectures on Calvinism* (Grand Rapids, MI: Eerdmans, 1931), 151.

[2]Throughout this essay I use *art* and *the arts* to refer to the full range of artistic practices, products, and events: not only the visual arts but also dance, film, literature, music, theater, and the like.

[3]This essay was published as chapter 7, "Imagination, Art, and Civil Society," in Lambert Zuidervaart, *Art, Education, and Cultural Renewal: Essays in Reformational Philosophy* (Montreal:

ART AND THE AESTHETIC DIMENSION

Immediately we face a problem. Philosophers disagree not only about how to define art but also about whether art can be defined. Nor are they alone in such debates. Artists also disagree about how to define art or say it cannot be defined. Moreover, many ordinary folks think art is whatever you call "art." Although I do not intend to discuss these disagreements, it is important to acknowledge them up front and ask what they might tell us about art.

One thing they tell us is that art is puzzling. What's puzzling is that people in Western society experience art every day, yet many think it is not an ordinary part of their lives. This puzzle stems from the kind of society we inhabit and how art has developed within Western society. Until the sixteenth century or thereabouts, art was not a special and distinct branch of culture. Gradually, however, certain forms of practice and experience came together under the heading "fine art" (*schöne Kunst* in German; *beaux arts* in French) and became distinct from craft, manufacturing, and entertainment. Then in the twentieth century the separation of fine art from other branches of culture came under attack from within fine art itself—notably in the anti-art movement of Dada and its spinoffs—to the point that today conflicts about what art is and why it matters are central to art itself.

Social institution. This history, so briefly sketched, leads me to say art is primarily a social and historical institution. What art is and what roles it plays in society are wedded to patterns and trends that shape society as a whole. For example, both as a concept and as a complex arrangement of practices and experiences, fine art emerged in conjunction with the development of a capitalist economy, the rise of a middle class, and the formation of a more democratic public sphere. This does not mean that art is not a distinct social institution, different from other social institutions and having its own roles to play in society. Yet it does mean that the most prominent features of art change as society changes, making it very difficult to say which features (if any) are essential to all art at all times and in every society. Hence I prefer to talk about art as a changing constellation of prominent

McGill-Queen's University Press, 2017), 103-25, 219-21, and it appears here with the permission of McGill-Queen's University Press.

features. Some features are more prominent than others in certain societies and at certain times: different stars in the constellation shine more brightly or they fade, depending on the sociohistorical context.

The development of fine art in Western society made two features especially prominent. One is the artifactual character of art: art involves the making, distribution, and interpretation of individual products or events. Artists paint paintings or write poems or compose and perform pieces of music; these artifacts are shared with other people; and those who view, read, or listen to the artifacts interpret their meaning. Obviously this artifactual character is not peculiar to art. All practices that involve making and distributing things have an artifactual side: craft, manufacturing, and entertainment, for example, but also education, communication, and science. Nevertheless, the rise of fine art brought art's artifactual character to the fore, as artists became more and more intent on making individual products and events that could stand on their own as artworks to be interpreted by others.

The other prominent feature highlighted by the rise of fine art is the aesthetic character of art. Artists, art critics, art publics, and philosophers gradually came to agree that fine art primarily serves aesthetic purposes rather than, say, economic, political, moral, or religious purposes. They did not agree about how to describe fine art's aesthetic character. The important point, however, is not the disagreements but how leading cultural figures after Immanuel Kant largely agreed that fine art primarily serves aesthetic purposes. Indeed, some have said cultural practices and products that do not primarily serve aesthetic purposes—advertising, for example, or political posters or liturgical banners—either are not really art or they are bad art. Not surprisingly, the anti-art movement tended to be anti-aesthetic, challenging the emphasis on art's aesthetic purposes in much of Western philosophy and culture since the eighteenth century.

Although important as a challenge to destructive social forces, this anti-aesthetic movement seems to throw out the baby with the bathwater. In my view, the fact that aesthetic purposes became a prominent star in the constellation of art is an important historical achievement, and it can contribute to human flourishing. It not only calls attention to the importance of aesthetic features in all art, including commercial, political, and liturgical art, but also

makes us more acutely aware of the aesthetic dimension in all of life, all of culture, and all of society. Our philosophical challenge is to understand both how art and the aesthetic dimension are related and how the aesthetic features of art relate to its other features. For there is more to art than its aesthetic character, and there is more to life than its aesthetic dimension.

Before taking up this double challenge, let me pause to consolidate what I have said thus far. I have described art as a distinct social institution whose most prominent features shift as society changes. The development of fine art in Western society has highlighted two prominent features: the artifactual and the aesthetic character of art. Based on that development, we can say, at a minimum, that art is a social institution within which people create, share, and interpret products and events for aesthetic purposes. People also pursue non-aesthetic purposes within this institution. If they refuse to pursue aesthetic purposes, however, or if social patterns make it impossible for them to pursue aesthetic purposes, then either they are not participating in the social institution of art or art is changing into a different kind of institution.

Imagination. Elsewhere I have described the aesthetic dimension of life, culture, and society as imagination.[4] By "imagination" I do not mean a mental faculty or an individual trait. Instead, I mean something that is intersubjective, something that involves interaction among people. Imagination is a complex process in which people interact with each other and with their environment. Three practices make up this intersubjective process, namely, exploration, presentation, and creative interpretation. These practices are part of everyday life. We regularly engage in exploration: we seek to make discoveries when we are not sure what we hope to learn. We also regularly make presentations: we fashion objects or products or events that capture nuances of the meaning we wish to discover. And we regularly practice creative interpretation: we try to make sense of objects or products or events that hold more meaning than ordinary language can convey. In other words, we regularly engage in the practices of imagination: exploring, presenting, and interpreting aesthetic signs.

[4]See chapter 3 ("Kant Revisited") in Lambert Zuidervaart, *Artistic Truth: Aesthetics, Discourse, and Imaginative Disclosure* (Cambridge: Cambridge University Press, 2004), 55-73. What follows is a very brief summary of this chapter.

Aesthetic signs, in this context, are simply the ways in which objects, products, and events function within our practices of exploration, presentation, and creative interpretation. They function as aesthetic signs in their capacities to sustain discovery, to acquire nuances of meaning, and to call forth creative interpretation. For example, a public ceremony, such as the inauguration of a president or a wedding celebration, can function as an aesthetic sign. The lighting, the sound system, the tone of the speeches, the sequence of ceremonial actions, the pacing of the event all contribute to our exploration, presentation, and interpretation of the event's meaning. Obviously such events are more than aesthetic signs: the inauguration is primarily a political event, cementing a transfer or continuation of administrative power; and the wedding ceremony might be primarily a familial event, officially sealing an intimate partnership that interweaves distinct families and personal histories. Yet public ceremonies are events where we carry out the intersubjective process of imagination, where together we engage in exploration, presentation, and creative interpretation. To that extent, they are aesthetic events.

Or, to say it more carefully, they are events that have an important aesthetic dimension. They also are events where we engage in aesthetic evaluation, where we consider the aesthetic merits of what we experience. Why do people dress up when they go to a wedding? Why do they sit or stand where they do and when they do? At more traditional weddings in North America, why do vows get said and rings get exchanged? There are many ways to address such questions. One way is in terms of aesthetic considerations: people dress and gesture and act as they do because they are contributing to the imaginative character of this event. Moreover, they know when a wedding ceremony is aesthetically flawed—when it takes too long, for example, or the costumes, flowers, and ambience do not hang together, or the tone of the spoken remarks is inapt, or the whole event is pretentious or trivial or downright boring. Although we often voice such concerns as praise or criticism of the person in charge, they really are aesthetic evaluations of the event itself—an event in which all who attend are participants.

Philosophers have debated for a long time what the marks of aesthetic merit are and whether these are objective or "merely subjective." Is beauty, for example, merely in the eye of the beholder? My emphasis on imagination as an intersubjective process suggests a different approach. On the one hand,

we can identify standards that people commonly employ, whether they realize it or not, when they evaluate the aesthetic merits of objects, products, and events, standards such as the intensity of a ceremony or the complexity of a design or the depth of a story. On the other hand, we can acknowledge that none of these standards in and of itself captures the full extent of our aesthetic expectations, the full range of what we need and desire when we engage in imaginative practices. Rather, we must point to an open horizon where something like a shared principle holds for us and draws us onward.

I call this open horizon "imaginative cogency." Imaginative cogency is the shared expectation that our practices of exploration, presentation, and creative interpretation should be neither rigid nor arbitrary, that, instead, they should be valid. Imaginative cogency is a societal principle of aesthetic validity. It is the ever-alluring horizon within which we identify and follow aesthetic standards.

Nothing I have said about imagination up to now is peculiar to the arts. Imagination and imaginative cogency are features of everyday life: they occur in all the institutions that make up contemporary society. They also are *crucial* features of everyday life and society: a failure of imagination has serious consequences in education, politics, ethics, and religion. That's why imagination should be a central concern of schooling. Science, technology, engineering, and math—the so-called STEM—subjects are not enough. In fact, these themselves are undermined if schools do not foster or pursue imagination. If, in addition, the arts are crucial for fostering and pursuing imagination, then one can see why the arts are not optional in good schooling. At a minimum, STEM should become STEAM.

Are the arts crucial for fostering and pursuing imagination? I think they are. For art is the one institution in contemporary Western society where aesthetic considerations are decisive. In the language of traditional reformational philosophy, imagination is—or rather, it has become—the qualifying function of art, and artifactuality has become art's founding function. No matter what other features art has, and no matter what other practices are involved in making, sharing, and experiencing art products and events, exploration, presentation, and creative interpretation must accompany and enframe such features and practices in order for them to belong to art as art. Even the artifactual character of art is guided by imagination: making,

sharing, and experiencing art products and events necessarily proceed through media of imagination such as sculptural techniques or musical performance practices or poetic diction. Although the development of site-specific and performance art, along with the rapid acceleration of digital techniques, has vastly expanded the range of media in the visual arts, artists and their publics must still approach these as media of imagination if they intend to be making and experiencing art.

Correlatively, the practices of imagination in art are necessarily tied to art's artifactual character. This places constraints on what can count as art. Your animated conversation with a friend is not art, no matter how inspired and creative it might be, unless you have somehow staged it to be shared with others as a product or event. Although conceptual artists push against such constraints, and although the new social media might seem to turn every user into a proto-artist, the artifactual character of art provides a backdrop against which to judge the purportedly artistic character of such efforts.

Multidimensional art. At the same time, art has many other features beside the artifactual and the aesthetic. Art involves perception and feelings; it both relies on and contributes to education and scholarship; it inevitably involves language and communication; it has economic, political, moral, and religious dimensions. Moreover, the prominence of these other features, and their relation to artifactual and aesthetic characteristics, can change over time and in different contexts. Johann Sebastian Bach's 1727 *St. Matthew Passion* was first composed, performed, and experienced as liturgical music in a church setting, such that its moral and religious dimensions stood out. Since Felix Mendelssohn revived it in 1829 it has been primarily concert music, presented on stage in music halls, with its moral and religious dimensions subsumed for aesthetic purposes. Performers and audiences still experience the music's moral and religious qualities, but they do so non-liturgically and in a concert setting.

This does not mean, however, that somehow Bach's oratorio first became art in the nineteenth century. It was art all along, a complex imaginative product of music, originally liturgical in orientation and now staged primarily for aesthetic purposes. Further, whatever liturgical use it originally fulfilled, it was primed for this use by musical media—instruments, voices, compositional techniques, and so on—that served imaginative purposes.

So-called religious art is still art, as are political art and commercial art. It can be better or worse both liturgically and aesthetically. After the development of fine art, however, religious art cannot be art unless it is artifactual and imaginative.

It is precisely because art is multidimensional that art is crucial for fostering and pursuing imagination in society. If art were only an isolated hothouse for imaginative experiments, as some artists and philosophers think it is, we might wonder about its importance in society. But if, as I have suggested, art is in fact connected with the rest of society by way of its various dimensions, and if imagination is an indispensable dimension in all of life, culture, and society, then art, as a societally connected institution devoted to the practices of imagination, can nurture these practices in education, politics, and, indeed, all of life. Conversely, art itself benefits when imaginative practices in other institutions feed back into art. Isolating art from society would be bad for art. It also would be bad for society.[5]

Unfortunately, elements in both the fine art and the anti-art movements have encouraged the isolation of art, as have technological, economic, and political developments in Western society. To challenge such isolation, and to point toward alternatives, I have developed two notions that highlight art's interconnection with the rest of life. One is the concept of artistic truth. The other is the idea of art in public.

ARTISTIC TRUTH

Controversy. In 2013 controversy broke out in the United States about the truthfulness of the film *Zero Dark Thirty* (fig. 10.1). Critics of Kathryn Bigelow's movie about the search for Osama bin Laden accused it of twisting the truth. The critics were especially upset about the film's disturbing depictions of CIA torture. Some charged that these scenes demean America's battle with the terrorists behind 9/11. Others, such as Senators Dianne Feinstein, Carl Levin, and John McCain, claimed the film grossly exaggerates the role torture played in tracking bin Laden to his compound in Abbottabad, Pakistan, where he was killed on May 2, 2011.

[5]For an elaboration of these points, see Lambert Zuidervaart, "Creating a Disturbance: Art, Social Ethics, and Relational Autonomy," *The Germanic Review: Literature, Culture, Theory* 90, no. 4 (2015): 235-46.

Figure 10.1. Still from the movie *Zero Dark Thirty*, Kathryn Bigelow (Columbia Pictures, 2013)

Roger Cohen, in an op-ed published by *The New York Times*, says such criticisms miss the point. The movie presents a wide audience with "images of a traumatized America's dark side," he writes, and this is important. The movie's "portrayal of torture is truthful," and it builds a case that "whatever torture's marginal usefulness, it is morally indefensible." So, charging the movie with inaccuracy "is a poor thing measured against the potency of truth." Cohen concludes: "Truth is art's highest calling. For it the facts must sometimes be adjusted. *Zero Dark Thirty* meets the demands of truth."[6]

I do not plan to take sides in this debate. What intrigues me is how Cohen makes his case. He appeals to "truth" as art's highest calling, such that it either trumps factual accuracy or justifies inaccuracy. He never says exactly what he means by truth. Yet he employs the term to strong rhetorical effect, so much so that Columbia Pictures incorporated his op-ed into a full-page ad for the movie.

What sustains Cohen's rhetoric, I want to suggest, is an idea of artistic truth. He appeals to an idea that refuses to equate truth with propositional correctness (true propositions) or factual accuracy (established or objective facts). Even though this idea of artistic truth lives mostly underground in contemporary culture, it nevertheless plays a crucial role in our experiences and justifications of the arts. Yet it has fallen out of favor among both analytic and continental philosophers. Among the many reasons for this, two stand out.

[6]Roger Cohen, "Why 'Zero Dark Thirty' Works," *New York Times*, February 11, 2013, www.nytimes.com/2013/02/12/opinion/global/roger-cohen-why-zero-dark-thirtyworks.html.

On the one hand, the mainstream of analytic philosophy has remained attached to what I call a propositionally inflected correspondence theory of truth. According to this theory, truth amounts to the correspondence between propositions and facts, with propositions or their equivalents being the primary or sole bearers of truth. After Monroe Beardsley convincingly argued in 1958 that artworks typically do not convey propositions and do not correspond to facts, many analytic philosophers gave up on the idea that art can be true. Moreover, when prominent analytic philosophers such as Nelson Goodman and Richard Rorty subsequently challenged the dominant correspondence theory, their approaches made artistic truth even harder to conceptualize.

On the other hand, many philosophers in the continental tradition have given up the kinds of sweeping claims about art and truth made in the writings of Martin Heidegger, Hans-Georg Gadamer, and Theodor W. Adorno. Either, like Jürgen Habermas, they have returned to a more modest and primarily propositional view of truth—without necessarily embracing a correspondence theory—or, like Jacques Derrida, they have deconstructed the metaphysical pretensions that seem to inhabit such sweeping claims. Either way, little room remains for a comprehensive conception of truth that gives substantial weight to the role of truth in art.

Cogent imaginative disclosure. Nevertheless, I am convinced that artists and philosophers alike need a robust conception of artistic truth, and I am just foolhardy enough to propose one.[7] I want to capture the widespread intuition that truth is at stake when we make and interpret art. This intuition pertains to all forms of art in contemporary culture—not simply fine art or high art but also mass-mediated art, popular art, and folk art. On my view, art's capacity for truth is crucial to both its aesthetic worth and its societal importance.

I conceive of artistic truth as a dynamic correlation between imaginative disclosure and aesthetic validity. As already indicated, my technical term for aesthetic validity is "imaginative cogency." So we can also say that artistic truth is a dynamic correlation between imaginative disclosure and imaginative cogency. Let me unpack this idea of artistic truth by saying first how

[7]What follows is a very brief summary of Zuidervaart, *Artistic Truth*, 118-39.

I understand imaginative disclosure. Then I will discuss the three relations that make up artistic truth.

Imaginative disclosure has to do with acquiring and sharing insights. I regard the arts as ways in which we discover, disseminate, and test insights into ourselves, others, and the society and universe we inhabit. These insights need not be articulated in language, although they often can be articulated, nor do they usually need to take propositional form, although we sometimes can translate them into propositions. At the same time, however, these insights are not simply feelings or emotions, even though our feelings and emotions help give us access to them. We have access to these insights via the media employed in the various arts—musical, literary, visual, and so on—and via trained sensory capacities. In fact, one could revitalize the static and visual metaphor of "insight" by coining more dynamic terms such as *inhearing*, *inreading*, and *intouching*. Instead, I replace the term *insight* with the term *disclosure*, which suggests both discovering and uncovering via various media and sensory capacities. In the arts we employ imaginative media to imaginatively disclose ourselves, others, and the society and universe we inhabit.[8]

Indeed, I see the practices of imagination and the pursuit of imaginative cogency as one important way in which we can contribute to interconnected flourishing of human beings and other creatures. Of course, as we have seen, there is much more to art than imagination. The arts are multidimensional. Yet the practices of imagination—exploration, presentation, and creative interpretation—are decisive in the arts, such that whatever the arts contribute to politics, economics, and civil society must flow through imaginative channels. That is why artistic truth is crucial for the roles art plays in society. The arts are a dedicated site in society for imaginatively cogent disclosure in which human beings and other creatures can come to flourish.

[8]Disclosure, however, includes more than imaginative disclosure, and truth, in its most comprehensive sense, is more than disclosure. I explore these broader notions of disclosure and truth in Zuidervaart, *Artistic Truth* (chaps. 4-5), when I discuss Martin Heidegger's conception of truth in *Being and Time* and in his essay "The Origin of the Work of Art." See also Lambert Zuidervaart, "Unfinished Business: Toward a Reformational Conception of Truth," *Philosophia Reformata* 74 (2009): 1-20, republished as chapter 14 in Lambert Zuidervaart, *Religion, Truth, and Social Transformation: Essays in Reformational Philosophy* (Montreal: McGill-Queen's University Press, 2016), 277-97. I will work out the details in *Social Domains of Truth: Science, Politics, Art, and Religion* (New York: Routledge, 2023).

Authenticity, significance, integrity. We can specify what artistic truth amounts to by distinguishing three relationships in which cogent imaginative disclosure occurs. One is the relationship between the artist or art producer and the art product or art event. The second relationship lies between the audience or art public and the art product/event. The third relationship is internal to the art product itself when it is institutionally constituted as a work of art.[9] Moreover, the first two relationships are not simply between artists or audiences and art products/events. They are simultaneously interrelations between artists and their audiences: artists and audiences interact with each other by way of the art products and events they make and interpret.

Artistic truth in the first relationship—that between the artist and the art product/event—amounts to the expectation of authenticity. Artists bring their personal histories, traditions, training, concerns, and community involvements to the process of making art. It is common for them to try to be authentic in this process. It is also common for audiences to expect authenticity in the making of art.

What does this expectation of authenticity come to? I do not think it is simply a matter of each individual artist being true to the artist's own self, whatever that might mean. Rather the expectation is that the artist's practices and the resulting art product or event will be true with respect to what drives the artist to engage in art making. I summarize this driving force as the experience or vision from which competent art making allows an art product to arise. We expect art products to disclose in an imaginative fashion the experience or vision that gives rise to their production. We tend to prize more highly art products that are cogent in this regard—ones that are "original," that give surprising and compelling expression to the

[9]Throughout this essay I assume a distinction between art products and art events. Whereas a piece of music is a product, for example, a music recital is an event. Everything I say about artistic truth is meant to apply to both products and events, even though sometimes I mention only products. I also consider artworks to be only one type of art product. Artworks are art products that are fashioned to stand on their own, thanks to an elaborate nexus of institutional supports—in music, for example, published music scores, professional musicians, concert and recital halls, specialized performance groups, electronic modes of music dissemination, educated listeners, and a philosophical idea of the autonomy of art. For more on these distinctions, see Zuidervaart, *Artistic Truth*, 7-8, and Lambert Zuidervaart, "Fantastic Things: Critical Notes Toward a Social Ontology of the Arts," *Philosophia Reformata* 60 (1995): 37-54—republished as chapter 5 in Zuidervaart, *Religion, Truth, and Social Transformation.*

originating experience or vision. We also turn to art products for insight into and from the personal worlds of those who make art, seeking to learn something important for our own lives. This is so regardless of whether the artist is an individual or whether the art product results from a collaborative effort. In short, artists and audiences alike expect art products to be true in the sense of being authentic. They expect art products and events to be cogently and imaginatively disclosive of the experience or vision from which these arise.

Artistic truth in the second relationship—that between the audience or art public and the art product—amounts to the expectation of significance. Audiences and art publics bring their histories, traditions, preparation, interests, and community involvements to the process of interpreting art. It is common for them to find art products and events more or less significant. And it is common for artists and art producers to try to make art that can be significant.

What is this expectation of significance? It is not the same as relevance. An art product or event can be relevant by addressing an urgent issue or by connecting with an audience's interests, yet not be very significant. The movie *Zero Dark Thirty* is certainly relevant in that sense. But is it significant and, if so, how significant is it? The expectation of significance pertains to the degree to which the art product presents something that is worth an audience's engaging with it. It concerns whether and to what extent an art product is worth our while, the degree to which it deserves our attention. Behind this expectation lies a need for cultural presentations that help us make imaginative sense of our lives within the society and universe we inhabit. Art products that fail to do this can seem like a waste of time. Art products that do this with a high degree of cogency come across as provocative or even profound. They can uncover our interpretive needs and help us discover or rediscover ourselves and the social world within which our interpretive needs arise.

Significance is the shared expectation that art products should be true with respect to an audience or public's need for cultural presentations that are worth its while. We expect art products and art events to be cogently and imaginatively disclosive of our own need for worthwhile cultural presentations. As this formulation suggests, when we creatively interpret a

product or event of art, we simultaneously come to terms with our own need for what this art does or does not present. In that sense, the cogent imaginative disclosure accomplished in art is also a disclosure of those who interpret art.

The third relationship in which artistic truth occurs is internal to artworks as such. Here I refer to the integrity of the artwork. Integrity has to do with the meaning or import that is intrinsic to a work of art. Like all other aesthetic signs, artworks present nuances of meaning about something other than themselves. *Zero Dark Thirty*, for example, is about the political, legal, strategic, and moral struggles Americans and others have faced after 9/11. Unlike other aesthetic signs, however, artworks simultaneously are very much about themselves. Whether explicitly or implicitly, an artwork calls attention to its own status and role as a nuanced presenter of meaning. In *Zero Dark Thirty*, the camera angles, crosscutting of scenes, and high-powered soundtrack remind one repeatedly that this is a filmic dramatization of recent history, not a documentary film, and certainly not a presentation of evidence in a court of law. Like other artworks, Kathryn Bigelow's movie presents its import by presenting itself, and it presents itself in presenting its import. An artwork with integrity will do both of these successfully and at the same time.

Integrity is the expectation that the import of an artwork should be true. To be true, this import must occur in an artwork that lives up to its own internal demands, one of which is to live up to more than its own internal demands. That is simply another way to say that the artwork whose import is true will succeed at simultaneously presenting itself when it presents import about something other than itself. When an artwork is cogent in such (self-)disclosure, we find it "unique" or "challenging," and we prize it for this. We also discover that it points us to its own world, one that can illuminate or disturb or reorient our personal and social worlds. The imaginatively cogent artwork asks us to interpret its configured import and, in doing this, to interpret its world—a world that exceeds the artist's world or the world of the interpreter.

Artistic truth, then, has to do with three expectations and how they are satisfied. We expect art products and events to be authentic with respect to their production, significant with respect to their use, and, when they are

artworks, integral with respect to their internal demands. An artwork that meets all three expectations in a cogent way will imaginatively disclose the experience or vision that sustained its production, an audience's need for worthwhile cultural presentations, and the artwork's internal but not simply internal demands. Artistic truth is a matter of cogent imaginative disclosure in all three respects.

As I said before, art's capacity for artistic truth helps make it important in society. Truthful art can introduce us to an artistic vision that disturbs our sense of justice and injustice, our understanding of who is oppressed and why. It can call attention to unmet needs that we would otherwise ignore or shrug off as someone else's problem. And it can usher us into an imaginative world where the struggle for justice and solidarity is complex and compelling, a world where we can find both inspiration and critique. The question of artistic truth does not remove art from the hubbub of daily life. Rather, it points to the important roles art plays in contemporary society. To highlight these roles, I have proposed a theory of art as "art in public." Let me explain.

ART AND SOCIETY

Heated debates in North America in the early 1990s about government funding for the arts prompted my first thoughts about art in public. It struck me that the advocates and the critics of government funding actually shared several problematic assumptions about the arts, government, and the nature of a democratic society. For the next two decades I tried to expose these assumptions and replace them with a better understanding. The result was a book titled *Art in Public*.[10]

Art in public. I use the term "art in public" to indicate two features of much contemporary art, features that debates about government arts funding often overlook. First, the state is heavily involved in the production and use of the arts, regardless of whether it provides direct subsidies. Not only does the state provide indirect subsidies via tax concessions and tax exemptions, but also it maintains the regulatory framework within which artists and arts organizations operate, most notably in the areas of

[10]Lambert Zuidervaart, *Art in Public: Politics, Economics, and a Democratic Society* (Cambridge: Cambridge University Press, 2011). What follows is a brief summary of some themes in this book.

copyright, international trade, and freedom of expression.[11] Second, the term "art in public" points to the fact that much of contemporary art has a public orientation. That is to say, the meaning of such art is available to a broader public than the original audience for which it is intended or to which it speaks. Given how extensively the state is involved in culture and how rapidly computer-based technologies for creating and experiencing art have proliferated, much of contemporary art has become art in public, regardless of how direct or indirect are its links to the state. Very little art that is intended for some audience is private in the strict sense. In fact, the traditional distinction between public and private, which is problematic in any case, seems ever less applicable to the arts.[12]

The concept of art in public immediately affects how one justifies government funding. The standard arguments, whether economic or political, presuppose a static and fixed boundary between artistic creation and experience, on the one hand, and matters of state, on the other. They also assume that unattached individuals privately create or experience discrete works of art either to satisfy their aesthetic needs or to achieve some other end. The standard framework is individualist with respect to who participates in art, privatist with respect to where their participation occurs, and instrumentalist with respect to how.

The concept of art in public challenges these mainstream assumptions. On the one hand, it suggests that the state is unavoidably present in the societal framework of contemporary art and that very little artistic creation and experience would occur without the state's fiscal and regulatory involvement. On the other hand, because much of contemporary art is public in orientation, we can no longer regard art as a field in which unattached individuals carry out private transactions with discrete objects that either have intrinsic value or give rise to external benefits. Rather we need to devise a new model, a post-individualist, non-privatist, and

[11]On the topics of regulation and taxation, see John W. O'Hagan, *The State and the Arts: An Analysis of Key Economic Policy Issues in Europe and the United States* (Cheltenham, UK: Edward Elgar, 1998), 73-130.

[12]Hilde Hein, *Public Art: Thinking Museums Differently* (Lanham, MD: AltaMira, 2006), notes this tendency yet continues to use a distinction between "private art" and "nonprivate art" (which includes what she labels "public art").

communicative model for understanding both the recipients and the rationale of government arts funding. Specifically, we must identify the roles of art in civil society and determine whether government funding can and should strengthen these roles. That is what my book tries to do, thereby recasting the hackneyed debate between advocates and opponents of government arts funding and showing why the arts are important in a democratic society.

Civil society. To show this, I need to say something about civil society. I regard civil society as one of three macrostructures in contemporary Western societies. The other two macrostructures are the for-profit or proprietary economy and the administrative state. Whereas the economy and the state are highly integrated systems that operate according to their own logics, civil society is a more diffuse array of organizations, institutions, and social movements. It is the space of social interaction and interpersonal communication where economic alternatives can thrive and where informal political publics can take root.

The intersections between civil society and the proprietary economy, on the one hand, and between civil society and the administrative state, on the other, have special significance for the role of the arts in a democratic society. I call the first of these intersections "the civic sector." The civic sector is the economic zone of nonprofit, cooperative, and mutual benefit organizations within national and international economies. It is the zone in society that is most conducive to a "social economy"—an economy in which considerations of solidarity take precedence over "efficiency, productivity, and maximal consumption for their own sakes."[13]

I call the second intersection—that between civil society and the state—"the public sphere." The public sphere is a continually shifting network of discourses and media of communication that supports ongoing discussions about social justice and the common good. The public sphere is essential to any modern democratic society. It sustains widespread participation in the shaping of societal structures that affect everyone. It facilitates challenges to the economic system and the administrative state that open these to nonmonetary and nonadministrative

[13]Lambert Zuidervaart, *Social Philosophy After Adorno* (Cambridge: Cambridge University Press, 2007), 129.

considerations. And it promotes democratic communication about matters of general concern.

Philosophical questions. Using these concepts of art in public and civil society, let me now briefly address the debate about government funding. A satisfactory case for government arts funding should address at least five philosophical questions: What good is art? What should the arts contribute to a democratic society? What is the best form of economic organization for art in a democratic society? What right do people have to participate in the arts? And what if anything justifies government funding for the arts?

First, what good is art? Is it a private good? A public good? A merit good? Or are such economic concepts insufficient in order to understand art in public? I argue that art is primarily a sociocultural good. More specifically, art in public is a societal site for imaginative disclosure. That is why people today turn to the arts in order to find cultural orientation. Cultural orientation has to do both with discovering purpose and meaning and with learning why purpose and meaning are absent. People look to the arts for this because the arts have developed in the West as organized settings for exploring, presenting, and creatively interpreting multiple nuances of meaning in our lives, in society, and in the world we inhabit. Accordingly, my own justification for government arts funding argues that by virtue of being positioned in civil society via a civic sector and a public sphere, the imaginatively disclosive character of art in public fulfills important political and economic roles that it is in the public interest to protect, support, and promote.

That introduces the second question: What should the arts contribute to a democratic society? Many things, to be sure, but one contribution stands out when one considers relations between civil society and the state. Art in public helps shape and renew a vital public sphere. A vital public sphere requires cultural organizations and practices in which matters of general concern can be explored, presented, and interpreted. These organizations and practices include the ones that make up art in public. The special contribution of art in public is to help people take up matters of general concern in an imaginative fashion. It helps us disclose in fresh and insightful ways the felt quality and lived experience of concerns that merit public attention.

Art products and events that accomplish such imaginative disclosure foster critical and creative dialogue, both within various publics and among them.[14]

What about the economic underpinnings of art in public? What is the best form of economic organization for art in a democratic society? Should art be a commercial enterprise? Should it be owned and operated by the state? Or is there another option? Clearly there *is* another option. The best way, if art is to help shape and renew a vital public sphere, is that of the civic sector organization. The reasons for this are complex, but they have to do with how solidarity has priority in the social economy of the civic sector.

By "solidarity" I mean the democratic expectation that no individual, group, or community should be excluded from the recognition we owe each other as fellow human beings. It is the expectation that everyone, regardless of their wealth, power, and cultural orientation, should be able to participate in public life and have their worth respected. Whereas the proprietary economic system allows resources to flow constantly toward the private profit of those who control the market, the civic sector brings a different principle to bear on the use of resources. This principle is the imperative to share resources without assurance of private gain. Arts organizations that follow this principle are in a better position than either commercial enterprises or state agencies to foster critical and creative dialogue about concerns that merit public attention.

Yet the civic sector form of economic organization creates a tension between art in public and the proprietary economy, just as art's participation in the public sphere creates a tension between art in public and the administrative state. In fact, we cannot reframe the debate about government arts funding unless we recognize both an economic and a political tension or dialectic.

Economically, civic sector arts organizations foster a sociocultural good that society needs but neither the capitalist marketplace nor the administrative state can adequately provide. Civic sector arts organizations offer real resources in an imaginative fashion and relatively free from the

[14]Understood along these lines, art in public can have political relevance without needing to be overtly political. See, for example, the discussion in Zuidervaart, *Art in Public*, 126-27, of the AIDS Memorial Quilt as a project that offered "profoundly moving and politically relevant imaginative disclosure."

systemic constraints of marketplace and state. They do this within a social economy where solidarity among participants outweighs considerations of efficiency and control. At the same time, however, the most dramatic threats to civil society and to art as a sociocultural good come from the financial imperatives of a global capitalist economy dominated by transnational corporations. Global capitalism threatens to wipe out any form of economic organization that does not make monetary objectives primary and does not fully embrace commercial strategies. This economic pressure threatens art in public. It threatens community-based health care. It threatens genuine education, academic research, and noncommercial broadcasting. It even threatens religious communities and organizations. That is why, in the interest of preserving creative economic alternatives to a dominating economic system, governments do well to protect and subsidize arts organizations in the civic sector. Such arts organizations strengthen the social-economic fabric of society, without which the capitalist market itself would implode.[15] That is one reason why they warrant government support.

The other side to this dialectic is political. It occurs between the communicative role of the arts and the imperatives of state power. On the one hand, art in public has a central role to play in helping people articulate issues and interests that require government attention. Because this articulation occurs as imaginative disclosure, it affords access to public issues and interests in ways that open rather than close conversation and debate. On the other hand, the administrative state is a relatively self-sustaining system that tends to be culturally tone-deaf. Following its own bureaucratic logic, it puts enormous pressures on the public sphere in which such art participates. These pressures undermine the imaginatively disclosive public communication that democratically elected governments nevertheless require. In the interest of preserving avenues for critique and redirection of the state's own power-driven operations, then, governments do well to protect and subsidize civic sector organizations that sponsor art in public.[16]

[15]On the importance of civil society to a market economy, see John Keane, *Global Civil Society?* (Cambridge: Cambridge University Press, 2003), 75-88.

[16]Zuidervaart, *Art in Public*, 77-83, discusses these systemic economic and political pressures at greater length under the heading "Hypercommercialization and Performance Fetishism."

Figure 10.2. The NAMES Project AIDS Memorial Quilt, shown in various places since 1987. Each panel is 3 feet by 6 feet, approximately the size of a grave. The panels made typically of fabric are created in recognition of a person who died from AIDS-related complications. The panels are made by individuals and by groups or organizations.

To say that governments should subsidize art in public (fig. 10.2) assumes that people have a right to participate in the arts. What right is that? I do not think it is the economic right to pursue one's own self-interests, as political liberals suggest. Rather, it is a cultural right, and it pertains not simply to individuals but also to the social institutions and cultural communities in which they participate. The problem with the standard liberal notion of rights is twofold. First, it construes the bearers of rights as unattached individuals pursuing their own self-interests. Second, it portrays the state as a neutral agency for sorting out these competing individual rights. By contrast I think that all individual members of society are participants in institutions and communities, and that not only individuals but also institutions and communities are bearers of cultural rights. I also think that the primary normative task of the state is to achieve and maintain public justice for all the individuals, communities, and institutions within its

jurisdiction.[17] So the right to participate in the arts is a cultural right held by individuals, communities, and institutions, and the debate about government arts funding forces us to ask how we envision public justice in the first place. Is public justice simply the state's duty to uphold the rights of discrete individuals and to mitigate economic disparities among them? Or does public justice include the state's obligations toward various social institutions and cultural communities? If it includes these obligations, then the political justification for government arts funding must take them into account. Government funding must help ensure that the social institution of art has room to flourish in a structurally complex society. Art subsidies must also help uphold the cultural rights of diverse communities in a multicultural setting.

That brings us to our final question: What justifies government funding for the arts? I have indicated already that I consider the reasons given in standard economic and political arguments to be insufficient. That's why the following three claims are crucial. First, art is a social institution that has its own legitimacy and makes an important contribution to society. This contribution is primarily one of imaginative disclosure. Second, society needs what the arts offer. Third, the normative task of public justice obliges the state to support the arts in a wide variety of ways, including the provision of direct subsidies. More specifically, the basis for justifying government arts funding has to do with what art in public offers within the context of civil society and with a view to economic and political systems. It offers an imaginative disclosure of meaning that can foster solidarity within a social economy and democratic communication within a public sphere.[18]

REFORMATIONAL AESTHETICS

The account I have given concerning art, the aesthetic dimension, and their roles in society arises from the reformational tradition in aesthetics. This tradition has guided my work for more than fifty years: Hans Rookmaaker's

[17]This understanding of the state's primary normative task, discussed at greater length in Zuidervaart, *Art in Public*, primarily derives from the political and legal philosophy of Herman Dooyeweerd. See in this connection Jonathan Chaplin, *Herman Dooyeweerd: Christian Philosopher of State and Civil Society* (Notre Dame, IN: Notre Dame University Press, 2011).

[18]This gives only the gist of my justification for government arts funding. The last chapter in Zuidervaart, *Art in Public*, lays out a detailed argument that has five primary premises and nearly twenty secondary premises—see 304-11.

Modern Art and the Death of a Culture strongly influenced my early attempts, as an undergraduate at Dordt College (now Dordt University), to understand the challenges facing Christians in the arts today; Calvin Seerveld was my mentor during graduate studies at the Institute for Christian Studies (ICS) and the VU University Amsterdam (VU); Nicholas Wolterstorff was my faculty colleague in the Department of Philosophy at Calvin College (now Calvin University); Adrienne Dengerink Chaplin completed her doctoral dissertation under my supervision at the VU, and later I became her faculty colleague at ICS. The roots of my aesthetics in the reformational tradition might not be obvious, however, because I have reworked reformational insights and emphases to address the issues I consider most important. So let me undertake some excavation.[19]

Seerveld and Wolterstorff. To begin, I should say that I have a Seerveldian understanding of the discipline of aesthetics. In the first instance I consider it a branch of Western philosophy that took shape in eighteenth-century Europe around two main topics: the nature and purposes of the arts, and the nature and role of the aesthetic dimension in life, culture, and society. Like Seerveld, I believe that studying the principles of interpretation and criticism in the various arts also is intrinsic to philosophical aesthetics.[20] Also like Seerveld, I think aesthetics could and perhaps should become a specialized area of research in its own right and not simply a subdiscipline of philosophy, although I would see it as an interdisciplinary field rather than a single discipline.

This understanding of aesthetics is itself indebted to the reformational philosophy of Herman Dooyeweerd and Dirk Vollenhoven. Dooyeweerd and Vollenhoven turned Kuyper's social teaching of sphere sovereignty and John Calvin's theology of creation and redemption into an expansive and

[19]See also Lambert Zuidervaart, "A Tradition Transfigured: Art and Culture in Reformational Aesthetics," *Faith and Philosophy* 21 (2004): 381-92—republished as chapter 5 in Zuidervaart, *Art, Education, and Cultural Renewal*, 87-96.

[20]In his inaugural address as senior member in philosophical aesthetics at ICS, Seerveld says philosophical aesthetics has three tasks: to map out the structure and normative principles of aesthetic life, to develop a general theory and historiography of the arts, and to study the principles that should guide arts criticism and literary criticism, a study he calls *hermeneutics*. See Calvin Seerveld, "A Turnabout in Aesthetics to Understanding," published in 1974 as Institute for Christian Studies Publication No. 1; now republished in Seerveld, *Normative Aesthetics*, ed. John H. Kok (Sioux Center, IA: Dordt College Press, 2014), 233-58.

complex ontology, epistemology, and social philosophy. They translated the teaching of sphere sovereignty into a philosophical theory concerning the distinct character of different social institutions and of creation's modal dimensions. Moreover, Calvin's theology inspired them to call for an inner reformation of the academic disciplines and a transformation of social life. My accounts of art as a multidimensional social institution and of the aesthetic as a ubiquitous dimension of life presuppose their philosophy, just as the socially engaged character of my thoughts about art in public continues the project of inner reformation and social transformation.

There are more specific links to the work of Seerveld and Wolterstorff, however. Seerveld describes the aesthetic dimension in terms of "allusiveness" and "imaginativity." My account of imagination is very similar to this description, even though I emphasize processes and practices more than subjects and objects. Also similar is the fact that I think aesthetic matters necessarily involve normative considerations, which Seerveld discusses in terms of an aesthetic law or aesthetic imperative, and which I formulate as a horizon of aesthetic validity (i.e., the societal principle of imaginative cogency). Moreover, both of us follow Dooyeweerd and Vollenhoven in thinking that art is aesthetically qualified and technically founded,[21] although my account of art as a changing constellation regards its internal organization as a historical achievement and not a permanent and transhistorical structure.

Wolterstorff's book *Art in Action*, which appeared just as I was completing my doctoral dissertation on Adorno's aesthetics, helped move my account of art in this more social and historical direction.[22] I found Wolterstorff's characterization of the West's "institution of high art" very insightful. I also appreciated his attention to the great diversity of roles that art can play in human life and his refusal to privilege aesthetic purposes in an elitist fashion. His emphasis on human actions, and not simply on artworks, pointed me toward the importance of human practices and interrelationships within the arts and led me to an account of art products and events that does not remain stuck in a modernist fixation on the work of art.

[21]Seerveld speaks of the "techno-formative" foundation of art; Dooyeweerd and Vollenhoven speak of its "historical" foundation, but by "historical" they mean roughly what Seerveld means by "techno-formative."

[22]Nicholas Wolterstorff, *Art in Action: Toward a Christian Aesthetic* (Grand Rapids, MI: Eerdmans, 1980). See also my review of this book in *Philosophia Reformata* 48, no. 1 (1983): 87-90.

None of this is to suggest, however, that I have simply picked random elements from reformational aesthetics and used them in my own fashion. Rather, my entire approach is informed by debates within reformational aesthetics and by my questions about shared assumptions underlying those debates. One issue in particular is relevant for the topics of this essay, dating back to the years when I received my graduate training in reformational philosophy (1972–1981). It has to do with faith and contemporary art.

Faith and contemporary art. Three Kuyperian emphases are at the heart of reformational aesthetics. One is the theological story of a good creation disrupted by sin and evil, renewed in the life and ministry of Jesus Christ, and moving toward fulfillment in a new heaven and a new earth. A second is the calling of Christians to be agents of renewal in culture and society. And the third is the notion that such renewal involves not only persons but also cultural practices, social institutions, and the structure of society as a whole.

Because of these emphases, reformational thinkers have asked repeatedly what stance Christians should take toward contemporary art and culture, and they have made their own proposals. Rookmaaker, for example, saw the modern art movement as the expression of a dying culture. He encouraged Christians neither to denigrate art nor to put it on a pedestal, approaching it instead in a spirit of "love and freedom" and accepting it "as a great gift of God."[23] Seerveld, in an essay whose title implicitly takes issue with Rookmaaker's book, says that modern art has made important contributions to the unfolding of art as such. He calls on Christians both to repent of their own "guilt in the plight of those caught in cultural dead ends" and to develop a contemporary Christian culture that builds on what modern art has achieved and displays its own spirit of "compassionate judgment."[24] Wolterstorff, by contrast, says that the institution of high art has blinded us to the many legitimate non-aesthetic purposes of art and to our aesthetic responsibilities in everyday life. He urges Christians to address the aesthetic squalor in everyday life and to be discerning when they decide whether and how to participate in

[23]H. R. Rookmaaker, *Modern Art and the Death of a Culture* (London: Inter-Varsity Press, 1970), 231.

[24]Calvin Seerveld, "Modern Art and the Birth of a Christian Culture," in *Rainbows for the Fallen World: Aesthetic Life and Artistic Task* (Toronto: Tuppence, 1980), 177, 182.

the institution of high art.[25] So we see that the key figures in reformational aesthetics have different views about how Christians should engage with modern art and, presumably, with postmodern art as well.[26] To simplify, whereas Rookmaaker recommends cultural reorientation and Wolterstorff calls for critical discernment, Seerveld urges a communal alternative.

Although I find something right about each of these stances, none seems sufficiently nuanced and comprehensive, for several reasons. First, the challenges facing all participants in the arts today, regardless of their religious orientation, are largely generated by economic, political, and technological systems that neither individuals nor religious communities can address on their own. Second, those who participate in the arts are members of many communities, not simply religious communities, and their membership in ethnic, national, and other communities is no less decisive than their religious adherence or nonadherence. Third, and perhaps most important, the art projects and arts organizations that have the greatest potential to contribute to cultural renewal and social transformation today are neither established museums, galleries, and the like, nor faith-oriented endeavors, but rather collaborative and participatory ventures that have a public orientation and help build a social economy.

I believe the entire discussion about faith and art needs to catch up with such factors. That is why my accounts of artistic truth and art in public emphasize not only how people interact in the arts but also how societal macrostructures frame their participation. I have no doubt that, as an important contemporary social institution, art needs to be redeemed. Yet I am convinced that such redemption must go hand in glove with the transformation of society as a whole. As agents of renewal, Christians need to work alongside others for the sake of such transformation.[27]

[25]Wolterstorff, *Art in Action*, 175-99. Wolterstorff specifically addresses the city, the church, and the reappropriation of a Calvinist aesthetic tradition as sites where blindness to aesthetic responsibility needs to be overcome.

[26]This is more than a presumption. Seerveld, Wolterstorff, and I all gave keynote lectures at a 1995 conference on the arts at Calvin College and aired our differences about postmodern art in the concluding panel discussion. The title of my lecture indicates my misgivings with both Rookmaaker and Seerveld's approaches to faith and art. See Lambert Zuidervaart, "Postmodern Arts and the Birth of a Democratic Culture," in *The Arts, Community and Cultural Democracy*, ed. Lambert Zuidervaart and Henry Luttikhuizen (New York: St. Martin's, 2000), 15-39.

[27]For more detailed accounts of the normative and structural transformation I envision, see *Art in Public* and my essay "Macrostructures and Societal Principles: An Architectonic Critique,"

BIBLIOGRAPHY

Begbie, Jeremy S. *Voicing Creation's Praise: Towards a Theology of the Arts*. Edinburgh: T&T Clark, 1991.

Brand, Hillary, and Adrienne Chaplin. *Art and Soul: Signposts for Christians in the Arts*. 2nd ed. Carlisle, UK: Piquant, 2001.

Brown, Frank Burch, ed. *The Oxford Handbook of Religion and the Arts*. Oxford: Oxford University Press, 2014.

Gruchy, John W. de. *Christianity, Art and Transformation: Theological Aesthetics in the Struggle for Justice*. Cambridge: Cambridge University Press, 2001.

Guyer, Paul. *A History of Modern Aesthetic*. 3 vols. Cambridge: Cambridge University Press, 2014.

Kelly, Michael, ed. *Encyclopedia of Aesthetics*. 4 vols. 2nd ed. Oxford: Oxford University Press, 2014.

Romanowski, William D. *Eyes Wide Open: Looking for God in Popular Culture*. Grand Rapids, MI: Brazos, 2001.

Seerveld, Calvin G. *Bearing Fresh Olive Leaves: Alternative Steps in Understanding Art*. Carlisle, UK: Piquant, 2000.

———. *Normative Aesthetics*. Edited by John H. Kok. Sioux Center, IA: Dordt College Press, 2014.

———. *Rainbows for the Fallen World: Aesthetic Life and Artistic Task*. Toronto: Tuppence, 1980.

Thiessen, Gesa Elsbeth, ed. *Theological Aesthetics: A Reader*. Grand Rapids, MI: Eerdmans, 2004.

Wolterstorff, Nicholas. *Art in Action: Toward a Christian Aesthetic*. Grand Rapids, MI: Eerdmans, 1980.

———. *Art Rethought: The Social Practices of Art*. Oxford: Oxford University Press, 2015.

Zuidervaart, Lambert. *Art, Education, and Cultural Renewal: Essays in Reformational Philosophy*. Montreal: McGill-Queen's University Press, 2017.

———. *Social Domains of Truth: Science, Politics, Art, and Religion*. New York: Routledge, 2023.

Zuidervaart, Lambert, and Henry Luttikhuizen, eds. *Pledges of Jubilee: Essays on the Arts and Culture, in Honor of Calvin G. Seerveld*. Grand Rapids, MI: Eerdmans, 1995.

originally presented as a keynote lecture during the conference titled The Future of Creation Order at the VU University Amsterdam in August 2011, published as chapter 13 in Zuidervaart, *Religion, Truth, and Social Transformation*, 252-76.

Redemptive Art Criticism

LAMBERT ZUIDERVAART

Anyone who experiences a product or event of visual art inter-
prets it in some fashion. If it is made to stand on its own as an
artwork, then it strongly elicits interpretation. What should be the
focus of art interpretation? Simply saying whether one likes or
dislikes an artwork is not enough. Interpretation is not the same as
reporting one's personal preferences, even though personal
preferences unavoidably inflect our interpretations. Perhaps, for
example, we pay closer attention to an artwork we like and
hence find more to say about it when someone asks. Yet the point
of art talk is not merely to report on our likes and dislikes but to
interpret the work of art.[1]

Many of us are amateur interpreters, not having studied or
practiced in the media visual artists employ. Often we rely on more
highly trained interpreters to guide or challenge our responses: art
educators, art journalists, art critics, art historians, art theorists, and
philosophers of art, as well as the artists themselves. We can call
such professional interpreters art commentators. They comment on
the work of art in order to bring out its meaning.

Because art is a social institution with many dimensions, and
because artworks have many features, competing schools of art
commentary have taken shape. Formalists, for example, concen-
trate on aesthetic matters; technical commentators zero in on art's
artifactual character, elucidating how artworks are made and the
visual media deployed; reception criticism focuses on how art
audiences experience an artwork; hermeneutical approaches tend

[1] I explain what I mean by *art talk* in Lambert Zuidervaart, *Artistic Truth: Aesthetics,
Discourse, and Imaginative Disclosure* (Cambridge: Cambridge University Press,
2004), 68-73, 134-39.

to emphasize the import of an artwork; various instrumentalist approaches try to explain an artwork's economic, political, moral, or religious functions, often without worrying too much about its import or its artifactual and aesthetic features. Each of these schools finds a legitimate point of entry. Yet none does justice to the multidimensionality and societal complexity of art.

I recommend instead an approach I call "redemptive criticism." Redemptive art criticism tries to interpret the meaning of an artwork in light of its artifactual and aesthetic character, with a view to its import and reception, and with reference to its roles in society. Although the emerging import of an artwork guides such interpretation, the work's artifactual, aesthetic, and societal features, all of which mediate this import, also receive careful attention. Moreover, the approach is critical: it raises normative questions about technical achievement, aesthetic validity, interpretive needs, and social ethics. Redemptive criticism regards the meaning of an artwork not as a neutral fact but as a more or less worthwhile contribution to human flourishing in society.

I can illustrate this approach by discussing an artwork whose meaning makes an important contribution, in my view: *Earth's Lament*,[2] a sculpture by American and Canadian artist Joyce A. Recker. Let me begin with some biographical background. Although formalists who reject the "intentional

Figure 10.3. Joyce A. Recker, *Earth's Lament*, 2003
Photograph: Patty Watteyne.

[2]Joyce A. Recker, *Earth's Lament*, 2003, corkscrew willow, whittled branches, found rocks, sand, 65 x 22 x 22 inches.

fallacy" may regard such background as irrelevant or worse, I understand the meaning of a visual artwork to include its origins in lived experience and artistic practices, as framed by the social institution of art.

Joyce A. Recker (b. 1951) came to the visual arts with a strong background in music. An accomplished pianist, song writer, and piano teacher, she mastered the fiber arts (weaving, dyeing, paper making, and the like) before studying with sculptor Ron Pederson and receiving a BFA in 1988 at Aquinas College, a Catholic liberal arts school in Grand Rapids, Michigan. Taking up residence as a studio artist at the Urban Institute for Contemporary Arts, the largest multidisciplinary arts center in the state of Michigan, she soon discovered wood and plant materials as her favorite medium. She has exhibited her work in public museums and art centers as well as both commercial and nonprofit galleries, taught art at the Kendall College of Art and Design, and juried and curated shows in Michigan and Ontario. Her exquisite wood sculptures are found in homes across Canada and the United States.[3] She also works as an interior re-designer who helps homeowners reconfigure their houses into aesthetically enriched homes.

Recker's sculptures display a strong architectural understanding of spatial relations, a musician's attunement to rhythm and timing, and a fiber artist's sensitivity to the texture and consistency of materials. Each piece emerges from a painstaking process in which Recker listens to what the materials are telling her as she shapes them into a unique work of art. A personal, socially engaged spirituality animates such care and attentiveness. She describes her sculptures as "figurative abstractions that whisper reflections of the soul. They bespeak the tensions of living gracefully amid injustice and pain."[4]

[3]Images of Recker's sculptures appear on the covers of three of my books. In the interests of full disclosure, I should mention that Joyce and I have been a married couple since 1977.

[4]Joyce A. Recker, "Artist's Statement," *Speak on Memory*, Gallery 1313, Toronto, February 20, 2003.

This combination of socially attuned spirituality and architectural craftsmanship is evident in *Earth's Lament* (fig. 10.3). An early version, exhibited in the 1990s at the Grand Rapids Art Museum, employed a young corkscrew willow that the artist had removed from its soil and implanted within a constructed wooden frame. As the willow lost its leaves and looked increasingly bedraggled, Recker became dissatisfied with the sculptural result. So she took the dead willow apart branch by branch, removed its remaining leaves, whittled the ends of branches into spears, and rejoined them to the original trunk, using two-pronged wooden rivets she had carved for this purpose. To enframe this reconstructed tree, Recker stripped the bark from branches she had collected, whittled them to just the right lengths, and bound them together using strong plastic twine. To "plant" the tree, she fabricated an intricate nest from scraps left over from her whittling, filled it with fine white sand she had cemented with glue, and placed five polished rocks around the base of the tree. The nested tree sits on a latticework Recker laced together from other branches, a platform echoed by the porous ceiling through which the willow tree thrusts. To bring out both fragility and strength, she oiled nine-inch-thick wooden blocks on which the points of the sculpture's legs can stand. As a result, the twisting wildness of the reconstructed willow resides within a tightly constructed frame that looks loosely assembled.

The casual viewer might not notice all the artifactual details I have mentioned. Yet they are crucial to the work's import and aesthetic qualities. Recker says she aims to create tensions of subtle ambiguity in her sculptures:

> Ambiguous relationships emerge between the materials. The juxtaposition of smooth and sharp creates ambivalence; one is inclined to touch the smoothness and simultaneously recoil from the sharpness. Whittled branches . . . appear both naked and elegant, strong in their weakness. . . .
>
> Ambiguous relationships also exist within the skeletal framework of each sculpture. They can suggest containment,

confinement, and control as well as preservation, protection, and potential. As transparent structures they can also evoke openness and vulnerability—a vincible shield on the one hand and an imprisoned freedom on the other; an open frame that is both penetrable and entrapping.

In the end, my teetering, sometimes suspended objects whisper reflections of my soul. The challenge to live—to keep living—is a cyclical process of learning to embrace the rough and the smooth, the harsh and the gentle, the whole and the broken—not just around me but also within.[5]

Even without knowing exactly how Recker fashioned *Earth's Lament* and without reading her artist's statement, the viewer cannot miss such ambiguities, especially given the sculpture's human size at nearly five and a half feet tall and nearly two feet wide and deep.[6]

I shall have more to say about the work's import and aesthetic qualities. First, however, let me comment on it as art in public. Like much of contemporary art in the West, *Earth's Lament* has a public orientation beyond the specific audience for which it was made. This is evident from the history of its exhibition and reception. It has never been displayed in a commercial gallery. It was first shown at a not-for-profit, artist-run gallery in Toronto called Gallery 1313. Then it was part of a special exhibition in connection with my inaugural lecture at the Institute for Christian Studies (ICS), an independent graduate school for interdisciplinary philosophy in the reformational tradition. It remained in the Board Room at ICS for several years, until Jack de Klerk, a lawyer who is a personal friend of the artist, purchased it. The sculpture now stands in de Klerk's living room. Hence the sculpture has addressed multiple publics: an art-going public, a higher education public, the collector's friends and colleagues, and, perhaps most broadly, the entire range of

[5]Joyce A. Recker, "Artist's Statement."
[6]The precise dimensions are 65 inches high by 22 inches wide and 22 inches deep.

people around the world who come across the sculpture's image in connection with lectures and publications that discuss it.

The sculpture's public orientation does not preclude highly personal experience, however. Gallery 1313 exhibited *Earth's Lament* in 2003 as part of *Speak on Memory*, a show featuring the work of three women artists. One of the other artists was the photographer and print maker Laurie Zinkand-Selles. Laurie is the sister of Jeanie Zinkand, who died of lung cancer at age forty-seven in 2000. Jeanie was one of Joyce Recker's best friends. She also was the wife of Jack de Klerk. Many of the viewers on opening night were connected to this intimate circle. *Earth's Lament* served as a mute reminder of the one we had lost, even as it bore witness to a larger rip in creation's fabric. Subsequent publics, who may have no knowledge of this personal sorrow, may find it speaking to their own senses of loss and longing. The occasions on which this piece is experienced help shape the interpretations that emerge— and this, in my view, is legitimate and important for all art in public. Moreover, even though the sculpture makes no overt reference to the politics of health care or debates about environmental sustain-ability, it obliquely resonates with these concerns. In that sense, too, it is art in public.

It is because of the artifactual, aesthetic, and broadly social features already mentioned that *Earth's Lament* can exemplify the authenticity, integrity, and significance that make up artistic truth. This is how my book on artistic truth describes it:

> A brilliantly illuminated sculpture stands on nine blocks of wood in the center of an artist-run gallery in Toronto. It is opening night for a three-woman show on loss and retrieval titled *Speak on Memory*. People crowd around the sculpture but keep their distance, struck by its stark com-plexity. A young corkscrew willow has been cut off before it could flourish, its dead leaves removed, its bare branches disassembled. Now it stands forcibly reconstructed, twisting within and through a skeletal cage of whittled maple

translucently twined. The willow's branches, their ends carved into spears, have been rejoined with sharp wooden rivets into the simulacrum of a tree. Snakelike, they writhe through each other as their trunk stands rootless in a nest made from tiny interlaced twigs. The nest lies on a bed of pointed lateral branches arranged in two crosswise layers. Cemented sand fills the nest, blasted soil where something once grew. Graying rocks, circling the tree trunk like petrified eggs, are all that remains. The gnarled but youthful branches of this caged and nested and refabricated tree spiral upward toward an elevation they will never reach. The piece, by Joyce Recker, is titled *Earth's Lament.*

Why does the sculpture so visibly move its public on this occasion, calling their attention and prompting their conversation? It makes no direct statement and asserts no propositions. Yet it offers more than an innovative treatment of nontraditional materials that, under proper lighting and in the right space, creates wonderful juxtapositions of angles and curves, of light and shadow, of the found and the fabricated. It is simultaneously an open-ended metaphor for hope amid loss, for renewal amid destruction. And the import it offers comes through the sculpture's own imaginative and self-referential structure, even as it testifies to the artist's vision of art and life and interacts with a public's need for echoes of earth's lament. The piece is a work of imaginative disclosure, one that can meet the multidimensional expectation of artistic truth.[7]

In the end, these are the questions that sustain the redemptive criticism of visual art: Is the artwork true? How do the work's construction, reception, and import mediate its truth? And how does cogent imaginative disclosure, accomplished in and through

[7]Zuidervaart, *Artistic Truth*, 217-18. An image of *Earth's Lament* is featured on this book's cover.

a unique work of art, contribute to human flourishing in a misdirected society that cries out for redemption?

In a supposedly post-truth society where people often reduce art to either mindless entertainment or commercial propaganda—or ignore it altogether—redemptive art criticism can contribute to cultural renewal and social transformation. While it appreciates and attends to the technical and aesthetic features of the artworks it interprets, it does not lose sight of art's multiple roles in society. Nor does it forget how art can help people connect with one another and find cultural orientation. For redemptive art criticism, art is neither a fringe on the garment of life nor a crown on the pedestal of culture. Art is, as Kuyper said, a "serious power,"[8] and its imaginative truth can foster human flourishing. Through nuanced and probing commentaries on specific artists, works, events, and organizations, redemptive art criticism aims to show whether and how such flourishing occurs.

BIBLIOGRAPHY

Zuidervaart, Lambert. *Artistic Truth: Aesthetics, Discourse, and Imaginative Disclosure.* Cambridge: Cambridge University Press, 2004.

[8]Abraham Kuyper, *Lectures on Calvinism* (Grand Rapids, MI: Eerdmans, 1931), 151.

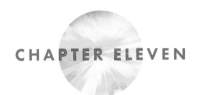

CHAPTER ELEVEN

ART, BODY, AND FEELING: NEW ROADS FOR NEO-CALVINIST AESTHETICS

ADRIENNE DENGERINK CHAPLIN

IN REFLECTING ON THE SOCIAL FUNCTION of poetry, T. S. Eliot once wrote: "In expressing what other people feel [the poet] is . . . changing the feeling by making it more conscious; he is making people more aware of what they feel already, and therefore teaching them something about themselves. . . . He can make his readers share consciously in new feelings which they had not experienced before."[1]

Calvinism is not generally known for its attention to feelings or the body.[2] It is more often associated with intellectualism, stoicism, and austerity. Attention to feelings would be considered indulgent and self-absorbed. Neo-Calvinist aesthetics, likewise, has not generally foregrounded feeling or the body in relation to art. Rejecting art theories of self-expression or the Romantic genius, it has focused more on worldviews, cultural calling, and social transformation.

[1]T. S. Eliot, "The Social Function of Poetry," in *On Poetry and Poets* (London: Faber and Faber, 1957), 20.

[2]This article is adapted from Adrienne Dengerink Chaplin, "Art and Embodiment: Biological and Phenomenological Contributions to Understanding Beauty and the Aesthetic," *Contemporary Aesthetics* 3 (2005), article 19, https://digitalcommons.risd.edu/liberalarts_contempaesthetics /vol3/iss1/19.

Even so, there are several themes within the (Neo-)Calvinist tradition that are intrinsically conducive to a more positive appraisal of feelings and the body. Moreover, rather than detracting from the cultural transformative role of art, I suggest that further development of these themes will give this emphasis a more complete and comprehensive grounding. To that end it is worth looking at a number of philosophers whose thinking about art contains promising points of connection with the Neo-Calvinist tradition. I will argue that attention to these thinkers' thought can enrich Neo-Calvinist aesthetics.

In the first part of this chapter I will discuss four philosophers—Ellen Dissanayake, Susanne K. Langer, Maurice Merleau-Ponty, and Mark Johnson—who have made major contributions to a better understanding of the role of feeling, sensing, and the body in the making and receiving of art. While coming from a diversity of philosophical backgrounds that include sociobiology, process philosophy, phenomenology, and embodied cognition, they all share the belief that art articulates prereflective, affective experience that cannot be rendered available for conscious experience otherwise. They all emphasize that we stand in a relation to our environment that is in its first instance felt and sensed—by skin, eyes, ears, nose, and mouth. Vice versa, in their view, the world reveals itself to us primordially by the way it is sensed and felt. Most important, though, they all share the view that this primordial encounter with the world can be made visible, audible, and tangible in artistic forms of painting, film, dance, music, stories, and the multiple other expressions of art throughout history. Despite their immense historical and cultural variety, all arts are united in one single task: to articulate pre-theoretical affective experience. As such they are not only fundamental to all individual human existence, but they also belong to the deep structure of every society.[3]

[3] A substantial section of the following material was first presented as a paper at the International Association for Aesthetics meeting in Rio de Janeiro in 2004. The section on Mark Johnson was first presented as a paper at the International Association for Aesthetics meeting in Krakow in 2013 and subsequently published as Adrienne Dengerink Chaplin, "Feeling the Body in Art: Embodied Cognition and Aesthetics in Mark Johnson and Susanne K. Langer," *Sztuka i Filozofia/Art and Philosophy* 48 (2016): 5-11.

In the second part I will discuss some prominent themes in Calvinist and Neo-Calvinist thought that show promising points of connection with the thinkers discussed. These themes include a positive theology of created reality, including its bodily and physical dimensions; an affirmation of day-to-day lived experience as a legitimate form of cognition and way of knowing; and an emphasis on the "social body" as the embodied community of believers working together for the common good. I will also offer some concrete examples of the way that a stronger foregrounding of the body and feelings can enrich the thought of three prominent Neo-Calvinist aestheticians: Calvin Seerveld, Nicholas Wolterstorff, and Lambert Zuidervaart.

THE BODY AS SITE OF THE SENSES AND FEELING

One of the first thinkers to take the senses seriously was the founder of aesthetics as a distinct discipline, the philosopher Alexander Baumgarten (1714–1762). Baumgarten conceived aesthetics as a science of sense perception, the latter to be considered as a source of knowing, as a *scientia cognitionis sensitivae* (a science of knowledge by means of the senses).[4] Indeed, the father of aesthetics was eager to show that such "cognition of the senses" was not, as Spinoza and Leibniz believed, subordinate to logical knowledge but possessed an autonomy and perfection of its own. Poetry, as Baumgarten argued with a nod to Descartes, was able to give us clear and "con-fused" knowledge, the latter not to be taken in the sense of muddled or fuzzy, but of fused, condensed, or converging. In his account, poetry and, by extension, all art has both an intensive clarity—to the extent that it takes concrete objects or images as its focus—and an extensive clarity—insofar as it is able to evoke a wide range of allusions and associations.[5] It provides us with a form of condensed knowledge, which captures our concrete and lived experience, which escapes discursive prose.

However, as Richard Schusterman correctly points out, despite Baumgarten's emphasis on sense perception, he did not in fact take the body seriously. This is because, for him, the higher senses of sight and hearing did

[4] Alexander Baumgarten, "Kollegium über die Ästhetik," in *Texte zur Grundlegung der Ästhetik*, ed. Hans Rudolf Schweizer (Hamburg: Felix Meiner, 1983), 79.
[5] Alexander Baumgarten, *Reflections on Poetry* (Berkeley: University of California Press, 1974), 42-43.

not belong primarily to the body but to the mind.[6] For him, as it was to be for Kant, sense perception was part of the higher mental faculty whereas smell and taste belonged to the inferior bodily realm.[7] He held that the body with its lower appetites and drives operated according to "natural" and causal laws, whereas the mind belonged to the realm of freedom and imagination. Therefore, despite his re-evaluation of sense perception as a legitimate form of poetic, artistic knowing, Baumgarten still remained trapped in a dualistic mind-body anthropology, which prevented him from developing a proper aesthetics of the body.

ELLEN DISSANAYAKE AND MAKING SPECIAL

Since Baumgarten, philosophers found different solutions to the mind/body problem and the senses in relation to the production and reception of art. Some turned to Darwin to explore the role of art and beauty in human evolution.[8] These "socio-biological" approaches foregrounded the putative adaptive values of artistic practices and behavior—beautification as foreplay, music to enforce solidarity, singing as a warning of danger, play as a practice for life skills, and so on—for evolutionary human and other animals' survival. Even so, as philosopher and anthropologist Ellen Dissanayake points out, none of these diverse behaviors point to a *single* rationale for considering art as adaptive. Equally important, all the supposedly selective benefits that were achieved by artistic practices could also have been achieved by other means, such as, for instance, sport. However, according to Dissanayake, there is one aspect of art that *does* stand out and is not something accommodated for otherwise: this is the fact that all art involves "marking of something as special." As she extensively argues in her books *Homo Aestheticus:*

[6]Richard Schusterman, *Pragmatist Aesthetics: Living Beauty, Rethinking Art* (Lanham, MD: Rowman & Littlefield, 2000), 263-67.

[7]A similar separation between the body and the mind can be found in Kant's distinction between a liking for the agreeable, which is rooted in our sensuous bodily nature, and a liking for beauty, which is the result of the contemplative mind's reflection. The liking for the agreeable is "a liking that is conditioned pathologically by stimuli" and "holds for non-rational animals too." It gratifies our bodily needs and desires. By contrast, a liking for the beautiful transcends those bodily desires and is always devoid of practical purpose or "interest." Immanuel Kant, *Critique of Judgment*, trans. Werner S. Pluhar (Indianapolis: Hackett, 1987), 51-52.

[8]For an account of three different socio-biological approaches to art, see Ellen Dissanayke, "Sociobiology and the Arts: Problems and Prospects," in *Sociobiology and the Arts*, ed. Jan Baptist Bedaux and Brett Cooke (Amsterdam: Rodopi, 1999), 28-32.

Where Art Comes From and Why and *Art and Intimacy: How the Arts Began*, this feature is specific to humans. Unlike other animals, humans deliberately "artify, by shaping, embellishing and otherwise fashioning aspects of their world with the intention of making them more than ordinary."[9] Every act of art, whether dance, poetry, or song, can thus be viewed as ordinary behavior made special or *extra*ordinary. By devoting special attention to important objects and life events (whether cooking utensils, tools, weapons, birth, marriage, death, etc.), they are being treated with the necessary care and respect. By promoting both individual competitive advantage as well as group adhesion, art furthers the survival of the species. Ceremonies involving dancing and singing, for instance, instill a sense of belonging and group values that promote solidarity, cooperation, and confidence. They also benefit a general sense of psycho-somatic well-being, whether improved body coordination by dance, or an enhanced sense of narrative self and identity by means of storytelling. Whether individually or collectively, the arts, according to Dissanayake, promote better well-being all around, something confirmed by many contemporary arts educators and therapists.

SUSANNE K. LANGER AND THE ARTICULATION OF FELT LIFE

Variations of the above view could also be found earlier in the work of the American philosopher Susanne K. Langer (1895–1985). While mostly known for her philosophy of art as expounded in *Philosophy in a New Key* and *Feeling and Form*, Langer's later biologically based philosophy of mind and consciousness as developed in her trilogy *Mind: An Essay on Human Feeling* (1967, 1971, 1982) is equally, if not even more, relevant to understanding her philosophy of art. For Langer, aesthetic awareness is rooted in the deep structures of the human body's sensory apparatus. For her, as for Dissanayake, it starts with a vague awareness of something having significance, with assigning value and meaning to something: "The earliest manifestation of any symbol making tendency [is] a mere *sense of significance* attached to certain

[9]Dissanayake, "Sociobiology and the Arts 28-32, 35, 36. It should be noted that Dissanayake's use of the word *art* is broader than the notion of "fine art" as it emerged in the modern era. As she comments, "It seems faintly ridiculous to look for an evolutionary origin and function for something that being made and revered by the few is rare, elite, and by its own stipulation removed from practical utility" (29).

objects."[10] Unlike Dissanayake, however, Langer makes a clear distinction between symbolic activity and conditioned reflexes. This is based on her distinction between signs and symbols. Signs typically announce or signal something—clouds announce rain; scars indicate wounds; bells signify dinner, train departures, and the like—whereas symbols are *vehicles for conception*—they stand for things that are either unavailable or imaginary. Whereas signs call for action, symbols invite reflection.

When humans encounter something of significance in the world, they assign it with a meaning that enables it to stand for that particular experience. This can be merely the recognition of a particular visual or audible form or *Gestalt* in the midst of what William James calls the "great, blooming, buzzing confusion," or it can be a more complex awareness about life, death, or the meaning of existence. Articulation of the first can result in simple words or gestures, the second in sophisticated liturgical rituals or works of art. Over time, repeatedly used expressions come to be recognized by a community as standing for particular meanings and thus enters into conventional discourse with shared grammar, codified syntax, and vocabulary with dictionary meanings. Langer suggests that originally *images* rather than sounds or words were most prone to becoming vehicles for conceptions, to becoming symbols. In a brain where the imagination was just beginning to take on the function of symbolization, there would have been a lively production of images mingling with each other in a variety of ways. In this process images that shared some particular features might fuse into one single image by means of the suppression of other features. Complex images can modify each other and become more simplified. This process of simplification is the natural basis for abstraction. All abstract symbolic thinking is ultimately rooted in the visual image. It enables the mind to remember—and voluntarily recall—images or sounds. Langer holds that mere sounds, and in particular *vocal* sounds, can hold *a sense of significance* for humans, which can lead to particular affective responses.[11] The most basic form of abstract

[10]Susanne Langer, *Philosophy in a New Key: A Study in the Symbolism of Reason, Rite, and Art* (Cambridge, MA: Harvard University Press, 1996), 110. Langer's emphasis on significance recalls the Greek roots of the word *semantic* in the adjective *semantikos*, which means "significant."

[11]This "sense of significance" or "associated meaning" belonging to the pure sounds of words is long recognized by poets. It is also exploited and reflected on by, for instance, Mallarmé and

thinking is the projection of a bodily sensation or feeling onto an object.[12] It endows them with meaning. A projection is a typically human form of "objectification" of bodily, sensuous awareness onto external objects which enables them to serve as a symbol:

> The mental act of "projecting" . . . lets the subjective element . . . be perceived as an external datum, i.e., as a quality belonging to an independently existing object; and that object, which thus presents our own sensory feeling to us, is a primitive symbol. . . . Body feelings may be the first thing man projected and thus, all unwittingly, imputed to everything he objectified as material bodies in his world.[13]

For Langer any bodily sensation, such as a sense of space, balance, temperature, texture, pressure, size, and weight but also fear, safety, danger, and the like can all be projected on something external, which then takes on the "objective image" of such feelings.[14] According to Langer, these affective "aesthetic" sensations are the foundations of conceptual thought and language: "Aesthetic attraction, mysterious fear, are probably the first manifestations of that mental function which in man becomes a peculiar 'tendency to see reality symbolically' and which issues in the *power of conception*, and the life-long habit of speech."[15]

A special place in the realm of human sensations in the sense of touch. This began with the gradual freeing of the hands from their motor duties. This resulted not only in the hands' increased manipulative powers, but in their gradual specialization as a sense organ. As she describes it:

> The sensory reactions of the skin and underlying structures are engaged together in the tactile perception of substances: feelings of pressure and release

later by Derrida and Kristeva. Although meaning roughly the same as Langer's "symbolic realm" for Kristeva, these meanings belong to the "semiotic" realm.

[12] Langer draws here on anthropological studies by, among others, Sigmund Freud, Margaret Mead, Mircea Eliade, and Claude Levi-Strauss, and also on empathy theories such as those developed by Wilhelm Wundt, Theodor Lipps, and Robert Vischer.

[13] Susanne K. Langer, *Mind: An Essay on Human Feeling* (Baltimore: Johns Hopkins University Press, 1982), 3:48.

[14] Langer, *Mind* 3:49.

[15] Langer, *Philosophy in a New Key*, 110. In contrast to her position in *Mind*, Langer claims in this earlier work that some apes also respond to "certain [visual] objects and gestures [which] appear to have this phenomenological, dissociated character." However, for unspecified reasons, Langer does not believe that they can also respond in that way to sounds. See *Philosophy in a New Key*, 117.

of pressure, of warm and cold impingements, pin-pointed encounters with resistance, oiliness, wetness, and mixtures like sliminess, hairiness, stickiness. The result is that we have not only a report of surfaces and edges, but of volume imbued with multimodal, often nameless qualities.[16]

Put differently, human tactile sensations of these various substances develop into a typically human form of sense perception, which allows those sensations to stand for more than purely physical encounters framed in the context of meeting primary needs such as food, shelter, or procreation. Both touch and taste evoke strong affective reactions to textures—slimy or sharp—or tastes—sweet or sour. It is the reports of "often nameless qualities" which make the tactile sensitivity of the hands the basis for a range of experiences which are typically referred to as aesthetic: "Like all . . . aesthetic perceptions they meet and merge with emotional elements which are not current sexual, maternal or hostile feelings toward other beings, but modes of consciousness, felt attitudes, which motivate the earliest artistic expressions, dance and vocalization."[17]

Different sensations of touch create a variety of different experiences which correspond with subtle nuances of experiences outside the realm of touch. This phenomenon lends sensations of touch a particular metaphoric quality, whereby symbols (words, images, or gestures) used to refer to tactile sensations can be transferred to nonphysical entities, such as character or mood. The tactile sensation of, for instance, sharpness or warmth can evoke an affective experience such that "the name we use for the physical experience can be transferred to other realms of reality such as persons or moods."[18]

It is a way of making sense of the world by rendering these experiences available to a shared human consciousness. In the process of symbolization physical, sensuous, cognitive, and emotional aspects of consciousness come together: "'Language is born of the need for emotional expression,' says Langer, and it is meant to 'hold the object of feeling' rather than communicate it."[19]

[16]Langer, *Mind* 2:258.

[17]Langer, *Mind* 2:259.

[18]For a more recent treatment of the same phenomenon, see George Lakoff and Mark Johnson, *Metaphors We Live By* (Chicago: Chicago University Press, 1980).

[19]Susanne K. Langer, "On Cassirer's Theory of Language and Myth," in *The Philosophy of Ernst Cassirer*, ed. Paul Arthur Schilpp (Evanston, IL: Library of Living Philosophers, 1949), 385-86. Although Langer wrote this about Cassirer's view of language, it also reflects her own.

Through habitual communal appropriation of particular sounds, the original affective associations fade into the background while the sounds themselves fuse with their newly acquired representational meaning. This eventually leads to the functional and instrumental uses of language, which have been the focus of most communication theories of language. Since most of our day-to-day language is instrumental, it is only its poetic use which can prevent people from forgetting the originally integral connection between name and object. Langer warns against such forgetting: "Speech becomes increasingly discursive, practical, prosaic, until human beings can actually believe that it was invented as a utility and was later embellished with metaphors for the sake of a cultural product called poetry."[20]

It will be clear that feelings, for Langer, are not the clearly definable garden variety of emotions such as joy, sadness, anger, or fear. Instead they are more complex, subtle, and nuanced. Langer presents art and poetry with the challenge to keep alive the original and authentic connection between artistic representation and embodied experience.

MAURICE MERLEAU-PONTY AND LIVED EXPERIENCE

This coming together of sensing, thinking, and feeling links Langer's philosophy of art with the phenomenological aesthetics of French philosopher Merleau-Ponty (1908–1961). Influenced by Heidegger's notions of "being-in-the-world" and "facticity" in *Being and Time* (1926), Merleau-Ponty developed a fresh understanding of the body-subject's primordial contact with the world, rooted in a distinctive notion of perception. As he explains in his seminal *Phenomenology of Perception* of 1945, perception is not a question of deliberately taking up a position or engaging in a particular act but a holistic and integrated prereflective experience. It is "the background from which all acts stand out and is presupposed by them."[21] We never merely perceive isolated sense-impressions which are then being formed into mental representations or ideas. We can't even perceive such atomic isolated sensations because we can only see things as figures against a ground and in relation to other figures.

[20]Langer, *Philosophy in a New Key*, 142.
[21]Maurice Merleau-Ponty, *Phenomenology of Perception*, trans. Colin Smith (London: Routledge, 1962), xi.

This ground is part of our embodied experience, prior to it being a mental representation. It is the horizon which consists of experiences of the past and expectations of the future. This can be illustrated with the kind of visual experiments as had been developed within *Gestalt* theory, whereby we experience certain properties of shapes or colors differently depending on their context. Drawing on his psychiatric practice, Merleau-Ponty illustrates this with the phenomenon of a phantom limb. In his view, neither purely physiological nor purely psychological accounts can explain this phenomenon because they do not allow for the presence of things other than in terms of representation. Those accounts have "no middle term between presence and absence." In the case of a phantom leg, however, even though there is no representation of the absent leg, the leg's presence is still felt as part of our body schema. It both *is* and isn't. For Merleau-Ponty this means that the body is fully present with us, without or before us having a representation of it. His main point is to show that these perceptual "mistakes" are not perceptual anomalies but disclosures of the way perception and consciousness normally work. Perception is not a static, single-focus affair but an active, bodily involvement with the world we live in. Reaching out my hand to pick something up does not consist of two actions, first my thinking about the action and then my arm responding to perform the action; it is one integrated bodily performance. Driving a car, playing an instrument, and so forth, all testify to the body's capacity to find its way in the world—to judge distances, speed, touch, pressure, positions, and the like—without resorting to lingual or other symbolic representation. In Merleau-Ponty's words: "Consciousness is being-towards-the-thing through the intermediary of the body."[22] Consciousness does not need to imply language. Instead, the body "understands its world, without having to make use of my 'symbolic' or 'objectifying function.'"[23] The body-subject stands in an ongoing living dialogue and reciprocal relation with her existential environment of which the symbols of science are merely "a second-order expression." For Merleau-Ponty, abstract science stands to the lived world as geography stands to our rich, firsthand experience of the fields and forests.

[22]Merleau-Ponty, *Phenomenology of Perception*, 138-39.
[23]Merleau-Ponty, *Phenomenology of Perception*, 140-41.

My field of perception is constantly filled with a play of colors, noises, and fleeting tactile sensations which I cannot relate precisely to the context of my clearly perceived world, yet which I nevertheless immediately "place" in the world, without ever confusing them with my daydreams.[24]

This leads Merleau-Ponty to his philosophy of art. For him the unity of the mental and the physical in perception is exemplified in a work of art. Just as expressions and gestures of the body are indistinguishable from what they are perceived as expressing, so works of art or music cannot be separated from what they express. In a picture "the idea is incommunicable by means other than the display of colours," and in a piece of music "the musical meaning of a sonata is inseparable from the sounds which are its vehicle."[25] There is no idea behind the work of art. The painter thinks with his brush and paints. A paint brush or musical instrument functions like a walking stick for a blind person, that is, as a "bodily auxiliary, an extension of the bodily synthesis."[26] Both language and painting are rooted in the primordial, expressive gestures of the human body. For Merleau-Ponty I do not *have* a body; I *am* my body.

For Merleau-Ponty a theory of the body already implicitly contains a theory of artistic perception.[27] This is because the body and the senses are not merely means for gaining and communicating information. They are part of the dynamic system in which humans attribute meaning to their environment. When discussing the affective meaning of colors he writes, "We must rediscover how to live these colours as our body does, that is, as peace or violence in concrete form."[28] A color is never merely a color, but always a color *of something*: "It is impossible to completely describe the colour of the carpet without saying that it *is* a carpet, made of wool, and without implying in this colour a certain tactile value, a certain weight and

[24]Merleau-Ponty, *Phenomenology of Perception*, x.

[25]Merleau-Ponty, *Phenomenology of Perception*, 150, 182.

[26]Merleau-Ponty, *Phenomenology of Perception*, 152.

[27]Merleau-Ponty, *Phenomenology of Perception*, 203.

[28]Merleau-Ponty, *Phenomenology of Perception*, 211. For a comparison with Langer, see his essay "Eye and Mind," in *The Merleau-Ponty Aesthetics Reader: Philosophy and Painting*, ed. Galen A. Johnson (Evanston, IL: Northwestern University Press, 1993), 125, where he writes, "Since things and my body are made of the same stuff, vision must somehow come about in them; or yet again, their manifest visibility must be repeated in the body by a secret visibility. . . . Quality, light, color, depth, which are therefore before us, are there only because they awaken an echo in our bodies and because the body welcomes them. Things have an internal equivalent in me" (125-26).

a certain resistance to sound."[29] In other words, even if objectively the red of the carpet has the same color as blood, we would nevertheless experience the two kinds of red very differently, both in terms of texture and, of course, association. In reverse, we experience an object such as a fountain pen as having the same black color even if the light reflection gives certain parts a whitish radiance. In other words, the value of the color remains constant despite these changes in appearance. Moreover, this value crosses different types of sense-perceptions. Merleau-Ponty calls this an object's "syn-aesthetic" value or "unity of style." When, for instance, talking about a wine glass, he writes, "The brittleness, hardness, transparency and crystal ring of glass all translate in a single manner of being."[30] He refers to Cézanne as having said that a picture contains within itself even the smell of the land-scape.[31] In *Eye and Mind* Merleau-Ponty explains how Cézanne's paintings can help us relive that holistic, dynamic way of perceiving the world. They

Figure 11.1. Paul Cézanne:, *Still Life with a Curtain*, ca. 1898

[29]Merleau-Ponty, *Phenomenology of Perception*, 323.
[30]Merleau-Ponty, *Phenomenology of Perception*, 319.
[31]Merleau-Ponty, *Phenomenology of Perception*, 318.

draw on what Merleau-Ponty calls "the fabric of brute meaning."[32] In his still lifes, for instance, Cézanne does not show his objects from a static, "one-eye" camera perspective but in the way they would normally be encountered by a person moving around in a room, that is, from different angles mingled into one image. Hence the often-tilting surfaces and uneven horizons in his still lifes (fig. 11.1). His paintings try to capture the prereflective experience that allows us to see the world afresh. Each "celebrates no other enigma but that of visibility."[33]

MARK JOHNSON AND EMBODIED COGNITION

Drawing both on Langer and on Merleau-Ponty, philosopher Mark Johnson shows how art plays a central role in embodied cognition. In *The Meaning of the Body: Aesthetics of Human Understanding* (2007) he argues that art is an exemplary form of human meaning-making and that "understanding the nature of the arts could give us profound insight into how humans experience and construct meaning in their lives."[34] For Johnson, as for Langer, an "aesthetics of human understanding" is not confined to the study of art, beauty, or aesthetic experience in the traditional sense, but entails an exploration of the whole spectrum of "qualities, feelings, emotions, and bodily processes that make meaning possible."[35] Aesthetic understanding concerns our primordial, embodied, visceral connection with the world as shaped by the interaction between the organism and its environment. Depending on their shape, complexity, and sensuous apparatus—Johnson called this their "body schema"—different organisms relate differently to their environment and move about differently. Because humans move about upright and have their eyes in front, they relate differently to their environment than, say, an octopus. Humans interpret their environment in typically human terms of distance, gravity, balance, and the like. These foundational experiences shape the way they view the world. What distinguishes

[32]Merleau-Ponty, "Eye and Mind," 123.

[33]Merleau-Ponty, "Eye and Mind," 127.

[34]Mark Johnson, *The Meaning of the Body: Aesthetics of Human Understanding* (Chicago: University of Chicago Press, 2007), 212. See also Eleanor Rosch, Evan Thompson, and Francisco J. Varela, eds., *The Embodied Mind: Cognitive Science and Human Experience* (Cambridge, MA: MIT Press, 1992).

[35]Johnson, *Meaning of the Body*, x.

humans from other animals is that they can extend these basic image schemas to other realms. Drawing on his and Lakoff's earlier work on metaphor, Johnson argues: "One of the chief ways that humans are different [from non-human animals] is that we have neural mechanisms for metaphorically extending image schemas as we perform abstract conceptualisation and reasoning."[36] Such metaphorical extensions do not imply any rupture or gap between lower and higher levels within an organism. Instead, "higher" cognitive processes have to emerge from complex interactions among "lower"-level capacities."[37]

In *Philosophy in a New Key*, Langer had already argued that "there is an unexplored possibility of genuine semantic beyond the limits of discursive language."[38] Johnson, likewise, claims that, in order to develop a philosophical theory of embodied meaning and cognition, we have to look "beyond linguistic meaning and into the processes of meaning in the arts, where immanent bodily meaning is paramount."[39] We need to recover "the deep processes of meaning, by looking beyond and beneath the formal, structural, conceptual, propositional, representational dimensions of meaning."[40]

SHARED THEMES

This brief sketch may suffice to show some important themes as shared between these thinkers. Art, so they all suggest, can recapture some of the shades of feeling of our primary engagements with the world. This emphasis on feeling is not the same as a theory of art as self-expression. As Langer does not cease to stress, self-expression does not require artistic form. It is mere venting of emotions. By contrast, art is always a product of the hard work and careful craft of seeking visual shapes or audible forms that are appropriate for the articulations of certain moods and feelings. It is the symbolic projection of feeling—fears, repulsions, hopes, or desires—onto the forms and shapes of certain objects or events. This suggests a much closer affinity between our inner mental and outer

[36]Johnson, *Meaning of the Body*, 141.
[37]Johnson, *Meaning of the Body*, 145.
[38]Langer, *Philosophy in a New Key*, 86.
[39]Johnson, *Meaning of the Body*, 209.
[40]Johnson, *Meaning of the Body*, 267.

sensible worlds than traditional subject-object epistemologies typically tend to allow.

This was particularly recognized by Merleau-Ponty when he developed his notion of the body-subject. Human embodiment is more than just biological functioning and surviving but involves a complex web of culturally mediated embodied encounters with the world, in the context of a perceptual field and horizon which lends them their meaning. His notion of art as an expression of the silent qualities of the *Lebenswelt* thus echoes Langer's understanding of art as a non-discursive *symbol* of human bodily understanding. Art, whether in Lascaux or in the Louvre, captures the affective primordial contact with the world that tends to get lost in the functionality of day-to-day life and in scientific abstraction. Art, I suggest, *is a symbolic practice that gives shape to our embodied encounter with the world.*[41]

THEATER OF GOD'S GLORY

Although none of the above philosophers touches explicitly on theology or are known to be informed by specifically religious concerns, Neo-Calvinist thinkers might well be enriched by engaging with the above thinkers. This is particularly so given that there are a number of important themes in Neo-Calvinist thought that contain promising points of connection with these thinkers. This applies particularly to the following themes: a positive theology of created reality including its embodied and physical dimensions as, in Calvin's words, "a theater of God's glory"; an affirmation of day-to-day embodied experience as a valid form of knowing the world; an emphasis on the "social body" as the embodied community of believers working together for the flourishing of humanity.

Contrary to widespread popular opinion, early Calvinists did not spurn aesthetic delight. Moreover, they have a high appreciation for the body and the senses as creational gifts from God. The original goodness of creation always included its embodied, physical and material dimensions. Calvin had already praised creation as the theater of God's glory. In a famous passage he writes, "Has the Lord clothed the flowers with great beauty that greets our eyes, the sweetness of smell that is wafted upon our nostrils, and yet will

[41]Merleau-Ponty calls it "re-achieving a direct and primitive contact with the world." *Phenomenology of Perception*, vii.

it be unlawful for our eyes to be affected by that beauty, or our sense of smell by the sweetness of that odor?"[42]

This is not the language of a cold intellectual merely concerned with abstract concepts and doctrinal thought. Neo-Calvinist Abraham Kuyper picked up the theme of beauty in connection with art in his Stone Lectures at Princeton Seminary in 1898.[43] Artistic beauty, for Kuyper, was an important reminder of the original beauty and goodness of God's creation and a celebration of its Creator as well as a foretaste of heaven and the new earth. In short, Neo-Calvinists reject Gnostic and related theologies that consider the body or matter as a source of evil or a fall. Spiritual life is not conceived as an escape from the body but as embodied living in accordance with God's Spirit—*ruakh* in Hebrew Scriptures; *pneuma* in the New Testament.[44] This way of conceiving spiritual reality avoids some of the unhelpful traditional hierarchies whereby a lower and imperfect human realm of materiality, physicality, embodiment, sensibility, particularity, temporality, and the like is pitted against a higher and perfect, transcendent realm of immateriality, invisibility, spirituality, intelligibility, non-physicality, disembodiment, and eternity. Indeed, the only fundamental ontological distinction held by Neo-Calvinists is that between Creator and creation. All other distinctions are located *within* the realm of creation. As a result, fall and redemption applies to all created reality, beauty being no exception.

Applied to aesthetics this means that beautiful art is not, as is sometimes assumed, a privileged entry point to some higher invisible realm—earthly beauty serving as a stepping stone to some putative "spiritual" beauty—but a creational gift meant to promote general human flourishing. Rather than lifting us out of our embodied, physical existence and world, it is meant to bring us into more intimate contact with it. This view of art aims to regain

[42] John Calvin, *Institutes of the Christian Religion*, ed. John T. McNeill, trans. Ford Lewis Battles (Philadelphia: Westminster, 1960), 3.10.2.

[43] Abraham Kuyper, *Lectures on Calvinism* (Grand Rapids, MI: Eerdmans, 1999). For a discussion of Kuyper's lectures see Peter Heslam, *Creating a Christian Worldview: Abraham Kuyper's Lectures on Calvinism* (Grand Rapids, MI: Eerdmans, 1998).

[44] In order to avoid any misunderstanding, there is an important distinction between *materiality*, which is part of God's good creation, and *materialism*, understood as the belief that everything can be *reduced* to matter or, alternatively, as an obsession with material wealth. There is also a difference between physicality, which, again, is part of God's good creation, and physical*ism*, which is the view that everything can be *reduced* to the physical.

a renewed sense of the depth, richness, and nuances of creation rather than taking it for the putative flat, disenchanted world that the modernists took it for. Art gives us a heightened experience and imaginative understanding of God's world as we encounter it through our senses. This can re-invoke a renewed sense of wonder for the beauty of the world but also a deeper understanding of its brokenness and suffering. Art nurtures the perception of its numerous, often nameless qualities that lie underneath the radar screen of conscious awareness. Artists are aficionados of nuance par excellence.

The notion of nuance features prominently in Calvin Seerveld's definition of the aesthetic: "There is a nuanceful dimension to all creatures and an imaginative feature within corporeal human life that it makes biblical and historical sense to call aesthetic."[45] He also foregrounds nuance in the term he coins for the defining feature of art: *allusivity.* "Artworks . . . are objects or events produced by imaginative humans who have the skill to give media . . . a defining quality of allusivity that brings nuanced knowledge to others who give the object informed attention."[46] Allusivity has to do with hinting at, suggesting and, obviously, alluding to. Seerveld rejects beauty as the decisive feature of a work of art. For him, the notion of allusivity enables one to articulate what distinguishes a beautiful work of art from any other beautiful object, person, or natural phenomenon. It also clarifies that while craft (*technē*) is essential in art, that does not mean that everything that is skillfully made qualifies as art. In other words, for something to qualify as artistic, whether an architectural building, a painting in an art gallery, or a lullaby sung to a child, it must, in addition to whatever other role or character it may have, at least also have an "allusive quality."

Even so, the term *allusivity* may need some qualification. To allude to something often assumes that what is alluded to can also be obtained or captured by some other means. Yet, as is widely agreed, one of the characteristics of art is that its meaning cannot be articulated by some other means. Its content is wrapped up in its form. The "nuanced knowledge" that the work conveys is too fine-grained, too complex, or too ambiguous for it to be conveyed by any other means. I suggest that the notion of nuanced allusivity can

[45]Calvin Seerveld, *Redemptive Art in Society*, ed. John H. Kok (Sioux Center, IA: Dordt College Press, 2014), 2.

[46]Seerveld, *Redemptive Art*, 264.

be deepened by connecting it with the *body's pre-conscious engagement with the world.* The body can capture the kind of nuances that escape analytic, discursive thinking. In light of this, the term *allusivity* can be understood to refer to complex embodied experience that can be captured in its fine-grained integrality in art.

NAIVE EXPERIENCE

Another point of overlap between philosophers of an embodied aesthetics and Neo-Calvinist philosophers is the notion of lived experience or what the philosopher Herman Dooyeweerd, perhaps somewhat unfortunately, calls naive experience.[47] Similar to Merleau-Ponty's notion of lived experience, Dooyeweerd's naive, pre-theoretical experience grasps day-to-day reality in its totality before it is analyzed in different elements or aspects. Naive experience engages with the world's entities and events as individual unities or wholistic *Gestalts* in the rich fullness of their integrated existence. Seerveld describes naive experience as "the idea that our basic, common, every day human knowing is the full-fledged bodily action of an individual enmeshed in the very continuity of temporal reality."[48] Although different thinkers in the Neo-Calvinist tradition conceive the difference between naive experience and scientific thinking slightly differently, they all want to safeguard the realm of naive experience over against the hegemony of the specialized and abstracting sciences.[49] According to them, there are many different ways of knowing and understanding the world and direct, naive day-to-day experience of concrete objects and events is one of them.

A variation on the need to safeguard day-to-day life experience against the narrow focus of a specialized, abstracting form of attention can be found in Nicholas Wolterstorff's *Art Rethought.*[50] One of Wolterstorff's enduring criticisms of modern philosophies of art, including those in the

[47]Herman Dooyeweerd, *A New Critique of Theoretical Thought,* trans. D. H. Freeman and W. S. Young (Philadelphia: P&R, 1969), 1:3-5, 83-86.

[48]Calvin Seerveld, *A Christian Critique of Art and Literature* (Toronto: Tuppence, 1995), 79.

[49]For a comparison of the distinction between naive experience and scientific thinking among Vollenhoven, Dooyeweerd, and Van Riessen, see René van Woudenberg et al., eds., *Kennis en werkelijkheid: Tweede inleiding tot een christelijke filosofie* (Amsterdam: Buijten & Schipperheijn, 1996), 37-48.

[50]Nicholas Wolterstorff, *Art Rethought: The Social Practices of Art* (Oxford: Oxford University Press, 2015).

Neo-Calvinist tradition, is that they buy into the idea of what he calls the "grand narrative." This idea entails that art *came into its own* only in the eighteenth century with the emergence of separate art galleries and concert halls and that the only proper way of engaging with art is by means of aesthetic contemplation. Instead, so he argues, art is a social practice that can perform different functions such as, for example, commemorating, protesting, or worshiping. When artworks perform these functions, they do not operate as objects of art but count as commemorative practices. The practice of making, presenting, and engaging with art as an object for absorbed aesthetic attention is just one social practice alongside others, neither more nor less appropriate. By focusing exclusively on art as an object of aesthetic contemplation, art theory and philosophy have neglected a vast array of social practices of art we encounter in everyday life and that are of great importance.

Although there is much to agree with here, Wolterstorff nevertheless leaves one important question unanswered. Even if art can count as a range of different social practices and perform different functions, what is the difference between a social practice done by artistic means and by some other

Figure 11.2. Maya Lin, *Vietnam Veterans Memorial*, 1981–1982

means? How is, for example, the social practice of commemorating the dead through Maya Lin's *Vietnam Veterans Memorial* (fig. 11.2) different than honoring them through, say, reading a declaration or raising a flag? Or how is the social protest practice of Harriet Beecher Stowe's *Uncle Tom's Cabin* different from, say, reading an abolitionist tract or going on a civil rights protest march? In order to get at this "how," it is impossible to avoid the question of the characteristic way of being of art. And if we look closer at that way of being in the above examples, we might come to the conclusion that that way has to do with the involvement of bodily feelings.

When we commemorate the fallen by walking along the Vietnam Veterans Memorial, we are deeply affected by the reflection of the granite surface, the wall's gradual descent into the earth, the overwhelming list of names of the dead, the sense of intimacy despite it being a public space, even the pace of our walking, and so on. It is a wholistic experience touching all our senses. Likewise, when reading *Uncle Tom's Cabin,* we enter imaginatively into another world where we engage empathetically with the characters and share their pain and indignation becoming emotionally involved.

Wolterstorff does not deny this. He admits that we engage with the memorial by "descending into it, touching it, weeping, noticing our reflection, and so forth."[51] He acknowledges that *Uncle Tom's Cabin* engages the readers emotionally with the characters and enables them not only to feel empathy with those who are wronged but to transfer those emotions to people and situations in the real world. But he does not draw any consequences from these observations, that is, that the arts do something unique that other social practices with the same end do not: they articulate how it feels to be a human of a certain kind in a particular location in a particular period in time. This makes practices done by means of art fundamentally different from those done without.

THE SOCIAL BODY

Following Abraham Kuyper, who, as a statesman, founder of a newspaper and a university, and public intellectual had a major influence on Dutch culture in his time, Neo-Calvinist thinkers have placed great emphasis on

[51]Wolterstorff, *Art Rethought,* 77.

the need to be agents of renewal in culture and society. This also applies to their view of the arts. Part of a Christian artist's vocation or "ministry of reconciliation" is to produce culturally transformative art. Art can bring shalom to the world, even as it may highlight the world's brokenness. Indeed, it is part of art's prophetic calling to expose the world's fragmentation and pain *as* part of our fallen condition.

For Langer and Johnson, too, art plays an important cultural role. Art reveals the affective undercurrents of individuals and whole societies. This makes art important as a way of giving shape to cultural moods— dissatisfactions, fears, hopes, and aspirations. Without sounds and shapes those feelings remain unarticulated and formless. The arts can take the pulse of a society. As Johnson puts it: "People turn to art . . . because it is meaningful and because it helps us to understand our human condition."[52]

Art is both a product and a source of feeling. That brings with it a particular responsibility: the education of feeling. Unlike elephants, bees, and dolphins, humans do not merely adapt to their environment, they also shape it. There was something uncannily prophetic about our own time when Langer wrote in 1958: "Art education is the education of feeling, and a society that neglects it gives itself up to formless emotion. Bad art is corruption of feeling. This is a large factor in the irrationalism which dictators and demagogues exploit."[53] Similarly, writer Yann Martel once said: "If literature does one thing, it makes you more empathetic by making you live other lives and feel the pain of others. Ideologues don't feel the pain of others because they haven't imaginatively got under their skins."[54]

For Lambert Zuidervaart, too, the arts play an important role in civil society. They are a condition for a healthy democratic culture and society. People turn to the arts for cultural orientation. For Zuidervaart, too, art articulates nuances that escape discursive language: "Aesthetic signs are presentations [that] make multiple nuances of meaning available in ways that either exceed or precede both idiosyncratic expressions of intent and

[52]Johnson, *Meaning of the Body*, 208.
[53]Susanne Langer, "The Cultural Importance of Art," in *Philosophical Sketches* (Baltimore: Johns Hopkins University Press, 1962), 94.
[54]Stephen Moss, "Interview with Novelist Yann Martel," *The Hindu*, June 23, 2010, www.thehindu .com/books/Interview-with-Novelist-Yann-Martel/article16196390.ece.

conventional communications of content."[55] Key moments in this process are the exploration, presentation, and creative interpretation of those nuances of meaning. In order to capture this process in a shorthand term, Zuidervaart coins the evocative term "imaginative disclosure."[56] The arts are societal sites for imaginative disclosure that enable people to explore issues that concern them by having them articulated and rendered available for experience and reflection. As such they are what Zuidervaart, after Charles Taylor, calls "irreducibly social goods."[57] This irreducibility is tied to their aesthetic worth. As he puts it: "Intersubjective imaginative processes within the arts both complement and disrupt other societally constituted sites in which cultural orientation occurs."[58]

Here too, I suggest, the notion of imaginative disclosure could be developed and enriched by reference to the body and feeling. Like Wolterstorff, Zuidervaart does not ask the question *why* art might be capable of exploring, presenting, and interpreting "nuances of meaning." At one point he comes close: "The special contribution of art in public is to help people . . . disclose in fresh and insightful ways the *felt quality and lived experience* of concerns that merit public attention."[59] But this idea needs further development.

Imagination, I suggest, is rooted in the body's capacity to image or envisage something not currently present but nevertheless felt as carrying some meaning and significance. The reason people turn to the arts for cultural orientation is that art registers and presents what the critical intellect may not, or may not yet, be able to process. Art captures hunches, hints, and intuitions. It can announce, or warn of, a situation, relation, or society being safe or unsafe; fair or unfair; trustworthy or unreliable; caring or uncaring; inclusive or exclusive; sacred or profane; moral or immoral; and so on. The body's antennae receive many signals about things meriting public attention that go unnoticed by political and critical thought.

[55]Lambert Zuidervaart, *Artistic Truth: Aesthetics, Discourse, and Imaginative Disclosure* (Cambridge: Cambridge University Press, 2004), 60.

[56]Zuidervaart, *Artistic Truth*, 101-9.

[57]Lambert Zuidervaart, *Art in Public: Politics, Economics, and a Democratic Culture* (Cambridge: Cambridge University Press, 2011), 41.

[58]Zuidervaart, *Artistic Truth*, 215.

[59]Zuidervaart, *Art in Public*, 126.

Moreover, as sculptor Antony Gormley once said: "Art shows what politics can only talk about."[60]

EDUCATION OF FEELING

Both biologically based and phenomenologically oriented theories have made substantial and insightful contributions to a better understanding of the role of feelings and the body in the production and reception of art. These approaches to art have proven to be valuable correctives to those theories which aim to explain art exclusively in terms of its particular cultural-historical context. They are a salutary reminder of the fact that, despite their immense historically and culturally mediated diversity, aesthetic experience and artistic practices are a deep feature of every society and can be considered a fundamental, if not universal, dimension of human existence. As I have argued, *art is the imaginative articulation of nuanced, prereflective affective experience.*

In a world dominated by social media, discourse is often reduced to a thumb up or down, a tweet or a shout. Yet, to ensure that societies do not neglect their "education of feeling" and give themselves over to "formless emotion," it may well be necessary to learn again how to listen attentively to the feeling body as it finds its nuanced expression in art. In the words of Yann Martel:

> To read a book, one must be still. To watch a concert, a play, a movie, to look at a painting, one must be still. Religion, too, makes use of stillness, notably with prayer and meditation. Gazing upon a lake in autumn or a quiet winter scene—that too lulls us into contemplative stillness. Life, it seems, favours moments of stillness to appear on the edges of our perception and whisper to us, "Here I am. What do you think?"[61]

Only if art can reclaim this kind of quiet attentiveness to the whispering of embodied feeling can it become truly transformative.

BIBLIOGRAPHY

Chaplin, Adrienne Dengerink. *The Philosophy of Susanne Langer: Embodied Meaning in Logic, Art, and Feeling.* London: Bloomsbury Academic, 2020.

[60]"Politics v the Arts: Listen to the Debate," *The Guardian*, May 27, 2007, www.theguardian.com /artanddesign/artblog/2007/may/22/politicsvtheartslistento.

[61]Yann Martel, *What Is Stephen Harper Reading?* (Toronto: Vintage Canada, 2009), 3-4.

Langer, Susanne K. *Mind: An Essay on Human Feeling.* 3 vols. Baltimore: Johns Hopkins University Press, 1967–1982.

——. *Philosophy in a New Key: A Study in the Symbolism of Reason, Rite and Art.* Cambridge, MA: Harvard University Press, 1942.

Johnson, Mark. *The Meaning of the Body: Aesthetics of Human Understanding.* Chicago: University of Chicago Press, 2007.

Merleau-Ponty, Maurice. *Phenomenology of Perception.* Translated by Colin Smith. London: Routledge, 1962.

Seerveld, Calvin. *A Christian Critique of Art and Literature.* Toronto: Tuppence, 1995.

——. *Redemptive Art in Society.* Edited by John H. Kok. Sioux Center, IA: Dordt College Press, 2014.

Wolterstorff, Nicholas. *Art Rethought: The Social Practices of Art.* Oxford: Oxford University Press, 2015.

Zuidervaart, Lambert. *Art in Public: Politics, Economics, and a Democratic Culture.* Cambridge: Cambridge University Press, 2011.

——. *Artistic Truth: Aesthetics, Discourse, and Imaginative Disclosure.* Cambridge: Cambridge University Press, 2004.

Chris Ofili: Contemporary Art and the Return of Religion

ADRIENNE DENGERINK CHAPLIN

Religion is back, not only in political debates and the public arena, but also in the arts. Mainstream contemporary art now incorporates the kind of religious references and iconography, including Christian iconography, which, since the origins of modern art in the nineteenth century, had largely been absent. Religion is back in art, not—or at least not primarily—because of any religious beliefs held by the artist, but as the result of a changed society, including religion's place therein. In that sense, contemporary artists do what artists have done throughout the ages: explore, critique, celebrate, lament, transform, and subvert whatever they encounter in the world.

Often, however, religious imagery—including Christian imagery—is being used outside of its traditional context and accepted understandings, which raises some interesting questions: how do these images relate to their historic, traditional meanings? To whom do religious stories and symbols belong? And how should Christians respond to such works?

One artist referencing Christian themes outside their familiar context is the British artist of Nigerian descent Chris Ofili, who won the Turner Prize in 1998 and represented Britain at the Venice Biennale in 2003. For those with short memories, Ofili also produced the painting *The Holy Virgin Mary* (1996) (fig. 11.3), which formed part of the controversial *Sensation* exhibition in New York's Brooklyn Museum in 2001 and which became a lightning rod for the ire of the then-mayor Rudy Giuliani. The reasons for Giuliani's outrage were not only Ofili's use of tiny cut-outs from pornographic

magazines as decorative devices but also his employment of elephant dung, both on the painting's surface and by way of supports. For Giuliani, this could not be interpreted other than as a deep insult to and blasphemous attack on the holy status of the virgin Mary.

Ofili himself had this to say:

> It's about the way the black woman is talked about in hip-hop music. It's about my religious upbringing, and confusion about that situation. The contradiction of a virgin mother. . . . I wanted to juxtapose the profanity of the porn clips with something that's considered sacred. It's quite important that it's a Black Madonna. . . . It's about stereotyping of the black female. . . . It's about beauty. It's about caricature. And it's about just being confused.[1]

Ofili had started using dried-out elephant dung for the first time after a visit to Zimbabwe in 1992, his first ever to Africa. He was so taken by this experience that he wanted to import something of the African landscape into his paintings. Elephant dung seemed the right choice.

In order to compensate for the foul nature of the dung, however, he took special care to make the overall effect of his paintings especially aesthetically attractive. He did so by making richly layered decorative surfaces incorporating colored dots, sparkling glitter, polyester resin, map pins, and collage cut-outs, all carefully combined into a dazzling display of vibrant, folksy energy. The unsettling juxtaposition of the seductive quality of these beautiful surfaces with the repulsive feelings associated with elephant dung was to become Ofili's trademark for the next two decades.

This trademark is also evident in the paintings used in his installation *The Upper Room* (1999–2002). The installation consists of a large rectangular room containing thirteen

[1]Quoted in Judith Nesbitt, "Beginnings," in *Chris Ofili*, ed. Judith Nesbitt (London: Tate, 2010), 16. Catalogue for the exhibition *Chris Ofili*, Tate Britain, January 27–May 16, 2010.

canvasses: six each on the long walls and a thirteenth on a short wall. Like *The Holy Virgin Mary*, each painting is set on two balls of elephant dung and displays the dazzlingly decorative quality referred to above. The luminosity of the surfaces is even enhanced by the lighting above each painting which creates the suggestion of stained-glass windows reflecting colored light on the floor. The total space is thereby lent a chapel-like effect.

As might be expected, however, there is a twist. The paintings do not represent the twelve disciples flanking Jesus, as the title and arrangement of the installation might suggest. They represent thirteen rhesus monkeys, all but one with identically shaped outlines, though differently finished

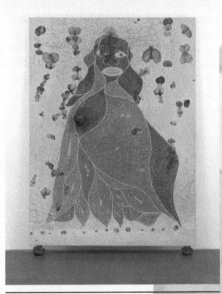

Figure 11.3. Chris Ofili, *The Holy Virgin Mary*, 1996. Acrylic, oil, polyester resin, paper collage, glitter, map pins, and elephant dung on canvas, 99 3/4 × 71 3/4′ (253.4 × 182.2 cm). Gift of Steven and Alexandra Cohen. Acc. no.: 211.2018.a-c.

and colored. Each has a different Spanish title expressing its particular color: *Mono Gris* (gray monkey), *Mono Amarillo* (yellow monkey), *Mono Rojo* (red monkey), *Mono Oro* (golden monkey, the one on the short wall), and so on. Each monkey holds a chalice or cup in their hands and, apart from the one at the end, is depicted in profile.

What to make of it? Are these paintings, as Giuliani would have it, of *The Virgin Mary*, another instance of making a mockery of the Christian faith? Should this be seen as a case of blasphemy to be vigorously condemned and rejected by any true believer?

Interpreting art is a tricky business. Ofili himself has not commented much about this piece except to say that the idea of the installation as a whole only emerged *after* he had finished most of the individual monkey paintings. Yet the fact that this piece presents us with an iconographical and theological puzzle should not lead

us to condemn it outright. As American theologian and aesthetician Wilson Yates puts it:

> Traditional Christian symbols are a part of the culture and lie far beyond the final control of the church. The symbols will be imaged in diverse ways by non-Christians as well as Christian artists, often contrary to the church's dominant interpretation. But this should not be viewed as threatening but as a means by which, paradoxically, the traditional symbols are kept vital—are kept alive in the midst of human life.[2]

What might that mean for Ofili's *Upper Room*? Let's give it a try: monkeys in Christian iconography symbolize sin and evil and sometimes the devil. Furthermore, in Orthodox icons, the only figures represented in profile are demonic figures or Judas Iscariot. This is because they do not have both eyes focused on God and should therefore also not be looked at frontally. Now, as it happens, Ofili has a certain fascination with the Judas figure. He is, for instance, the main character in the painting *Iscariot Blues* (2006), where he is depicted hanging from a gallows, accompanied by a blues duo on drums and guitar. This may give us some clues.

Traditional depictions of the Lord's Supper—such as, for instance, the one by Leonardo da Vinci—often capture the moment of consternation among the disciples after they have been told by Jesus that one of them is going to betray him. It is the moment where they exclaim: "Surely not I, Lord!" (Mt 26:22; Mk 14:19). Interestingly, when recording Jesus' reply, the Gospel writers use different tenses: the one who has dipped his hand in the bowl with me (Mt 26:23); *the one who dips* bread into the bowl with me (Mk 14:20); *the one to whom I will give* this piece of bread when I have dipped it in the dish (Jn 13:26). But the main point is clear: the traitor is in the process of sharing a meal with Jesus—a sign of great intimacy, trust, and friendship in most

[2]Wilson Yates, "Conflict and Conversations Between Religion and Art: Brooklyn and Beyond," *Arts: The Arts in Religious and Theological Studies* 12, no. 1 (2000): 4.

Eastern cultures, both then and now. This makes the predicted act of betrayal all the more shocking.

But note that *all* disciples were sharing bread and wine with him at that supper. Considering the Eastern practice of sharing bowls with stew for dipping bread or meat in, it is very likely that most of them would, at some point or the other, also have dipped their bread in the same bowl as Jesus. Does that make all of them potential betrayers? Not necessarily, although Peter's subsequent denial of Jesus is of course also a form of betrayal. However, Ofili's piece may serve as a reminder that there is a potential Judas in every disciple and, indeed, in all of us, each carrying our own cup of sin and sorrow and turning in profile to Jesus, looking for forgiveness and redemption.

I'm not suggesting that Ofili himself would have had any of this specifically or consciously in mind, although he has talked in an interview about Judas being "transformed from a 'baddie' to a 'goodie'" on account of his role in God's plan of redemption. As with *The Virgin Mary*, he is more likely to say that he is "confused"—about Jesus, about Judas, and about God's ways for bringing about salvation. But that does not prevent us from allowing the work to speak to our religious imagination and have it invite us to take a sideways look at the momentous events that took place during that historic supper in an upper room approximately two thousand years ago.

Put more generally: rather than seeing works like these as threatening to our faith, they can, as Yates reminded us, serve to keep the traditional symbols alive in the midst of our human life—and, we may add, our confusion. Because, after all, God's precise ways for bringing about redemption remain, at root, a mystery to us all.

BIBLIOGRAPHY

Yates, Wilson. "Conflict and Conversations Between Religion and Art: Brooklyn and Beyond." *Arts: The Arts in Religious and Theological Studies* 12, no. 1 (2000): 2-5.

Part Four

THEOLOGY
AND ART

THE THEOLOGY
OF ART OF GERARDUS
VAN DER LEEUW
AND PAUL TILLICH

WESSEL STOKER

GERARDUS VAN DER LEEUW (1890–1950) and Paul Tillich (1887–1965) were leading scholars of aesthetics within the Protestant theological tradition. Together with Schleiermacher, they are of the opinion that religion and art stand beside each other as "two sympathetic souls, who are as yet ignorant of their inner connection, even though they immediately have a vague suspicion of this connection."[1] Van der Leeuw and Tillich each convey this in a different way. Van der Leeuw examines the place of art within the Christian tradition and devotes much attention to the religious art of other religions. Tillich points to religious art that is often hidden in what we usually call secular art. I will first describe the theological view of art of van der Leeuw and subsequently that of Tillich. In the concluding section, I will briefly indicate the similarities and differences between these two great Protestant thinkers of the twentieth century.

[1]F. Schleiermacher, *Über die Religion. Reden an die Gebildeten unter ihren Verächtern* (Stuttgart: Philip Reclam, 1969), 113.

GERARDUS VAN DER LEEUW

Ways and boundaries between art and religion. Originally, van der Leeuw was an ethical theologian. This Dutch theological current from the nineteenth century aimed to connect orthodox theology with science and culture. Van der Leeuw's field of research was broad. He wrote about the phenomenology of religion, religious art, theology as a science, liturgy, and sacraments. Even though we can discern three phases in his development, there are no clear breaks in his thinking.[2] From the very start, the incarnation, God becoming a human being, was central in his theology.[3] This also applies to his theology of art as he developed it in his principal work on aesthetics *Wegen en grenzen* (*Ways and Boundaries*).[4] He agrees with the statement of the Second Ecumenical Council of Nicea of 787 that the use of icons and images is permissible, as God became human in Christ and Christ is the image of God. For that reason van der Leeuw rejects the "Reformed fear of images in the church," although he recognizes the danger of idolatry.[5] Religion demands *Gestaltung* (formation, embodiment): "Religion always looks for art because it cannot live without form and shape."[6] In Christianity we may not lose the image (considered broadly), precisely because of the incarnation:

> The expression of the Holy One is the Son of God, the servant-figure of Christ. That is not a self-willed image, not a human usurpation of God's majesty; it is the act of God himself who took on form, of the Word that became Flesh. That is why they rightly appealed to Christology during the Byzantine struggle about images: if God could assume the characteristics of a human being, then the human image cannot be an entirely unworthy expression of the Holy One.[7]

The first edition of his principal work about art, *Wegen en grenzen: studie over de verhouding van religie en kunst* (*Ways and Boundaries: A Study About the Relationship Between Religion and Art*) appeared in 1932.[8] In the second edition of 1948 he reorganized the material. Apart from the

[2]J. Waardenburg, *Reflections on the Study of Religion: Including an Essay on the Work of Gerardus van der Leeuw* (The Hague: Mouton, 1978), 187-247.

[3]Gerardus van der Leeuw, *Inleiding tot de theologie*, 2nd ed. (Amsterdam: Paris, 1948), 164.

[4]Gerardus van der Leeuw, *Wegen en grenzen*, 2nd ed. (Amsterdam: Paris, 1948), 470-72.

[5]Van der Leeuw, *Wegen en grenzen*, 2nd ed., 248, 250.

[6]Van der Leeuw, *Wegen en grenzen*, 2nd ed., 254.

[7]Van der Leeuw, *Wegen en grenzen*, 2nd ed., 250; cf. 252, 466.

[8]Gerardus van der Leeuw, *Wegen en grenzen* (Amsterdam: Paris, 1932).

phenomenological part about art, he now emphasized more fully (Christian) theological reflection. In the preface of the second edition we read: "The book of 1932 was a phenomenological study with a theological perspective. The new book is still a phenomenological one, but I have tried to add the theological sequel, at least in its main outlines. . . . In this way theology regains her rightful place in this renewed edition."[9]

I am basing my comments on the second edition but will also indicate the importance of the first edition.[10] Before going into the specifics of the contents of van der Leeuw's contribution to art theory, I first want to say something about his method in his theology of art.

The phenomenological and the theological method. In his theological art theory van der Leeuw shows how—right through history and cultures—ways were carved between art and religion, and boundaries were delineated between them. He does not do this as an historian, nor does he see his research as philosophical or dogmatic. Rather, it is phenomenological.[11] In his art theory, he states as follows:

> Whereas history asks "how was it?," the phenomenologist asks "how do I understand it?" Where philosophy investigates truth or reality, phenomenology is content with the givenness as such without asking about its truth or reality. So we do not attempt to trace causal relationships, but rather understandable connections. We do not seek to penetrate the truth behind the phenomena, but to understand the phenomena themselves in their simple givenness.[12]

Apart from phenomenology we also encounter theology in his research of art. In his *Phänomenologie der Religion* he remarks about the relationship between the two that the phenomenologist looks for understandable

[9]Van der Leeuw, *Wegen en grenzen*, 2nd ed., xiv.

[10]In 1955, after his death, a third edition was published, as revised by E. Smelik. The text is that of van der Leeuw, but Smelik made a different setup. It has the advantage that repetition is sometimes omitted, but the price was too high, as Hubbeling correctly pointed out. Paragraphs and sections were given a different meaning by Smelik's regrouping. Unfortunately, the translations into German and English of *Wegen en grenzen* are based on this edition. H. G. Hubbeling, "Divine Presence in Ordinary Life: Gerardus van der Leeuw's Twofold Method in His Thinking on Art and Religion," *Mededelingen der Koninklijke Nederlandse Akademie van Wetenschappen, Nieuwe Reeks* 49, no. 1 (1986): 26.

[11]Van der Leeuw, *Wegen en grenzen*, 2nd ed., 4.

[12]Van der Leeuw, *Wegen en grenzen*, 2nd ed., 4-5.

connections and exercises *epoché*, suspension of judgment, because God is not a phenomenon. He can only study humanity's answer to revelation. The phenomenologist searches for a meaningful structure in the chaotic reality of the world of religions. The theologian on the other hand appeals to revelation and speaks about God, whereby he goes back and forth between hiddenness and revelation.[13]

Van der Leeuw is both in *Wegen en grenzen*; his phenomenology and his theology are closely connected. Phenomenological descriptions even flow into theological judgments. Van der Leeuw emphasizes this merging of phenomenology and theology in his art theory at the end of his *Wegen en grenzen*:

> This is how we find ways and boundaries as *phenomenologists*, as scholars who study art and religion. This is how we experience again and again as religious human beings the miracle of the blending of both currents of religion and art. As *theologians*, who cannot artificially separate revelation in Christ and the seemingly other given to us as revelation, nor wish to blur it in the generality of an idea of God, we find the unity of art and religion there where we only know unity: in the teaching of the Incarnation.[14]

In this way the theologian van der Leeuw follows two ways in his theology of art: the theological way of revelation to the world and the phenomenological way of the world to revelation, the incarnation in Christ.[15] As a phenomenologist he determines that all religions are concerned with a power that humanity perceives in reality.[16] That power is named in very different ways. Speaking as a theologian he asserts that this power is in a definitive way revealed in Christ. In his phenomenological way van der Leeuw is also interested in the art of other religions. That is why he already was a pioneer in the 1930s of what in today's theory of art is only now slowly receiving attention: a comparative, intercultural philosophy of art. Outside Western art there are many views of art of different religions, not only of world religions but also of the religions of illiterate people (referred to by

[13]For this and what follows, see G. van der Leeuw, *Phänomenologie der Religion* (Tübingen, DE: Mohr, 1933), 650-52.

[14]Van der Leeuw, *Wegen en grenzen*, 2nd ed., 471-72; emphasis original.

[15]Van der Leeuw, *Inleiding tot de theologie*, 163-75.

[16]Van der Leeuw, *Phänomenologie der Religion*, 643.

van der Leeuw as "primitive religion"). Via the second way, van der Leeuw provides magnificent examples of religious art of all kinds, such as dance, drama, poetry and literature, visual arts, architecture, and music.

The second edition of Wegen en Grenzen. How does van der Leeuw research the connection between what is holy and beautiful, between religion and art? He does not formulate his research theoretically but from the standpoint that art and religion are events: "Can art be a holy action?"[17] In this form he looks for ways and boundaries between what is holy and what is beautiful, religion and art. As a phenomenologist he looks for "the Beautiful, the way it makes an impression on our spirit and is expressed by our spirit. Impression and expression of the Beautiful is now usually called Art by us."[18] He is concerned with the experience of art. He understands the Holy to be the totally Other, "that forces itself on us as being of a wholly different character, origin and effect from everything else that is otherwise known to us."[19] Whatever manifests itself to us in this manner, we respond to it, as Rudolf Otto has already observed, with a two-sided emotional response: a consciousness of awe and insignificance, and of fascination, a surprised joy and love.

Van der Leeuw examines the relationship between art and religion in the areas of dance, drama, *belles-lettres*, visual arts, architecture, and music. For each type of art he presents phenomenologically *four structures* for the relationship between art and religion, starting with dance: initial unity, weakening of the unity, conflict, and unity of art and religion.

Originally dance and religion formed a *unity* in primitive culture. Gradually they grew apart. At first there was a *weakening of the unity*. The dance became profane.[20] There is also the situation where dance and religion are *enemies* of each other, where he refers to the *conflict* between dance and religion among the Reformed and the Lutherans.[21] Finally, the *unity* of dance and religion is discussed. What makes dance religious is the surrender of oneself to a stronger power, adjusting one's own movement to the movement of the whole. That can happen in the manner of the

[17]Van der Leeuw, *Wegen en grenzen*, 2nd ed., 5.
[18]Van der Leeuw, *Wegen en grenzen*, 2nd ed., 5.
[19]Van der Leeuw, *Wegen en grenzen*, 2nd ed., 3.
[20]Van der Leeuw, *Wegen en grenzen*, 2nd ed., 47.
[21]Van der Leeuw, *Wegen en grenzen*, 2nd ed., 63-71.

primitives or of the religious *extatici*, but also in the heavenly dance. In dance, humans try to keep time with the angels and to follow the movement of their heavenly dance. On Fra Angelico's painting of *The Last Judgment* (1435–1440) women and martyrs dance the heavenly dance.[22]

He also indicates to these four structures in the other mentioned kinds of art, always concluding with the theological aesthetics of the artform. The final chapter, titled "Wegen en Grenzen" (Ways and Boundaries) closes with theological observations about art resulting in a theology of the arts. Visual art is central here due to the outer appearance in which God embodied himself, that of the crucified One.[23]

We will look more closely at van der Leeuw's view of visual art on the basis of the four structures.

Four positions of visual art in relation to religion. Van der Leeuw does not restrict the visual arts to painting, sculpture, or drawing. The capacity to represent things through images is also a principal feature of other arts such as dance or literature.[24] In art the things of life move with a rhythm of their own. But in the more restricted sense of visual art the rhythm is fixed, the movement blocked. Van der Leeuw wonders why people actually make images. He looks for an answer with primitive and ancient people. The image originally functioned in worship. That is the first structural position of art in relation to religion.

Perfect unity of art and religion.[25] In primitive and ancient cultures the character of the image is religious-symbolic. Man has the capacity to place different imagined forms next to and instead of himself and the forms he encounters. He erects symbols of living reality, images in which the form that he perceives and the form that he creates converge.[26]

Art has a practical purpose in primitive and ancient art. People make an image of something in order to enter into a relationship with it, to benefit from it or to make it harmless. What happens to the image also happens to the creature it represents, a man, animal, plant, or other being. In that way the image has power. It is a cultus-image; "cultus" in the broadest sense of

[22]Van der Leeuw, *Wegen en grenzen*, 2nd ed., 91.
[23]Van der Leeuw, *Wegen en grenzen*, 2nd ed., 465-67; cf. 303-4.
[24]Van der Leeuw, *Wegen en grenzen*, 2nd ed., 205.
[25]Van der Leeuw, *Wegen en grenzen*, 2nd ed., 205-25.
[26]Van der Leeuw, *Wegen en grenzen*, 2nd ed., 208.

"holy act."[27] The holy act consists of mastering the depicted creature by picturing it in a second, often masked form. In that way people ensure the efficacy of the power of the represented being.[28]

Characteristic for a religious representation is, moreover, the less it is a portrayal of reality, the greater chance there is for a genuine representation of a different reality. *"Representation is reproduction of power, not of appearance."*[29]

As far as the Christian tradition is concerned, Puritanism is of the opinion that it can do without images and that words suffice. Van der Leeuw emphasizes once again that to fulfill their cultic function images are in no way portrayals. You cannot make a portrait of God, but you can make a symbol of his presence. The lamb is an image for Christ, just as the Good Shepherd.[30]

Weakening of unity.[31] The connection between art and religion was loosened. Art liberated itself from the sacred bonds and broke with the identity of the image and object. The older Greek statues of the gods show the gods as dressed. That points to the distance inherent in that which is holy. The later statues of the gods from the classical period show the gods as naked. The awareness of distance is lost in the joy of the beautiful body. He points to a similar development in the Christian tradition. In the Middle Ages, holiness was the leading factor in shaping the image of Christ or Mary in sculpture or frescos. In Renaissance art, the divine is not of another nature, but human. From now on even the completely human can refer to the holy. In the *Demeter of Knidos,* Raphael's *Sistine Madonna,* or the *Assunta* by Titian we can experience the revelation of the holy. Sometimes that is also true of undressed figures, such as the *Hermes* by Praxiteles or the *Christ* by Michelangelo. In that case it is human purity that is being sought, human in a perfection that we as humans can never attain. Therefore it can be the bearer of the wholly Other.[32] This is religious humanism, that is, harmony of holiness and beauty. This is different where harmony gives way to an

[27]Van der Leeuw, *Wegen en grenzen,* 2nd ed., 214.
[28]Van der Leeuw, *Wegen en grenzen,* 2nd ed., 215.
[29]Van der Leeuw, *Wegen en grenzen,* 2nd ed., 217; emphasis original.
[30]Van der Leeuw, *Wegen en grenzen,* 2nd ed., 218.
[31]Van der Leeuw, *Wegen en grenzen,* 2nd ed., 226-37.
[32]Van der Leeuw, *Wegen en grenzen,* 2nd ed., 227.

external relationship, where human beauty is still very beautiful, but no longer seen as divine or holy. Van der Leeuw cites as examples the *Apollo Belvedere* and the Madonnas of Rubens or Van Dyck. The Mother of God turns into an endearing mother of humans. Here beauty kills holiness, thereby providing the conditions for the conflict between art and religion.

The conflict.[33] There is always the danger that a religious image becomes a realistic representation, whereby holiness is harmed. It was especially Protestantism that fought against this, although it was not only during the Reformation that there were iconoclastic outbreaks. Van der Leeuw sketches two extreme positions about images. One is naturalism, which you encounter not only during the Renaissance. In ancient Egypt king Akhenaten already promoted the free development of apparel and the realistic reproduction of the body over against the sculptures of his time that were controlled by religion. The other extreme is asceticism that ends in an absence of images.

Van der Leeuw alternates his phenomenological description with his theological judgment about the use of images. As theologian he looks for a way between the autonomy of the image in secular art and the absence of images of mysticism or the prohibition images by Calvinists. Even though the latter reject images in the church, they can on no account do without pictorial language. Religion does not speak in abstract concepts; its language is that of the myth and that is the language of imagination. Van der Leeuw even rejects a spiritual, spiritualizing religion:

> Religion does indeed look for the other-than-the-world, but it does not look for it—unless it is given over to asceticism—the immaterial. "Spirituality" and faith do not converge. The Christian Church has always believed in the resurrection of the body, and with that has postulated that God glorifies this world. Whatever is wrong in this world, it is not its materiality, its perceptibility to the senses, but its sinfulness.[34]

Artists are not illustrators but imaginators. They create in their art a new, different reality; they try to penetrate the deepest reality. That is how art and religion touch each other and we arrive at the fourth position.

[33]Van der Leeuw, *Wegen en grenzen*, 2nd ed., 238-53.
[34]Van der Leeuw, *Wegen en grenzen*, 2nd ed., 242.

The newly found unity.[35] The intersection of religion and art is located at the point where art expresses holiness. Beauty is holiness, but holiness is not necessarily beauty. *Holy* is the last word, *beauty* the penultimate. Religious art is determined in the first instance by the particular religion and not by art or by aesthetics. I call to mind how, according to van der Leeuw, the encounter with the wholly Other evokes a double reaction: that of fear and fascination. How is it possible to express that in art? "In Beauty we search for both God's friendly face as well as the Fear of the Lord, both the Comforter who calls us to himself, weary and burdened as we are, as well as the Frightful One who rejects us with a: What have I to do with you?"[36]

It seems that van der Leeuw narrows his phenomenological understanding of the latter position with respect to the relationship between (visual) art and religion to the Christian religion only. He discusses primarily images of the Christ figure. Does he hereby suggest that real religious art is only found within the Christian religion? This is how he writes about it at the end of *Wegen en grenzen*:

> It must be possible, it can be possible to recognise in human works of beauty God's characteristics, since God himself has given the characteristics of his own image to his earthly creation. It must, it *can* be possible to praise all the riches of human life, the colourful whirl of artistic and religious forms as a revelation of God's glory, when God gave himself to humanity and took on a form to live as a man among mankind.[37]

Does the "colourful whirl of artistic and religious forms" that is to be praised as "a revelation of God's glory" apply only to art within the Christian religion or also to art within other religions? The focus of the last structural position on Christianity suggests the former, the extensive phenomenological description of the religious art of other religions, both dead and living, the latter. I will return to this later. First we will look at how the holy impacts the beautiful in the representations of the Christ figure.

Where there are no fixed rules for religious art, it is often difficult to determine whether something is religious art. If it concerns a depiction of a biblical figure or a saint, the style can sometimes be nonreligious. Can we still

[35]Van der Leeuw, *Wegen en grenzen*, 2nd ed., 254-61.
[36]Van der Leeuw, *Wegen en grenzen*, 2nd ed., 256.
[37]Van der Leeuw, *Wegen en grenzen*, 2nd ed., 471.

call it religious art? Van der Leeuw gave a few examples in a similar way that Tillich will do that further on (see below). Van der Leeuw applies the rule of appropriateness. That means that if a work of art intends to express something religious, then it should do so in an appropriate or proper manner.[38] The Madonnas by Rubens or Van Dyck do not depict Mary properly as the Mother of God: they don't radiate enough of the holy, because the image of Mary could be exchanged for any other mother. With regard to religious art, van der Leeuw speaks about "moments" that indicate whether a work of art renders the pictured figure appropriately. I myself use the term *religious hints* in such a context, where the color, form, or style of a painting invites the viewer to experience a work of art as religious.[39] If visual art is to be genuine religious art, then, according to van der Leeuw, one or more of the following six moments or religious hints should be somehow apparent in a work of art.[40]

1. The *fascinans*: the appeal of the holy can be expressed by the colorful and sunny, in contrast to the dark. One example is the *Pieta* (1894) of Max Klinger, where the darkness of death stands in contrast with the divine light of the meadow in spring.

2. The *tremendum* expresses the frightening in what is holy. That comes to expression in the monstrous character of Indian representations of the gods or in the threatening majesty of the Byzantine icon art. It is also visible in the *Ecce Homo* by Dürer or Michelangelo's *Damned* on the ceiling of the Sistine Chapel.

3. The *ghostly*, the abhorrent, is a nuance of the *tremendum*. Grünewald depicted that well in his *Resurrection of Christ* as part of the *Isenheim Altarpiece*.

4. The *darkness and semi-darkness* show an analogy with the negative way in theology in the development of the concept of God: God's being is approached as closely as possible by denying what is human and earthly. In Roman church architecture this is expressed by narrow windows that do not allow much light to enter. Rembrandt's *chiascuro* also makes a strong, numinous impression, for instance in his *Hundred Guilder Print*.

5. The *human aspect* is the clearest religious feature in the visual arts according to van der Leeuw. The human figure is in this context an expression

[38]The term *decorum*, the *appropriate*, originates from classical rhetoric.
[39]W. Stoker, *Imaging God Anew: A Theological Aesthetics* (Leuven, BE: Peeters, 2021), 9.6.
[40]Van der Leeuw, *Wegen en grenzen*, 2nd ed., 257-61.

of the superhuman and superterrestrial. That is preeminently obvious in the rendition of Christ in whose humanity holiness is fully expressed, as in Rembrandt's rendering of "the humility of the despised Jew" (fig. 12.1).[41]

6. *Harmony* is found in the relationship between what is beautiful and what is holy. Often one or the other predominates. Fra Angelico, Van Eyck, and Memling are masters in harmony.

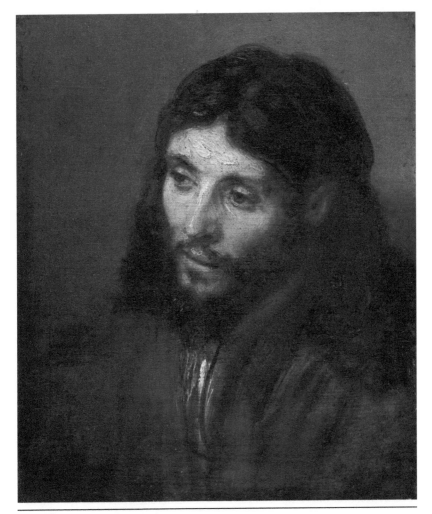

Figure 12.1. Rembrandt, *Head of Christ,* ca. 1648

[41]Van der Leeuw, *Wegen en grenzen*, 2nd ed., 260. See Rembrandt, *Head of Christ*, ca. 1648, oil on oak panel, 25 x 21.7 cm. Gemäldegalerie of the Staatliche Museen Berlin.

These moments or religious hints form the prerequisite to speak about the visual arts as religious art. As to other art forms, van der Leeuw names other moments that make a particular work of art religious. For example, the different moments in the dance are, among others, the Apollonian and the Dionysian movement. Here the *human* moment is of outstanding application. This moment as an expression of the divine is most prominent in the dance: "The movement of the body often expresses more of the totality and background of life than what word or tone can manage. Here, in the dance, everything is very human."[42] Literature, architecture, and music likewise have their own religious moments or hints.

While van der Leeuw speaks about "newly found unity" of religion and art, at the same time he also takes that back, because the Christian faith is for him eschatological in character. On the one hand, he sees the unity of art and religion in "the divine Figure, in the Son of Mary, Son of God, in the Most Beautiful."[43] On the other hand, unity is a matter of the future: God's kingdom is still to come. Hence, he formulates the unity of art and religion elsewhere eschatologically: "Religion and art are parallel lines that only cross each other in infinity. They find each other in God."[44]

We see how van der Leeuw limits his discussion of the newly found unity of art and religion to the Christ figure. Does this mean that genuine religious art, except for primitive or ancient cultures (especially mentioned in the first structural position) can only be found within the Christian tradition? That is not the case, as is more clearly shown in the first edition of *Wegen en grenzen* than in the second edition.

The first edition about religious art. To the question of how to speak of "the unity of being of Beauty and Holiness," how the holy can stamp the beautiful, van der Leeuw indicates in the first edition of *Wegen en grenzen* approximately seventeen moments or religious hints, which he randomly pinpoints in different artforms from different religions. These show the inner cohesion of art and religion. With these moments van der Leeuw defines what appropriateness actually entails for religious art. He shows that for one religion the religious moments are different from another religion,

[42]Van der Leeuw, *Wegen en grenzen*, 2nd ed., 88.
[43]Van der Leeuw, *Wegen en grenzen*, 2nd ed., 472.
[44]Van der Leeuw, *Wegen en grenzen*, 2nd ed., 460.

because holiness is conceptualized differently. The subtitle of the first edition, "Study About the Relationship Between Religion and Art," was left out in the second edition and the moments or religious hints received a less prominent place, because they were now applied to different artforms. This was evidently done to emphasize the more Christian-theological character of the second edition of *Wegen en grenzen,* as stated earlier.

Van der Leeuw has not changed his opinion but places a different emphasis in the second edition. When he writes in the second edition that the revelation of God's glory preeminently comes to expression in the incarnation, in the representation of Christ, then this is not meant to be exclusive, but inclusive. "We believe in God becoming Man. But we do not need to believe that God has availed himself of only one human way of expression in order to reach us."[45]

In Christ we meet everything that is of value in other religions and that applies also to the art that we encounter in other religions. That is why van der Leeuw, as phenomenologist, takes the religious art of other religions seriously.[46] For him as theologian it is a reflection of the holiness that is definitively revealed in Christ.

In principle, he also judges art in general in a theologically positive manner. Here a classical difference between Catholicism and Protestantism plays a role. Catholicism posits that grace does not cancel nature but perfects it. Protestantism is less optimistic and believes that nature has been harmed by sin. Hence it speaks of sin and grace instead of nature and grace. Van der Leeuw agrees with the Catholic opinion that grace does not cancel nature. He does, however, reject the notion that grace perfects nature and corrects it as follows: grace does not cancel nature, but recreates it. In that way he can appreciate art without the church theologically: "The work of God's creation is being built right through nature and culture in its heathen holiness—also in the human work of art that serves Him."[47]

Art as symbol. Van der Leeuw emphasizes how much art and religion are sympathetic souls (as mentioned already), as well as his opinion that art is *sacramental* in nature. Art expresses the secret of life. The

[45]Van der Leeuw, *Wegen en grenzen,* 2nd ed., 167.
[46]Van der Leeuw, *Wegen en grenzen,* 2nd ed., 471.
[47]Van der Leeuw, *Wegen en grenzen,* 2nd ed., 301; cf. 293, 295, 300, 305-6.

phenomenologist calls this secret "a power" that presents itself in and through art and religion. The theologian recognizes this presence as sacramental and knows that art in its sacramental nature is part of the kingdom of God.[48] Art and religion build a different reality. He stresses the power of the image for the believer by conceiving of art as a symbol.

Van der Leeuw harks back to the image in primitive cultures and antiquity that is religious-symbolic in nature. He adopts this insight in his own theological conception of image as symbol.[49] An image derives its existence from the desire to express something, that it wants to be the resemblance of something. It always represents something, otherwise it would just be an ornament.[50] It is characteristic of an image that its reality corresponds to another reality, a symbol, that is, a convergence in a literal sense. "Your portrait is not just a piece of canvas with paint, it is a piece of reality that coincides in a mysterious way with your reality."[51] The relationship between the two realities is not coincidental: the image is not something arbitrary but is the "essence of what is pictured, its manifestation, the visible form."[52]

The symbol is conceived as a coherence of being, as the convergence of two things: the signifier and the signified.[53] The image of a god is not itself the god, nor is it merely an indication of God. Two realities, of the god and of the image, converge in the image. In that way it ensures the presence of God; it has, even though it has been produced by a human being, creative power. That is why the image is indispensable in religion in general, but also in the Christian religion.[54] The divine reality only exercises power toward us when it appears to us in material form. "We only know divine reality as a symbol, i.e., only when this reality converges with the one represented by the image, when it receives form in our reality."[55] So we see that the symbol is considered here to be "presentative" because it makes God or gods present.[56]

[48]Van der Leeuw, *Wegen en grenzen*, 2nd ed., 467.
[49]Van der Leeuw, *Wegen en grenzen*, 2nd ed., 308; G. van der Leeuw, *Sacramentstheologie* (Nijkerk, NL: Callenbach, 1949), 9.
[50]Van der Leeuw, *Wegen en grenzen*, 2nd ed., 307.
[51]Van der Leeuw, *Wegen en grenzen*, 2nd ed., 307.
[52]Van der Leeuw, *Wegen en grenzen*, 2nd ed., 308.
[53]For this and what follows, see van der Leeuw, *Sacramentstheologie*, 9.
[54]Van der Leeuw, *Wegen en grenzen*, 2nd ed., 308-10.
[55]Van der Leeuw, *Wegen en grenzen*, 2nd ed., 308.
[56]M. Barnard, *De dans kan niet sterven: Gerardus van der Leeuw (1890–1950) herlezen* (Zoetermeer, NL: Meinema, 2004), 89-90.

Conclusion. An important contribution of van der Leeuw to the philosophy of art in general is that he looks at art in a world perspective and not just from a Western point of view. With his phenomenological description of the art of other, non-Western religions, he is a pioneer of what we nowadays call comparative or intercultural philosophy or history of art.[57]

The contribution of van der Leeuw to theological aesthetics is that with his "moments" or "hints," he indicates what is religious in art. He is correct in pointing out that these moments depend on both the kind of art as well as the type of religion that the work of art shows. The character of religious art is partly determined by the religious tradition of a group or community. It depends on the artist how much convincing iconography he adds to it.

I also add a critical marginal note. In the theological evaluation of the visual arts, van der Leeuw places every emphasis on the incarnation of the Word of God. The Christ figure is central for him. Does that mean that figurative art deserves to be preferred above abstract art? It stands out that van der Leeuw selects his examples mostly from older art and less from his own era. He barely pays attention to the religious art of his own time.[58] This, however, does not alter the fact that *Wegen en grenzen* belongs to the classics of theological aesthetics.

PAUL TILLICH

Religious art in a secular time. Already at an early age, Tillich was enthused by the art of painting. As army chaplain during World War I, he experienced the Battle of Verdun. Pictures in magazines of paintings such as Botticelli's *Madonna and Child and Singing Angels* (1477) comforted him in the midst of death and destruction. At the end of the war he saw Botticelli's painting with his own eyes in Berlin and was deeply moved by it. "Gazing up at it, I almost felt a state of ecstasy. In the beauty of the painting there was Beauty itself. It shone through the colours of the paint as the light of day shines through the stained-glass windows of a medieval church."[59]

[57]R. L. Anderson, *Calliope's Sisters: A Comparative Study of Philosophies of Art* (Englewood Cliffs, NJ: Prentice Hall, 1990); A. van den Braembussche, H. Kimmerle, and N. Note, *Intercultural Aesthetics: A Worldview Perspective* (Berlin: Springer Science, 2009).

[58]F. Bosman and T. Salemink, *Avantgarde en Religie over het spirituele in de moderne kunst 1905–1955* (Utrecht: Van Gruting, 2009).

[59]Paul Tillich, "One Moment of Beauty," 1955, in Paul Tillich, *On Art and Architecture*, ed. John and Jane Dillenberger (New York: Crossroad, 1987), 235.

Tillich developed his theological art theory as part of his cultural theology. He saw himself as a *Vermittlungs* (mediation) theologian who wants to reconcile faith and culture, because the chasm between faith and culture is unacceptable. He wants to point out the ultimate and with that the ultimate meaning in culture.[60] He summarizes his point of view as "culture is the form of religion and religion is the substance of culture."[61] From this perspective Tillich as a theologian approaches art. Especially art shows something of religion in culture. Art gives insight in the spiritual or religious climate of a certain era.[62]

Apart from his later articles about the theology of art from his American period, I also use some earlier German writings from the period before 1933, the year he moved to the United States. His articles about religious art were collected and published in the volume *On Art and Architecture*, edited by John and Jane Dillenberger. For a good understanding of Tillich's theology of art, I will first say something about how he spoke about God and his concept of religion.

God as a power that can be experienced in secular culture. According to Tillich, there are two ways to come to God: either we come to God by conquering the alienation that hinders our original connectedness with him, or we consider the meeting with God as the meeting with a stranger. Tillich rejects the second possibility; in such a case the meeting with God would be something coincidental. He chooses the first way and is of the opinion that people have an immediate connectedness with God, even though God is infinitely above and beyond us, and we are alienated from him.[63]

Every person has to do with God in one way or another, even though it is not always perceived as such. God is as wide as human experience can be. That is why Tillich speaks in theological terminology about God as Father

[60]For his theology of culture, see R. R. Manning, *Theology at the End of Culture: Paul Tillich's Theology of Culture and Art* (Leuven, BE: Peeters, 2005); W. Stoker, *Zingeving en plurale samenleving: Hoe actueel is Tillich's visie op zin, religie en cultuur* (Bolsward, NL: Het Witte Boekhuis, 1993).

[61]Paul Tillich, *Systematic Theology* (Digswell Place, UK: James Nisbet, 1968), 3:168; "Kirche und Kultur," in *Gesammelte Werke 9* (Stuttgart: Evangelisches Verlagswerk, 1967), 42.

[62]Paul Tillich, *On Art and Architecture*, ed. John and Jane Dillenberger (New York: Crossroad, 1987), 67.

[63]Paul Tillich, "Zwei Wege der Religionsphilosophie," 1946, in *Gesammelte Werke* 9:122-37.

of Jesus Christ, but also in philosophical terminology about him as "Being-Itself" or as "Power of Being."[64] Philosophical language is supposedly more generally accessible than theological language.

Every person needs courage to exist, as he explains in his *Courage to Be* (1952), which made him well-known to a broad readership in the United States. Every person is threatened by destruction, by one or another form of non-being, of despair, loneliness, sickness, or approaching death. "Being-Itself," as Tillich states, has conquered non-being. From that, people take courage to conquer non-being in all kinds of forms of fear and loneliness. This is possible because a human being, however much estranged, still lives in an immediate connectedness with "Being-Itself" as in a kind of mystical relationship. In this context, the believer speaks of a relationship with God the Creator. Only thanks to the power of Being-Itself are humans able to resist non-being. It is not only in his existential questions about life that humans encounter the power of Being-Itself, but also in culture, especially in art. To that end Tillich employs a broad concept of religion.

God is present in secular as well as in explicitly sacred existence.[65] Therefore Tillich understands religion broadly as the state of being engaged with the ultimate.[66] We all have our finite and temporal concerns, but there is also an "ultimate concern," one matter that touches our inmost being. Tillich deduces such an "ultimate concern" from the commandment to love God with heart and soul and with the drive of all our strength (Deut 6:4).

People experience the ultimate in diverse ways. That can happen in the experience of gods or of God as in official religions, but also apart from official religions in secular existence. Apart from the usual concept of religion as indicative of institutional religion, Tillich also provides a broad concept of religion: religion as the state of being ultimately concerned. This refers to the experience of the ultimate in people's reality, regardless of whether they count themselves as belonging to an official religion or not. "Being religious

[64]See W. Stoker, "Can the God of the Philosophers and the God of Abraham be Reconciled? On God the Almighty," in *Being Versus Word in Paul Tillich's Theology*, ed. G. Hummel and D. Lax (Berlin: Walter de Gruyter, 1999), 206-24.
[65]Tillich, *On Art and Architecture*, 94.
[66]Tillich, *On Art and Architecture*, 31-32, 92.

means being grasped unconditionally, and this can be in both profane forms as well as in forms that are religious in a direct sense."[67]

With this twofold concept of religion, there are also two kinds of religious art: art that is closely related to the church, such as images of Christ, Mary and child, or saints, but also art in connection with the broad concept of religion as expression of our "ultimate concern."[68] In the latter case, a work of art can be religious, even when there is no religious theme or representation. Secular art is also religious if it is an expression of ultimate concern.[69]

We may wonder whether all art is religious according to Tillich, for God is as wide as reality itself. And yet Tillich does explicitly pose the question of what makes a work of art religious and how the viewer can recognize it as religious. He pays particular attention to painting, even though he also published about architecture.

What makes a work of art religious? In his theology of art, Tillich does not so much address church art but primarily secular art. In order to do so he employs concepts borrowed from his looking at art. In that way there is an interplay between theology and art, and art is also a source for his theology.[70] In a retrospective of his theology in 1962, Tillich wrote that after his experience of the painting by Botticelli, he arrived at the basic concepts of his philosophy of religion and culture especially via German expressionism: form (*Form*) and depth (*Gehalt*).[71] The word *Gehalt* does not mean the subject or the content of a work of art, but indicates its religious depth, the ultimate or "unconditional."[72] Remember what was said earlier about God as power of Being and of humanity's immediate connection to it.

Tillich saw especially in expressionism but also in the work of Cézanne and other painters that the *Gehalt* breaches the *Form* of line, color, and

[67]"Religiös sein heißt unbedingt Ergriffensein, mag sich nun dies Ergriffensein in profanen Formen ausdrücken oder in Formen, die im engeren Sinne religiös sind." Paul Tillich, *Die Protestantische Ära*, 1948, in *Gesammelte Werke* 9:7, 15.

[68]The term *ultimate concern* can be subjective as an expression of what someone is preoccupied with at the most profound level, and objective as a reference to the ultimate, to God.

[69]Tillich, *On Art and Architecture*, 92.

[70]W. Schlüsser, "Die Bedeutung der Kunst, der Kunstgeschichte und der Kunstphilosophie für die Genese des religionsphilosophischen und kulturtheologischen Denkens Paul Tillichs," in *Kunst und Gesellschaft: Drei Vorlesungen*, by Paul Tillich (Münster: Litverlag, 2004), 51-87.

[71]Paul Tillich, *Auf der Grenze*, 1962, in *Gesammelte Werke* 9:12, 21.

[72]Tillich, *On Art and Architecture*, 51-53.

Figure 12.2. Paul Cézanne, *Still Life with Peppermint Bottle*, 1895

perspective. With Cézanne's *Still Life with Peppermint Bottle* (fig. 12.2)[73] he provides this comment: "With a will to create objectively, Cézanne battled with the form and restored to things their real metaphysical meaning."[74] In the form-breaking power of such paintings something of *Gehalt* lights up, of the ultimate, the power of Being. How precisely does that happen?

Tillich thus does not determine what is religious in art by whether it represents a religious subject but on the basis of *style*. He considers style as "the immediate influence of the 'Gehalt' on the Form of a work of art."[75] In his later work, as in his article "On the Theology of Fine Art and Architecture," he states the same thing more simply. He speaks only about style and drops the term *Gehalt*: "In a work of art the element in which the experience of ultimate meaning and ultimate being is expressed is its style."[76] Style is the

[73]Paul Cézanne: *Still Life with Peppermint Bottle*, 1895, oil on canvas, 65.7 x 82 cm. National Gallery of Art, Washington.
[74]Tillich, *On Art and Architecture*, 68.
[75]Tillich, *On Art and Architecture*, 51-53.
[76]Tillich, *On Art and Architecture*, 206.

special way in which the form of a work of art expresses religious depth. In that way the style shows whether a work of art displays something of the ultimate. Another word for religious depth is *expressivity*. This term is here not an indication of the expression of an emotion or the subconscious, but a religious term. The style determines whether a painting has expressivity (*Ausdrucksmächtigkeit*), religious depth.[77] Cézanne's still lifes embody a cosmic power of Being.[78] The painter does not show us things in isolation, but as referring to the "creative ground" from which they emerge.[79]

In his first article about art, "Religiöser Stil und religiöser Stoff in den bildenden Kunst" ("Religious Style and Religious Matter in the Visual Arts"), Tillich constructs a typology of styles based on the concepts of form (*Form*) and depth (*Gehalt*). Styles in which there is the least breakthrough of depth, he calls *form-dominant styles*.[80] As an example he mentions the Claude Monet painting *On the Bank of the Seine* (1880), or Degas's paintings of café life in Montmartre such as *Dans un café* (also known as *l'Absinthe*; 1875–1876). With Monet the light plays on the surface of the natural world, and there is no breakthrough. His critique on Degas is that what is individual is shown isolated in all its abandonment.[81] From a theological point of view Tillich considers this naturalism.[82] In the history of art this is a current (in reaction to Romanticism) that pictures reality as true to nature as possible. Tillich uses the term *naturalism* with the connotation of being inner-worldly. Elsewhere he gives as an example of such a nonreligious style the naturalism of Von Uhde's *Christ at Emmaus* (1895–1900). Even though the painting gives a religious representation, it remains inner-worldly because the form dominates, and there is no breakthrough to the ultimate. The figure of Jesus is trivial and meaningless.[83]

He characterizes religious styles in a narrower sense as *depth (Gehalt)-dominant styles*. You can find them in Romanticism and expressionism. The religious depth is shown in the painting thanks to the expressive style by which something of the ultimate lights up. You can see that, for example, in

[77]Tillich, *On Art and Architecture*, 206-7.
[78]Tillich, *On Art and Architecture*, 135-36.
[79]Tillich, *On Art and Architecture*, 54, 94-95.
[80]Tillich, *On Art and Architecture*, 53.
[81]Tillich, *On Art and Architecture*, 61.
[82]Tillich, *On Art and Architecture*, 175.
[83]Tillich, *On Art and Architecture*, 35, 68, 178.

the well-known paintings of animals by Marc or in Nolde's *Dance Around the Golden Calf* (1910). Absolute reality shines through what is pictured, giving it a holy character.[84]

Between the religious and nonreligious styles there is an intermediate group of styles where there is a balance between *form and depth*. Idealism and classicism are examples of that. With idealism—which is not a common term in the history of art—Tillich emphasizes the universal in something individual that is made into an ideal, while classicism wants to express things in a perfected form.[85] Here we can speak of religious art, albeit less obviously than with the depth-dominant styles. Think about classic Greek art or art from the Renaissance. I will come back to this.

This first inception of his theology of art from 1921 Tillich later developed further. In his lectures "Religion and Art" in 1952 and "Existentialist Aspects of Modern Art" of 1955 he provided an expanded typology of various kinds of religious art.[86] We shall see that style and form are the basic concepts. I will base my comments on the latter article and will supplement this where necessary with details from "Religion and Art."

A typology of religious art. Tillich indicates four positions of how art expresses religion.

1. *Nonreligious style, nonreligious content.*[87] The first is a style wherein the "ultimate concern" is not expressed directly, but only indirectly. It concerns secular art without religious content. Here we do not encounter a religious style, yet also not a completely secular style because something of the power of Being becomes visible. *The Dancing Couple* (1663) by Jan Steen, for instance, expresses power of Being and is therefore indirectly religious. According to Tillich the same applies to Toulouse-Lautrec's *A Corner of the Moulin de la Galette* (1892), even though it concerns a scene from the worldly café life of Montmartre.[88]

2. *Religious style, nonreligious content.*[89] Here it concerns art with a religious style—art that expresses our "ultimate concern" with special

[84]Tillich, *On Art and Architecture*, 54.
[85]Tillich, *On Art and Architecture*, 53.
[86]Tillich, *On Art and Architecture*, 31-41, 89-101.
[87]Tillich, *On Art and Architecture*, 93-94.
[88]Tillich, *On Art and Architecture*, 33-34.
[89]Tillich, *On Art and Architecture*, 94-98.

stylistic characteristics, through which everyday reality is shown in its religious depth. As we already saw, that is the style of expressionism, not considered as a current but as an expressive style that can occur everywhere, with Jeroen Bosch and in modern art by Cézanne, Van Gogh, Munch, Picasso, or Braque. The subject can but does not have to be religious.

In his article "Contemporary Visual Arts and the Revelatory Character of Style" (1958) Tillich is more specific about what is involved in such an expressive style.[90] Yet also other artistic styles of art, apart from expressionism, show a breaking open of the surface, as in cubism or surrealism. The representation can even disappear completely in favor of a nonrepresentative style. Moreover, in the religious style a two-dimensional space is preferred over a three-dimensional one. This may be found in archaic images of God or saints on a cathedral wall. You cannot walk around it. The viewer is looked at; the image is "not a part of the world of objects, which he is used to handling."[91]

3. *Nonreligious style, religious content.*[92] As example, Tillich points to the *Madonna and Child* by Raphael or Rubens. Here there is no religious style as a breaking open of the everyday. It could be portraying an ordinary mother and child. Tillich poses the question whether Christian art from the high Renaissance or from the nineteenth century with its naturalism is possible.[93] Yet we shall see that he later judges Renaissance art differently and wonders whether it is not a matter of religious humanism after all.

4. *Religious style, religious content.*[94] By this we mean art that is used within the liturgy. The style is expressionistic, just like the category above of "non-religious style, religious content." Examples of these are the *Crucifixion* by El Greco, Mathias Grünewald, and Graham Sutherland.

In short: what is religious in art is determined by the style. It does not matter whether the representation is secular or religious. The style of religious art is expressionistic or expressive. Religious art expresses ultimate

[90]Tillich, *On Art and Architecture*, 135-37.
[91]Tillich, *On Art and Architecture*, 136.
[92]Tillich, *On Art and Architecture*, 98.
[93]Tillich, *On Art and Architecture*, 35.
[94]Tillich, *On Art and Architecture*, 98-99.

concern. In religious art, reality is transformed to that end in order to symbolize its religious depth. That is how reality is shown in its ultimate, religious character, both in religious and secular representations.

What is remarkable in Tillich's first position of *nonreligious style, nonreligious content* is that it seems contradictory with his own assertion that a religious style is the defining characteristic of religious art. Something of the power of Being is visible here, according to him. And yet he speaks about a "non-religious style." The question of what exactly is religious in the style can in this way no longer be posed.

Religious art as symbol and revelation. Tillich stresses the religious character of art by noting that in the expressive style an image is not merely an object. The usual viewing direction is changed from the position of the viewer to the position of the image.[95] Think of the Eastern Orthodox icon of Christus Pantocrator, who looks at the person looking at the icon. This theme of the changed viewing direction has been elaborated by Jean-Luc Marion.[96]

Tillich specifies religious art further by conceiving of it as a symbol. Sometimes people say, "It is only a symbol," as if it were less real. Tillich has a contrary opinion: the symbol has power precisely because it represents ultimate reality. A symbol discloses reality that is unable to be disclosed in any other way. The essence of a symbol in religious art is that it is more than a sign. A symbol, like a sign, does not only refer to something outside itself but also participates in the meaning and power of what it symbolizes. It has a revelatory capacity; it reveals the meaning of something that cannot be approached in another way.[97]

The symbolic character of art means that a religious work of art participates in the power that it represents.[98] Tillich can say so because, according to him, everything in the world can be the bearer of what is holy. In other words, reality is *sacramental*. Religious art is the bearer of the holy, for it reaches for the religious transcendent.[99]

[95]Tillich, *On Art and Architecture*, 136.
[96]J-L. Marion, *La croisée du visible* (Paris: Presses Universitaires de France, 1991), 9-46.
[97]Tillich, *On Art and Architecture*, 36-38.
[98]Tillich, *On Art and Architecture*, 133.
[99]Tillich, *On Art and Architecture*, 143.

I agree with Palmer and Begbie that, according to Tillich, in art is revelation.[100] Tillich himself does not raise the subject explicitly. He does write, as we saw, that art as symbol has revelatory power and that we can see an "immediate revelation of absolute reality" in paintings.[101] An experience of the ultimate is a revelation, both within official religion as well as in religion broadly considered. And that throws new light on what religious art can mean for people.

Tillich differentiates between an objective and a subjective side in revelation.[102] The objective side of the revelatory experience is the miracle: the giving of the gift from the side of the ultimate or of God. The subjective side is the ecstasy, its reception. This concerns an *original revelation*, where we can speak about a revelation for the first time, as with the first witnesses, such as Peter, who came to confess: "You are the Messiah, the Son of the living God" (Mt 16:16). For the readers of this Gospel story it also concerns revelation, but then it is *dependent revelation*. They repeat in their own way Peter's experience. This distinction can also be applied to the artist and those who look at his work of art. The artist can have an original revelation while he is creating his work of art. For those who are looking at a work of art, there is a revelation in the sense of dependent revelation.

By speaking about revelation in art, we take religious art seriously. Religious art is not merely an illustration for a Bible story but has its own validity. However, does Tillich not go to the other extreme? If art is also a matter of revelation, does art not then become a religion, a religion of art? As a Christian theologian Tillich rejects a religion of art. Christ as the "New Being" is normative for him. In this connection I point to the difference and similarity between the God of biblical religion and the ultimate. The ultimate is active in all of reality. That came to expression above in his broad concept of religion. The term *ultimate reality* is not another name for God in the religious meaning of the word. But the God of biblical religion is, according to Tillich, not God if he is not also ultimate reality. On the other hand, the God of religion is more than ultimate reality. That is how he expressed it

[100]M. F. Palmer, *Paul Tillich's Philosophy of Art* (Berlin: Walter de Gruyter, 1984), 127-44; J. Begbie, *Voicing Creation's Praise: Toward a Theology of the Arts* (London: T&T Clark, 1991), 54-58.
[101]Tillich, *On Art and Architecture*, 54, 128.
[102]For this and what follows, see Tillich, *Systematic Theology* 1:140-46.

in his lecture "Art and Ultimate Reality" (1959) held in the Museum of Modern Art in New York: "If the idea of God includes ultimate reality, everything that expresses ultimate reality expresses God, whether it intends to do so or not. And there is nothing that could be excluded from this possibility because everything that has being is an expression . . . of being itself, of ultimate reality."[103]

In short: art can truly be a religious revelation for people, but according to Tillich that is not a religion of art as in Romanticism or with Clive Bell.[104] The God of biblical religion incorporates the ultimate and thus he or Christ as New Being continues to be the norm and not a philosophical religion of art.

Religious experience and art. Tillich takes as his point of departure the (Christian) religion and not art when he speaks about religious experience and how this is expressed in art. He does that in his 1959 lecture "Art and Ultimate Reality."[105] Starting from different kinds of religious experience, he speaks about stylistic elements in art that express people's various religious experiences. Here also the religious style par excellence is the expressionistic or expressive style.[106] In comparison with his typology of religious art, he takes the opposite way here. To prevent repetition I refer only to the extra that is given here in comparison with the typology of religious art. They are these three issues: an expansion of religious art to other religions, a religious experience that he elsewhere calls typically Protestant, and a correction of his earlier view of Renaissance art.

Religious experience can be *mystical*.[107] This concerns an experience as in Hinduism, Buddhism, Taoism, and Neoplatonism, and also, albeit in a different way, in Judaism, Christendom, and Islam. Whereas a sacramental experience concerns a mediated experience—something in the world such as bread, water, or wine can be the means or bearer of the holy—the mystical experience is an experience of God without such means. In art this is expressed with stylistic elements that allow the special characteristics of things to be dissolved in a visual continuum. Examples are paintings of

[103]Tillich, *On Art and Architecture*, 140-41.
[104]Tillich, *Systematic Theology* 3:66-69.
[105]Tillich, *On Art and Architecture*, 139-57.
[106]Tillich, *On Art and Architecture*, 149-51.
[107]Tillich, *On Art and Architecture*, 145-47.

Chinese landscapes where water and air symbolize the cosmic unity and where individual things like rocks are barely pictured in their independent existence. With regard to Western art, he refers to *Improvisation* by Kandinsky and Pollock's *Number One* (1948).

The religious experience which he denotes elsewhere in his theology as "typically Protestant" is the *prophetic-protesting* experience.[108] It concerns a critique of a demonically disturbed religion in the name of personal or social justice. Holiness without justice is rejected. It is here not nature but especially history that is the place ultimate reality is manifested. The stylistic element in art is *(critical) realism*. Examples are Pieter Brueghel's *Fall of the Rebel Angels* (1562) or Max Beckmann's *Departure* (1932–1933).

Another religious experience is the *religious-humanistic* one, which sees in the present time the anticipation of a future perfection.[109] In the here and now it sees God in human beings and human beings in God, in spite of all human weakness, and it expects the complete realization of this unity of God and human beings in history and anticipates it in art. The artistic style that responds to this is idealism as shown in Renaissance art or Greek classical art. Renaissance art in this context receives, in contrast to what was said previously, the benefit of the doubt. What strikes him here is that this art expresses the divine character of human beings and their world in its essential, undisturbed created perfection. Examples of this are Piero della Francesca's *Procession of the Queen of Sheba* (1452–1466) and a landscape painting by Poussin, where we can see an idealized paradise. And yet Tillich hesitates when he remarks that this style is quite different from the expressive style. In his terminology you could call this art a style in which religious depth and form are in balance.

We conclude that here we are not always referred to the expressionistic style as a distinguishing feature of religious art. Mention is now made of, for example, critical realism and idealism. The reason for Tillich's rather loose terminology is that he always starts with the viewing experience in a museum while wondering whether a certain painting is religious. Sometimes he undergoes a different viewing experience.[110] However this

[108]Tillich, *On Art and Architecture*, 147-48.
[109]Tillich, *On Art and Architecture*, 148-49.
[110]Tillich, *On Art and Architecture*, 144, xxiii-xxiv.

may be, his basic contention is that we should infer from the style whether a painting is religious. He maintained this idea consistently for his whole life, as well as his opinion that the expressionistic or expressive style is the religious style. However, it seems that he cannot quite retain this opinion when he names the style that fits in with the mystical and the religious-humanistic experience.

Conclusion. Tillich's contribution to theological aesthetics is that he evaluates art outside of the church positively, thanks to a broad concept of religion. God as Being-Itself is as wide as reality itself. He attempts to bridge the chasm between secular art and church art. He is a pioneer by pointing at the religious element in art outside of the church in a secular society.

Elsewhere I have typified his position with respect to religious art outside the church as *inclusivism*.[111] It is true that the term "ultimate reality" is not, as mentioned already, another name for God in the religious sense of the word, but God does enclose ultimate reality. In this way Tillich reduces the ultimate in art to the biblical God and the Christian religion. Such a theological choice has the disadvantage that a phenomenological description of the religious in secular art does not fully come into its own. The work of art in question can also point to something ultimate that is named differently than Tillich's theological explanation of it. The ultimate is described in various ways as pantheistic (Spinoza), as spirit (Hegel), as matter (Marx), or as the inner sound of things (Kandinsky). It is also not possible in this way to give a good description of art that has its source in other religions, for example that of Anish Kapoor or Antony Gormley.

Tillich asserts that the expressionistic style is the religious style par excellence. It is the core of his typology of religious art. The objection to that is that he cannot do justice to the religious in some works of pop art or of abstract expressionism because in both currents the transcendental is evoked in a different way than by the breaking open of the surface. Renaissance art and impressionism are therefore also judged too easily as theologically negative. Dillenberger judges concisely: "The typology does not fit much of Western art."[112] I add that we ought to be cautious about a priori determining what is the religious style as Tillich does.

[111]W. Stoker, "God meester van de kunsten," *Tijdschrift voor Theologie* 4 (2006): 383-86.
[112]Tillich, *On Art and Architecture*, xxiii.

Tillich is especially concerned to point to the ultimate in art, whereby content or the theme is of a lesser significance. Insofar as he pays attention to the content of a painting, he prefers subjects like alienation and negativity. In his article "The Demonic in Art" (1956) he pays special attention to paintings about the Last Judgment and about human suffering.[113] According to him, that is the Protestant element. In 1957 he wrote: "No premature solutions should be tried; rather, the human situation in its conflicts should be expressed courageously."[114] But why? Tillich's explanation of Lutheran doctrine of justification plays a role here.

By expressing alienation and recognizing guilt, this is already transcended through the liberating insight of God's "acceptance in-spite-of."[115] For that reason, Tillich considers Picasso's *Guernica* as the most Protestant painting. Religious art relates especially to the cross of Christ and not his resurrection.[116]

Religion and spirituality are very different and have many nuances, both within the Christian religion and outside of it. Tillich does not do enough justice to these differences. Only in his "Art and Ultimate Reality" does he make distinctions between various religious experiences and their relevant styles. As a rule Tillich does not focus on the "what" of religious art, but on the fact of the breaking open of the surface of the painting as the evocation of the ultimate. Elsewhere I have supplemented Tillich's theology of art by means of types of transcendence to indicate differences of various kinds of religion or spirituality in secular art.[117]

CONCLUDING REMARKS: VAN DER LEEUW AND TILLICH

Historic research will have to show whether van der Leeuw and Tillich knew each other's theology of art. Tillich nowhere alludes to van der Leeuw in his

[113]Tillich, *On Art and Architecture*, 104-18.

[114]Tillich, *On Art and Architecture*, 124.

[115]Tillich, *On Art and Architecture*, 124.

[116]Tillich, *On Art and Architecture*, 124, 138.

[117]W. Stoker, *Where Heaven and Earth Meet: The Spiritual in the Art of Kandinsky, Rothko, Warhol, and Kiefer* (Amsterdam: Rodopi, 2012). For the typology of transcendence, see W. Stoker, "Culture and Transcendence: A Typology," in *Culture and Transcendence: A Typology of Transcendence*, ed. W. Stoker and W. L. van der Merwe (Leuven, BE: Peeters, 2012), 5-26; W. Stoker and W. L. van der Merwe, eds., *Looking Beyond: Shifting Views of Transcendence in Philosophy, Theology, Art, and Politics* (Amsterdam: Rodopi, 2012), 5-28.

theology of art. Van der Leeuw does cite Tillich once in *Wegen en grenzen*. Most articles by Tillich were published after the death of van der Leeuw. The negative judgment of both of naturalism and Renaissance art is remarkable (although Tillich was later more nuanced about Renaissance art). However this may be, they are closely related Protestant thinkers. I refer to the similarity and difference between them as regards their vision of art. To that end, first a rough sketch as a summary of the foregoing.

Both are *Vermittlungs* (mediatory) theologians in the footsteps of Schleiermacher. Religion and culture belong together, although they evaluate this in different ways.[118] They also look differently at art as part of culture. Van der Leeuw focuses on religious art from other religions right through cultures and eras. Tillich is directed toward the religious in secular art, especially in his own Western culture.

Both emphasize art's *sacramental* character: art can be the bearer of the holy. That is why they speak about a religious work of art as *symbol*. A religious work of art shares in the reality to which it refers. Therefore, both stress the material side of religion. Reality has a sacramental character.

Both consider power to be a central concept for religion. With van der Leeuw the term *religion* refers to religions as a field of research within religious studies, while Tillich uses the term religion as being engaged with the ultimate also in secular situations.

I would like to point out that, apart from the theological image theories of van der Leeuw and Tillich, there are also two other such theories that stress the presence of God or the divine in or via the image: the theory of the religious image as relic (e.g., John of Damascus and Paul Moyaert) and the theory of the religious representation as a "holy portrait" (e.g., Theodorus of Stoudios and Jean-Luc Marion).[119]

In my opinion, there are also many religious works where there is no "presence," for instance, Marc Mulders's stained-glass window *The Last Judgement* (fig. 12.3). This work represents in an image an important element of faith, the struggle between good and evil. It moves the viewers to

[118]For van der Leeuw, see Barnard, *De dans kan niet sterven*, 17-51, and for Tillich, Stoker, *Zingeving en plurale samenleving*; for an analysis of the relationship between art and culture in Tillich, see W. Stoker, "Correlation of Theology and Art," in *Theology and the Arts* (*Theology and Art Companion*), ed. I. Adkins and S. M. Garret (Edinburgh: T&T Clark, 2023).

[119]Stoker, *Imaging God Anew*, 9.2-3.

Figure 12.3. Marc Mulders, *The Last Judgement*, 2006

meditation and gives them food for thought about their own position regarding good and evil. The religious image here is also regarded as a symbol, but in a different way than van der Leeuw and Tillich do. Apart from a symbol as a non-arbitrary sign with a *participative* relationship, the symbol can also be regarded as a non-arbitrary sign that refers to something via *association* and moves one to think. In that way, *The Last Judgement* by Marc Mulders is a symbol.[120]

The difference between the theology of art of van der Leeuw and that of Tillich lies in their method, which they borrow from their own disciplines. Van der Leeuw, the scholar of religion, analyzes art with the help of his religious-phenomenological method supplemented by his theology. Tillich, the philosopher of religion, makes use of a philosophical method according to which theological reference to a (supra) personal God can be translated into philosophical terms such as Being-Itself and the power of Being, and Christ as the New Being.

They motivate their theological evaluation of art outside the Christian tradition in different ways. Van der Leeuw asserts that grace does not cancel nature but rather recreates it. Right through nature and culture the "work of God's creation" is being built, also in art. That is how he as a theologian

[120]Marc Mulders, *The Last Judgement*, 2006, Sint-Janskathedraal, Den Bosch, The Netherlands. For *The Last Judgement* of Marc Mulders, see Stoker, *Imaging God Anew*, 7.5. For a theory of image that considers religious images both as presence and as representation, see my theory of the religious image as interaction and disclosure in *Imaging God Anew*, 9.6.

recognizes religious art of other religions. Tillich speaks about an "ultimate concern" and the ultimate reality that in a hidden way is active in everything, and is especially present in art.

On the question whether something is religious art, they start with the work of art itself, although van der Leeuw also points to the creative process of the artist.[121] With both of them, what is religious in art is not determined by the religious representation or by the intention of the artist. They use the rule of appropriateness: what is holy, the ultimate, ought to be appropriately expressed. Van der Leeuw points to "moments," or religious hints. Tillich locates these in the style that should be expressionistic or expressive.

They explain in different ways what exactly is religious in art. For Tillich art outside of the official religion is religious if its style shows indirectly the ultimate, the power of Being, or God. Van der Leeuw points to the numinous power that is variously named in religions and is definitively revealed in Christ. Ultimately he judges religious art on the basis of the recreated image of God, Jesus Christ.

Van der Leeuw's and Tillich's views of the visual arts are fruitful also for the society that has changed so much after their deaths. The visual arts have undergone new developments after 1960, thanks to Duchamp, Rauschenberg, Warhol, and others. Religion and spirituality have become pluriform. A dialogue with other religions or kinds of spirituality outside the church is not only a matter of an exchange of opinions about faith. Art, and with it the material dimension of religion, is important. Dialogue also needs to be carried on at the level of ritual,[122] and of the image and art in general. Van der Leeuw provides us with a means for discussing image and art where it concerns the place of the image in other religions. Tillich does that where it concerns spirituality outside of the church in a secular era.

BIBLIOGRAPHY

Leeuw, G. van der. *Wegen en grenzen.* 2nd ed. Amsterdam: Paris, 1948.

Stoker, Wessel. *Imaging God Anew: A Theological Aesthetics.* Leuven, BE: Peeters, 2021.

Tillich, Paul. *On Art and Architecture.* Edited by John and Jane Dillenberger. New York: Crossroad, 1987.

[121] Tillich, *On Art and Architecture*, 300-301.

[122] M. Moyaert, *Voorbij de christianisering van religie: Comparatieve theologie tussen tekst en materie* (Amsterdam: Vrije Universiteit, 2013).

THE ELUSIVE QUEST FOR BEAUTY

WILLIAM EDGAR

I USED TO BE A RUNNER. In my advancing years I have become much more of a walker. I go out at least once a day. Walking clears my mind of its cobwebs, helps me think through an issue, and affords me the opportunity to consider various options in personal relations. Oh, and the exercise is good for me, so my physician tells me. On the path I often take, there is a splendid oak tree. The tree is enormous, with branches spreading in every direction. I love the tree in the spring and summer with its lush foliage covering much of the space above. I love it in the fall when the leaves turn yellow and reddish. I love it in the winter when all there is to see is the gangly branches spreading and dividing with delicacy and strength. No wonder so many countries have the oak tree, its leaf with acorns, as their national emblem.

When I look at this magnificent tree, everything in me wants to say, "How beautiful!" But may I feel this way? At one level, the question is rather silly. When we talk of a beautiful object with a friend, say a lovely sunset, we expect to be understood. The predication requires no further explanation unless it is to discover and further explore some special colors or graceful lines. Not only natural objects may move us aesthetically, but artificial ones can as well. I love many artists. But I love none more than Paul Cézanne. His still lifes, his forests, or the series *La Montagne Sainte-Victoire* are simply

Figure 13.1. Paul Cézanne, *Montagne Sainte-Victoire*, 1904–1906

unparalleled compositions, combining building form with color and seeing shapes in nature as few others have (fig. 13.1).

Yet, if we want to go deeper and actually define what qualifies an object as beautiful, we run into serious challenges. What is beauty? Are there objective qualities to it, or is it only "in the eyes of the beholder"? According to a longstanding Greek tradition, beauty is a matter of proportionality, because proportion is like the harmony found in human reason, which in turn reflects the divine. Though stemming from the Greeks, the imitation view was Christianized by theologians from Augustine to Thomas and finds expressions even up to the present. Thomas Aquinas once stated, "Let that be called beauty, the very perception of which pleases." He further explains that "beauty consists in due proportions; for the senses delight in things duly proportioned, as in what is after their own kind—because even sense is a sort of reason."[1] The source of this beauty is in heaven. For Thomas the

[1]Thomas Aquinas, *Summa Theologiae*, trans. Fr. Laurence Shapcote (Steubenville, OH: Emmaus Academic, 2013), I.5.4.

ultimate source was God. For Plato it was in the higher order of things, the ideas.

Beauty for the Greeks was found in the best imitation of those higher ideals. Indeed, their aesthetic philosophy is called *mimesis*. Of great interest is the fact that Plato had a fairly low regard for the arts. In *The Republic* he states that an artist is "an imitator of fantasies and is very far from the truth."[2] He had a particularly low regard for poetry, especially tragic poetry, because such poetry is a bad imitation of the good. It might teach that virtue may not always be rewarded and thus is a betrayal of good social order. For Augustine (AD 354–430), who also Christianized certain aspects of Greek thought, the art object fared a bit better. He even refers to a craftsman working his clay or stone or wood, but only because God is behind the entire process. "It was you [God] who made the material from which he makes his goods. It was you who made the intelligence by which he masters his craft and visualizes whatever he is to make. It was you who made his physical senses, which are the channels through which his mental picture of the thing he is making is transmitted to the material."[3]

Remarkable artistry was in fact produced within this philosophy. One could think of the majestic Gothic cathedrals in Europe, which predominated from the twelfth to the sixteenth centuries. The great pioneer of the Gothic style in architecture was Abbott Suger (1081–1151). Strongly influenced by Neoplatonism, which taught that artists were the earthly intermediaries of heavenly goodness and beauty, he integrated this philosophical outlook into his architecture. Two architectural principles were generated by Suger and his successors. The first is proportionality. For example, the floor plan of many Gothic structures is based on simple ratios, which were believed to be a replica of divine order. The second is luminosity. Suger wanted light to erupt through the fretworks and the stained-glass windows. Again, light was believed to be an emanation from above. Thomas taught that luminosity (*claritas*) was the vehicle for the pure light of God.

<hr/>

[2]Plato, *The Republic*, trans. Desmond Lee (New York: Penguin Classics, 2007), 10.27. See A. O. Scott, "The Year in Ideas A-Z: Beauty Is Back," *New York Times Magazine*, www.nytimes.com/2001/12/09/magazine/the-year-in-ideas-a-to-z-beauty-is-back.html.
[3]Augustine, *Confessions*, trans. Henry Chadwick (New York: Oxford University Press, 2009) 10.34; 11.5.

Despite such glorious replicas of heavenly harmony, there was something less than human about the Gothic. At first this was intentional. But then a lack was felt. A reaction set in, bringing far more psychological and emotional features to the arts. One can trace this shift in the evolution of the Madonna and Child motif from the iconic, almost impersonal mother, with her nearly adult looking baby, for example in Duccio (1300), to the more human, even playful mother and child, say in Raphael (sixteenth century) (figs. 13.2 and 13.3).[4] For a number of centuries there was a struggle to

Figure 13.2. Duccio, *Madonna and Child*, 1290–1300

hold on to the Greek ideal of beauty-as-harmony, and yet simultaneously celebrate the earthly, flesh-and-blood nature of life. It was not to last.

THE DEATH OF BEAUTY

If beauty is restricted to higher ideals and only derivatively found in the art object, what is the real value of calling anything concrete beautiful? What of the hard work, indeed the skill of the artist, the wordsmith, the contrapuntist, the tap dancer, the potter, all of whom labor intensively with raw materials? Although the artist might admit with great humility of being far from God's standards, as did Johann Sebastian Bach on occasion, yet is the artist only a sort of conduit for higher ideals? Is there no sense in which the actual work of art is beautiful? If we held consistently to the *mimesis* view, we would have to say that earthly art is but a very dim reflection of the heavenly forms.

[4]Duccio, *Madonna and Child*, 1290–1300, tempera and gold on wood, 23.8 x 16.5 cm, The Metropolitan Museum of Art, New York. Raphael, *Colonna Madonna*, 1507–1508, oil on wood, 77 x 56 cm, Gemäldegalerie Berlin.

Figure 13.3. Raphael, *Colonna Madonna*, 1507–1508

So problematic is the *mimesis* view that Calvin Seerveld, the fertile *Reformational* philosopher, proposes a taboo on the word *beauty* altogether. His argument is as follows.[5] First, the great European theory of beauty began its decline precisely at the same time that aesthetics became a science.

[5]His thoughts are found in several places. Here we will draw on Calvin Seerveld, "A Contribution of Christian Aesthetics," in *Rainbows for the Fallen World* (Toronto: Tuppence, 1980), 116. He likes to capitalize the word *Beauty*.

In the same way that a general sense of beauty as order was challenged, so the concept of beauty had to be "broken." He notes that Plato affirmed that contemplating absolute beauty is the only way life can be worthwhile. He also notes that this idea became Christianized, as we saw above. But then beauty became less and less necessary, particularly in the Enlightenment. As Seerveld puts it, the God of heaven and hell faded into the deity of Alexander Pope's "Universal Prayer" (1738), and the divine attributes of beauty (concinnity, perfection, and immediate brilliance) were transferred to human sense activity, summarized as "taste."[6] Immanuel Kant (1724–1804) and others tried to distinguish this human sense-perceptivity from ordinary feelings. Somehow, for him, human taste was disinterested, pointing to universal values. This human faculty could recognize the "sublime," which for Kant was not simply a tranquil, lovely feeling, but one of fear and terror before overpowering natural phenomena.

The traditional concept of beauty was finally destroyed by two events, Seerveld argues. First, elevating the sublime exercised a sort of transcendental critique against the very idea of beauty in the classical sense. Kant even asserted that objects were not sublime, but only the human subjective experience of them was. This notion would pave the way for Romanticism and the nineteenth-century ideals of genius and originality. Accordingly, what was being set forth was completely opposed to the Greco-medieval idea of harmony and mathematical balance. Instead, proponents of the sublime were trying to find a deeper kind of aesthetic perception, a good corrective as far as it goes. The second event fatal to beauty in the traditional sense was the philosophy of G. W. F. Hegel (1770–1831). Natural beauty and taste were relegated to the sidelines in Hegel's view. Instead, Seerveld argues, the focus was now on art, "the fine arts" such as architecture, sculpture, painting, music, and poetry. With a complete reversal of the older degradation of the art object, now there could be no aesthetic life outside of these concrete expressions.[7] Hegel, the consummate rationalist, thus absorbed any idea of beauty and the transcendent character of beauty into art itself, that is, the human activity of painting, composing, and the like. As a corollary, and most significantly, this meant that the *ugly* was a fundamental property

[6]Seerveld, "Contribution," 118.
[7]Seerveld, "Contribution," 120.

of art. Hegel described this combination of beauty and the ugly in what he called the "Christian" medieval crucifixions and in Shakespeare's tragedies.[8] Again, some of this is good, according to Seerveld.

I would add a third factor to the death of beauty. For nearly a century now, various thinkers have held that to speak of beauty is to sidestep a concern for social justice. It was deemed that talk of the beautiful is a distraction from injustice and therefore undermines our commitments to bringing about equity and well-being in the world. It holds to a wrong agenda.[9] Second, when we look at something beautiful, be it a person, a natural object, or a work of art, we are judging it. We thus feel superior to it and reduce it to an object. Gianni Vattimo rails against regarding poetry and art as timeless expressions of genius. At best they are reminders of mortality and decay.[10]

In the "new historicist" school, works of art are examined as symbols of attitudes toward power. For Roger Greenblatt, as an example, the plays and literature of the Renaissance are a commentary on the transition between the rule of the church to the rule of modernity. To call Shakespeare's writings beautiful is to miss the point of their true language.[11] Louis Montrose adds that literary texts are symbolic formations which ultimately differ in no respect from other symbolic formations, which include historical events and trends. Typically, the literary texts are "complex" simply because the history they produce and the history they reflect are incapable of coherence and stability. Struggle, not beauty, is the issue in *The Faerie Queene* or *Hamlet*.[12]

ALLUSIVENESS

So, what is the fate of beauty after these deathblows? Seerveld recommends we jettison the word altogether. Of course, he does not mind the naive

[8] The fullest elaboration of Hegel's theories on aesthetics can be found in his *Lectures on Aesthetics*, published posthumously (Berlin, 1820).

[9] Some of the following material reflects an article I wrote earlier, "Beauty Avenged, Apologetics Enriched," *Westminster Theological Journal* 63 (2001): 107-22.

[10] Gianni Vattimo, *The End of Modernity: Nihilism and Hermeneutics in Post-modern Culture* (London: Polity, 1988), 27.

[11] See Roger Greenblatt, *Renaissance Self-Fashioning: From More to Shakespeare* (Chicago: University of Chicago Press, 1980), 2; see also his *Marvelous Possessions: The Wonder of the New World* (Oxford: Oxford University Press, 1991), 14, 24.

[12] Louis A. Montrose, "Professing the Renaissance: The Poetics and Politics of Culture," in *The New Historicism*, ed. H. Aram Veser (New York: Routledge, 1989), 22.

description of certain objects as beautiful. The oak tree on my walk can legitimately be called beautiful. But that should have nothing to do with a biblical world and life view on aesthetics. Indeed, he dismisses those who point to the many biblical references to beauty or the beautiful. He argues on exegetical grounds that most of the biblical references to beauty have nothing to say about aesthetics. For example, he maintains, the oft-cited phrase, "the beauty of holiness" from Psalm 29:2 is not a reference to the beautiful, but to "the Lord God Yahweh in his terribly majestic Holiness, who is speaking creationally!"[13] Seerveld argues that not only will a verse-by-verse reexamination of the terms translated "beauty" reveal results that

have nothing to do with aesthetics, but that those who look at such verses hoping to find aesthetic norms are victims of a "gaze-on-God theology," which is scholastic, using a "substance-and-attributes philosophy," rather than biblical. Seerveld has no quarrel with the way Scripture describes things or people as "beautiful," but believes those to be based on general statements of grace rather than being "an *aesthetic* affair."[14]

Figure 13.4. Orren Jack Turner, *Einstein*, 1947

If we want to safeguard the arts from the tyranny of beauty, Seerveld argues, then we must look elsewhere for a way to discover the aesthetic dimension in human crafting. In a word, that place is in what he calls *allusiveness*. He explains this concept with a series of illustrations of what does not and what does qualify as art. For example, he compares two photographs, one of Einstein by Ernst Haas (here by Orren Jack

[13]Seerveld, "Contribution," 123n10.
[14]Seerveld, "Contribution," 124.

Figure 13.5. Passport photo of Albert Einstein

Turner; fig. 13.4), and the other a passport photo (anonymous; fig. 13.5). Of the photo he says, "When the reproduced lines, shadows and lighting subtly nudge into visibility character flaws or subterranean strengths of the person," we have art.[15]

The passport photo is merely a depiction. In another example, Seerveld compares the mime Marcel Marceau to a trapeze tumbler, affirming that the mime is allusive whereas the gymnast is only a virtuoso.[16] Allusiveness in an artwork is not a "'second-storey' epiphenomenal ascription by occasional human subjects, but is an existential, aesthetic object-functional reality binding upon all and sundry subjects."[17] Seerveld does not deny other functions of art. It may refer to various truths in a pedagogical way. It may be allegory. And it must build on various other aspects of reality, such as language, sounds, and technology. But these do not annul the fundamental artistic quality which builds on them, that is, allusiveness.

There is a good deal more to appreciate in Seerveld's theory. He is surely one of the most original and creative Christian philosophers of our time. One very helpful consequence of his views is to rehabilitate Hegel, Ernst Cassirer, Susanne K. Langer, and Mikel Dufrenne, whose approaches had been snuffed out by the "blanketing ontological empiricism of our day."[18] When we reexamine these writers, particularly Cassirer and Langer, we find wonderful insights on the arts and on aesthetics. One of Langer's important contributions is to explain the human being as a creature who constantly seeks *meaning* by a process of making analogies, of seeing one thing in terms of another. Through her studies of music-making and other aesthetic activities, she explains how our minds constantly make symbolic

[15]Calvin Seerveld, *Rainbows for the Fallen World* (Toronto: Tuppence, 1980), 116; Seerveld, *Bearing Fresh Olive Leaves: Alternative Steps in Understanding Art* (Toronto: Tuppence, 2000), figs. 13.4 and 13.5.

[16]Seerveld, "Contribution," 127-28.

[17]Seerveld, "Contribution," 129.

[18]Seerveld, "Contribution," 131. He is thinking not only of deconstruction but of Thomism. Seerveld does not fully endorse Cassirer, Langer, etc., but he finds much to commend in them, particularly their attention to symbolism.

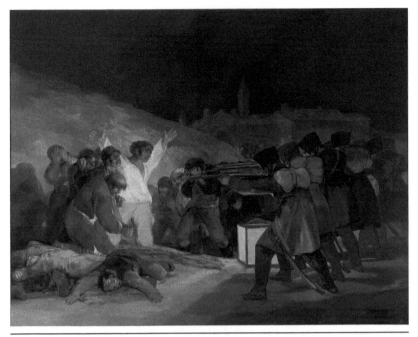

Figure 13.6. Francisco Goya, *El Tres de Mayo* (The Third of May), 1814

transformations from the data of our experience.[19] At the time, in mid-century, her work was a refreshing critique of positivism.

Another helpful insight from Seerveld is to put into question the assumed necessary relation between art and beauty. Often it had been assumed that the requirement for a work of art was that it be beautiful. When people ask, "Is it art?" they often mean, "Is it beautiful?" But of course, following Hegel and others, if the ugly can qualify as art, then is it not possible to have art that is not beautiful in the traditional sense but yet is still art? On the surface, the answer would appear to be obvious. Think of artists who depict tragedy. Much of Goya's work is about calamity and destruction. Think of his desperate *The Third of May*, which depicts an arbitrary firing squad during Napoleon's occupation (fig. 13.6). Hardly beautiful in any traditional sense. And yet it is unquestionably artistic, since it skillfully depicts the cruel soldiers on the right and the helpless Spaniards on the left, with the central

[19]See Susanne K. Langer, *Philosophy in a New Key: A Study in the Symbolism of Reason, Rite, and Art* (Cambridge, MA: Harvard University Press, 1957).

figure in a white shirt raising his hands to suggest a crucifixion. In the background is a village with its church steeple, reminding the viewer of the way things used to be. The tension between art and the beautiful is further exhibited in much modern art, which stands in conscious rebellion against the Western canon. Abstract expressionist Barnett Newman once remarked, "The impulse of modern art is the desire to destroy beauty."[20]

So if Seerveld is simply reminding us that the real character of art is to be skilled, then he has made an area that could be quite confusing much more clear. If by "allusiveness" he means the ability to render an object suggestive, symbolic, or analogical, by using skillfulness or craft rather than by making it simply attractive or lovely, then Seerveld liberates us from a too-narrow linkage between art and beauty. Yet I struggle with the theory at a couple of levels. First, the elementary nature of *allusiveness*. I struggle with what seems to be an artificial separation between allusiveness as an irreducible modal reality, as he puts it, and the many other functions of art—psychological, pedagogical, semantic, and so on. It is certainly true that to read a poem as a collection of oppositions that reveal hidden agendas for power, as do the deconstructive analysts, is often misleading and becomes tiresome. But must we throw out the proverbial baby with the bathwater? In other words, cannot allusiveness be one quality of art among others, but not its foundational one?

Philosophically, Seerveld is arguing against reductionism. He is arguing that the arts belong to their own sphere and cannot be reduced to another. Someone's change of behavior, he says, cannot be reduced to factors of sensory-motor functions. Behavior change can only be recognized using the empathetic dimension of human sensitivity. This leads Seerveld to claim, "The proof of my theoretical hypothesis on 'allusiveness' will come in the pudding of concrete insights, and the concrete flesh of experiential insight should be strengthened by the backbone of theoretical ordering afforded by a (Christian) systematic aesthetic science."[21] But must the theory be so narrowly attached to "experiential insights" into what is allusive only? It seems to me that making art and receiving art involve many different qualities together, though some do focus more on one or two than on others. The list

[20]Seerveld, *Bearing Fresh Olive Leaves*, figs. 13.4 and 13.5.
[21]Seerveld, "Contribution," 134. The word *christian* is with a small *c*.

of such qualities would have to include a number of dimensions: historical, cultural, meaningful, decorative, entertaining, pedagogical, and so on.

Against those who claim that beauty should be banished because it is socially insensitive, a number of voices have been raised. Among the most interesting authors to defend the notion of beauty recently is Elaine Scarry. Her book *On Beauty and Being Just* has become something of a bestseller.[22] Scarry takes issue with the opponents of beauty who claim it leads to the abuse of power. She argues that the very opposite is the case. She says, for example, that the word *fair* can mean both beautiful and just. This points to a convergence of two sensitivities, one for aesthetics and the other for ethics. If we contemplate beautiful things, we eventually develop a greater awareness of the world and its problems. Drawing partly on John Rawls, she notes that beauty involves symmetry, and this is close to the social ideal of equality, a sort of symmetry in human affairs.[23]

Drawing on the ancients, particularly Plato and Dante, she makes the point that a person gazing at a beautiful object is vulnerable, even weak. Think of Dante as he moves higher and higher toward the *Paradisio*. Think of his account of contemplating Beatrice. He is awed and humbled. The beautiful, according to Scarry, makes the viewer more modest, ready to revise his location, looking higher up. This is not patronizing at all. Calling on more recent advocates, she notes Iris Murdoch and Simone Weil make the same point. The beautiful bursts the bubble of our own autonomy, makes us attuned to the needs of the world around. Scarry claims that the beautiful "acquaints us with the mental event of conviction, and so pleasurable a mental state is this that ever afterwards one is willing to labor, struggle, wrestle with the world to locate enduring sources of conviction—to locate what is true."[24] While Scarry's approach lacks biblical foundations, it certainly jibes with the Bible's general sense that beauty and God's plans are not necessarily divorced.

Along with that, second, I cannot so quickly dismiss the host of biblical texts on the subject of beauty as does Seerveld. To be sure, it is easy to force our Platonic idea of beauty-as-harmony into biblical texts which have a

[22]Elaine Scarry, *On Beauty and Being Just* (Princeton, NJ: Princeton University Press, 1999).
[23]Scarry, *On Beauty and Being Just*, 110.
[24]Scarry, *On Beauty and Being Just*, 31.

rather different take on beauty. But beauty is there nevertheless. God's creation is called "beautiful."[25] While Seerveld may be right about Psalm 29:2 as referring to the creation, it certainly refers to much more. It is spoken by a redeemed person. Indeed, we will find references to beauty in all three of the biblical triad, creation-fall-redemption.

First, creation. The Genesis account of God's creation concludes, "And God saw everything that he had made, and behold, it was very good" (Gen 1:31). The Hebrew word for good is *tov*, which carries meanings beyond simply "good." It includes happiness, kindness, welfare, pleasantness, and, indeed, beauty. The original goodness of the creation is fundamental to a biblical world- and life-view. Throughout, even after the fall, we are told that God cares for his creation, and that the creation bespeaks his beneficent presence (Ps 19:1-6). Certain animals are considered beautiful as well (Gen 49:21; Jer 46:20). One of the heresies of the end times is to deny the goodness of God's world and to drift into asceticism. Paul tells Timothy that people will forbid marriage and refuse certain foods, whereas "everything created by God is good" and should be received with thanksgiving (1 Tim 4:1-4). Indeed, God made "everything beautiful in its time" (Eccles 3:11).

We may notice how being beautiful is joined to a number of other qualities such as goodness, and so forth. Seerveld rightly asks us to guard against seeing merely the harmony-and-balance idea of beauty when many of the passages we like to appeal to involve far more than these. But do they involve less? Seerveld is also concerned to allow for the ugly to be a part of the art object. That is right. But if we are faithful to Scripture, we should see at least two ways in which the ugly can be a part of a beautiful art object.

First there was a tension built into the original creation. Not sin, not evil, but tension. Perhaps we should not call it ugliness, but it certainly is a darker side of reality. Without getting into debates about the length of the days of creation, nor what the new heavens and new earth will look like, there is no reason to think that before the fall animal deaths were absent. Predators feeding on their prey could well have been a part of the good creation (Ps 104:21). When God told humanity to go and subdue the earth, that presupposes an untamed quality. When God forbade our first parents from

[25]Some of the following material is parallel to an article of mine, "Beauty and Apologetics," *Theofilos* 8, no. 2 (2016): 246-55.

partaking of the tree of the knowledge of good and evil, he was not, contrary to the tempter's suggestion, keeping them from any understanding of good and evil at all. He put them to a test, called the "probation" by theologians, which, had they succeeded in resisting the temptation, would have led them to greater maturity. Geerhardus Vos argues that this maturation is a part of the way people grow in strength and knowledge. By putting Adam and Eve to the test, God meant to improve their estate, going from sinlessness to eternal life.[26] As we know, they did fail; however, God provided another way to achieve eternal life. Through Christ, who himself would learn obedience through suffering, we may obtain eternal life as a free gift (Heb 5:8).

Second, the fall. Here we really do confront ugliness. The original creation was indeed beautiful, both in its loveliness and its wildness. But because of the fall, the creation, though still glorious in many ways, has been cursed, subject to futility and bondage, as it awaits the freedom of the glory of God's children (Gen 3:17-18; Rom 8:19-22). Without speculating too much, we can surely assert that there is a sorrow and pain in the creation which is not normal. When we talk of "natural disasters," we mean hurricanes, tsunamis, volcanic eruptions, and the like. These too are connected in Scripture with the fall, and thus profoundly unnatural. So if there is room for beauty, it is out of the ashes (Is 61:3). We do not want to say here that evil is good or pain *is* beautiful, as do certain philosophers, including Hegel and John Dewey.[27] Neither do we want to justify evil in the manner of Leibniz, who sees it as a necessary part of the best of all possible worlds.[28] We do want to say that a beautifully crafted art object can and must involve the recognition of the fallen world.

Thus, any notion of beauty that derives from Scripture must include tension, either from the untamed portions of creation or from the fall. Too much so-called Christian art portrays beauty as "prettiness," or as "harmony," which is indeed more from Plato than from Moses. Not only is it wrong, but it is irresponsible to leave tension out of the equation. One thinks of the paintings of Thomas Kinkade, with his garish colors and over-cheerful scenes. Or one thinks of some contemporary Christian music, which is

[26]Geerhardua Vos, *Biblical Theology* (Grand Rapids, MI: Eerdmans, 1948), 39-47.
[27]John Dewey, "The Live Creature," in *Art as Experience* (New York: Perigee, 1934), 1980.
[28]Gottfried Leibniz, *Theodicy* (Chicago: Open Court, 1998).

more "happy-clappy" than true to life. Compare that to the beauty of the Negro spirituals, which are all about suffering, loneliness, and homelessness, and yet they are profoundly hopeful.

Third, redemption. One of the problems I have with Seerveld's model is what appears to be the relegation of the arts to common grace, the vestiges of creation, but not redemption. The arts for him are a function of the creation and may be pursued in a common grace postponement of judgment, but they are not per se part of the plan to save the world. Yet, while we may not want to say with the Orthodox tradition, "Beauty will save the world," can we not attribute to the arts some redemptive functions?[29] Seerveld is of course aware that art can have a message and that it can help us see God's world aright. That is not the problem. The problem is that the primary character of art is allusiveness, not redemption, which is only a secondary characteristic of certain art. But why does it have to be a secondary characteristic? Cannot an artist aim at helping people to see the Savior?

Perhaps the problem is with the theology of common grace. For thinkers such as Meredith Kline there is an essential difference between common grace, which produces "common culture," and the coming of God's kingdom. The two have fundamentally different orientations.[30] I do not think Seerveld means to separate the two quite so radically, but by relegating culture and the arts to the creation he makes too sharp a contrast between the order of creation and the order of redemption. He is thus not comfortable with having culture and the arts in any way contribute to redemption. However, in classic Reformed theology the link is greater. John Murray, a major theologian from the twentieth century, explains that not only is common grace given as a restraint of sin and evil, but it also has positive value.[31] While common grace has many functions, one of them is to "serve the purpose of special or saving grace." He adds,

> The redemptive purpose of God lies at the center of this world's history. While it is not the only purpose being fulfilled in history and while it is not the one

[29]The saying is from Prince Myshkin in Dostoyevsky's *The Idiot*. (Later reiterated by Alexandr Solzhenitsyn in his Nobel Prize lecture.)
[30]Meredith Kline, *Kingdom Prologue* (Eugene, OR: Wipf & Stock, 2006), 156.
[31]John Murray, "Common Grace," in *Collected Writings of John Murray*, vol. 2, *Systematic Theology* (Carlisle, PA: Banner of Truth Trust, 1977), 93-122.

purpose to which all others may be subordinated, yet it is surely the central stream of history. It is however in the wider context of history that the redemptive purpose of God is realized. . . . In other words, it is that sphere of life or the broad stream of history provided by common grace that provides the sphere of operation for God's special purpose of redemption and salvation.[32]

Thus, even if we want culture and the arts to function primarily in common grace, the relation of common to special grace is so close we may as well appreciate how culture and the arts fully contribute to the purposes of the coming of the kingdom. We see this in the ways Scripture describes beauty and the beautiful. Sometimes beauty is in connection with the good character of the redeemed, while at other times it is seductive and deceptive. Often, the beauty of God's people is connected to redemption. Several women in Scripture are identified as beautiful in various ways. This includes Sarah, Rebekah, Rachel, Abigail, Tamar, Abishag the Shunamite, Bath-Sheba, and Esther. Men also can be described as beautiful or fair: Absalom, Daniel, David, Joseph, and Jonathan. Even a man's eyes may be beautiful, as was the case of David (1 Sam 16:12). Abigail was called "discerning and beautiful" (1 Sam 25:3). The opposite is a beautiful woman without discretion (Prov 11:22). One may gather this deeper sense of beauty from reading through the song of Solomon, with similes that rather astonish the modern reader. Solomon's bride is beautiful, with eyes like doves, hair like a flock of goats, teeth like shorn ewes, and so forth (Song 4:1). There is something here far beyond common grace.

Particularly beautiful are God's redeemed people (Is 60:9). So are those who bear the good news. The feet of the messenger are beautiful (Is 52:7; Rom 10:15; Nah 1:15). People's clothing can be beautiful. Still, when celebrating God's presence, is it often appropriate to put on beautiful raiment, or headdress (Is 52:1; 61:3, 10). Royal garb, like a glorious crown, can possess beauty of a dazzling nature (Prov 4:9). The priest's garment is radiantly beautiful (Ex 28; 39). Again, not all such beauty is redemptive. Achan coveted a beautiful cloak from Shinar (Josh 7:21).

Even nations and geographical locations can be called beautiful. The Hebrew people's homeland was deemed beautiful. God said, "How I would

[32]Murray, "Common Grace," 113.

set you among my sons, and give you a pleasant land, a heritage most beautiful of all nations" (Jer 3:19). Jerusalem, God's city, was considered beautiful beyond all others. "Great is the Lord and greatly to be praised in the city of our God! His holy mountain, beautiful in elevation, is the joy of all the earth" (Ps 48:1; cf. Lam 2:15). And within Jerusalem, the temple is called beautiful. The king could "beautify" the house of the Lord there (Ezra 7:27). Still in the New Testament the entry to the temple was by the "Beautiful Gate" (Acts 3:2, 10). A nation, a land, a building can be called beautiful because they embody far more than simple lovely landscape. The bucolic scenes on church bulletins and Hallmark cards belong more to sentimentality than to the rich, many-faceted beauty of a place in biblical parlance. They are beautiful because of what they signify. Thus, we may have pleasant places, a "beautiful inheritance" (Ps 16:6).

One of the most special places where beauty was exhibited is the tabernacle and the temple. Seerveld would say these are only temporary and should not be used to exemplify a norm of beauty. Yet they do stand as exhibits of the glory of redemption. We might remember Oholiab and Bezalel, who were specially gifted by the Holy Spirit to craft the stones and furnishings for the tabernacle (Ex 31:1-11). Of course, as in all these cases, artistic skill may also be used to make idols, which have superficial beauty (Ex 32:1-6). A striking account of how something well-crafted for the good can become an object of corruption is the bronze serpent ordered by Moses for the rescue of the people from real serpents (Num 21:4-9; see Jn 3:14). By the time of Hezekiah, the reformer, this same serpent had become an object of worship, and so it had to be destroyed (2 Kings 18:4).

Such cases of beauty in the Bible are not quite as unconnected with aesthetics as Seerveld avers. True enough, we should be careful not to isolate verses and load too much into them. Yet if we understand them in the context of creation-fall-redemption, we may certainly appeal to them.

THE SOURCE OF BEAUTY

Finally, what of the source for beauty? Is all "gaze-on-God" theology mistaken? Is it ever proper to call God beautiful? If we are careful to respect the biblical way of describing God's beauty and not confuse it with the more Platonic way, then my answer is affirmative. Not only does God

create a beautiful world, but he is gloriously beautiful. Even terrifyingly beautiful. That is why his tabernacle and his temple had to carry such loveliness. To be sure, when the Lord came down, it was in a fearsome cloud of glory that filled the entire temple (1 Kings 8:10-11). That is why both Jerusalem of old and the new Jerusalem are gloriously beautiful. John says the new Jerusalem comes down from heaven as a bride beautifully prepared for her husband (Rev 21:2). Isaiah describes God as becoming a beautiful diadem for his people (Is 28:5). The Messiah will be a beautiful king, although in his suffering and death, he does not keep that beauty (Is 33:17; cf. Is 53:2). God on his throne has the appearance of jasper, carnelian, and an emerald-like rainbow (Rev 4:3). He dwells in the beauty of holiness (1 Chron 16:29; Ps 29:2). While Seerveld is right to look at the "beauty of holiness" as far more than a sort of harmony or balance, why shouldn't we too actually have these qualities of resplendent loveliness, which we would expect to find in the presence of God? Indeed, here we have allusion in its ultimate reference. If the arts are allusive, in order to avoid relativism, there would have to be an ultimate source for the symbols and cross-references.

So then, in the light of the death of beauty in the nineteenth century, it would appear we have a choice of two options. The first is to jettison the term *beauty* altogether. That is Seerveld's preference. He calls beauty a "curse" and invites us to move to a more basic, "modal" approach to aesthetics, using the concept of the allusive. This has the advantage of guarding against confusing beauty with Plato's ideal and then applying it, however inappropriately, to the arts and to biblical phrases. The second is to expand the meaning of beauty to a deeper, richer concept, one that includes tension, fallen creatures, depictions of evil, as well as the articulation of hope. While this approach will have to meet the challenge of erasing our old habits of thinking Platonically, it has the advantage of including the skillfulness of the artist (who knows how to "allude" to many realities) as well as the freedom to participate in God's plan of redemption. That would be my own preference.

Seerveld is gently critical of Christians who cling to some form of beauty in the traditional sense. He cites Abraham Kuyper (1837–1920) as one who desired to keep a connection between the work of the artist and the higher

ideals. Beauty, he argues, is a creation of God.[33] Our sense of beauty has a divine origin. Though the fall has obscured the beauty of God's world and our perception of it, through common grace the Holy Spirit has preserved the sense of beauty in peoples around the world. In his *Lectures on Calvinism*, Kuyper states that "the vocation of art [is] to discover in those natural forms the order of the beautiful, and, enriched by this higher knowledge, to produce a beautiful world that transcends the beautiful of nature. . . . Art has the mystical task of reminding us in its production of the beautiful that was lost and of anticipating its perfect coming luster."[34] Others, such as Étienne Gilson (1884–1978), wrestle with how an artist, while giving due attention to the "ideal of beauty," should incarnate that ideal into the "real," that is works of art themselves.[35]

Are these theologians quite so wrong? We would have to heed Seerveld's warnings and be sure they were not slouching toward the Platonic. But there is something right about the insights of Plato, is there not? While Greek philosophy wrongly sees the world as a shadow of higher ideals, that approach recognizes that we need a source for beauty and truth beyond this world. As John Calvin liked to point out, God is *distinctio sed non separatio* from his creation. A strong doctrine of the Creator-creature distinction also brings with it the immanence of God. That being the case, we ought to be able to recognize beauty, the beauty of God in his creation, and the beauty of his plan of redemption in Christ, who made himself ugly so that his church may become truly beautiful. As the hymn puts it about the church:

'Mid toil and tribulation,
And tumult of her war,
She waits the consummation
Of peace forevermore;
Till, with the vision glorious,
Her longing eyes are blest,

[33]See Abraham Kuyper, *Wisdom and Wonder: Common Grace in Science and Art*, trans. Nelson Kloosterman (Grand Rapids, MI: Christian's Library Press, 2011), 123.

[34]Abraham Kuyper, *Lectures on Calvinism* (Grand Rapids, MI: Eerdmans, 1931), 154-55.

[35]Étienne Gilson, *The Arts of the Beautiful* (Champaign, IL: Dalkey Archive, 2000), 55. Other advocates of the traditional view would include Roger Scruton, *Beauty First* (Oxford: Oxford University Press, 2009); Kenneth Meyers, *All God's Children and Blue Suede Shoes* (Wheaton, IL: Crossway, 1989); Jacques Maritain, *Creative Intuition in Art and Poetry* (London: Meridian, 1957); and various others.

And the great Church victorious
Shall be the Church at rest.
Yet she on earth hath union
With God the Three in One,
And mystic sweet communion
With those whose rest is won,
With all her sons and daughters
Who, by the Master's hand
Led through the deathly waters,
Repose in Eden land.[36]
Beautiful Eden!

BIBLIOGRAPHY

L'Engle, Madeleine. *Walking on Water: Reflections on Faith and Art.* Wheaton, IL: Harold Shaw, 1980.

Lewis, C. S. *An Experiment in Criticism.* Cambridge: Cambridge University Press, 1961.

O'Connor, Flannery. *Mystery and Manners.* New York: Farrar, Straus & Giroux, 1962.

Rookmaaker, H. R. *The Creative Gift.* Westchester, UK: Cornerstone, 1981.

Schaeffer, Francis A. *Art and the Bible.* Downers Grove, IL: InterVarsity Press, 1973.

Seerveld, Calvin. *Rainbows for the Fallen World.* Toronto: Tuppence, 1980.

[36]Samuel J. Stone, "The Church's One Foundation," in *Lyra Fidelium: Twelve Hymns of the Twelve Articles of the Apostle's Creed* (London: Parker, 1866).

CHAPTER FOURTEEN

FIFTY-PLUS YEARS OF ART AND THEOLOGY: 1970 TO TODAY

VICTORIA EMILY JONES

PROTESTANT[1] INVOLVEMENT IN THE VISUAL ARTS has increased tremendously in recent decades, as many church leaders and laypeople, scholars and practitioners have arrived at the conviction that art enriches the life of faith and ought to be engaged, with discernment, in both the public square and the church. This resolve has resulted in an infrastructure that now includes membership organizations, websites, many excellent books (even whole publishers' series!), periodicals, arts devotionals and art-based lectionary resources, awards, conferences,

This chapter, the original Dutch version of which was finalized in July 2019 for publication in 2020, has been updated here (and retitled from "Fifty" to "Fifty-Plus") to reflect developments over the past four years.

[1] I am restricting this chapter to this one branch of Christianity, while at the same time expanding coverage beyond just the Neo-Calvinist tradition, for a few reasons: (1) I am a Protestant, entrenched in that world, and thus able to offer an insider's perspective; (2) whereas art and theology have been companions for many centuries within Catholicism and Orthodox Christianity, the two disciplines have historically been at odds with each other or their relationship underdeveloped in Protestantism, but the past five decades have witnessed a positive change that I'd like to examine; and (3) to include voices and initiatives from across the full range of Christianity would make my task here unmanageable—though it's important to note that the field of art and theology has always been marked by ecumenical exchange, and thus many of the initiatives I do feature involve contributions and participation across Christian traditions.

symposia, degree concentrations, artist retreats and residencies, museums, and church art galleries.[2]

In the early 1970s, Hans Rookmaaker and Francis Schaeffer effectively jump-started an international conversation around Christianity and the visual arts with the publication of *Modern Art and the Death of a Culture* and *Art and the Bible*, both written for popular evangelical audiences. After introducing these two seminal works,[3] I will move on to discuss five key figures who followed in their wake, each of them launching and/or leading significant arts initiatives within theological institutions or departments of higher learning: Catherine Kapikian, William A. Dyrness, Jeremy Begbie, Ben Quash, and W. David O. Taylor. To be clear, none of these five individuals identifies as Neo-Calvinist; some have been partly influenced by such thought in regard to the arts but have also critiqued elements of it.[4] All but Kapikian, who is an artist, are theologians by primary discipline and are ordained ministers in their respective denominations: the Church of England (Begbie and Quash), the Anglican Church in North America (Taylor), and the Presbyterian Church (USA) (Dyrness).

Now, the field that is broadly called "theology and the arts," or sometimes "theological aesthetics," is interdisciplinary, encompassing not just visual art

[2]Lists in many of these categories can be found at www.ArtWay.eu, and a smattering are mentioned throughout this essay.

[3]That's not to say no one was working at the confluence of art and theology prior to these publications, only that little trickled down to the church community at large outside academia. Protestants writing in the slowly emerging field included Abraham Kuyper ("Calvinism and Art" Stone Lecture, 1898, published in English in *Lectures on Calvinism* [Grand Rapids, MI: Eerdmans, 1931; repr. 1987]), Paul Tillich (*On Art and Architecture*, a posthumously published compilation edited by John Dillenberger and Jane Dillenberger [New York: Crossroad, 1987]), Gerardus van der Leeuw (*Wegen en grenzen: Studie over de verhouding van religie en kunst [Paths and Boundaries: Reflections on the Relationship Between Religion and Art]* [Amsterdam: H. J. Paris, 1932], published in English as *Sacred and Profane Beauty: The Holy in Art*, trans. David E. Green [New York: Holt, Rinehart & Winston, 1963]), Finley Eversole (who edited the essay collection *Christian Faith and the Contemporary Arts* [Nashville: Abingdon, 1957]), Clyde S. Kilby (*Christianity and Aesthetics* [Downers Grove, IL: InterVarsity, Press, 1961]), Donald Whittle (*Christianity and the Arts* [London: Mowbray, 1966]), and Roger Hazelton (*A Theological Approach to Art* [Nashville: Abingdon, 1967]). For a compilation of theological excerpts on beauty and/or the arts that's inclusive of Catholic and Orthodox perspectives and that stretches all the way back to the early church, see Gesa Elsbeth Thiessen's *Theological Aesthetics: A Reader* (Grand Rapids, MI: Eerdmans, 2005).

[4]Jeremy S. Begbie, *Voicing Creation's Praise: Towards a Theology of the Arts* (Edinburgh: T&T Clark, 1991), 81-163; William A. Dyrness, *The Facts on the Ground: A Wisdom Theology of Culture* (Eugene, OR: Cascade, 2022); W. David O. Taylor, *The Theater of God's Glory: Calvin, Creation, and the Liturgical Arts* (Grand Rapids, MI: Eerdmans, 2017), discussed below.

but also music, literature, film, theater, and dance. And that's just the arts side. On the theology side, scholars might concern themselves mainly with the theology *of* art (what is art, and what role does it play in God's kingdom), whereas others focus on theology *through* art (using specific works of art as biblical exegetical or theological resources—for example, studying how a painting visually interprets a passage of Scripture or otherwise conveys some truth about God or things in relation to God), though the two approaches often go hand in hand. In terms of theological doctrines, creation and the incarnation come into heavy play in the field. Scholars might also bring to bear liturgical theology, historical theology, or global theology, depending on their task. Because our present book is about visual art, I use the slightly altered label "art and theology" to signify *visual* art and theology, and while only three of the five leading figures featured here specialize in visual art,[5] the other two are included because of the significant contributions they have made to the broader field with resounding implications for the visual.

As with any list of this nature, objections are bound to arise: Why didn't you include X? What about Y? The field has grown so much that it would be impossible to meaningfully mention all the influencers in this limited space.[6] I especially regret not being able to spend time on Jane Dillenberger (1916–2014), a pioneer of the field who taught theology and the arts for decades at Graduate Theological Union in Berkeley, California; Trevor Hart, founder of the Institute of Theology, Imagination and the Arts at the University of St. Andrews in Scotland; Frank Burch Brown, professor emeritus of religion and the arts at Christian Theological Seminary in Indianapolis; Wilson Yates,[7] founder of the journal *ARTS: The Arts in Religious and Theological Studies* and a major advocate of the integration of the arts into theological education; Diane Apostolos-Cappadona, professor emerita of religious art and cultural history at

[5]Begbie specializes in music and Taylor in the liturgical arts as a whole.

[6]The forthcoming *T&T Clark Handbook of Theology and the Arts*, ed. Imogen Adkins and Stephen M. Garrett (Edinburgh: T&T Clark, 2024), which I have not yet seen, should be an expansive resource in this regard.

[7]Yates is president emeritus of United Theological Seminary of the Twin Cities in St. Paul, Minnesota, one of few seminaries known for its dedication to the arts. His work gave rise to The Intersection: Wilson Yates Center for Theology and the Arts at UTS, which offers degree concentrations and organizes workshops, exhibitions, and community events.

Georgetown University in Washington, DC; and Makoto Fujimura, a Japanese American artist of faith whose promotion of what he calls "culture care," with an emphasis on beauty, has inspired a new generation of Christians. Also, I've purposefully overlooked art historians (other than, cursorily, Rookmaaker) and philosophers, who are treated in other sections of the book. There are countless others who have added to the dialogue, literature, and praxis of art and theology, many of them from outside academia. For the bulk of this essay, however, I've chosen to focus on just five key players—from the United States and the UK—whose influence is felt not only in the seminaries, divinity schools, and theology departments in which they teach or have taught but in the wider church culture.

CONVERSATION PIONEERS: HANS ROOKMAAKER AND FRANCIS SCHAEFFER

American evangelist, theologian, and popular author Francis Schaeffer (1912–1984), best known for establishing the spiritual community and study center L'Abri, was concerned with what he perceived to be the continuing decline of Western culture as it ventures farther away from a biblical foundation. In books like *Escape from Reason* (1968) and *How Should We Then Live?* (1976), he diagnosed the ever-increasing fragmentation and despair experienced by the modern individual, identifying several twentieth-century art movements as indicative of this trend.

Schaeffer was a close friend and associate of the Dutch art historian Hans Rookmaaker (1922–1977), whose book *Modern Art and the Death of a Culture* (1970), written for non-specialists, made waves among evangelicals, catapulting to bestseller status after being hailed by British journalist Malcolm Muggeridge as one of the best books of the year.[8] Dealing exclusively with visual art, it too exposes the philosophical nihilism reflected in many famous modern works. But that doesn't mean Christians ought to retreat from such works, Rookmaaker taught. On the contrary, as cultural artifacts, they should be given serious attention, for they offer "one of the keys to an understanding of our times."[9] By studying the language of

[8]Malcom Muggeridge, *The Observer*, December 1970.
[9]H. R. Rookmaaker, *Modern Art and the Death of a Culture* (Downers Grove, IL: InterVarsity Press, 1970), 35.

modern art, we will be able to better discern and tend to our culture's "cries . . . for humanity, for love and freedom and truth."[10]

At the conclusion of this landmark book, Rookmaaker calls for a renewal of Christian art. By "Christian art" he does not mean art that expresses biblical or other Christian themes; "what is Christian in art does not lie in the theme," he writes, "but in the spirit of it, in its wisdom and the understanding of reality it reflects." Rather than use the terms *Christian* and *non-Christian* art, he prefers to distinguish between "good" and "bad" art, categories that are not dependent on the artist's faith commitments. (Christians can indeed make bad art, and atheists can make good art.)[11] According to Rookmaaker, good art follows the "norms of art," which are the same norms laid out for the whole of human life in Philippians 4:8: whatever is true, noble, right, pure, lovely, admirable, excellent, and praiseworthy.[12]

Just three years after the publication of Rookmaaker's *Modern Art and the Death of a Culture*, Schaeffer published *Art and the Bible* (1973), a primer on biblical creativity. The arts are not peripheral to the Christian life, he said; "the lordship of Christ should include an interest in the arts."[13] Though Protestants tend to be wary of the human imagination, Schaeffer cuts through these suspicions with the bold assertion, "The Christian is the one whose imagination should fly beyond the stars."[14]

The first essay in the book, "Art in the Bible," addresses one of the most common objections Christians have against visual art: the second commandment, which states, "You shall not make for yourself an image in the form of anything in heaven above or on the earth beneath or in the waters below. You shall not bow down to them or worship them; for I, the LORD your God, am a jealous God" (Ex 20:4-5 NIV). This command is not a prohibition against images, says Schaeffer; it's a prohibition against the *worship* of images. This intention is made clearer in a parallel passage, Leviticus 26:1: "You shall not make idols for yourselves or erect an image or

[10]Rookmaaker, *Modern Art and the Death of a Culture*, 250.

[11]"In a way there is no specifically Christian art. One can distinguish only good and bad art, art which is sound and good from art which is false or weird in its insight into reality." Rookmaaker, *Modern Art and the Death of a Culture*, 228.

[12]He unpacks each of these traits in Rookmaaker, *Modern Art and the Death of a Culture*, 234-43.

[13]Francis Schaeffer, *Art and the Bible* (Downers Grove, IL: InterVarsity Press, 1973), 18.

[14]Schaeffer, *Art and the Bible*, 1.

pillar, and you shall not set up a figured stone in your land *to bow down to it*, for I am the LORD your God" (emphasis added).

If God forbade the making of images, then why did he later command Moses to make a bronze serpent (Num 21:8)? Per God's instruction, the Israelites looked to this image and were saved from death. For centuries the Israelites kept the bronze serpent, likely as a memorial to what God had done, but when it became for them an object of worship, Hezekiah destroyed it (2 Kings 18:4). This leads Schaeffer to affirm, as Martin Luther famously did before him, that "what is wrong with representational art is not its existence but its wrong uses."[15]

Moreover, right after giving Moses the Ten Commandments, God commanded him to fashion a tabernacle, a worship space, filled with artistic representations of both the seen and the unseen world. Cherubim (Ex 25:18), almond blossoms (Ex 25:31-33), and pomegranates (Ex 28:33)—and later, in the temple, palm trees (1 Kings 6:29), lions (1 Kings 7:29), and oxen (golden calves! see 2 Chron 4:3-4)—were among the things depicted.

In the second half of Schaeffer's book, "Some Perspectives on Art," Schaeffer offers eleven reflections on the nature of art and how to evaluate it. He emphasizes, first, that a work of art has value in itself apart from any utilitarian concern—or, as Rookmaaker put it, "art needs no justification." Second Chronicles 3:6 says that Solomon garnished the temple with precious stones "for beauty" (KJV), underscoring the fact that God loves beauty!

Schaeffer rejects the view that Christian artists are morally obligated to concentrate on religious subjects in their work, as if truth were found only in crosses and shepherds and such. Artworks, he says, can express a Christian worldview regardless of the subject matter. "Christian art is by no means always religious art, that is, art which deals with religious themes," he writes. "Christianity is not just involved with 'salvation' but with the total man in the total world."[16] That is why Christian art should touch on not only major (bright, happy) themes but minor (dark, sad) ones as well.[17] He also claims that "there is no such thing as a godly style or an ungodly style," although

[15]Schaeffer, *Art and the Bible*, 33. Cf. Martin Luther, "The Invocavit Sermons," trans. Martin J. Lohrmann, in *The Annotated Luther*, vol. 4, *Pastoral Writings*, ed. Mary Jane Haemig (Philadelphia: Fortress, 2016), 30.

[16]Schaeffer, *Art and the Bible*, 88.

[17]Schaeffer, *Art and the Bible*, 83-88.

care must be taken to not let the non-Christian worldviews out of which certain styles arose dominate.[18]

Schaeffer and Rookmaaker were among the first conservative Protestants to emphatically promote Christian engagement with the visual arts. Their publications were stepping-stones on the way to a more full-fledged development of the field of art and theology.

CATHERINE KAPIKIAN AND THE HENRY LUCE III CENTER FOR THE ARTS AND RELIGION AT WESLEY THEOLOGICAL SEMINARY

Catherine Kapikian (1939–) is a liturgical artist from Washington, DC, and a staunch advocate for the visual arts in theological education and church life. "The visual arts are a form of theological proclamation," she insists, and therefore "the church needs to embrace the arts as an equal partner in the proclamation of the wisdom of the gospel."[19] At the conclusion of her book *Art in Service of the Sacred* (2006), Kapikian wonders, "What would happen if adults were challenged and/or nurtured persistently by visual stimuli that companioned the Word? What if the religious community began to think seriously about the various aspects of the creative process and to treasure it as a reflection of being in the divine image?"[20]

Kapikian's primary medium is fiber—she designs and fabricates tapestries, banners, paraments, vestments, and large-scale wood traceries with fabric inserts. To enhance her theological literacy, she entered a theological studies program at Wesley Theological Seminary, earning her master's degree in 1979. While studying there, she became frustrated by the lack of art courses and the failure of professors to accept, on occasion, artistic responses to texts in lieu of papers. The day after she graduated, she proposed to Dean J. Phillip Wogaman and President Jack Knight that the seminary institute an artist residency and offer a basic art history survey course. After some deliberation, they accepted, and Kapikian served as the inaugural artist in residence as well as an adjunct instructor of art. Twenty students enrolled in that initial course, which Kapikian taught using significant historical works of sacred art available for viewing in

[18]Schaeffer, *Art and the Bible*, 76-77, 80, 83.
[19]Interview with the author, May 21, 2018.
[20]Catherine Kapikian, *Art in Service of the Sacred* (Nashville: Abingdon, 2006), 122.

local collections. She taught at night, and during the day she produced art in the modest space allotted to her in the basement under the chapel. By the spring semester of 1980, the administration was so impressed by her work that she was promoted to a large, open space inside Kresge Educational Building, where passing students and faculty could drop in to observe the creative process. The studio remains there to this day, a vital component of campus culture.

"The theological community needs fresh, challenging, nonverbal insights that only the arts can convey," Kapikian says.[21] While she is not against the more traditional methods of doing theology—that is, through propositional language—she insists that treating words as the only possible mediators of the sacred severely limits our access to scriptural truth. "No longer is theologizing through the language and structure of philosophical discourse alone adequate to the task of bringing us to, or keeping us in, a love affair with God."[22]

Wesley's artist-in-residence program expanded as Kapikian invited other artists to work on campus. After four decades, the program is still thriving, offering tangible support to diverse early- and midcareer artists, and has branched out to include creatives from other disciplines as well. I was surprised to learn that not all the artists who have applied for and even filled the residency position are Christians—Kapikian tells me that the opportunity to participate in interreligious dialogue, to audit religion courses for free, and to have ready access to theologians are draws. The artist in residence connects the seminary to the local arts community, Kapikian says, and she believes every theological school and church should consider bringing one on staff.[23] The arts community is, after all, a "mission field for hospitality";[24] as the church extends to artists the gift of welcome, artists tend to reciprocate, and blessings flow both ways.

Because of the excitement generated among students by the visiting artists and the increase in directed studies supervised by Kapikian,[25] in 1983 Kapikian received the go-ahead from the Wesley administration, then led by

[21] Interview with author. Also: "Engaging the imagination in wrestling with theological issues can promote insights not accessed in any other way."

[22] Kapikian, *Art in Service of the Sacred*, 31.

[23] This is an option even for small-budget communities. See Kapikian, "Sponsoring Artists-in-Residence," in *Art in Service of the Sacred*, 119-34.

[24] Kapikian, *Art in Service of the Sacred*, 119.

[25] And, Kapikian adds, a glowing profile published in the *Washington Post*: Paula Herbut, "Seminarians at Wesley Discover the Creative Process Through Art," *Washington Post*, April 23, 1983. ("After that, we could not be ignored!" Kapikian told me.)

President G. Douglass Lewis, to establish and direct a Center for the Arts and Religion. Then two years later, in 1985, the seminary implemented a revised curriculum that required all MDiv students to take at least one arts course that included exploration of the "historical and theoretical aspects of the art form; theological reflection on the practice and reception of the arts; and a sustained, practical engagement with the process of art-making."[26] While initially the offerings were limited to music and visual arts, the list soon expanded to include drama, poetry, dance, and more. Instructors of these courses encouraged their students to produce a work of art for their final assignment—an invitation that many students initially scoffed at but eventually came to embrace. "We're not endorsing mediocrity when it comes to product," Kapikian told me. "What we're valuing is the authenticity of the encounter with *process*. That's what's at stake."[27] Involving students in doing and making has always been of utmost importance to Kapikian. The requirement that every MDiv student at Wesley take at least one arts course is still in place.

Through the Luce Center, Wesley now offers a master's specialization in theology and the arts and a "curating community through the arts" track for doctor of ministry students. These courses are also open to non-degree learners. But beyond Wesley's arts course listings, the integration of the arts into *core courses* is a major hallmark.[28] "I got my colleagues to change the way they created their syllabi," Kapikian told me, such that the arts are utilized as a theological resource. That could mean, for instance, a Hebrew Bible professor discussing a leaf from a fifteenth-century *Biblia pauperum* as an example of typological interpretation; a church history professor contrasting art from the Protestant Reformation with art from the Catholic Counter-Reformation to reveal disparate beliefs; or a professor of Christian formation introducing *visio divina* ("divine seeing") in a course on spiritual practices.

Impressed by the support Kapikian was given at a time when very few other theological schools were making the arts a priority, I asked her whether

[26]"Our History," Henry Luce III Center for the Arts and Religion, http://lucearts and religion.org/our-history/, accessed June 1, 2018.

[27]Interview with the author.

[28]See Bruce C. Birch, "The Arts, Midrash, and Biblical Teaching," in *Arts, Theology, and the Church: New Intersections*, ed. Kimberly Vrudny and Wilson Yates (Cleveland, OH: Pilgrim, 2005), 105-24, and Catherine Kapikian, "Wesley Theological Seminary and the Arts," *ARTS: The Arts in Religious and Theological Studies* 7, no. 2 (1995): 4-8.

she encountered any resistance at first. "Oh yes," she affirmed. "It was a slow, gradual process that required a willingness to risk, a willingness to allow the arts to speak."[29] There was initially a core group of faculty who thought anything having to do with the arts was ridiculous, and there was a fear that the arts would take away limited resources from other initiatives. But President Lewis buffeted those concerns, championing Kapikian's vision, and a culture of arts appreciation developed bit by bit. Kapikian has also had to fight against academia's condescension toward practitioners—its preference for theoretical study and scholarly discussion to the exclusion of actual working artists.[30] One way that Wesley combated this bias under Kapikian's leadership was to invite Kapikian and other artists on the faculty to talk about their commissions during the "honors and recognitions" portion of faculty meetings, and to include completed artworks on their list of faculty publications.

As the arts culture at Wesley continued to grow and the community became better versed in the visual vocabulary of line, shape, color, and texture, Kapikian decided they were ready to support a gallery. She secured funding from Arthur Dadian, and the Dadian Gallery opened in 1989. Staffed by a curator, the gallery hosts several contemporary art shows a year.

Throughout the 1990s, because Wesley continued to demonstrate its commitment to the arts, the Henry Luce Foundation awarded the seminary three successive grants, enabling a deepening and an expansion of arts programming. Then in 2000 the foundation endowed Wesley with $1.7 million, at which time the arts center was renamed the Henry Luce III Center for the Arts and Religion. The following year, Kapikian, in collaboration with her artist colleague Deborah Sokolove, convened a national symposium titled "Trust the Arts to Speak," which brought together sixteen distinguished fellows in the field of art and theology, including Wilson Yates, Frank Burch Brown, John Dillenberger, and Diane Apostolos-Cappadona.[31]

[29]Interview with the author.

[30]Too often, artist-practitioners are pushed to the margins of conferences and symposia on art and theology—they haven't published enough, and they're not intellectual enough. This, Kapikian says, is a sore mistake, because then abstract theory asserts primacy over on-the-ground, contemporary practice, and there's a disconnect.

[31]In a panel discussion, they all responded to the question, "What is the one challenge that you see facing art and theology in the future?" For highlights, see Kapikian, *Art in Service of the Sacred*, 137-40.

"From the very start, I was interested in building a prototype model for the arts in theological education," Kapikian said. "For me it's ministry; it's always been ministry."[32] Creating new staff positions in seminaries, such as artist-in-residence, gallery curator, and professor of visual arts, is key,[33] and that requires seminary administrators getting on board with a robust vision of what the arts can contribute:

> The power of great art, whether the psalms, the parables, painting, or poetry, resides in its capacity to engage the whole person through encounter. That is why its insights continue to live in the hearts of the human family as defining sources of meaning. Our community [at Wesley] has learned that philosophical discourse is no longer adequate to the task, that theological education is truncated without the art-making enterprise integrated.[34]

Kapikian stresses art as process over art as object, even though historically, the church has done the opposite.[35] When she accepts church commissions, she advocates for what she calls "participatory aesthetics": the involvement of the congregation in the making of the work of art she has designed:

> I prefer designing work that is fabricated by members of a community. Then the work becomes the work of the people through a process of participatory aesthetics. In the shared experience of fabricating (painting, sewing, needle pointing, constructing, cutting, hammering, gluing, etc.), the community comprehends design choices, deduces the necessity of reciprocity in ascertaining meaning from the work, and blossoms in a joyful process. Deep correspondences exist between participation in creative processing and spiritual formation.[36]

By engaging art as process, the congregation develops aesthetic sensibilities and learns to value visual proclamation. This early ongoing exposure also enables the church to avoid the sudden appearance of an unfamiliar artwork in a communal space, which can be detrimental.[37]

[32]Interview with the author.

[33]Kapikian, *Art in Service of the Sacred*, 140: "If the conversations [on art and theology] exist for the sake of the church, they must argue for administrative leadership in theological schools to formulate positions in the arts. And some of these positions must be open to artists."

[34]Kapikian, *Art in Service of the Sacred*, 121.

[35]Kapikian, *Art in Service of the Sacred*, 58.

[36]Quoted in Debbie Hough, "Transformed Through Art," *Advocate*, September 1, 2014, http://advocateblog.apcenet.org/2014/09/01/transformed-through-art.

[37]Kapikian, *Art in Service of the Sacred*, 56.

In December 2008 Kapikian retired as director of the Henry Luce III Center for the Arts and Religion, and Deborah Sokolove stepped in to continue its legacy, serving from 2009 through the first half of 2019. Kapikian continued to teach arts courses at Wesley, retiring in 2020. The Luce Center's current director, since 2019, is Aaron Rosen, a professor of religion and visual culture who, as an externally hired scholar and curator who is Jewish, has been able to bring new perspectives to and build on the strengths of the center that Kapikian founded and, with Sokolove and others, developed. Rosen is committed to even further diversifying the artists the center works with as well as Wesley's permanent art collection, which ranges from ancient Near Eastern artifacts to Reformation Bible manuscripts to works by major modernists such as Marc Chagall and Louise Nevelson to recent acquisitions, facilitated by Rosen, from contemporary artists such as Jordan Eagles, Tobi Kahn, Antonio McAfee, and Mojdeh Rezaeipour.[38] Besides offering students opportunities to engage the arts within formal ministry contexts, the center also provides options for students to learn about museum work, not-for-profit arts leadership, and how the arts can be used in community organizing. The center is working on developing and strengthening external partnerships in teaching and research, "with a special interest in how religion and the arts intersect with urgent areas of concern including racial justice and ecology."[39]

WILLIAM DYRNESS AND THE BREHM CENTER
AT FULLER THEOLOGICAL SEMINARY

William Dyrness (1943–), an American theologian of culture, began his foray into art and theology in the late 1960s and has contributed widely to the field over his several decades of involvement. His specializations include globalization and the arts, visual culture in early modern Calvinism, interreligious aesthetics, and the Protestant imagination.

Having graduated with a bachelor of divinity degree from Fuller Theological Seminary in 1968, Dyrness pursued doctoral studies at the

[38]When I visited the campus in June 2018, I was struck by the quality art, owned by Wesley, that tastefully fills the halls, classrooms, and stairwells of every building. The art is not segregated from the everyday spaces of Wesley students.

[39]Devon Abts, email to the author, April 30, 2023. Abts is the assistant director of the Luce Center.

University of Strasbourg in France, combining his interests in both modern art and theology to write a dissertation on the expressionist painter and printmaker Georges Rouault.[40] After earning his doctor of theology in 1970, Dyrness struggled to find work, so he accepted an invitation from Hans Rookmaaker to come study under him at the Free University in Amsterdam. At the time, Rookmaaker was really the only art historian writing from a Reformed perspective, so the offer was attractive, and Dyrness set his eye toward a PhD in art history. But he also felt a call to ministry. Dyrness spent 1970–1971 in residence in Amsterdam, 1971–1974 as a college pastor in Portland, Oregon, and 1974–1976 as a missionary in the Philippines with his wife, Grace, meanwhile working on his *scriptie* (doctoral thesis), which was required for entry into the PhD program at Free University; because of his geographic locale and his interest in global theologies, he chose the topic of Christian art in Asia, covering India, China, Japan, and the Philippines.[41] In the summer of 1976 he returned to Amsterdam to defend his thesis and take his comprehensive exams, earning his doctorandus in art history.[42] But Rookmaaker died suddenly in 1977, leaving Dyrness without a mentor and champion. Rookmaaker's successor, who belonged to a liberal theological tradition, was uninterested in Dyrness's work, so Dyrness left the program, returning to the Philippines until 1982.

At this time there were no jobs available at the confluence of art and theology, so Dyrness taught on missions, apologetics, and other topics at New College Berkeley in California, where he also served as president from 1982 to 1990. Then in 1990 he was hired as dean of the School of Theology at Fuller Theological Seminary in Pasadena, California—a position that enabled him to finally teach courses on art and theology. None on this topic had been offered before at Fuller, so he was given leeway to design new ones as he saw fit; the courses he designed and has taught include Theology, Worship, and Art; Medieval Art and Theology (taught in Orvieto, Italy); Contemporary Theological Issues in Worship and the Arts; A Theology of Beauty; and

[40]Published in the United States the following year as William Dyrness, *Rouault: A Vision of Suffering and Salvation* (Grand Rapids, MI: Eerdmans, 1971). See also Dyrness, "Seeing Through the Darkness: Georges Rouault's Vision of Christ," *Image* 67 (2010), https://imagejournal.org/article/seeing-through-the-darkness/.

[41]W. A. Dyrness, *Christian Art in Asia* (Amsterdam: Rodopi, 1979).

[42]This Dutch degree is somewhere between a master's and a PhD.

Aesthetic Theology and Postmodern Culture. In the late nineties, William (Bill) Brehm, the chairman of Fuller's board of trustees, approached Dyrness with a vision he had for a center that would critically integrate worship, theology, and the arts, providing a degree emphasis, public programming, and more. In 2001 this vision became a reality, and the Brehm Center for Worship, Theology, and the Arts was born, with Dyrness a founding member. The Visual Faith Institute, directed by Dyrness, was one of its first initiatives. (This initiative has since morphed into Brehm Visual Arts and is led by Shannon Sigler.)

Dyrness belongs to the Reformed strain of Christianity, a tradition whose historical engagement with the visual he explores in *Reformed Theology and Visual Culture: The Protestant Imagination from Calvin to Edwards* (2004) and *The Origins of Protestant Aesthetics in Early Modern Europe: Calvin's Reformation Poetics* (2019). He shows that while Reformed Christianity impeded the development of visual representations of Christ and other biblical figures in its rejection of much medieval liturgical art, it opened up a wider range of subject matter—promoting, for example, the genres of still life, landscapes, portraits, and genre scenes. Dyrness challenges the simplistic narrative of the Reformation as hostile to the imagination and the arts, showing instead how the Reformers actually exercised enlarged aesthetic attention, which had theological intent: they wished to celebrate God's presence in everyday life.

Not all Protestants are averse to visual art of a religious nature—but certain "background commitments" influence the way they would describe an image's spiritual function and impact, or how it "means." A Henry Luce Foundation grant awarded in 2003 enabled Dyrness to interview a total of eighty people from ten church congregations in the Los Angeles area (three Catholic, three Orthodox, and four Protestant) regarding the ways they relate to images in public and private worship. He wanted to test the hypothesis that the "theophanic"—the mediation of God's presence—occurs primarily through the sermon for Protestants, through icons for Orthodox believers, and through the Eucharist for Roman Catholics.[43] The responses he gathered from pastors and laypeople, which mostly confirm his

[43]William A. Dyrness, *Senses of the Soul: Art and the Visual in Christian Worship* (Eugene, OR: Cascade, 2008), 8-9, 13.

hypothesis, are enlightening, and can be found in the book *Senses of the Soul: Art and the Visual in Christian Worship* (2008).

Another Luce grant in 2006–2008 funded an ethnographic study, led by Dyrness, of the visual and ritual elements in ten Muslim congregations and ten Buddhist congregations in Southern California. Seventy-five respondents were asked about the images, spaces, and practices of their religious experience. Recorded in *Senses of Devotion: Interfaith Aesthetics in Buddhist and Muslim Communities* (2013), the findings convey the richness and complexity of the nonverbal dimensions of religious practice in other faith traditions.

One of Dyrness's most recent books is *Modern Art and the Life of a Culture: The Religious Impulses of Modernism* (2016), coauthored with artist and art critic Jonathan A. Anderson.[44] Because the secularization thesis—the notion that society has, since the onset of modernity, been progressively turning away from religion—is now being repudiated by scholars from various fields, Anderson and Dyrness call into question the dominant narrative of modern art history, whose canonical texts, shaped extensively by said thesis, fail to acknowledge the role religion played in the development of several movements and key artworks of the period. The authors advance two claims: (1) "religious traditions have had deep shaping influence on the social and imaginative development of many important modern artists and movements, despite whatever ambivalence artists may have felt toward those traditions," and (2) "modernism is, in itself, a theologically meaningful project, whether or not religion played a conspicuous role in the biography of this or that artist."[45]

[44]As of fall 2023, Anderson is an associate professor of theology and the arts at Regent College in Vancouver. From 2015 to 2017 he was the executive director of Biola's Center for Christianity, Culture, and the Arts, during which time he convened a symposium at Biola titled "Art in a Postsecular Age," among whose distinguished presenters were Sally Promey, James Elkins, and Matthew J. Milliner. He is on the board of the Association of Scholars of Christianity in the History of Art (ASCHA), advises for the Art Seeking Understanding initiative of the Templeton Religion Trust, and has contributed as writer and speaker to Bridge Projects, a Los Angeles-based nonprofit that curates and convenes audiences at the intersection of contemporary art, spirituality, and religion. For one of his recent publications, see Jonathan A. Anderson, "The New Visibility of Religion in Contemporary Art: Four Interpretive Horizons," in *Religion and Contemporary Art: A Curious Accord*, ed. Ronald R. Bernier and Rachel Hostetter Smith (New York: Routledge, 2023), 21-36.

[45]William A. Dyrness and Jonathan A. Anderson, *Modern Art and the Life of a Culture: The Religious Impulses of Modernism* (Downers Grove, IL: IVP Academic, 2016), 41. They describe

The book won a 2017 Book of the Year Award of Merit from *Christianity Today*, giving it a lot of visibility in the North American evangelical world. This is a world the authors have lived and worked in, but they want to push back against its reading of modern art history as a gradual decline into a despairing nihilism—a view helped along by museums and the art academy, which have often missed, willfully neglected, or underinterpreted the long and significant threads of religious and theological thinking that run through much canonical twentieth-century art. Unfortunately, the art world tends to have just as anemic and misinformed an understanding of theology as churches and seminaries have of modern and contemporary art.[46] A major aim of *Modern Art and the Life of a Culture* is to help bring the better parts of each of these two worlds into more meaningful contact with each other, to promote mutual comprehension.

Dyrness is now dean emeritus and a senior professor of theology and culture at Fuller, his work there currently consisting mainly of mentoring PhD students. He continues to publish in the field of art and theology.

JEREMY BEGBIE AND DUKE INITIATIVES IN THEOLOGY AND THE ARTS

Jeremy Begbie (1957–) has been at the forefront of the field of theology and the arts for more than twenty years. Grounded by degrees in piano performance, philosophy, and systematic theology, his research and activities explore "the bearing of the riches of Christian theology, past and present, upon music and the other arts" and "the bearing of artistic practices and their associated theoretical disciplines upon the disciplines of theology."[47] He has emphasized the importance of bringing to bear a trinitarian imagination to the theology and the arts discourse. "God's very being," he says, "is constituted by relatedness-in-love, by a communion of Persons-in-relation,"[48] and the cultural mandate in Genesis 1, the call to *make*, is an invitation to participate

the book as "a modestly revisionist account of the history of modern art" that "attempt[s] to trace some long and significant threads of religious and theological thinking that run through the past two centuries of Western art" (43-44).

[46]Dyrness and Anderson, *Modern Art and the Life of a Culture*, 329.

[47]Jeremy Begbie, "Curriculum Vitae," https://divinity.duke.edu/sites/divinity.duke.edu/files/docu ments/cv/BegbieCV-0714.pdf.

[48]Begbie, *Voicing Creation's Praise*, 148.

in that communal life of the Divine. "Human creativity is supremely about sharing through the Spirit in the creative purpose of the Father as he draws all things to himself through the Son. . . . [It is] a means through which he develops and brings to fruition the world he loves."[49] In Begbie's theology of the arts, creation and redemption are intrinsically connected,[50] and the incarnation, crucifixion, and resurrection of Christ are central.

Begbie's inquiries into the interface between theology and the arts began in the early 1980s. His PhD dissertation, completed in 1987 at the University of Aberdeen, was "Theology, Ontology and the Philosophy of Art, with Special Reference to Paul Tillich and the Dutch Neo-Calvinists," which he developed into the book *Voicing Creation's Praise: Towards a Theology of the Arts* (1991). His prominence in the field really started to emerge in 1997, when he began directing the new research project Theology Through the Arts (TTA) at the Centre for Advanced Religious and Theological Studies at the University of Cambridge, a position he held through 2000. Aiming to discover and demonstrate ways in which the arts can contribute to the renewal of Christian theology in the contemporary world, the project involved performances, exhibitions, seminars, academic lectures and courses, a broadcast service, cross-disciplinary collaborations, and publications, culminating in a weeklong international arts festival called "Sounding the Depths."

The arts, Begbie asserts, have a certain "heuristic capacity"—an "ability to 'open up' and disclose in unique ways,"[51] serving as vehicles of theological discovery:

> Theology through the arts . . . means giving the arts space to do their own work as they engage with the primary testimony of Scripture and with the wealth of Christian tradition. It means that unfamiliar theological themes are uncovered, familiar topics exposed and negotiated in fresh and telling ways. . . . It also means benefiting from the extraordinary integrative powers of the arts, their ability to reunite the intellect with the other facets of our human make-up—our bodies, wills, emotional life, and so on.[52]

[49]Begbie, *Voicing Creation's Praise*, 179, 154.
[50]Begbie, *Voicing Creation's Praise*, 147, 181.
[51]Jeremy Begbie, ed., *Sounding the Depths: Theology Through the Arts* (London: SCM Press, 2002), 2.
[52]Jeremy Begbie, ed., *Beholding the Glory: Incarnation Through the Arts* (Grand Rapids, MI: Baker Academic, 2001), xii-xiii.

Moreover, by their very nature resisting a reductionist mindset, the arts can lead us to experience the "moreness," the inexhaustibility, of God and the world God has made.[53]

One of the highlights of the TTA was the formation of four "pod groups," whereby artists from various disciplines were commissioned to produce new works of art in collaboration with theologians. Though initially approached with misgivings from both sides, the project succeeded in holding together theological responsibility and respect for the integrity of the arts. In the visual art pod, sculptor Jonathan Clarke consulted with theologian Alistair McFadyen, canon John Inge, and parishioner Marianne Edson to create an aluminum sculpture titled *The Way of Life*, which was permanently installed inside Ely Cathedral. The group members' descriptions of the collaborative process and reflections on what they learned from their experiences are compiled in *Sounding the Depths: Theology Through the Arts* (2001).

In 2000 the TTA was absorbed into the Theology and Imagination project at the School of Divinity at the University of St. Andrews in Scotland, and the Institute of Theology, Imagination and the Arts (ITIA) was founded, with Trevor Hart[54] serving as director for its first thirteen years. Now one of the world's leading centers of scholarly engagement with Christianity and the arts, this institute offers undergraduate and postgraduate courses and regularly hosts conferences, seminars, festivals, and other events. Its online journal, *Transpositions*, is a rich resource that's freely available to the public.

Begbie and Hart worked together to shape ITIA while also launching and beginning their service as coeditors of the Studies in Theology, Imagination, and the Arts book series published by Routledge. Then, in 2009, Begbie crossed the pond to Duke Divinity School in Durham, North Carolina, in the United States, where he became the founding director of Duke Initiatives

[53]Jeremy Begbie, *Abundantly More: The Theological Promise of the Arts in a Reductionist World* (Grand Rapids, MI: Baker Academic, 2023).

[54]Hart's publications include *Making Good: Creation, Creativity and Artistry* (Waco, TX: Baylor University Press, 2014); *Between the Image and the Word: Theological Engagements with Imagination, Language, and Literature* (Farnham, UK: Ashgate, 2013); with editors Gavin Hopps and Jeremy Begbie, *Patterns of Promise: Art, Imagination and Christian Hope* (Farnham, UK: Ashgate, 2012); "Protestantism and the Arts," in *The Blackwell Companion to Protestantism*, ed. Alister E. McGrath and Darren C. Marks (Oxford: Blackwell, 2003), 268-86; and "Through the Arts: Hearing, Seeing and Touching the Truth," in *Beholding the Glory: Incarnation Through the Arts*, ed. Jeremy Begbie (Grand Rapids, MI: Baker Academic, 2001), 1-26.

in Theology and the Arts (DITA). Much like ITIA, this program is at the center of the theology-arts conversation, organizing public lectures, seminars, retreats, exhibitions, and performances throughout the year. DITA also offers graduate courses, making possible an arts concentration for theology students pursuing a master's or doctorate.

One of DITA's research projects, launched in 2015, is called Theology, Modernity, and the Arts, which consists of three strains: music, visual arts (led by Professor Ben Quash; see below), and literature. The project aims to show that "art bears witness to previously overlooked theological dynamics that have shaped modernity; art gives voice to questions and cultural quandaries that call for response rooted in a theology of New Creation; art addresses and moves beyond intractable dilemmas that have hampered modern theology; and the theme of New Creation—as realized in Jesus Christ—has the potential to theologically interrogate trajectories of modernity that have been previously underdeveloped in existing accounts."[55]

In 2019 DITA celebrated its ten-year anniversary with a large three-day symposium on the theme "Creation and New Creation: Discerning the Future for Theology and the Arts,"[56] featuring conversations with leading scholars and artists. The symposium included an introduction by artist Bruce Herman, composer J. A. C. Redford, and poet Malcolm Guite to their Ordinary Saints project; talks on placemaking and the arts by Jennifer Craft and "Art, Excess, and Human Need" by Natalie Carnes; a collaborative presentation by artist Steve A. Prince and dancer Leah Glenn; a conversation between artist Lanecia Rouse Tinsley and poet Christian Wiman on art and suffering, moderated by religion historian Kate Bowler; a conversation between Begbie and renowned New Testament scholar N. T. Wright; and more. This gathering also marked the launch of a smaller colloquium of dedicated theology and the arts scholars that has been gathering once a year (minus the two COVID years, 2020 and 2021) ever since, not just to share research but to build community.

[55]"Theology, Modernity, and the Arts Research Project," Duke Initiatives in Theology and the Arts, https://sites.duke.edu/dita/research/.

[56]This symposium resulted in the book *The Art of New Creation: Trajectories in Theology and the Arts*, ed. Jeremy Begbie, Daniel Train, and W. David O. Taylor (Downers Grove, IL: IVP Academic, 2022).

BEN QUASH AND THE CENTRE FOR ARTS AND
THE SACRED AT KING'S COLLEGE LONDON

One of the leading scholars of art and theology in the UK, Ben Quash (1968–) founded and directs the Centre for Arts and the Sacred at King's College London (ASK), a research center within King's Department of Theology and Religious Studies that offers an MA in Christianity and the Arts[57] as well as a host of public education opportunities. "A theological approach to the visual arts introduces questions and insights to the study of Christian works of art, both from the past and also contemporary art, that are not habitually articulated in art-historical approaches," Quash says.[58] His research follows two lines of inquiry:

> The first can be summarized as examining "Art in Christianity." It asks questions about the ecclesiastical settings, spaces for private devotion, and liturgical uses for which particular works of art were commissioned and made. This requires knowledge of church history, of theological writings and statements of the periods in question, the contents of sermons and other forms of popular piety—and the complex ways in which they feed into the arts. There is some consideration of these questions in existing art-historical scholarship, but considerably less than there should be.
>
> The second line of enquiry can be summarized as examining "Christianity in Art." This asks questions about how works of art themselves are "doing theology"; that is to say, expressing, developing, modifying and transmitting Christian viewpoints in a distinctively visual medium. It asks how, for example, a painting might be considered exhortatory—having some of the characteristics of a sermon; how it might seek to move or instruct; and above all how not only its visual content (or subject matter) but its very medium permits the exploration of theological truth claims and commitments.[59]

[57]The master's program invites participants to "investigate how Christian scripture, beliefs and practices have found expression in art over 2,000 years; trace the idea of beauty in Western theological tradition; make use of examples in London. . . . The MA will enable students to work across disciplinary and specialism boundaries, and in particular to explore simultaneously the art-historical and theological dimensions of Christian art." www.kcl.ac.uk/artshums/depts/trs /study/handbook/programmes/pgt/christianityandarts.aspx.

[58]King's College London, "'Art in Christianity' and 'Christianity in Art': A Collaborative Partnership with the National Gallery" (2014), http://impact.ref.ac.uk/casestudies2/refservice.svc /GetCaseStudyPDF/41291.

[59]King's College London, "'Art in Christianity' and 'Christianity in Art.'"

The MA program's hallmark is its partnership with London's National Gallery, which houses a world-class collection of art from the thirteenth through nineteenth centuries, a third of which has Christian subject matter. Although the gallery had turned down many previous requests for collaboration from university art history departments, when Quash approached them in 2008 with a proposal, they were enthusiastic to accept, as this was the first time a theology department had ever offered to work with them. The collaboration became official in 2010, and the following year the Gallery appointed its first Howard and Roberta Ahmanson Fellow in Art and Religion, art historian and curator Jennifer Sliwka.

According to Susan Foister, deputy director and director of collections at the National Gallery,

> The engagement with Ben Quash has made an extremely important contribution to the Gallery's decision to initiate, to renew and to strengthen the topic of "Art and Religion" as one of its four main research themes and priorities. . . . We see it as an important experiment in reaching a wider public with more sophisticated, deeper content, one that . . . places Art and Religion at the centre of the Gallery's Public Engagement strategy.[60]

Quash's research outputs have inspired the Gallery's educational department to more intentionally address the historical and contemporary interests of religious audiences for painting, and to offer public study days on theological themes. The theologians and religion scholars at King's are available to provide input on religious-themed exhibitions at the Gallery while they're in their development phase. Quash's input on the staging of the Gallery's 2011 summer exhibition *Devotion by Design: Italian Altarpieces Before 1500* contributed to its great success. (A churchlike atmosphere was created, with the devotional significance of the art objects emphasized over provenance or technique—a choice applauded by the press.)

In 2014 ASK and the Gallery produced a series of ten short films titled *Saint John the Baptist: From Birth to Beheading*, representing "the most ambitious investment to date by the National Gallery in online education."[61] Filmed in ultra-high resolution, the series follows Quash and Sliwka

[60]King's College London, "'Art in Christianity' and 'Christianity in Art.'"
[61]King's College London, "'Art in Christianity' and 'Christianity in Art.'"

through the Gallery and to nearby sites as they encounter and discuss various artworks that depict scenes from the life of John the Baptist, combining their respective backgrounds in theology and art history to make these works accessible to those without backgrounds in either. This video series was followed up in 2017 by the seven-episode *The Audacity of Christian Art*, written and presented by ASK research associate Chloë Reddaway, who explores some creative responses to the challenge of painting Christ. More recently, in 2022–2023, ASK partnered with the Gemäldegalerie and the Bode-Museum in Berlin to produce the video series *Unlocking Christian Art: Jesus Christ* and *Unlocking Christian Art: The Virgin Mary*, featuring works from these two institutions, as well as filmed conversations between Quash, a Jewish rabbi, and a Muslim theologian around sculpted representations of Eve and Abraham, figures that the three Abrahamic faiths hold in common.

Furthering its outreach to the public, in 2016 ASK released a new smartphone app, Alight: Art and the Sacred,[62] that features art-tour routes and audio commentaries written and read by artists, historians, and spiritual leaders, enabling users to discern the religious aspects of various artworks throughout London and other cities. The inaugural art trail was *Stations 2016*,[63] curated by Aaron Rosen, who was an ASK lecturer at the time, and artist Terry Duffy. Modeled after the ancient Christian devotional practice known as the stations of the cross, it weaved through sacred and secular spaces in London, using artworks to open up different aspects of Jesus's journey to the cross and to encourage reflection on particular twentieth- and twenty-first-century forms of suffering. The fourteen stops included a bronze statue of Gandhi in Parliament Square (corresponding to station two, "Jesus Takes Up His Cross"), a Limoges enamel plaque from the Wallace Collection, a quilt made of discarded baby clothes by Güler Ates (*Sea of Colour*, corresponding to "Jesus Is Stripped"), and the *Martyrs*

[62]The app was developed by Calvium. Read their interview with Quash at "Changing Stations: An Interview with Ben Quash, Professor of Christianity and the Arts at King's College London," April 12, 2018, https://calvium.com/changing-stations-an-interview-with-ben-quash-professor-of -christianity-and-the-arts-at-kings-college-london/.

[63]Two years earlier, PassionArt in Manchester organized a similar event: a Lenten art trail hosted by six venues throughout the city, which saw thousands come out. The organization reprised this concept in 2016 with *Be Still*, which was very sophisticated in both design and execution and included a published catalog.

video installation by Bill Viola at St. Paul's Cathedral. People of all faiths or no faith were invited to participate in the trail and to treat it as an exhibition if they were not comfortable engaging it devotionally. Similar Stations experiences were designed in 2017 in Washington, DC, and in 2018 in New York City, supported by the Alight app—and in 2019 in Amsterdam and 2022 in Toronto. Also on Alight you can find a Chichester Art Pilgrimage that explores the traditional and contemporary artworks in Chichester Cathedral, commentary by Quash on ten works from the National Gallery, and more.

Quash's specializations include art as scriptural exegesis and the theological aesthetics of Hans Urs von Balthasar, whose seven-volume work *The Glory of the Lord* argues that the substance of God's being and glory is beauty.[64] Quash focuses on works with explicit Christian content or works commissioned by or exhibited in churches, and is equally adept at speaking about art from the medieval, Renaissance, and Baroque periods as he is about modern and contemporary art. In his paper "Can Contemporary Art Be Devotional Art?,"[65] he examines three recent church commissions by highly regarded contemporary artists: the East Window in St. Martin-in-the-Fields by Shirazeh Houshiary; *Haruspex* by Elpida Hadzi-Vasileva, installed at the Holy See pavilion at the 2015 Venice Biennale, for which Quash served as principal theological consultant; and *For You* by Tracey Emin, a neon-tube work permanently installed in Liverpool Cathedral. He concludes that contemporary art, though deemed difficult by some Christians, exercises necessary moods of speech:

> It may be that the sort of contemporary art regularly characterized as ironic, transgressive, agoric [meant for a secular space, such as a gallery or museum], or of-the-moment will be better appreciated by churches when it's seen as exploratory, inquisitive, and testing. The moods of speech with which this sort of art works best are the subjunctive (imagining what could

[64]See especially Hans Urs von Balthasar, *The Glory of the Lord: A Theological Aesthetics*, vol. 1, *Seeing the Form*, trans. Erasmo Leiva-Merikakis, ed. John Riches (Edinburgh: T&T Clark, 1982). The objective beauty of God in Christ, Balthasar says, forms the context in which truth and goodness make sense.

[65]Ben Quash, "Can Contemporary Art Be Devotional Art?," in *Contemporary Art and the Church: A Conversation Between Two Worlds*, ed. W. David O. Taylor and Taylor Worley (Downers Grove, IL: IVP Academic, 2017), 58-78.

or might be different in our world), the interrogative (asking why things are like this and not that, and whether it must be so), and the optative (probing the complex anatomy of our desire). Christianity would be a poor thing if it abandoned its visual analogues to these moods of speech, which also run through its Scriptures and historical liturgical practices at every point. Without subjunctives, interrogatives, and optatives, it would be left only with indicatives and imperatives: trying to lecture an apostate world on "the way things really are" and what to do about it. It would only have a place for didactic art.

The church needs art that helps it to speak in all moods. It needs to be rooted and grounded in the contemplation of images that speak to many times and places, and also to have momentary events of encounter, exchange, and challenge where the church meets the world—at the church door, or even in a Biennale pavilion. To say that one sort of art is sacred and another is not might be an unnecessary mistake, especially when works such as the ones discussed here seem so ready to be embraced by the church.[66]

A major large-scale project led by Quash that has provoked widespread international interest is the Visual Commentary on Scripture, a freely accessible online publication, launched in November 2018, that provides theological commentary on the Bible in dialogue with works of art. With the aid of a small team, Quash commissions various individuals in the field of art and theology to each curate a virtual mini-exhibition of three works of art that converse with an assigned biblical text—the art could be a direct response to the text, or not—and then to write a short commentary on each artwork. Image selections are made for their ability to open up the biblical texts for interpretation and/or offer new perspectives on the themes the passages address, thereby showing how art itself can function as biblical commentary. With over three hundred "exhibitions" already published and new ones added regularly, the goal is to cover the entire Bible. That the launch took place at the Tate Modern, one of the world's leading art institutions, is a testament to how well the dialogue between art and theology is progressing, especially in the UK.

Concurrent with this, from 2018 to 2022, in collaboration with Duke University and funded by the McDonald Agape Foundation, Quash led a

[66]Quash, "Can Contemporary Art Be Devotional Art?," 75-76.

research project called Theology, Modernity, and the Visual Arts (TMVA), which consisted of a series of academic symposia hosted by major international art galleries: the Royal Academy of Arts in London in 2018, the School of the Art Institute of Chicago in 2019, and the Akademie der Künste and Bode-Museum in Berlin in 2022. These were accompanied by public events headlined by high-profile artists, theologians, and critics; the London gathering, for example, brought into conversation, before a packed house, the renowned British sculptor Antony Gormley (who is not religious but whose work often has often been described as having a spiritual quality) and the former archbishop of Canterbury, Rowan Williams. Over its four-year run, the project examined four expressions—art *for* Christianity, art *as a substitute for* Christianity, art *about* Christianity, and art *with* Christianity—and resulted in new scholarship that will be compiled in a forthcoming book. The success of TMVA led to the rolling out, in September 2023, of a new five-year project: Theology and the Visual Arts: Firming Foundations, Firing Imaginations. Again, Quash sits at the helm. The project's purpose is to strengthen the foundations of art and theology as a discipline within academic theology and to help shape its future, exemplifying how "the task of Christian theology can be pursued comprehensively, systematically, and fruitfully through engagement with visual art."[67]

W. DAVID O. TAYLOR AND THE LITURGICAL ARTS

The first alumnus of the Duke Initiatives in Theology and the Arts ThD program, W. David O. Taylor (1972–) is an associate professor of theology and culture at Fuller Theological Seminary; he is also the director of Brehm Texas, a worship and the arts initiative at Fuller's regional campus in Houston. He teaches the touchstone course Worship, Theology, and the Arts; The Vocation of Artists; The Theology of Beauty; and others. Liturgical theology and liturgical aesthetics are his primary interests, so his research, writing, and teaching focus on the arts in worship—what is already in use, what's possible, and why the arts matter, or what they contribute. He seeks to enable "art making by the

[67]"Theology and the Visual Arts," King's College London, www.kcl.ac.uk/research/theology -and-the-visual-arts.

church, for the church, for the glory of God in the church, and for the good of the world."[68]

Prior to his career in academia, Taylor served for over eight years[69] as a pastor of the arts at Hope Chapel, a midsize nondenominational church in Austin, Texas. (The position of "arts pastor," where "arts" refers to more than just music, is a rarely encountered position in any denomination.)[70] Hope Chapel already had an arts ministry in place when Taylor stepped in full time in 2001. His job was to shepherd the artists in the congregation both spiritually and professionally, encouraging them to use their gifts to serve the local body, and likewise to foster an appreciation of the arts among the non-artists in the congregation, encouraging receptivity and patronage.

> Artists can serve the church by being humble and generous and brave and patient. They can serve by volunteering on a committee or consulting on a project. On the other side, leaders can come alongside artists and say, "I'm not sure I get what you're doing, but I love you. Help me understand your work. Tell me how I can support you."[71]

During his tenure as arts pastor, Taylor directed the annual three-week HopeArts Festival; organized five rotating art exhibits built around the church calendar; established arts home groups where artists and supporters of the arts could gather for conversation and study; established an artist residency program to provide emerging artists with a twelve-month period to develop their skills; and taught an adult course Art and the Church, Art in the Church.

He also organized the conference "Transforming Culture: A Vision for the Church and the Arts," which convened in Austin in April 2008 and was attended by almost eight hundred people; it included seminars such as "Visual

[68]Quoted in Andrea Palpant Dilley, "Meet the Man Behind the Bono and Eugene Peterson Conversation," *Christianity Today*, May 20, 2016, www.christianitytoday.com/ct/2016/june /bridging-gap-between-church-and-arts.html.

[69]Eight years cumulative, but over a span of twelve years: part time during the summers of 1996 through 1999 and full time from January 2001 to May 2008.

[70]Some churches, though, are starting to expand the job description of the worship arts director to encompass the visual and other arts, or are empowering lay leaders to execute an arts ministry that utilizes the creative gifts of its congregants and/or brings in art from outside the church. Alternatively, the responsibility of promoting the church's engagement with the arts, especially outside the context of the regular worship service, might fall to a church employee of education or outreach.

[71]Quoted in Dilley, "Meet the Man."

Homiletics: How to Preach to the Eye as Well as the Ear" and "Seminaries and the Aesthetic Formation of Pastors." This conference spawned the book *For the Beauty of the Church: Casting a Vision for the Arts* (2010), a collection of essays by artists, theologians, pastors, and patrons that reflect on art's functions of worship, discipleship, community, service, and mission. In the afterword, Taylor expresses hope that the arts will become a normative part of the life of our churches, that a greater number of young Christians will enter art schools and pursue careers in the arts, that more seminaries will add art-related courses to their curricula, that the involvement in professional societies by believer artists will increase, and that Protestants will recapture a culture of patronage.

Counter to the claim that art should be for art's sake alone and ought not to be subservient to any use or agenda, the *liturgical* arts, Taylor says, must necessarily serve the actions of corporate worship, such as praise, petition, thanksgiving, and confession: "They should serve the church's worship in their own ways (with their own logic and powers), though not on their own terms."[72] The work of the liturgical artist is "to welcome the familiar and strange voice of creation into the liturgical sphere in response to the familiar and strange voice of God."[73]

Though visual art is not Taylor's exclusive focus, he has written and spoken abundantly on that discipline, perhaps in part because his wife, Phaedra Jean Taylor, is an artist! Sight and seeing, he says, are to be regarded as positive functions in God's world—just like hearing—but we need to learn how to see rightly, and that's where artists come in:

> The Scriptures present the relationship between eye and ear as interdependent rather than oppositional. Both ear and eye are a gift to a full human life, both are broken, both require healing. And the functions of the eye should not be made to perform the same kind of work as the ear, nor vice versa. God speaks and beholds. Jesus appears and preaches. The Holy Spirit is promised and becomes manifest at Pentecost. . . .

[72] Taylor, *Theater of God's Glory*, 10. Also: "To argue that the liturgical arts should be seen as servants of the activities and purposes of public worship (whatever those may be in any given ecclesial context) is to argue, on the one hand, against the presumption that the arts should be allowed to do their own thing on their own terms, and, on the other, against the presumption that the arts have nothing unique to contribute" (191).

[73] Taylor, *Theater of God's Glory*, 188.

In the end, our sight is limited because of creaturely status, and it is broken on account of our sinful condition, and as the theologian Stanley Hauerwas observes, "We do not see the world rightly just by opening our eyes." What are needed, then, to concentrate our thoughts over against a fickle memory and a false imagination are good works of art that train us to see God's world rightly. In the end, then, what we're after is not just the avoidance of false images or the absence of physical imagery in our spaces of public worship but the provision of images which offer the physical eyes something good to look upon in order that the eyes of our mind might be clarified and that the eyes of our heart might be aroused for the sake of a deeper love of God and a more faithful engagement with the world that God so loves.[74]

In the essay "Discipling the Eyes Through Art in Worship," Taylor says that "by questioning our habits of sight, the visual arts can train muscles of attentive perception" so that we might develop a sort of sanctified seeing. For example, art can help us see the world as not opaque to God's presence but charged with it. It can help us better see our neighbor too. These new habits of sight are formed over time and usually require a purposeful "training" period.[75]

Taylor's 2017 book, *The Theater of God's Glory: Calvin, Creation, and the Liturgical Arts*, wrestles with Calvin's theology for a blessing on church art. He notes that Calvin's account of materiality is distinctly optimistic when it comes to the physical creation, which shouts God's glory and provides occasion for delight; but when those materials of creation enter a public worship space, for Calvin they are a distortion, or a lesser vehicle.[76] Taylor argues Calvin beyond himself, asserting that "as Calvin perceives that God appropriates material things, such as the sweetness of creation or the eucharistic bread, to form and feed the church, so . . . God may take the liturgical arts to form and also feed the church."[77]

Taylor systematically addresses the four emphases that mark Calvin's thinking: "that the church's worship should be (1) devoid of the 'figures and

[74]W. David O. Taylor, "The Plastic Arts," lecture, Worship and the Arts summer course, Regent College, Vancouver, August 2, 2017. Content from this course has been developed into the book *Glimpses of the New Creation: Worship and the Formative Power of the Arts* (Grand Rapids, MI: Eerdmans, 2019).

[75]W. David O. Taylor, "Discipling the Eyes Through Art in Worship," *Christianity Today*, April 27, 2012.

[76]Taylor, *Theater of God's Glory*, 5.

[77]Taylor, *Theater of God's Glory*, 13.

shadows' that marked Israel's praise and should emphasize instead a (2) 'spiritual,' (3) 'simple,' and (4) 'articulate' worship, suitable to a new-covenantal era."[78] In conclusion, Taylor cites some of the contributions the arts make to the church:

> Against Calvin's worries over the power of the arts to arouse errant passions, I suggest that the liturgical arts contribute to the sanctification of the church, countering the idols of the mind, the forgetfulness of memories, a will that is bent against God, and the disorder of broken bodies and dysfunctional affections. Against Calvin again, I suggest that the liturgical arts, as sensory attestations of God's holiness, contribute to a distinctly Christian cosmology. As indispensable rather than dispensable material media that liturgically symbolize the new life in Christ, the liturgical arts form the church in a holy imagination, enabling the faithful to live "in Christ," "as Christ," in the rest of their lives, for the sake of a cosmos marked by shalom.

Sympathetic to Calvin's belief that the "affluence, sweetness, variety and beauty" of creation could train men and women to choose the good and to reject the evil and thereby to honor the Creator, I contend that the liturgical arts may disclose the knowledge of God, train the church in the "school of beasts,"[79] awaken desire for God through the beauty of the cosmos, foster obedience and love, chide ingratitude and pride in humanity's failure to acknowledge God's abundant provision, and summon the faithful to the praise of God in the common life of worship.[80]

Put in other words and elaborated: art can re-pray our prayers, kindle the affections for God, foster wisdom, generate ecclesial unity, create metaphors for the gospel, stimulate a commitment to the kingdom of God, and inspire a vision of a faithful life in the world at large.[81]

[78]Taylor, *Theater of God's Glory*, 5.

[79]Taylor is quoting from Calvin's commentary on Isaiah 1:3: "The ox knoweth his owner, and the ass his master's crib: but Israel doth not know, my people doth not consider." Though God constantly fed his people, Calvin writes, they did not gratefully acknowledge the source of the food as even animals do, and therefore "he sends them to the oxen and asses to learn from them what is their duty." Calvin writes elsewhere (e.g., in his commentary on Isaiah 43:20 and a preface for the 1534 French translation of the New Testament by Pierre Robert Olivetan) of how non-human creation praises God, from grass and rocks to birds and fishes to the winds and planets, acting as witnesses and messengers of his glory. The arts, Taylor suggests, are a way of joining creation's song. See Taylor, *Theater of God's Glory*, 44-45.

[80]Taylor, *Theater of God's Glory*, 192, 194.

[81]Taylor, "Plastic Arts."

Taylor has spoken extensively at churches, universities, conferences, and retreat centers about art,[82] including leading an annual retreat for artists and arts ministers at Laity Lodge in central Texas. His on-the-ground work with artists and in ministerial roles, implementing the very reforms he advocates, figuring out what works and what doesn't, has given him a unique perspective and set of experiences that inform how he now trains theologians- and ministers-to-be at Fuller.

CONCLUSION

The advancements made in art and theology over the past fifty years, and especially the past two decades, have been enormous. The academic programs at Wesley, Duke, Fuller, and King's College London have made an indelible mark on the landscape of the field, with students graduating and going on to implement much of what they learned in their own communities, and the general public benefiting as well from the arts events and resources on offer. As Protestants have shown how art can play a positive role in theological reflection and spiritual formation, churches have started (or in some cases, continued) integrating it into the fabric of their corporate life, and individual Christians have been inspired to visit more galleries, to purchase original art, and even to approach images not merely as objects of aesthetic contemplation but as potential guides into prayer. Artists of faith have been buoyed up by the fellowship, conversation, and professional opportunities emerging around art and theology, many feeling better equipped for their vocation, whether that is making art for the contemporary art market, for patrons, or for churches, or for some mix of all three. But despite increased funding,[83] publications, and programming, I still would not say these things represent a sea change: visual art is still not a normative part of either (Protestant) church life or theological education. Many worshiping communities live in complete, unwitting ignorance of these advancements and are often shocked to learn that good, theologically charged art is still being made today—some of it by Christians, some of it not—or that

[82]For a full list, see www.fuller.edu/wp-content/uploads/2020/08/Taylor-CV.pdf.

[83]Sandra and Robert Bowden and Howard and Roberta Ahmanson have been major donors toward art and theology projects over the years. But despite their largesse, funding for the arts remains an ongoing struggle for many institutions.

Protestant churches would include a line item on the budget for art, or that art can *do* theology in ways that words cannot. Regarding religious-themed art, some of the old suspicions still persist: How could it be anything other than idolatrous? And art in general is still mostly regarded as nice for those who have the time, the inclination, and the money to pursue it, but not having anything vital to offer to Christian faith.

Even when the value of art *is* recognized by Protestants, contention arises when it comes to how and where it should be used by the church, and how to reconcile a Reformed heritage with such uses. Art in the sanctuary or in the context of corporate worship is often avoided in Reformed churches,[84] while displays in the lobby or in a gallery space elsewhere in the building are deemed more acceptable. If new art *is* permanently installed in a Reformed worship space, it will likely *not* be a naturalistic image of Jesus (though of course there are exceptions); instead, it's probably something more abstract or symbolic. Connecting art to words such as *prayer, contemplation, devotion,* or *worship* still raises a red flag for many Protestants whose minds automatically flash back to historical abuses. It is right to think critically about such things and to interrogate what is appropriate, art-wise, within one's own ecclesial tradition and congregation, while at the same time not shying away from the challenge. Many of the people and programs I've mentioned above help individuals and churches to do just that. But church is not the only space in which art can be engaged. Whether on Instagram or YouTube or in a book or (most preferably) in person at a local gallery or museum, there are so many riches to be mined as we connect with our visual heritage that's come to us from the past and stand before new artistic offerings with a humble willingness to learn or simply receive.

In a chapter on art and theology since 1970, it would be remiss to not mention Christians in the Visual Arts (CIVA), a US organization founded in 1979 to connect artists of faith who felt doubly alienated: from churches that didn't understand or appreciate their vocation and from secular art institutions that scorned sincere Christian belief. Over the decades, CIVA

[84]Some Protestants hold to what's called the regulative principle of worship—promoted by the Westminster Confession of Faith, the Heidelberg Catechism, and the Belgic Confession, for example—which states that only those practices explicitly affirmed in Scripture can be used in public worship.

grew to 1,500-plus members, consisting mainly of artists but also of arts administrators, art critics, curators, collectors, art historians, theologians, and church leaders across Protestant, Catholic, and Orthodox lines. Its ecumenism was a boon, and its bringing together of artists and scholars an indispensable service. CIVA fostered community (which enabled networking), provided professional development opportunities, held a biannual conference and art auctions, organized traveling exhibitions, and published the semiannual journal *SEEN* as well as several portfolios of prints, such as the Florence Portfolio. It generated new art and scholarship. Sadly, in June 2023, CIVA dissolved due to rising operating costs and a challenging fundraising environment. This was a major blow to the thousands of arts professionals— three generations' worth—that it nurtured over its forty-four years, and to newer members in their student days or early careers. But in a statement from the board of directors, CIVA optimistically said it believes it "has achieved its mission of advancing the visual arts within the church and bringing the art and faith conversation into mainstream culture," alluding to the many local arts groups and initiatives that were founded in pockets all over the United States and Canada as a direct result of CIVA.[85] I would imagine that a book will be published in the future to tell CIVA's full story and commemorate its achievements, but until then, there's *Faith and Vision: Twenty-Five Years of Christians in the Visual Arts* (2005), edited by founding member and then-president Sandra Bowden along with Cameron J. Anderson, who would become CIVA's penultimate executive director.

The biggest successes in art and theology over the past fifty-plus years have been in persuasively showing why art matters to the theological enterprise and why everyday Christians should care about it. Where there's room for improvement is in cultivating a more serious engagement by Christians with modern and contemporary art. Jonathan A. Anderson (mentioned above) and Elissa Yukiko Weichbrodt, associate professor of art and art history at Covenant College in Lookout Mountain, Georgia, are breaking excellent new ground in this arena, and the internationally acclaimed arts journal *Image* has been laboring effectively on this front since 1989, exposing Christian readers to world-class contemporary art (as well as poetry, short

[85]"FAQ" (web page), Christians in the Visual Arts, April 2023, www.civa.org/faq.

fiction, and literary nonfiction). Relatedly, educating tastes is another area that needs improvement. Too often when churches purchase art, it is of low quality. An increased artistic literacy would help those in charge of making such decisions to distinguish between good art and mere kitsch. I'd also like to see more partnerships between religious and secular institutions whose interests, expertise, and financial resources can serve each other and the wider public, such as we've seen at King's and as is becoming more common at Wesley.

In closing, I must reiterate that while in this chapter I have focused mainly on voices from academia, just as important are all the artists, pastors, podcasters, bloggers, editors, ministry leaders, and patrons who have likewise impacted the field of art and theology, in many cases laboring faithfully in local contexts to bring about change.

BIBLIOGRAPHY

Anderson, Cameron J. *The Faithful Artist: A Vision for Evangelicalism and the Arts.* Studies in Theology and the Arts. Downers Grove, IL: IVP Academic, 2016.

Anderson, Jonathan A., and William A. Dyrness. *Modern Art and the Life of a Culture: The Religious Impulses of Modernism.* Studies in Theology and the Arts. Downers Grove, IL: IVP Academic, 2016.

Begbie, Jeremy S. *A Peculiar Orthodoxy: Reflections on Theology and the Arts.* Grand Rapids, MI: Baker Academic, 2018.

———, ed. *Sounding the Depths: Theology Through the Arts.* London: SCM Press, 2002.

Bowden, Sandra, and Cameron J. Anderson, eds. *Faith and Vision: Twenty-Five Years of Christians in the Visual Arts.* Baltimore: Square Halo, 2005.

Brown, Frank Burch. *Good Taste, Bad Taste, and Christian Taste: Aesthetics in Religious Life.* Oxford: Oxford University Press, 2000.

Bustard, Ned, ed. *It Was Good: Making Art to the Glory of God.* 2nd ed. Baltimore: Square Halo, 2006.

Dyrness, William A. *Reformed Theology and Visual Culture: The Protestant Imagination from Calvin to Edwards.* Cambridge: Cambridge University Press, 2004.

———. *Visual Faith: Art, Theology, and Worship in Dialogue.* Engaging Culture. Grand Rapids, MI: Baker Academic, 2001.

Fuijmura, Makoto. *Culture Care: Reconnecting with Beauty for Our Common Life.* Downers Grove, IL: InterVarsity Press, 2017.

Jensen, Robin M., and Kimberly J. Vrudny. *Visual Theology: Forming and Transforming the Community Through the Arts.* Collegeville, MN: Liturgical Press, 2009.

Kapikian, Catherine. *Art in Service of the Sacred.* Nashville: Abingdon, 2006.

Morgan, David. *The Forge of Vision: A Visual History of Modern Christianity*. Oakland: University of California Press, 2015.

Rookmaaker, Hans. *Modern Art and the Death of a Culture*. Downers Grove, IL: InterVarsity, Press, 1970.

Rosen, Aaron. *Art and Religion in the 21st Century*. London: Thames & Hudson, 2015.

Ryken, Philip Graham. *Art for God's Sake: A Call to Recover the Arts*. Phillipsburg, NJ: P&R, 2006.

Schaeffer, Francis. *Art and the Bible*. Downers Grove, IL: InterVarsity, Press, 1973.

Sokolove, Deborah. *Sanctifying Art: Inviting Conversation Between Artists, Theologians, and the Church*. Eugene, OR: Cascade, 2013.

Strine, C. A., Mark McInroy, and Alexis Torrance, eds. *Image as Theology: The Power of Art in Shaping Christian Thought, Devotion, and Imagination*. Arts and the Sacred 6. Turnhout, Belgium: Brepols, 2022.

Taylor, W. David O., ed. *For the Beauty of the Church: Casting a Vision for the Arts*. Grand Rapids, MI: Baker, 2010.

—―――. *Glimpses of the New Creation: Worship and the Formative Power of the Arts*. Grand Rapids, MI: Eerdmans, 2019.

—―――. *The Theater of God's Glory: Calvin, Creation, and the Liturgical Arts*. Grand Rapids, MI: Eerdmans, 2017.

Taylor, W. David O., and Taylor Worley, eds. *Contemporary Art and the Church: A Conversation Between Two Worlds*. Studies in Theology and the Arts. Downers Grove, IL: IVP Academic, 2017.

Thiessen, Gesa Elsbeth, ed. *Theological Aesthetics: A Reader*. Grand Rapids, MI: Eerdmans, 2004.

Weichbrodt, Elissa Yukiko. *Redeeming Vision: A Christian Guide to Looking at and Learning from Art*. Grand Rapids, MI: Baker Academic, 2023.

BIOS OF AUTHORS

Adrienne Dengerink Chaplin (PhD) was born and raised in the Netherlands. She studied philosophy and art history at the Free University and violin at the Sweelinck Conservatory in Amsterdam. She taught at the Institute for Christian Studies in Toronto and at King's College London, where she is still a Visiting Research Fellow. Adrienne works on the interface of philosophical and theological aesthetics and is the coauthor of *Art and Soul: Signposts for Christians in the Arts* (IVP). She is the founding director and curator of the traveling exhibition *Art, Conflict and Remembering: The Murals of the Bogside Artists*, and her latest book, *The Philosophy of Susanne Langer: Embodied Meaning in Logic, Art and Feeling*, was recently published by Bloomsbury. She lives with her husband Jonathan in Cambridge, UK.

William Edgar grew up in Paris, New York, and Geneva. He studied at Harvard University (Honors BA in Music), Westminster Theological Seminary (MDiv), and the University of Geneva (D Théol). He taught 1979–1989 at the Faculté Libre de Théologie Réformée, in Aix-en-Provence, France, where he continues as Professeur Associé. Since 1989 he is professor of apologetics at Westminster Theological Seminary. He is also an ethnomusicologist. In his books and articles, Edgar has treated topics such as cultural apologetics, the music of Brahms, the Huguenots, and African American aesthetics. Edgar is a jazz pianist and regularly performs evening concerts combined with lectures on the history of jazz. His publications include *Taking Note of Music* (1986), *Schaeffer on the Christian Life: Countercultural Spirituality* (2013), and *Created and Creating: A Biblical Theology of Culture* (2016).

Roger D. Henderson (BA, UC Berkeley; PhD, Free University of Amsterdam) is a father, writer, builder, and traveler. His dissertation was on the background of Herman Dooyeweerd's philosophy in Kuyper and discussion with neo-Kantians. He has taught in both Iowa and the Netherlands and now lives in Berkeley, California. He likes to study the Bible and build little houses.

Marleen Hengelaar-Rookmaaker is editor-in-chief of ArtWay. She edited the *Complete Works* of her father, art historian Hans Rookmaaker. She has published three books in Dutch, and articles about popular music, liturgy, and the visual arts in Dutch and English books and magazines.

Victoria Emily Jones is a writer on Christianity and the arts, living in the United States. In 2016 she founded ArtandTheology.org, a blog that explores how the arts can stimulate renewed theological engagement with the Bible. She serves on the board of the Eliot Society, a Washington, DC–based nonprofit that promotes spiritual formation through the arts, and as the assistant editor of ArtWay.eu. She is also a contributor to the Visual Commentary on Scripture, *Transpositions*, and other publications.

James Romaine is an associate professor of art history at Lander University. He is the co-founder of the Association of Scholars of Christianity in the History of Art (ASCHA). His videos can be seen on YouTube at SeeingArtHistory. His books include *Art as Spiritual Perception: Essays in Honor of E. John Walford* (Crossway, 2012) and *Beholding Christ and Christianity in African American Art* (Penn State University Press, 2018). He has an undergraduate degree from Wheaton College, an MA in art history from the University of South Carolina (thesis: "A Modern Devotion: The Faith and Art of Vincent van Gogh"), and a PhD in art history from the Graduate Center of the City University of New York (dissertation: "Constructing a Beloved Community: The Methodological Development of Tim Rollins and K.O.S.").

Calvin Seerveld is senior member in philosophical aesthetics, emeritus, at the Institute for Christians Studies in Toronto, and a past president of the Canadian Society for Aesthetics/Société canadienne d'esthétique. After several years of study in the Netherlands under D. H. Th. Vollenhoven, S. U. Zuidema, and G. Kuiper; in Switzerland under Karl Jaspers, Oscar Cullmann and Karl Barth; and in Rome under Carlo Antoni, he received his PhD in

philosophy and comparative literature from the Free University of Amsterdam (1957). Seerveld taught undergraduate philosophy and literature at Belhaven College, Mississippi (1958–1959), and at Trinity Christian College in the Chicago area (1959–1972) before he specialized in aesthetics at the graduate Institute for Christian Studies in Toronto (1972–1998), where his research and teaching concentrated on the study of fundamental categories in the systematics of philosophical aesthetics, such as imaginativity, artistic taste, and the playful aesthetic life. An earlier well-known text is his *Rainbows for the Fallen World, Aesthetic Life and Artistic Task* (1980/2005). Dordt University Press (Iowa) has recently published a collection of many of Seerveld's writings in six volumes (2014), including *Normative Aesthetics*, from which the article in this book is selected.

Wessel Stoker is professor emeritus of aesthetics at Vrije Universiteit Amsterdam. He has written various books on topics in philosophy of religion, including *Is the Quest for Meaning the Quest for God?* (1996) and *Is Faith Rational?* (2006), and on aesthetics: *Where Heaven and Earth Meet: The Spiritual in the Art of Kandinsky, Rothko, Warhol, and Kiefer* (2012) and *Imaging God Anew, a Theological Aesthetics* (2021).

E. John Walford was professor of art history at Wheaton College, Illinois, until his retirement in 2011 and served as Art Department Chair from 1981 to 2002. Educated at the Vrije Universiteit, Amsterdam, and the University of Cambridge, England, he is author of *Jacob van Ruisdael and the Perception of Landscape* (Yale University Press, 1991) and *Great Themes in Art* (Prentice Hall, 2002).

Nicholas Wolterstorff is professor emeritus of philosophy at Yale University. He has published books in the areas of aesthetics, ontology, epistemology, education, metaphysics, grieving, and political and religious philosophy. He studied at Calvin College (now University), Cambridge University, and Harvard University. His thought has been influenced by Alvin Plantinga, Augustine, Calvin, Kuyper, Thomas Reid, and Willliam Jellema. With Plantinga and W. Alston, he helped develop what is called Reformed epistemology. His main works in aesthetics are *Art and Action* (1980), *Works and Worlds of Art* (1980), and *Art Rethought: The Social Practice of Art* (2015).

Lambert Zuidervaart is emeritus professor of philosophy at the Institute for Christian Studies and the University of Toronto, and a visiting scholar at Calvin University in Grand Rapids, Michigan, where he resides. Internationally known in the fields of Adorno studies and critical theory, he is the author of *Artistic Truth: Aesthetics, Discourse, and Imaginative Disclosure* (Cambridge University Press, 2004) and *Art in Public: Politics, Economics, and a Democratic Culture* (Cambridge University Press, 2011). His most recent books include *Truth in Husserl, Heidegger, and the Frankfurt School* (MIT Press, 2017) and three volumes of essays in reformational philosophy published by McGill-Queen's University Press: *Religion, Truth, and Social Transformation* (2016), *Art, Education, and Cultural Renewal* (2017), and *Knowledge, Politics, and Social Critique* (forthcoming).

FIGURE CREDITS

1.1. van Coninxloo, Gillis. *Elijah Fed by the Ravens*, ca. 1590. Oil on wood, 115 × 178 cm. Musées royaux des Beaux-Arts de Belgique, Brussels. Public domain. Wikimedia Commons.

1.2. Victors, Jan. *Abraham's Parting from the Family of Lot*, ca. 1655– 1665. Oil on canvas, 147.3 × 165.4 cm. Metropolitan Museum of Art, New York. Public domain.

1.3. van Rijn, Rembrandt. *The Annunciation*, ca. 1635. Ink drawing, 14.4 x 12.4 cm. Musée des Beaux-Arts, Besançon. Public domain.

1.4. de Heem, Jan Davids, and Nicolaes van Veerendael. *Bouquet with Crucifix and Shell*, 1640s. 103 x 85 cm. Alte Pinakothek, Munich. Public domain. Wikimedia Commons.

1.5. van Ruisdael, Jacob. *View of Haarlem from the Dunes at Overveen*, ca. 1670. Oil on canvas, 62.2 x 55.2 cm. Kunsthaus Zürich. Public domain. Wikimedia Commons.

1.6. Bosboom, Johannes. *St. Andreaskerk or Grote Kerk in Hattem*, 1860. Oil on panel, 86 x 66 cm. Voerman Museum, Hattem, The Netherlands. Public domain.

1.7. Burnard, Eugène, *Peter and John Running to the Tomb*, 1898. Oil on canvas, 83 x 135 cm. Musée d'Orsay, Paris. Public domain. Wikimedia Commons.

1.8. van Gogh, Vincent. *Café Terrace at Night*, 1888. Oil on canvas, 80.7 cm x 65.3 cm. Kröller-Müller Museum, Otterlo, The Netherlands. Public domain. Wikimedia Commons.

1.9. Frenken, Jacques. *Crucifix/Target*, 1965/1966. Hout, verf, gips (corpus ca. 1900), doorsnede 133 cm. Museum voor Religieuze Kunst, Uden.

1.10. Koning, Roeland. *The Wives of Fishermen from Egmond*, ca. 1927. The Museum Egmond aan Zee and Simonis & Buunk.

1.11. Hendriks, Berend. Bergkerk, The Hague, 1964.

1.12. Helmantel, Henk. *Still Life with Large Rummer and Quinces*, 2011. Oil on panel, 96 x 122 cm. Permission by the artist.

1.13. Prescott, Catherine. *Daphne Holding Her Neck*, 2015. Oil on panel, 22.5 x 15 cm. Permission by the artist.

1.14. Benjamin, Zak. *Christ and Consumerism*, 1999. Acrylics on wood, 87 x 87 cm. Permission by the artist.

1.15. Modderman, Egbert. *Father and Son*, 2016. Oil on linen, 150 x 200 cm. Permission by the artist.

1.16. Duifhuizen, Martijn. *The Last Supper*, 2012. Real gold (gold leaf 24k) on stainless steel and black velvet, 688 x 102 cm. Permission by the artist.

1.17. Fujimura, Makoto. *John – In the Beginning*, 2011. Mineral pigments, gold on Belgium linen, 120 x 150 cm. Permission by the artist.

1.18. Schuurman, Margje. *At the Other Side of the Door*, 2011. Wooden door, paint, latex, 250 x 110 cm. Permission by the artist.

1.19. Thomann, Hans. *Aureole (Heiligenschein)*, 2011. Rebar steel with 50 firework rockets, height: 2.1 m. Permission by the artist.

2.1. Titian, *John Calvin*, ca. 1536. Oil on canvas, 66.5 × 57.5 cm. Public domain. Wikimedia commons.

2.2. Blake, William. *The Ancient of Days*, 1794. Frontispiece of *Europe a Prophecy*, hand-colored relief etching, 23.3 x 16.8 cm. British Museum. Public domain. Wikimedia commons.

3.1. Veth, Jan. *Portrait of Abraham Kuyper*, 1899. Oil on panel, 43.1 x 37.8 cm. Dordrechts Museum. Public domain. Wikimedia Commons.

3.2. Dürer, Albrecht. *The Large Piece of Turf*, 1503. Watercolor and opaque, 40.9 x 31.5 cm. Graphische Sammlung Albertina, Vienna. Public domain. Wikimedia commons.

3.3. *Venus de Milo*, ca. 130 BC. Marble, height 208 cm. Louvre, Paris. Public domain. Wikimedia commons.

4.1. Dooyeweerd, Herman. Nationaal Archief. Public Domain.

4.2. Andre, Carl. *43 Roaring forty*, 1988. Staal, 100 x 4300 cm. Kröller-Müller Museum, Otterlo. Public domain. Wikimedia commons.

4.3. van Rijn, Rembrandt. *The Jewish Bride*, ca. 1665–1669. Oil on canvas, 121.5 cm x 166.5 cm. Rijksmuseum, Amsterdam. Public domain. Wikimedia Commons.

4.4. Praxiteles, *Hermes and the Infant Dionysus*, ca. 340 BC. Parian marble, Hermes measures 212 cm, detail. Archaeological Museum of Olympia. Public domain. Wikimedia Commons.

5.1. de Buoninsegna, Duccio. *Madonna with Child and Two Angels*, 1283–1284. Tempera on wood, 89 x 60 cm. Museo dell' Opera del Duomo, Siena. Public domain. Wikimedia Commons.

5.2. van Goyen, Jan. *Approaching Storm*, 1646. Groninger Museum, Groningen. Public domain. Wikimedia Commons.

5.3. Poussin, Nicholas. *Landscape with the Funeral of Phocion*, 1648. Oil on canvas, 114 x 175 cm. National Museum of Wales, Cardiff (on loan). Public domain. Wikimedia Commons.

5.4. Steen, Jan. *The Feast of St Nicholas [or St Nicholas Morning]*, 1665–1668. Oil on canvas, 82 x 70.5 cm. Rijksmuseum, Amsterdam. Public domain. Wikimedia Commons.

5.5. Titian, *Venus and Music*, ca. 1550. Oil on canvas, 138 x 222 cm. Madrid, Prado. Public domain. Wikimedia Commons.

5.6. Picasso, Pablo. *Female Figure with Hat, Sitting on a Chair*, 1938. Oil and sand on wood, 21 5/8 × 18 1/8 in. (54.9 × 46 cm) painting, 1991-55 E, © Estate of Pablo Picasso / Artists Rights Society (ARS), New York. Menil Collection.

5.7. van der Goes, Hugo. *The Portinari Altarpiece*, 1476–1479. Oil on wood, central panel: 253 x 304 cm, wings: 253 x 141 cm each. Galleria degli Uffizi, Florence. Public domain. Wikimedia Commons.

5.8. Lippi, Filippino. *The Intercession of Christ and Mary*, 1495. Oil on panel, 156 x 147 cm. Alte Pinakothek, Munich. Public domain. Wikimedia Commons.

5.9. Dürer, Albrecht. *Melancholie (Melencolia I)*, 1514. Copperplate, 24 x 18.8 cm. Public domain. Wikimedia Commons.

6.1. Bruegel the Elder, Pieter. *The Painter and the Buyer*, 1565. Pen and black ink on paper, 25.5 x 21.5 cm. The Albertina, Vienna. Public domain. Wikimedia Commons.

6.2. Walford, John. *The Gendered Eye*, 2008. Digital image. Permission by the artist.

6.3. Walford, John. *If Statues Could Envy, and Girls Meet Their Heroes*, 2007. Digital image, reformatted 2018. Permission by the artist.

6.4. Bruegel the Elder, Pieter. *Peasant Wedding*, ca. 1567. Oil on panel, 114 cm x 164 cm. Vienna, Kunsthistorisches Museum. Public domain. Wikimedia Commons.

6.5. Bruegel the Elder, Pieter. *Peasant Wedding*, detail. Public domain. Wikimedia Commons.

6.6. Bruegel the Elder, Pieter. *Netherlandish Proverbs*, detail, 1559. Public domain. Wikimedia Commons.

6.7. Bruegel the Elder, Pieter. *Peasant Wedding*, detail. Public domain. Wikimedia Commons.

7.1. Rollins, Tim, and K.O.S. *I See the Promised Land*, 2000. Permission by the artist.

7.2. Rubens, Peter Paul. *The Martyrdom of St. Livinus*, 1633–1635. Oil on panel, 84.5 x 59 cm. Museum Boijmans Van Beuningen, Rotterdam. Public domain. Wikimedia Commons.

7.3. Gaugin, Paul. *Vision After the Sermon*, 1888. Oil on canvas, 93.1 x 74.4 cm. Scottish National Gallery, Edinburgh. Public domain. Wikimedia Commons.

7.4. Mondrian, Piet. *Composition No. II (Composition with Blue and Red)*, 1929. 40.3 x 32.1 cm. Private collection. Public domain. Wikimedia Commons.

8.1. *Puer natus est nobis, Liber Usualis, Solesmes*, 1961. Public domain.

8.2. *The Good Shepherd*, ca. 450. Mosaic in Mausoleum van Galla Placidia in Ravenna. Public domain. Wikimedia.

8.3. Heda, Willem Claesz. *Breakfast Table with Blackberry Pie*, 1631. Gemäldegalerie Alte Meister, Dresden. Public domain. Wikimedia Commons.

8.4. van Rijn, Rembrandt. *The French Bed*, 1646. Etching, 126 x 224 mm. Rijksmuseum, Amsterdam. Public domain. Wikimedia commons.

8.5. Rouault, Georges. *Girl at the Mirror*, 1906. Watercolor, Chinese ink and pastel on carton, 70 x 55.5 cm. Centre Pompidou, Paris.

8.6. Anderson, Chris. *Historical Dislocations: History Repeats Itself (The Standoff)*, 1988. Oil on canvas, 122 x 183 cm. Permission by the artist.

8.7. and 8.8. Breninger, Warren. *Art as a metaphor for childbirth, no. 1 and 2*, 1986. Mixed media, 54 x 74 cm and 52 x 81 cm. Permission by the artist.

8.9. Recker, Joyce A. *Murmurs of the Heart*, 1990. Purple heart wood, found rock, chicken wire, 43 x 36 x 24 inches. Permission by the artist.

8.10. and 8.11. Wikström, Brit. *Seagull I*, 1984. Bronze, 32 x 60 cm. *Seagull II*, 1985. Bronze, 75 cm. Permission by the artist.

8.12. Wikström, Brit. *Woman*, 1984. Bronze, 110 cm. Permission by the artist.

8.13. Pas, Gerard. *Red Blue Crutches #1–#12*, 1986–1987. Lacquer-painted wood. Sizes are variable as each of these individual objects can be altered in size: their measurements range from approximately 139 x 23 x 35 cm to approximately 60 x 23 x 48 cm. Permission by the artist.

8.14. Pas, Gerard. *Vision of Utopia*, 1986. Watercolor on paper, 57 x 40.5 cm. Collection of McIntosh Gallery, Western University, London, Canada. Permission by the artist.

8.15. Bucher, Carl. *The Petrified*, 1979. International Red Cross and Red Crescent Museum, Geneva. Public domain. Wikimedia Commons.

8.16. Fafard, Joe. *Pasture*, 1985. Toronto Dominion Centre. Wikimedia Commons.

8.17. Grünewald, Matthias. *Isenheim Altar*, center panel, 1512–1516. Public domain. Wikimedia Commons.

8.18. Perugino, Pietro. *The Crucifixion with the Virgin, St. John, St. Jerome, and St. Mary Magdalene*, center panel, ca. 1485. Public domain. Wikimedia Commons.

8.19. Grünewald, Matthias. *The Small Crucifixion*, 1519. Public domain. Wikimedia Commons.

9.1. Lin, Maya. *Vietnam Veterans Memorial*, Washington D.C., 1982. Wikimedia Commons.

9.2. The Bogside Artists, *Death of Innocence (Annette McGavigan)*, 1999. Lecky Road, Bogside, Derry, Northern Ireland. Martin Melaugh.

9.3. Kollwitz, Käthe. *Working Woman (with Earring)*, 1910. Soft-ground etching on woven paper, 31.4 x 23.7 cm. Brooklyn Museum. Public domain. Wikimedia Commons.

9.4. Kollwitz, Käthe. *Woman with Dead Child*, 1903. Line etching, drypoint, emery, and vernis mou with printing of handmade paper and Ziegler'schem transfer paper, with gold-colored, injected clay stone, 40.7 x 47.5 cm. Public domain. Wikimedia Commons.

9.5. Kollwitz, Käthe. *Municipal Shelter*, 1926. Crayon lithograph, 42.4 x 56.4 cm (varying). Public domain. Wikimedia Commons.

10.1. Bigelow, Kathryn. Still from the movie *Zero Dark Thirty*. Columbia Pictures, 2013.

10.2. The NAMES Project AIDS Memorial Quilt, shown in various places since 1987. Wikimedia Commons.

10.3. Recker, Joyce. *Earth's Lament*, 2003. Permission by the artist.

11.1. Cézanne, Paul. *Still Life with a Curtain*, ca. 1898. Oil on canvas, 55 x 74.5 cm. Hermitage Museum, Saint Petersburg. Public domain. Wikimedia Commons.

11.2. Lin, Maya. *Vietnam Veterans Memorial*, Washington DC, 1982. Wikimedia Commons.

11.3. Ofili, Chris. *The Holy Virgin Mary*, 1996. Acrylic, oil, polyester resin, paper collage, glitter, map pins, and elephant dung on canvas, 99 3/4 × 71 3/4' (253.4 × 182.2 cm). Gift of Steven and Alexandra Cohen. Acc. no.: 211.2018.a-c. Digital image, The Museum of Modern Art, New York/Scala, Florence.

12.1. van Rijn, Rembrandt. *Head of Christ*, ca. 1648. Oil on oak panel, 25 x 21.7 cm. Gemäldegalerie of the Staatliche Museen Berlin. Public domain. Wikimedia Commons.

12.2. Cézanne, Paul. *Still Life with Peppermint Bottle*, 1895. Oil on canvas, 65.7 x 82 cm. National Gallery of Art, Washington, DC. Public domain. Wikimedia Commons.

12.3. Mulders, Mark. *The Last Judgement*, 2006. Sint-Janskathedraal, Den Bosch. Permission by the artist.

13.2. Duccio. *Madonna and Child*, 1290–1300. Tempera and gold on wood, 23.8 x 16.5 cm. The Metropolitan Museum of Art, New York. Public domain. Wikimedia Commons.

13.3. Raphael. *Colonna Madonna*, 1507–1508. Oil on wood, 77 x 56 cm. Gemäldegalerie Berlin. Public domain. Wikimedia Commons.

13.4. Turner, Orren Jack. *Einstein*, 1947. Public domain. Wikimedia Commons.

13.5. Passport photo of Albert Einstein. Public domain.

13.6. Goya, Francisco. *El Tres de Mayo (The Third of May)*, 1814. Oil on canvas, 2.6 x 3.4 m. Museo del Prado, Madrid. Public domain. Wikimedia Commons.

GENERAL INDEX

abstract
 art, xiii, 22-24, 26-28, 97, 107, 153, 156,
 161-62, 164-66, 169, 226, 321
 concepts, 37, 290, 314
 expressionism, 333, 348
 science, 284
 techniques in art, 43, 388
 thinking, 280, 288
abstraction, xiv, 22, 27, 153, 161-62, 168,
 269, 280
action, xv, 140, 177, 280, 292
 Art in Action (Wolterstorff), 219, 263
 artistic, 50, 196
 in artwork, 114, 157
 divine, 158
 human, 49, 66
aesthetic
 aesthetic values in relation to
 gender, 128-30
 analysis of aesthetic quality, 132-33, 206,
 222, 296
 artifacts and work, 68-69
 contemplation, 122, 211-12, 293, 387
 dimension, xv, 79, 128, 133, 223,
 240-43, 345
 function, 69-72, 79
 Greek, 58
 harmony, 75-76
 history of aesthetic style, 225, 371
 life and activities, 50, 52-53, 212, 297,
 343, 346
 norms, 72, 345
 opinions on the aesthetic, 17, 37, 48, 206,
 211-12, 291, 343, 346, 368
 physiology of aesthetic experience, xv, 279,
 281-82, 286-87, 289

 qualities/elements of artwork, 78, 114, 122,
 165, 184, 220, 237, 267-74
 sphere, xiii, 39, 49-50, 54, 64, 67-68, 70-77
 theory, 63-66, 79
aesthetics, xi, xiv, 18, 67, 127, 283, 290, 307-8,
 315, 316, 342, 345-46, 349, 354-55,
 368-69, 371-72
 Calvinist and Neo-Calvinist, 35-36,
 275-77, 292
 Christian, 70
 founder of aesthetics, Baumgarten,
 Alexander, 277-78
 Kuyper and reformational aesthetics, 50,
 52, 240, 261-65
 The Meaning of the Body: Aesthetics of
 Human Understanding (Johnson),
 287-88
 theological, 312, 321, 333, 359, 380, 382
agency, 260
agent, 104, 168, 264-65, 295
allusive, 177, 184, 198, 263, 291, 344-46, 348,
 352, 355
Aquinas, 269, 339
Aristotle, 182
arrangement, xiii, 67-68, 76, 241
artifact, 68, 74, 206
artifacts, 50, 54-55, 66, 68, 71, 77, 132, 242,
 361, 369
Augustine, 66, 339-40
beautify, 230, 354
Begbie, 330, 359-60, 373-76
Calvin, John, xi-xii, 66, 289, 356, 385
 on art, 3, 9, 17, 35, 46, 386
 ban on images, 40-45
 criticism of art, 4, 36-38
 portraits of, 39-40

SCRIPTURE INDEX